ENCYCLOPEDIA OF FLOWERS

Makoto AZUMA
Shunsuke SHIINOKI

ENCYCLOPEDIA OF FLOWERS

Makoto AZUMA
Shunsuke SHIINOKI

LARS MÜLLER PUBLISHERS

ENCYCLOPEDIA OF FLOWERS

Flower works by Makoto AZUMA
Photographed by Shunsuke SHIINOKI

HYBRID ————————————————— 213

\ˈhī-brəd\ cross, mix, crossbreed

One variety is a result of natural crossbreeding,
while another is the product of artificial crossbreeding
for the purpose of beauty, and another is a product of
changes in the environment that yield a new, natural form.

APPEARANCE ——————————— 337

\ə-ˈpir-ən(t)s\ existence, look, posture

With time held in abeyance, a portrait that captures
the moment of a life's blossom in full glory,
gradually withering and changing.

Being in the Middle of
the Life and Death of Flowers

Makoto AZUMA

florist and artist

Creating a flower bouquet is first and foremost an extremely egoistic act. Only flowers that have grown in the wild are beautiful enough; for all that—cut from their roots, their branches removed—they are freely bound with completely different specimens. I have spent more than fifteen years dedicating each day to this activity, looking, without interruption and singularly focused, at the close proximity of life and death. By rough estimate I've probably cut over a hundred million flowers into pieces. There is a beauty to flowers and there are those who are charmed by that beauty. But my engagement with flowers is more of a confrontation, as I clutch at our two lives rubbing together. Moment after moment, as flowers continue to wither as I arrange them, my consciousness focuses intensely on one point alone: to what extent I can draw out the life of the flower and make it conspicuous, bringing it to life by killing it. That is the fate imposed upon my profession.

I made my first foray into this world at the age of twenty-one. I started working part-time at a typical flower shop, the kind found next to any

supermarket. My family's business, however, was not a flower shop or flower arranging (ikebana); I was brought up in an environment totally devoid of any relation to flowers. For me, flowers were something that bloomed in the wild unbeknownst to anyone or were raised by mothers in their backyard gardens. It was for that reason that working in a flower shop seemed entirely new to me. Visiting the Ota Flower Market (in Tokyo) for the first time left quite an impression on me. It was an honor to be there, at Japan's largest wholesale flower market. There was such a large variety of flowers, many of which I hadn't seen before.

Amongst these specimens, there were none of the natural flowers I expected to see. Instead, the flowers were just products made by people, controlled, distributed, and consumed in mass quantities. That is the highly artificial form that nature takes in Tokyo. The market not only had flowers produced in Japan but also flowers imported from across the seas, flowers from the tropics of Southeast Asia as well as from the Amazon, and even rare varieties of flowers that only exist in the harshest, coldest regions of the world. They were all brought here to Tokyo. The value of rare specimens from the wild is measured by the money they command at market. Flowers from the Southern Hemisphere were brought here, too. Thus, flowers in bloom in the middle of winter in the Southern Hemisphere were available for sale in mid-summer in Tokyo. Everything is mixed up. So much so that any sense of seasons,

the particularity of a climate, or the special quality of a breed no longer possesses a fixed definition. Instead, there is chaos. It takes the form of the here and now of the Tokyo ecosystem. The market is a miniature simulacrum of the unfaltering desire for an ever-new beauty, a reflection of our consumerist society and the constantly evolving world in which we live. That market and Tokyo itself have become my stage.

The Ota Flower Market is quite special, even within a global context. According to a 2011 study by Japan's Ministry of Agriculture, Forestry and Fisheries, alongside the United States, the Netherlands, and China, Japan is one of the world's largest producers of flowers. It is surprising that this small country can produce such a copious amount. There are more than 70,000 varieties in circulation in the market. In addition, every year two or three thousand new varieties or hybrids are artificially crossbred or refined, evidence of the high level of technical ability of the manufacturers who continually produce new kinds of flowers. The same level of precision in Japan's machines and industrial products can also be found in this country's agriculture, which couples technology and craft. This union develops most rapidly in the flower industry, and creates a large number of the finest specimens, both for Japanese and international markets. Producers cultivate their flowers with the utmost care and devotion, and their creations reach the level of a handcrafted object graced with well-balanced beauty. When compared to fruit and

vegetable production from outside of Japan, this precision is quite evident. Japanese produce is homogenous in both shape and size, and neatly packaged into individual cases. Flowers are treated in the same manner. Each petal of the flower is perfectly aligned, possessing robust color and vibrancy, and an astonishing shape. The volume and quality of production is outstanding. This is Japan's premier flower market and it also supports the creation of my work.

Such a flower market is prone to rapid and dramatic change, a change born directly from a desire found only in man. Market demands drive the creation of new varieties. According to the laws of the market, varieties that do not sell are immediately replaced by those that do. If a variety doesn't sell, it disappears; if it is in demand, then it will be produced and sold at a high price until the market tires of it. This is the universal principal of any marketplace. In just the past fifteen years I have come across many new varieties; in some instances, those I have used until last year have disappeared entirely from the market. The desire for something more beautiful, something newer, is what drives this market and determines whether a variety will continue to exist. As a result, compared to ten years ago the character of the flower market is now completely different. The rate at which flowers are introduced is so high that there is often no time for them to be named. That is a testament to the breadth of flower varieties being created. There are tens of

thousands of plants without an official name. Plant nomenclature—the scientific name shared throughout the world—is itself the result of botanical research. With the discovery of new species or the development of a variety or hybridization, names need to be assigned, and once every six years the International Botanical Congress convenes to revise the established nomenclature.

Flowers and plants are sensitive to the smallest of environmental changes, even more sensitive than humans. In the last several years, for instance, the color of cherry blossoms has gradually gotten whiter. There is no definite cause for this, but it is evident that the cherry blossom has changed. Those of us who work in the field can sense that change on our skin. An alteration in the environment leads to the extinction of a species of flower or a change in its shape. At the same time it stimulates the birth of new varieties. Within our dramatically changing environment, flowers give pleasure to the eye and touch the heart, fulfilling their duty with their small and brief existence. There isn't a single bud with a useless existence. Whatever the flower, it was born with a reason for being.

In 2002, I made a firm determination to stop working in a flower shop, and, together with Shunsuke Shiinoki, opened a "haute-couture" flower shop in Ginza (now located in the Minami Aoyama area). With haute couture, all the designs, materials, and arrangements are custom-

ordered. That is why we do not cut flowers in the flower shop. It is a flower shop without flowers, which explains the appellation of haute couture for what we do. A flower with even the smallest of bruises or that is beginning to wither is no longer sellable. A flower shop stocks a large volume of flowers, displays them, carries stock, and then, when they lose their commercial value, a large volume is thrown away. We did not want to throw away flowers. We borrow materials from nature and follow an inviolable rule: that existence will not be mistreated. Everything we as people have received—our very existence—we owe to nature. Occupying the fields and mountains, we have raised buildings and built cities. We have self-indulgently exploited nature, using it solely for our own aims. This cannot be undone. Even still, we coexist with nature. We are brought to life by nature. For that very reason, we must think deeply about nature, understand it, and continue to respect it. We cannot ignore this dynamic, nor can the coexistence of nature and man be planned. In choosing haute couture as our methodology, we looked to find a way to stop the loss of life, even in our own humble way.

While we are in the business of selling flowers, making arrangements based on received orders, we also search for different means to express the life that resides in plants and flowers. By showing the true form nature takes, we ask: What does it mean to live, what does it mean to exist? For that reason, it is essential to express these questions in flowers.

They play a significant role in our lives. We give them to those important to us on birthdays, to celebrate weddings or births, to symbolize condolence at a time of death. In ceremonies throughout our lives flowers are an indispensable presence. And this is not a new tradition. There have been discoveries of offerings of cut flowers to the deceased, now petrified, dating from the Jōmon period (ca. 10,000 to 300 BC). As an expression of life, celebration, appreciation, as well as condolence, people want flowers to make offerings. In this way, flowers have been introduced into man's consideration of life and death. From the mid-2000s, we started making what we call Botanical Sculptures from flowers and plants, releasing them domestically and internationally.

At the same time, Shiinoki took up the camera. His work begins the moment a flower is cut from its root and gradually starts to decay. As it changes shape and its life begins to fade, the photographs capture a moment, containing it in stilled time. Every day I focus on emotion and sensation, literally extinguishing life as I cut flowers. Meanwhile, Shiinoki watches this process at my side. Just as I complete my work, he photographs it. As I continue a process of trial and error, hollowing out a life force, that is the moment of a life's blossom in full glory, and that is the moment being captured. And yet, much like a man's life that cannot be summarized by one's twenties and thirties, a full bloom encapsulates the totality of life, from birth to death. Life exists as a cluster.

The true glory of flowers cannot be reduced to that time of life's blossoming, when they reach their peak commercial value. Which is why my arrangements include roots and bulbs, nameless weeds, or fifty-year-old pine bonsai. Plants wither and decay. It is their essence and their drama.

Outside of Japan my activity is considered Neo-Ikebana, along the lines of an avant-garde form of traditional ikebana. It is because I am a Japanese artist who has mastered the traditions of ikebana and bonsai, but also make use of non-traditional materials. I make use of materials like stainless steel, and mount large-scale installations and performances. And yet, it is only the giving of form. In other words, ikebana is a formalism based on a visual appreciation of the flower. In a sense, ikebana exists in a world of forms. But without breaking down those forms, the flower itself, the life that resides in the flower, cannot be touched or approached. Our predecessors saw artistry in flowers, the beauty of nature, eros, thanatos, culture, and metaphor. These are now no longer necessary. Stripping away form, what can be seen is the bitingly mad being of life. That is all that is needed. The works included in this volume are a record of the battle with form we wage every day—an exposure of life in its bare state.

The photographs in this book span approximately three years of work, starting in 2009, created in a studio in Tokyo's Minami Aoyama area.

At present, in 2012, unusual specimens that grow in the wild and artificially developed nature are in competition. This is a representation of the real aesthetic sensibility of people at this moment. However, they are images and, just as with a flower's life, they too will be extinguished. With the flow of generations, market trends, and alterations to the environment, it will all change. For this reason, the shape, the weight of its essence, has taken the form of this book. There is no fighting the advance of time, and I felt strongly about leaving a permanent record of this ephemeral life. In that sense, this book is an extension of what I have repeatedly done; it is as though I have arranged a bouquet using paper as my container. There is no aroma, no haptic quality; even if one changes the vantage point, the underside of the arrangement is not visible. In a semi-permanent way, the bookshelf is this book's forest, where it continues to blossom and the semblance of the life force it contains persists.

I chose the title *Encyclopedia of Flowers* because this book functions as an encyclopedia of the large variety of flowers raised on this planet. The book is also a microcosm unto itself. The book's appendix lists the names of the flowers and plants used. The mere fact that flowers have names is evidence that there has been artificial manipulation or intervention. A flower has either been discovered or created by man. In other words, nomenclature is man's fingerprint on nature. The attribution of

a binomial scientific name of genus and species—in some instances the name of the discoverer or the plant's developer is also used in the flower's name—to a flower is a process that barely maintains the connection of a cut flower with the roots from which it was cut. I researched as deeply as possible the accurate scientific name of each of the specific plants and the various flowers. Making this list required a great deal of effort. But, making the origins of each flower clear is an expression of deep respect and appreciation for all the decaying flowers that did not make it into the book.

There is another reason why I chose the word *encyclopedia*. The etymology of the word comes from Greek: *cyclo* means "round" or "circulation"; *pedia* means "child" or "education." Born, raised, matured, and then growing old and dying—the passage of time. Then—rebirth and decay. Everything is so—in a continuous, endless cycle. An encyclopedia is a manifestation of the workings of life itself. The seeds sown here will hopefully take root in the hearts of people, sprout buds, and carve out time in a new life. This is my aspiration in making this book. It is a hope for an earth where rich and fertile soil continues to exist—a hope that resonates with the spirit that resides within these flowers.

WHOLE

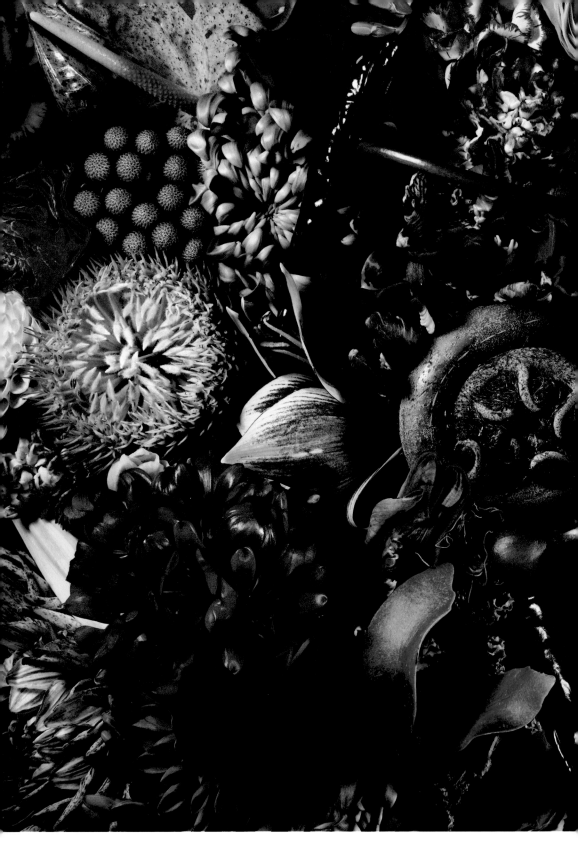

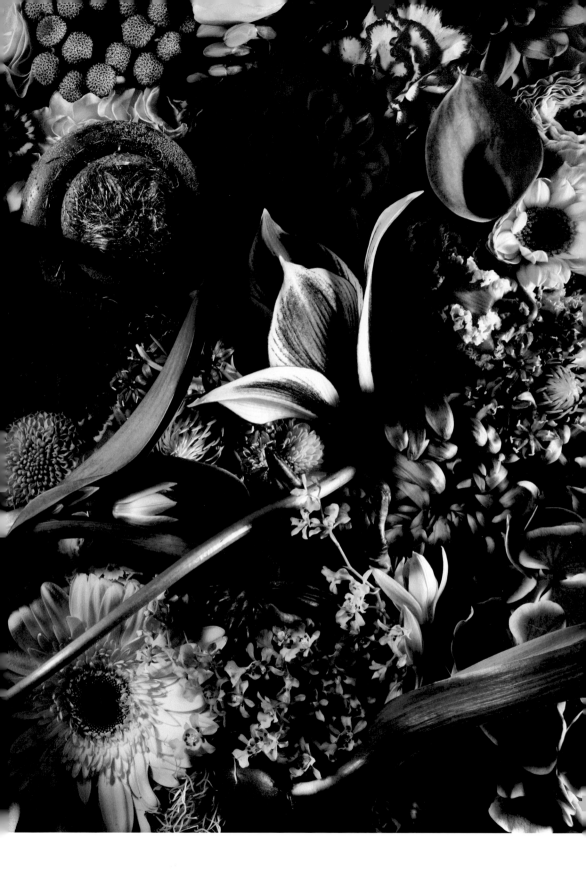

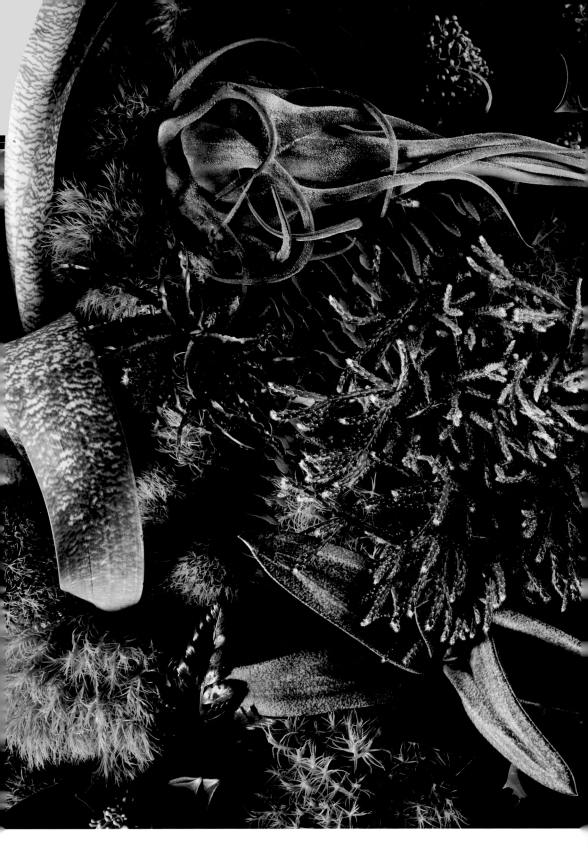

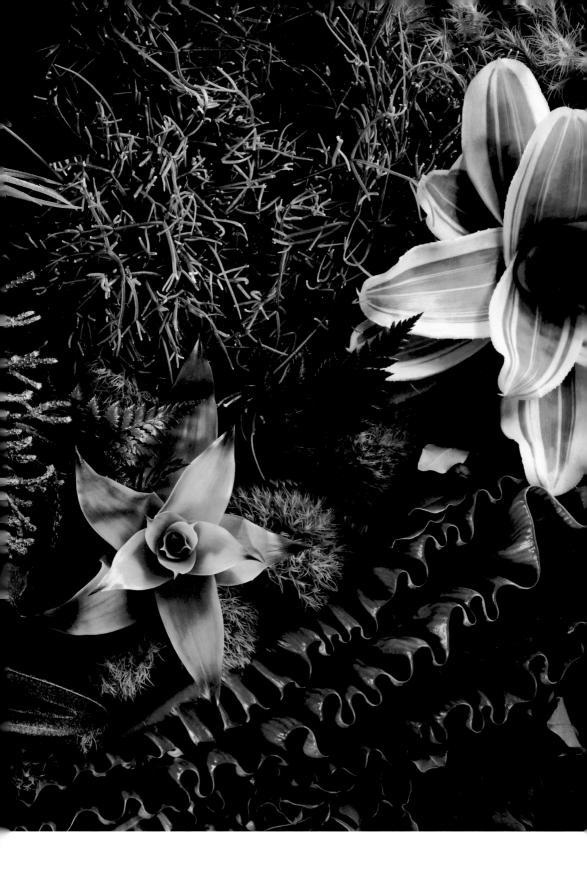

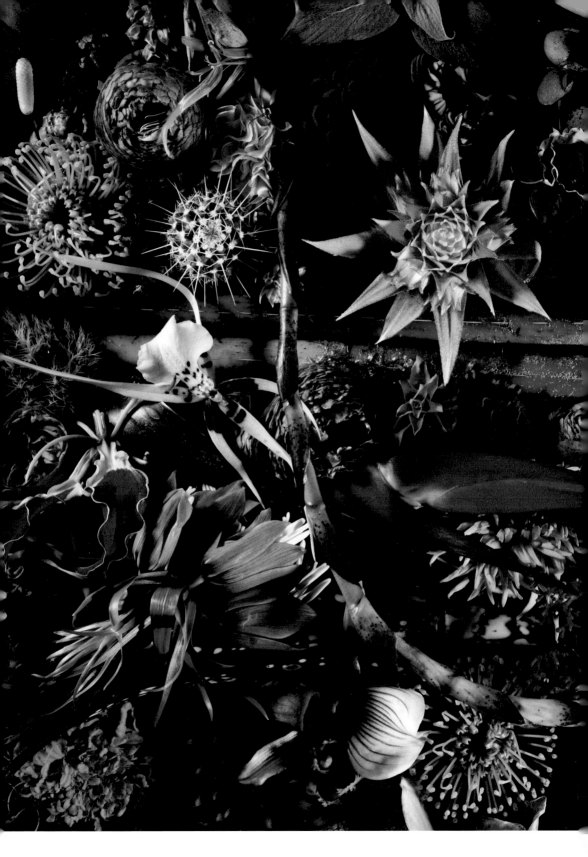

WHOLE 03

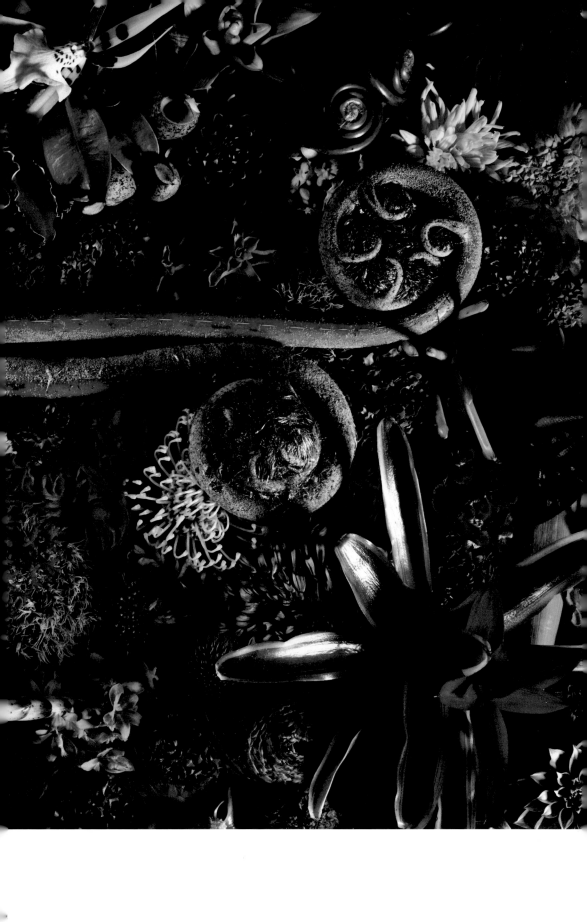

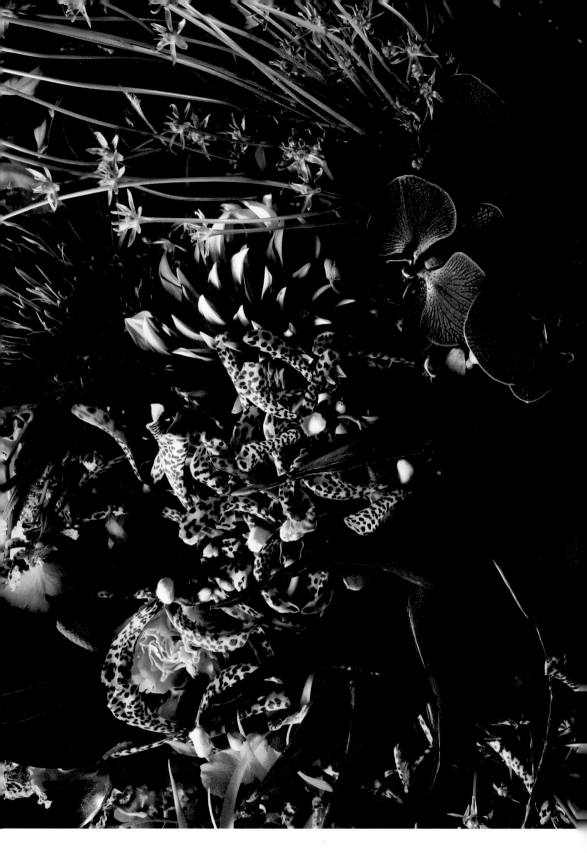

WHOLE 04

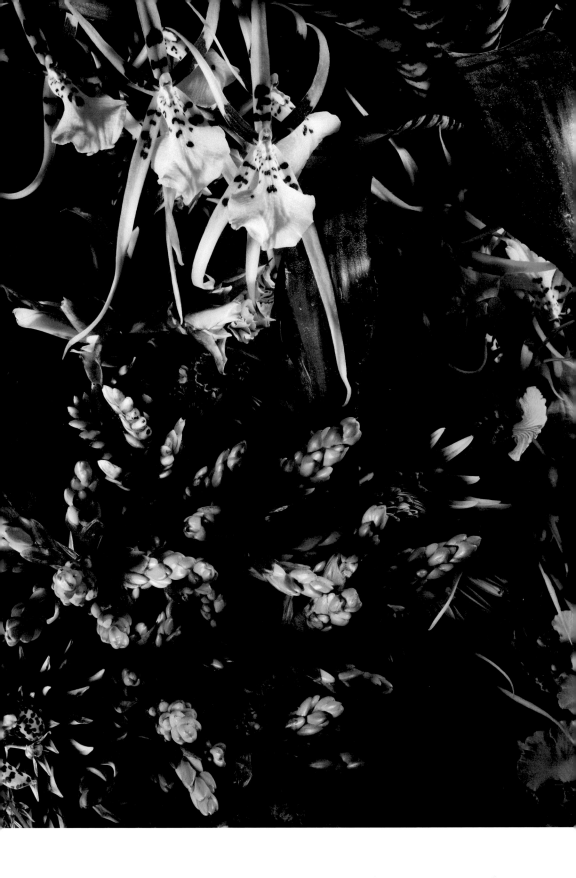

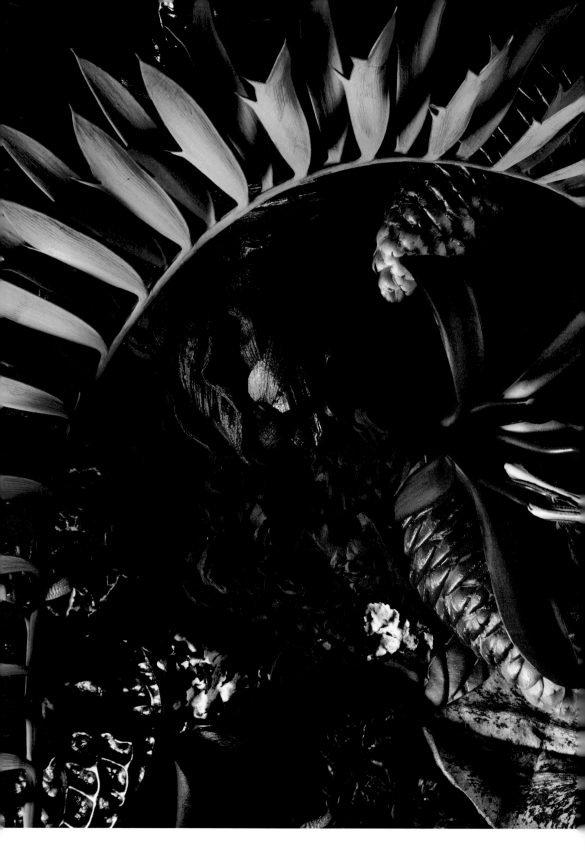

WHOLE 05

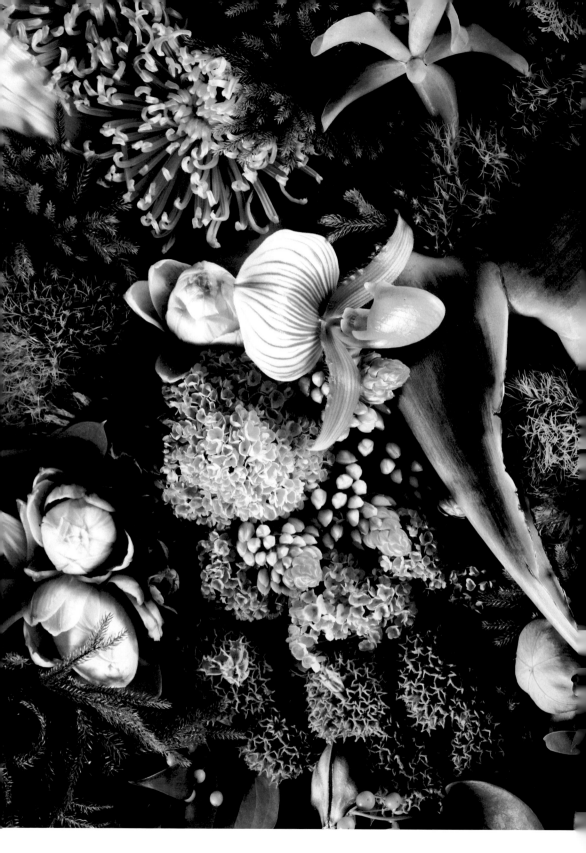

WHOLE 06

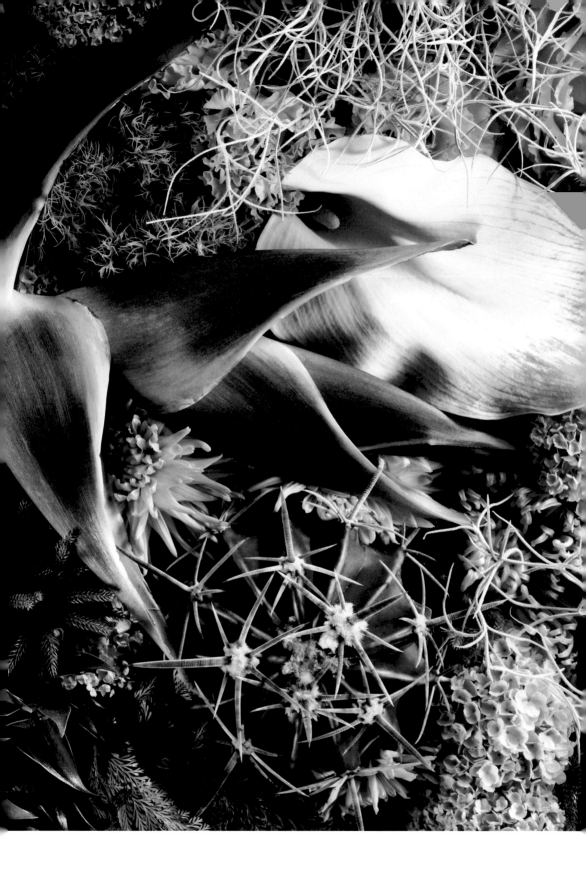

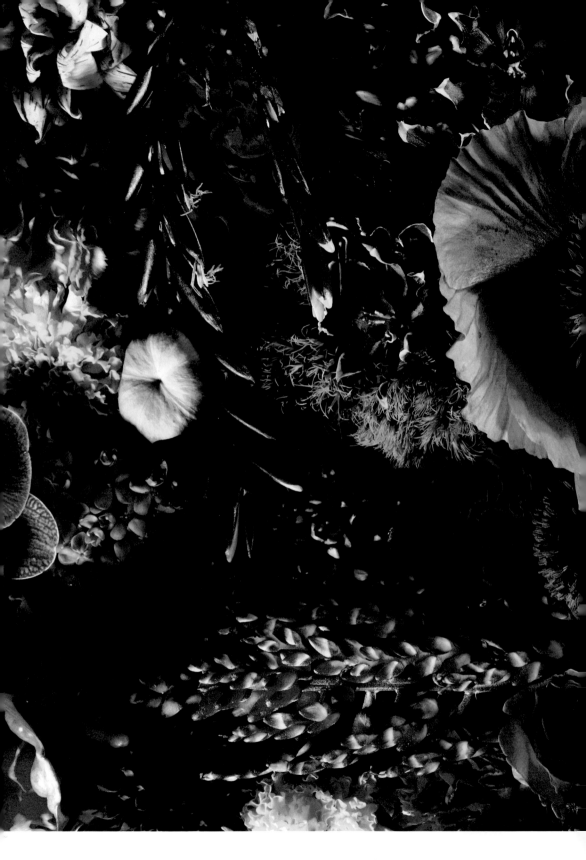

WHOLE 07

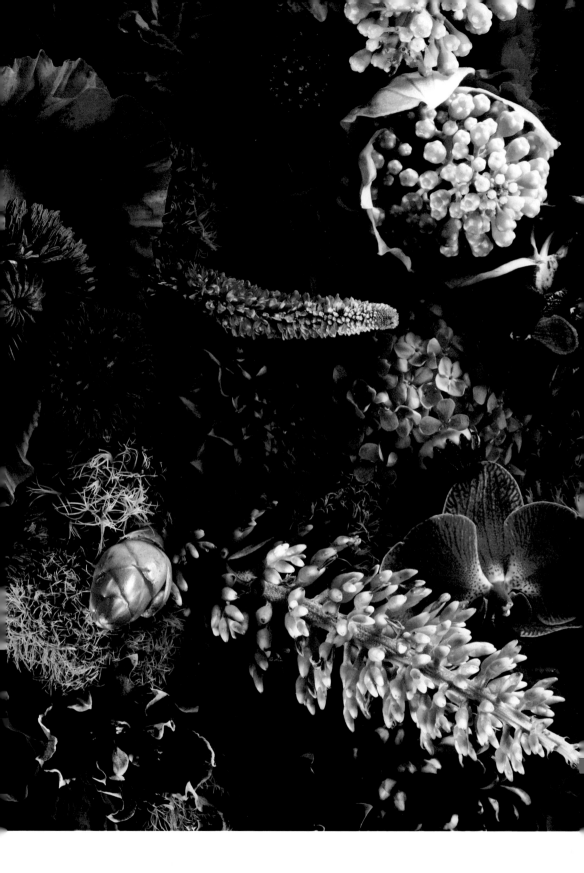

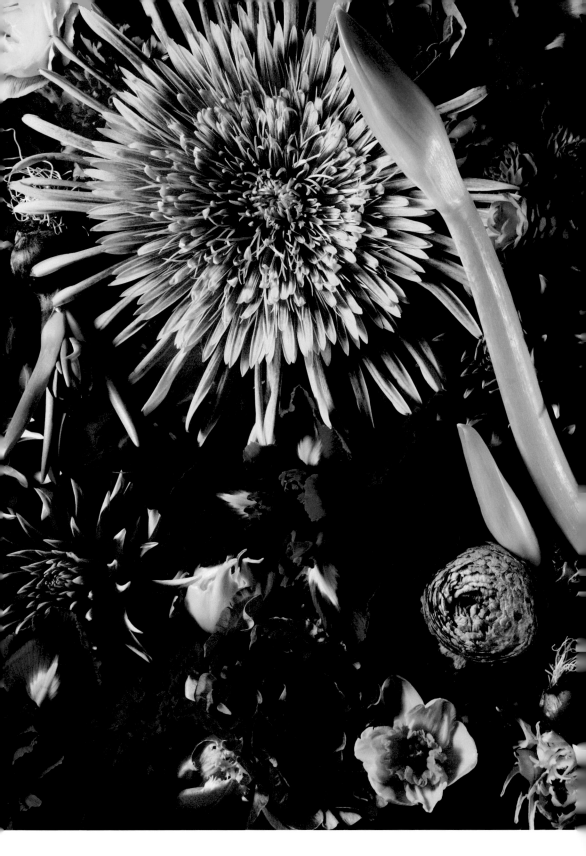

WHOLE 08

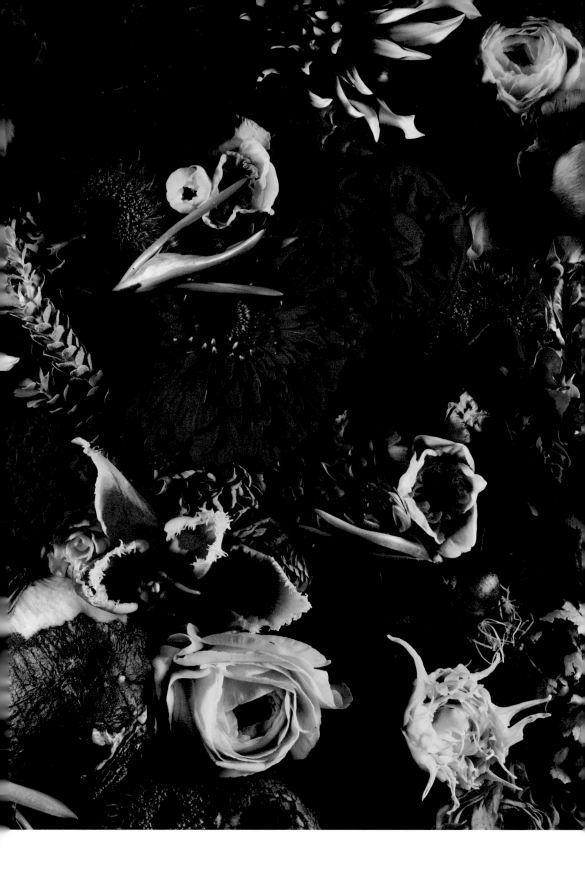

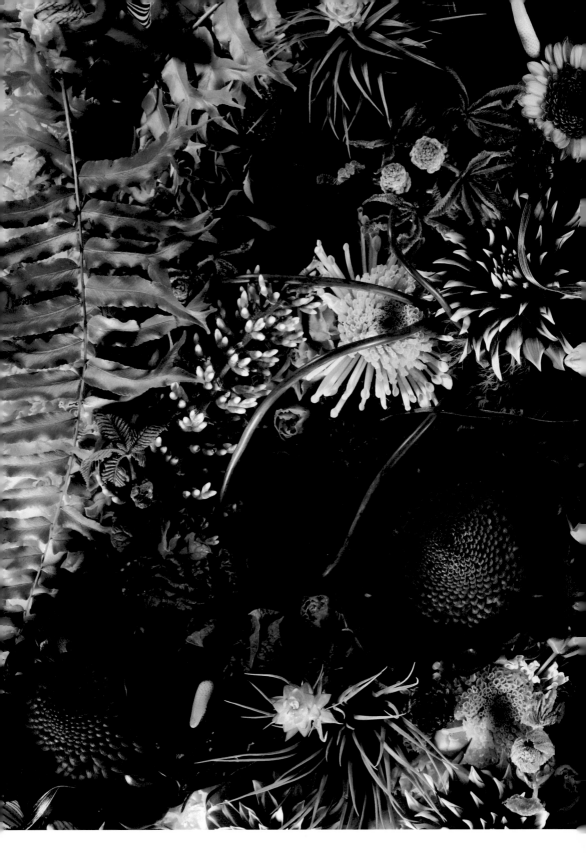

WHOLE 09

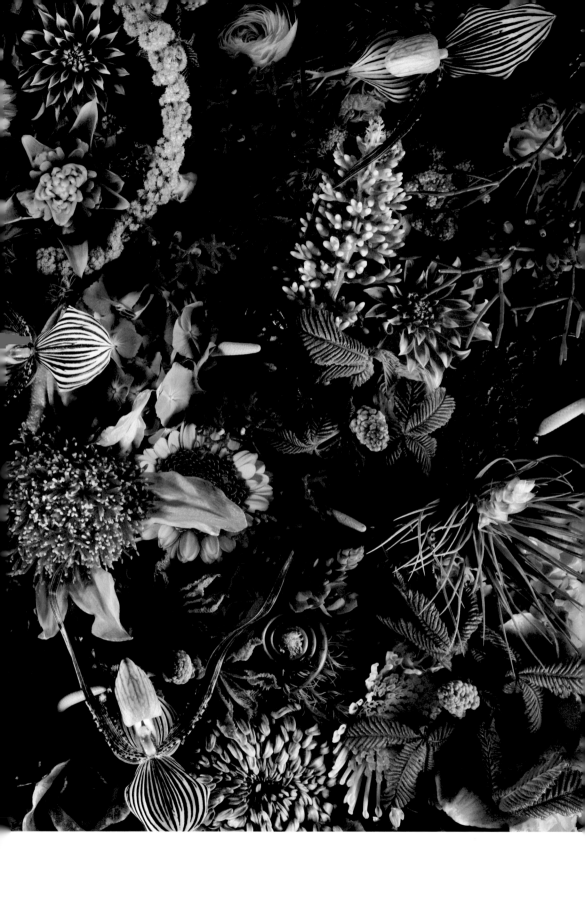

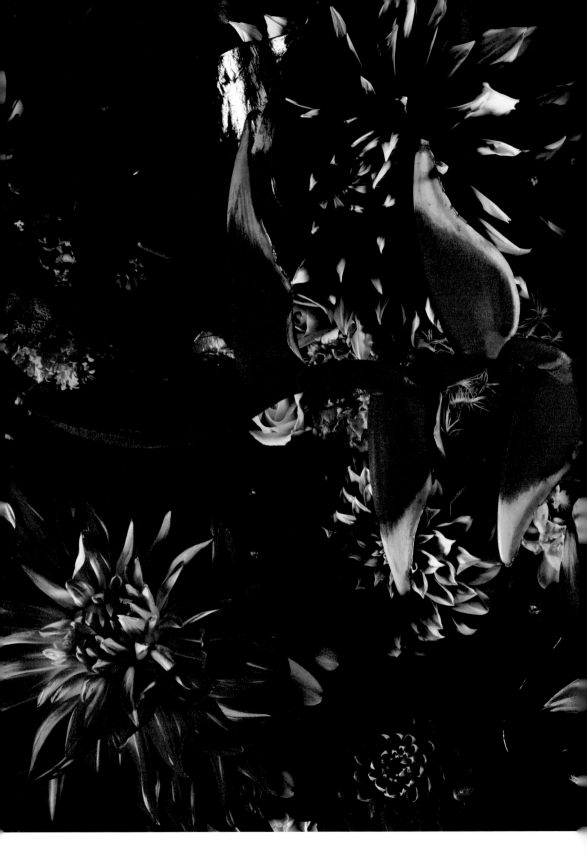

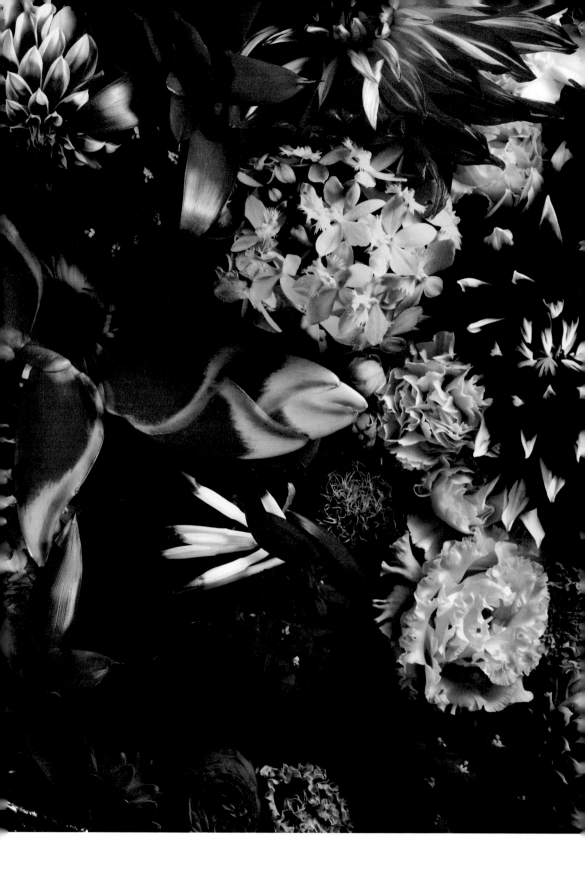

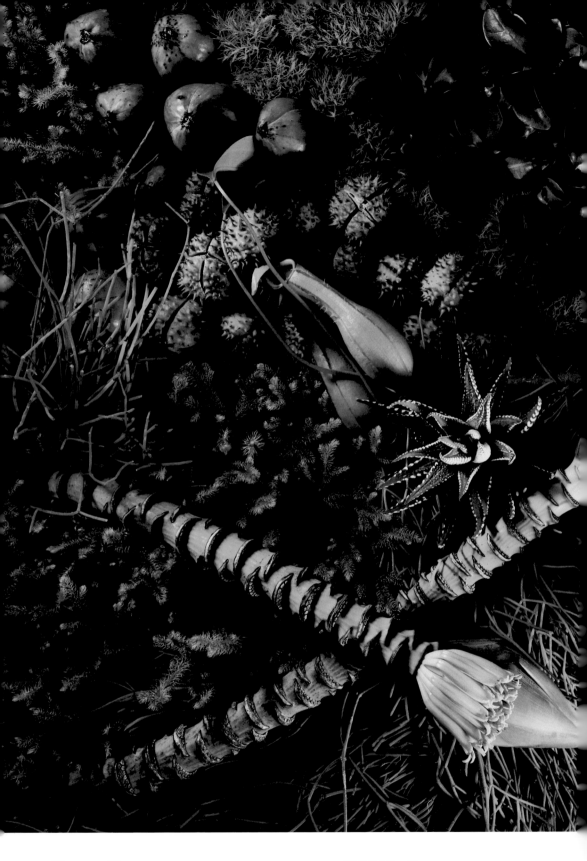

WHOLE 11

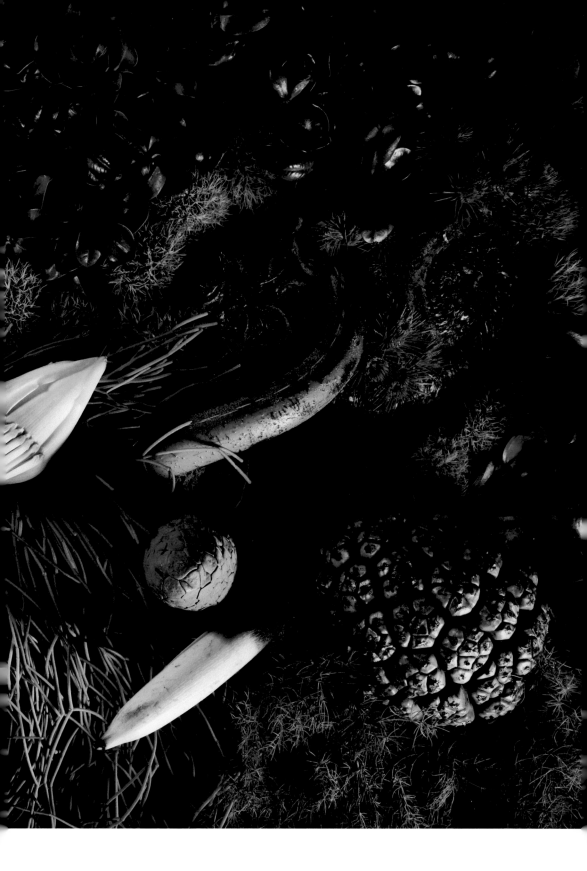

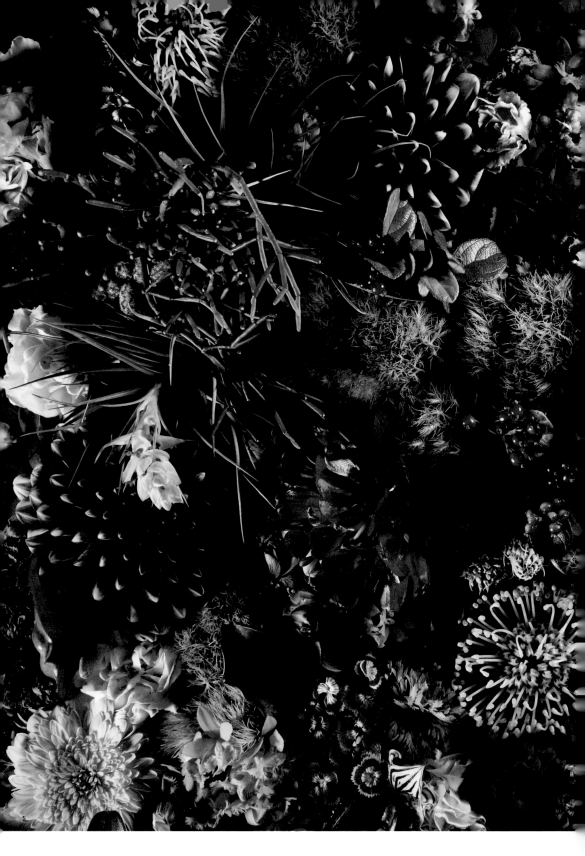

WHOLE 12

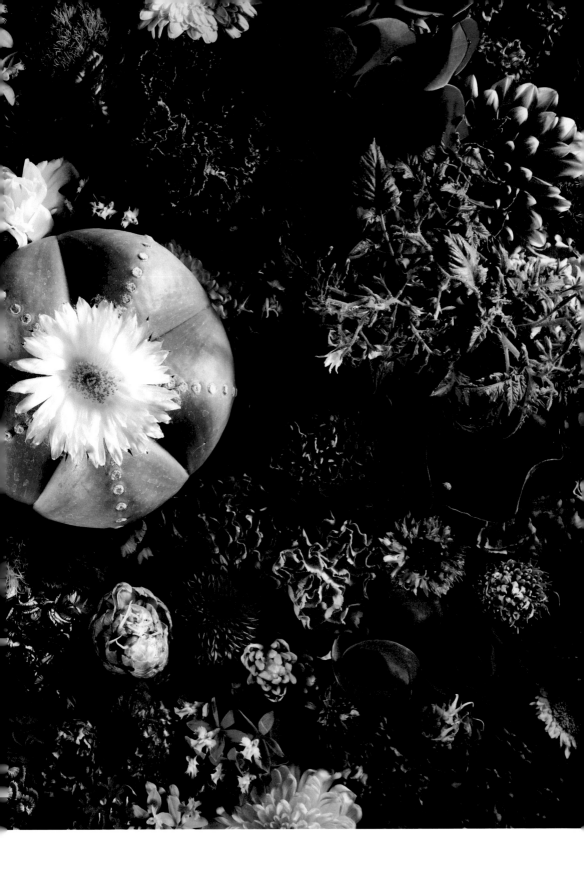

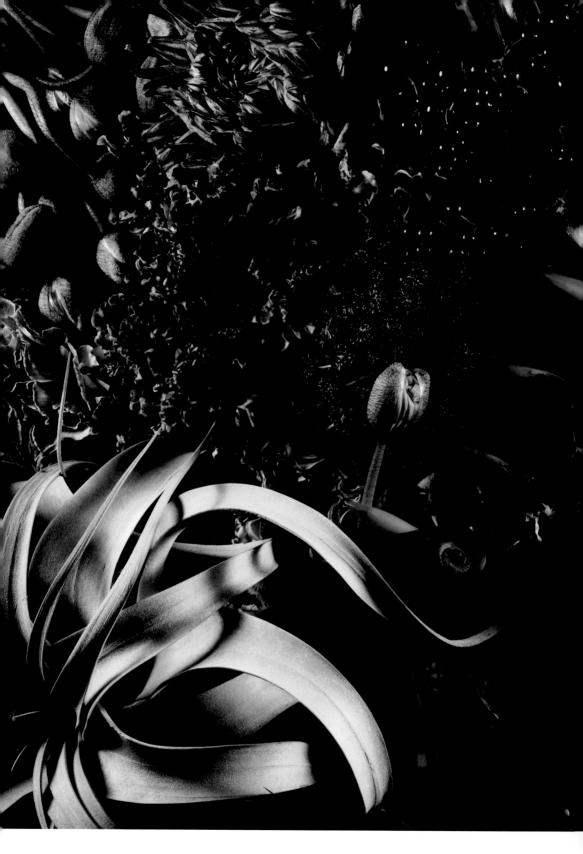

WHOLE 13

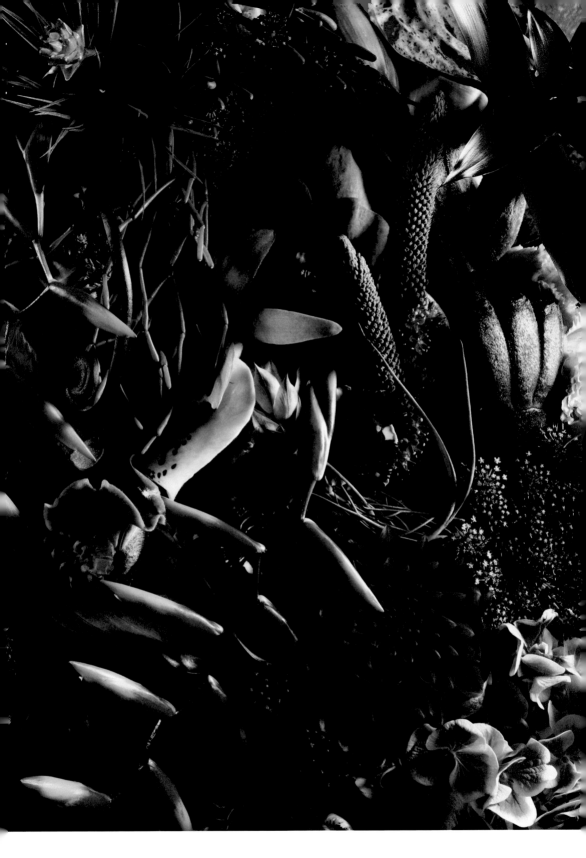

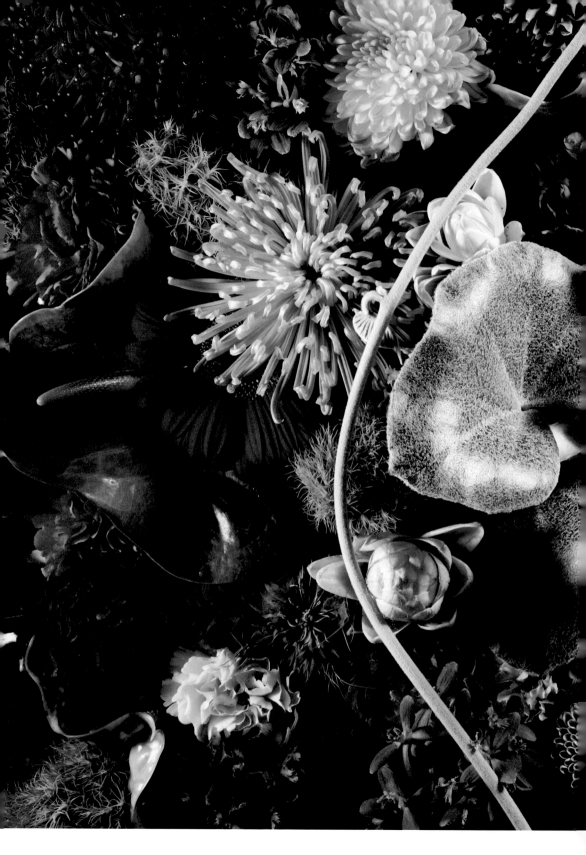

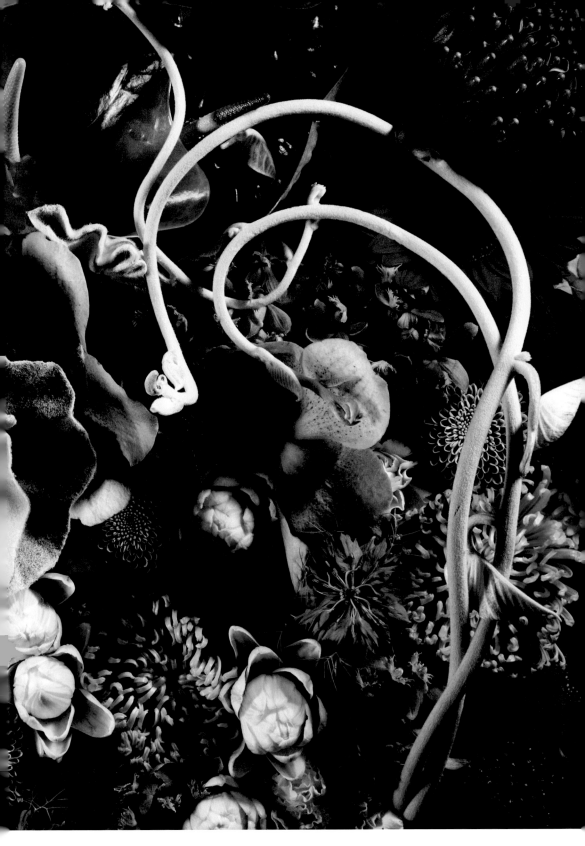

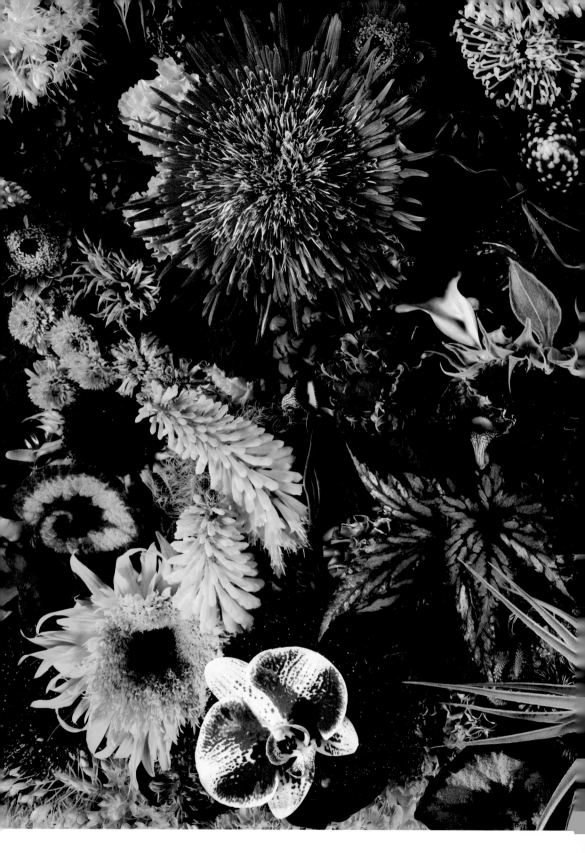

WHOLE 15

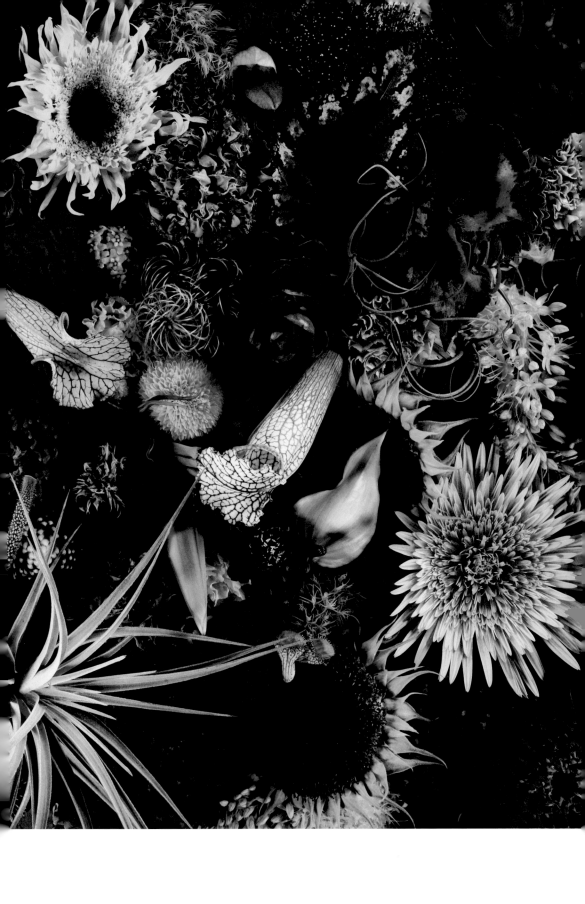

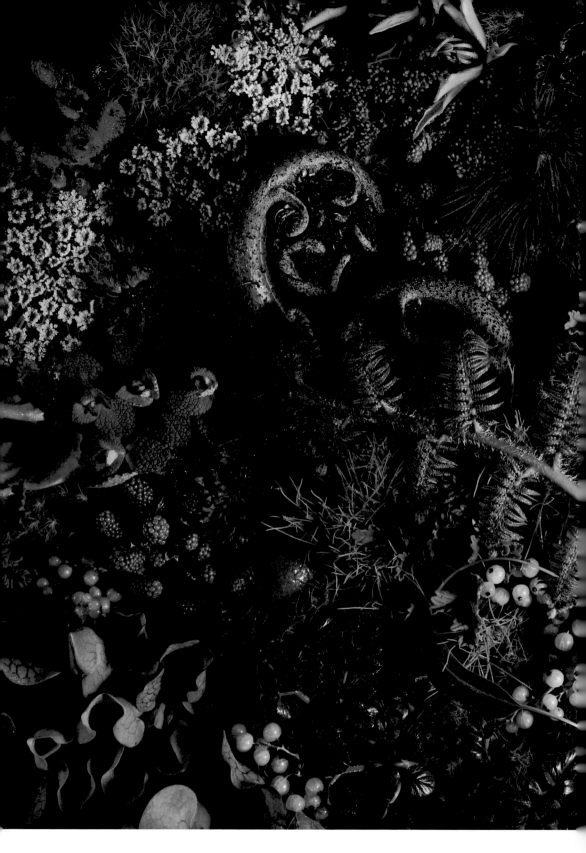

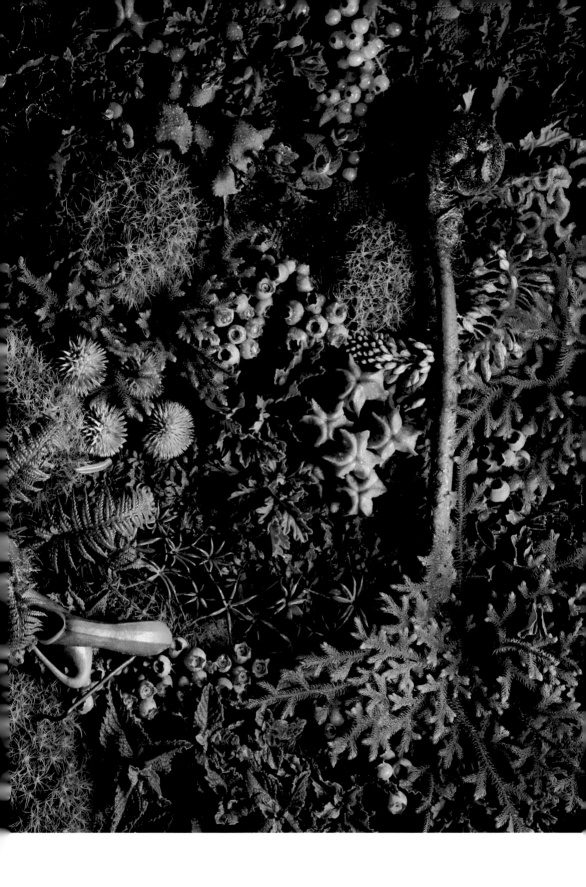

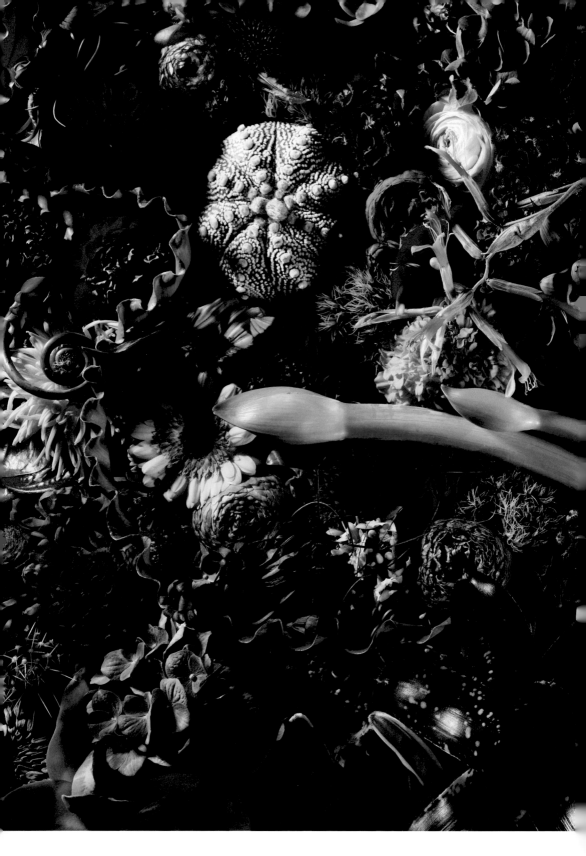

WHOLE 17

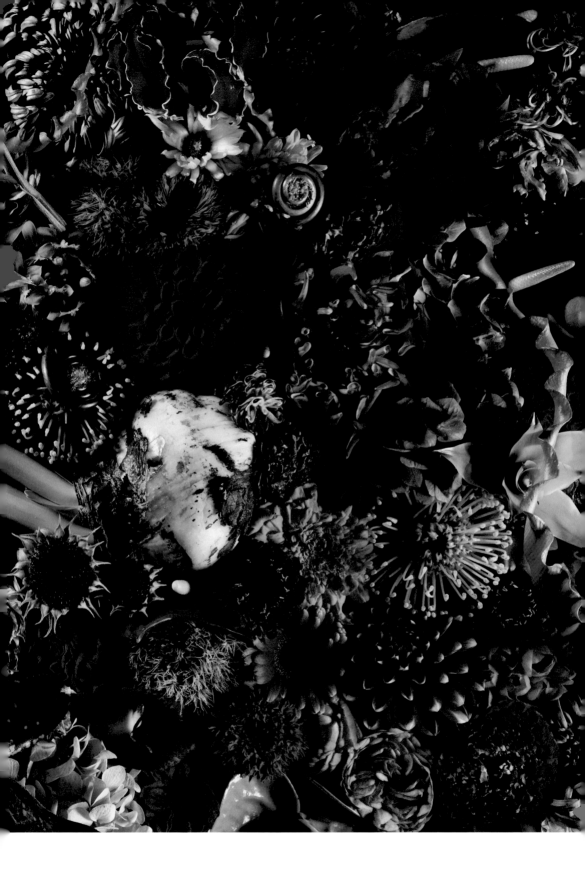

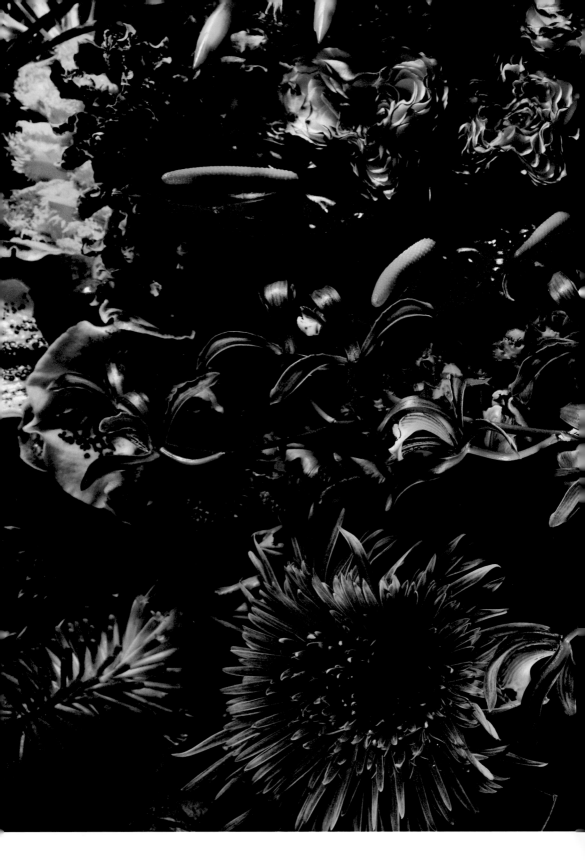

WHOLE 18

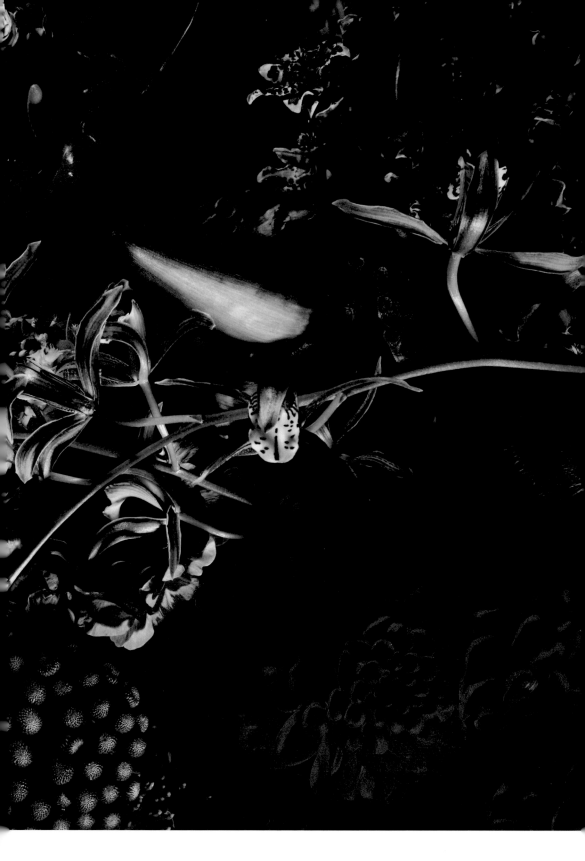

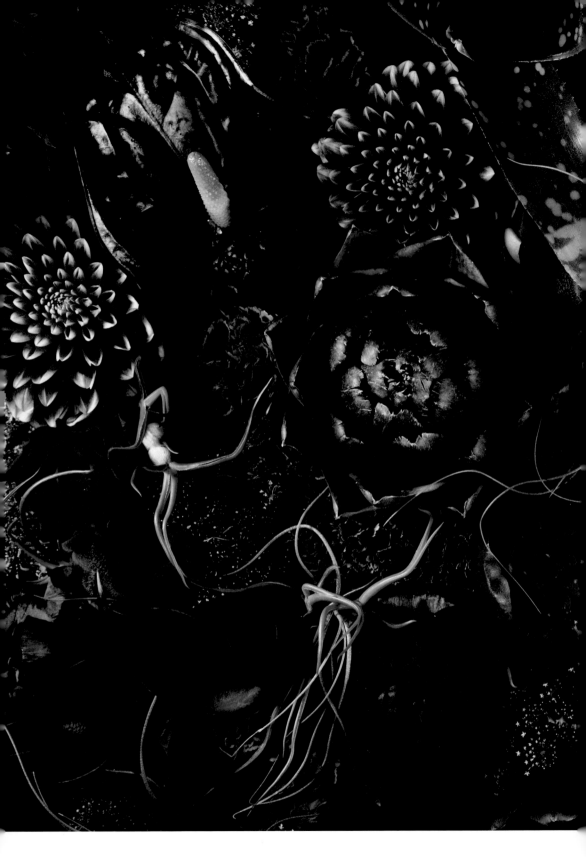

WHOLE 19

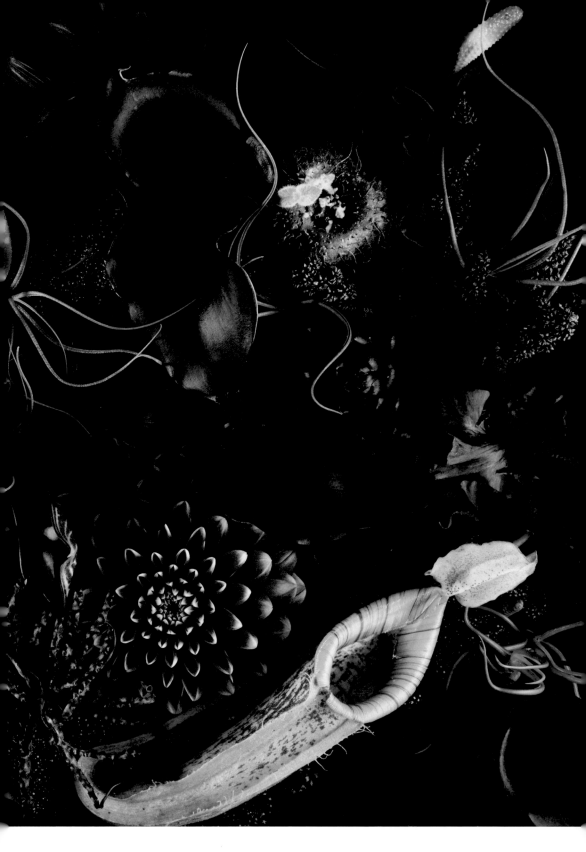

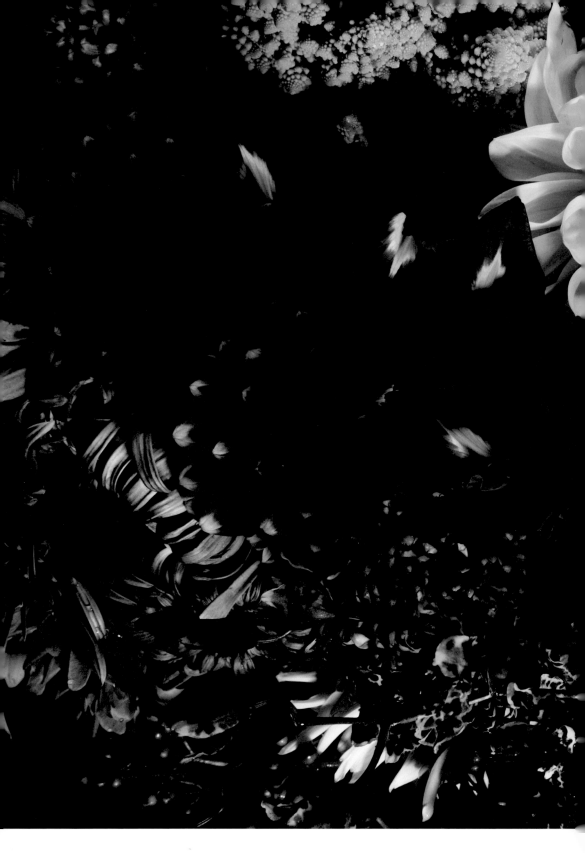

WHOLE 20

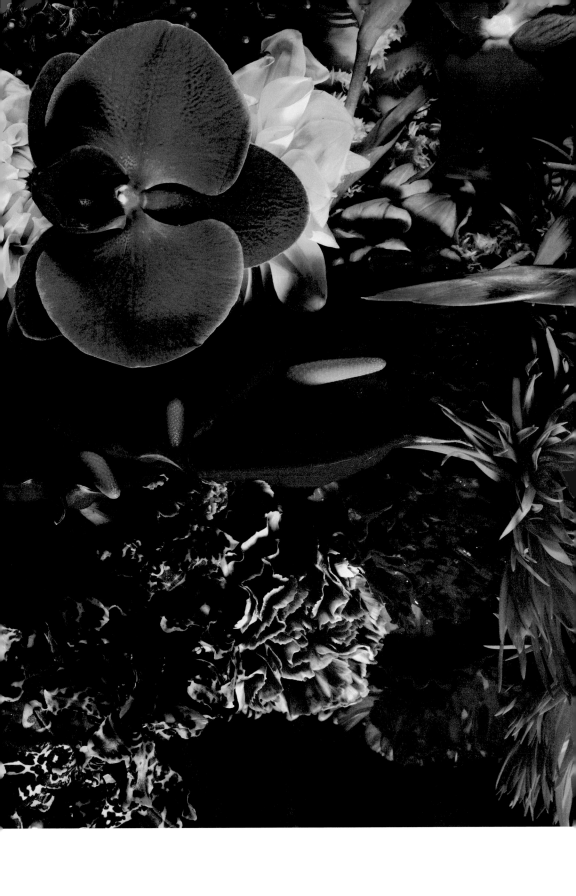

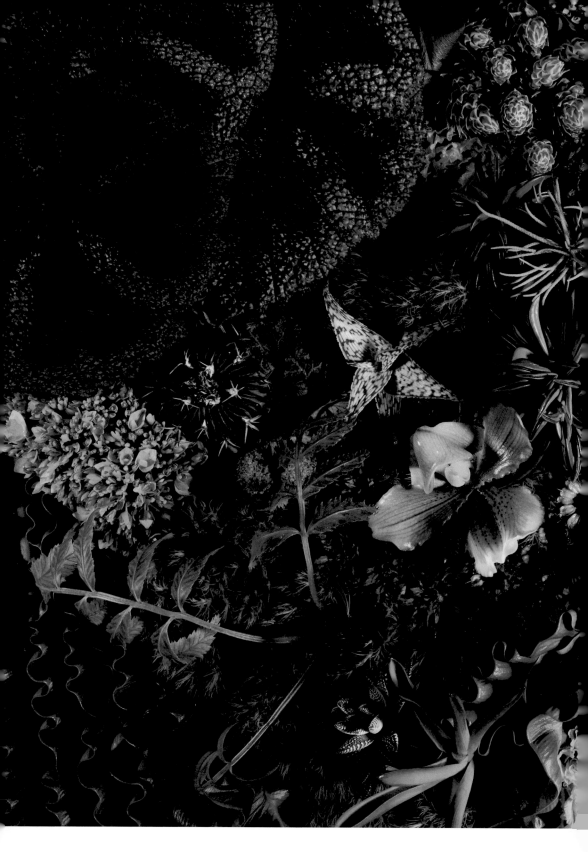

WHOLE 21

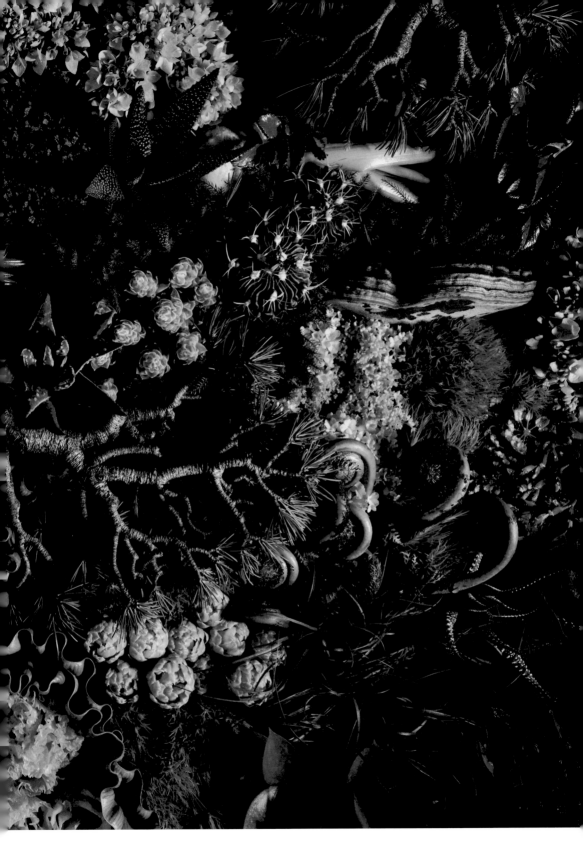

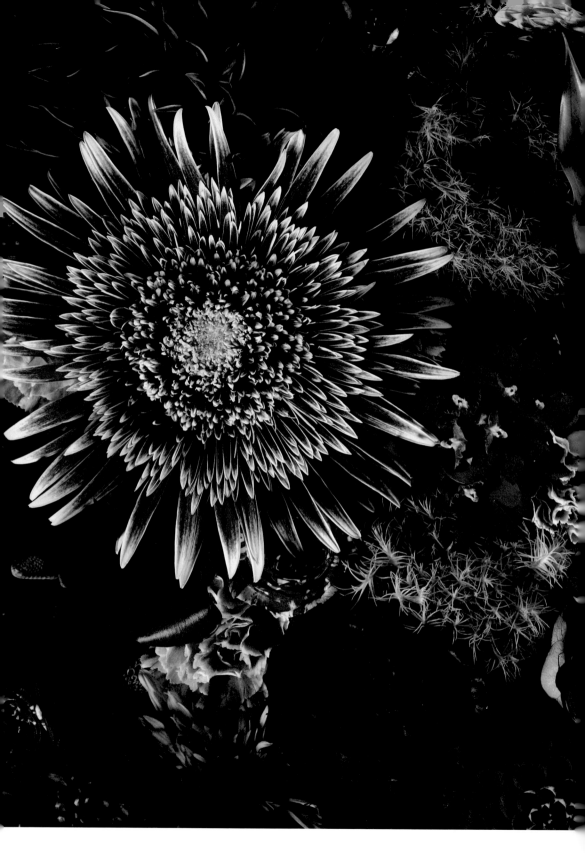

WHOLE 22

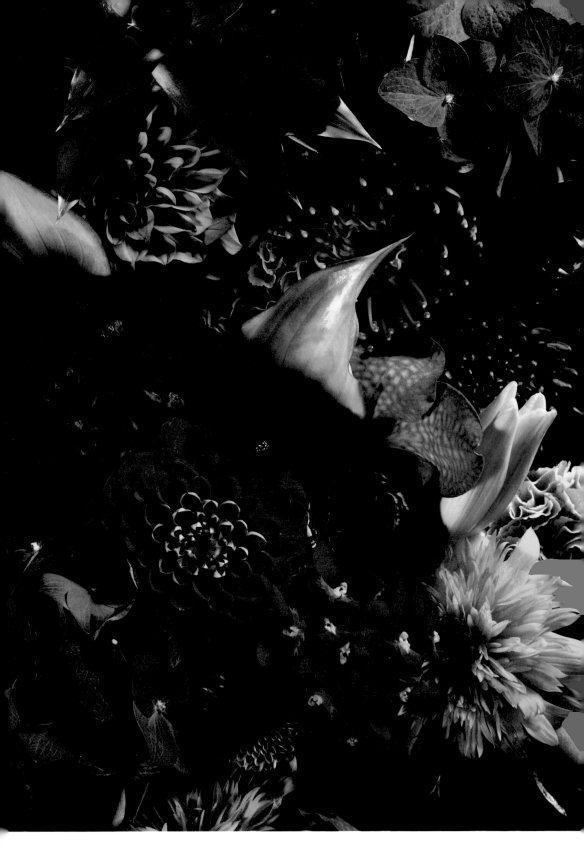

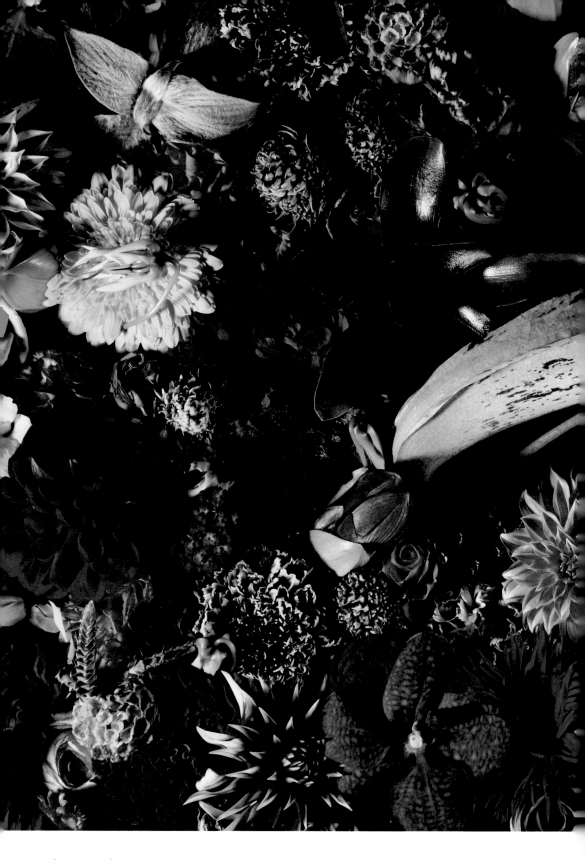

WHOLE 23

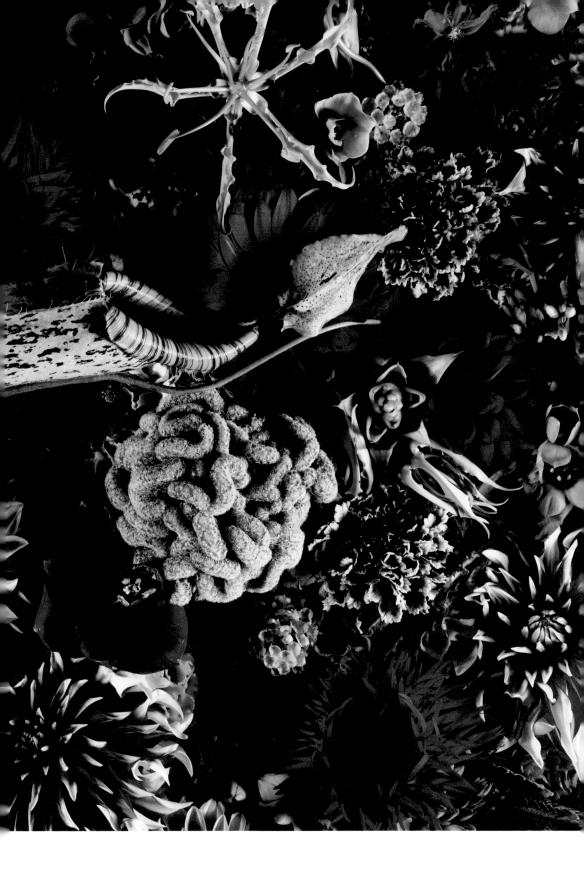

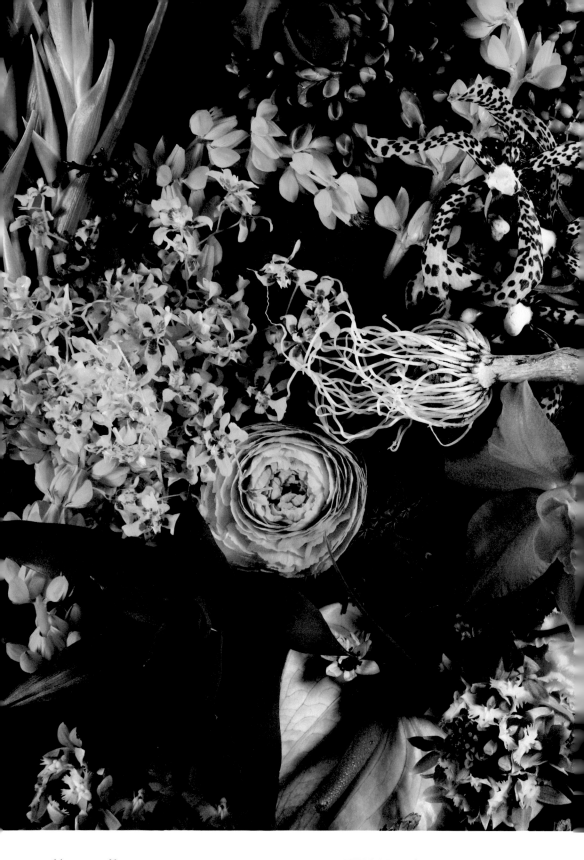

WHOLE 24

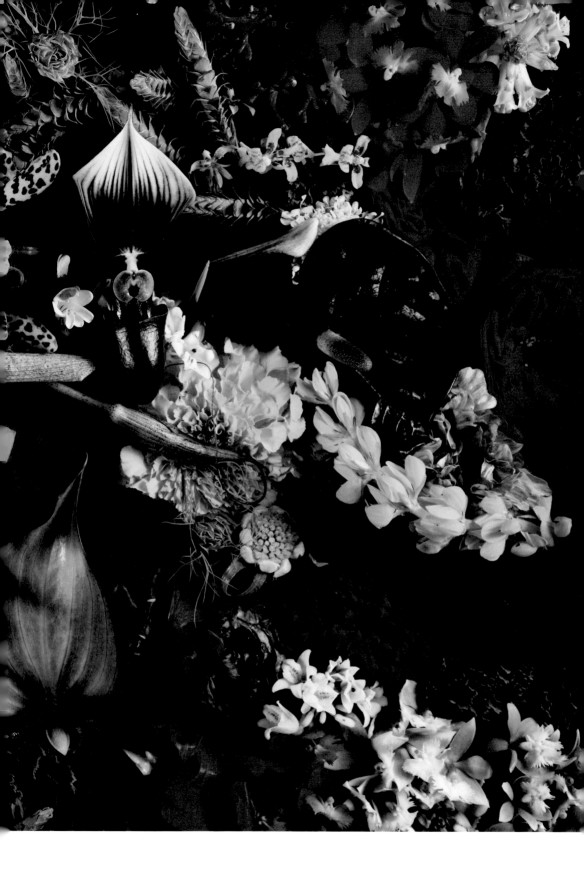

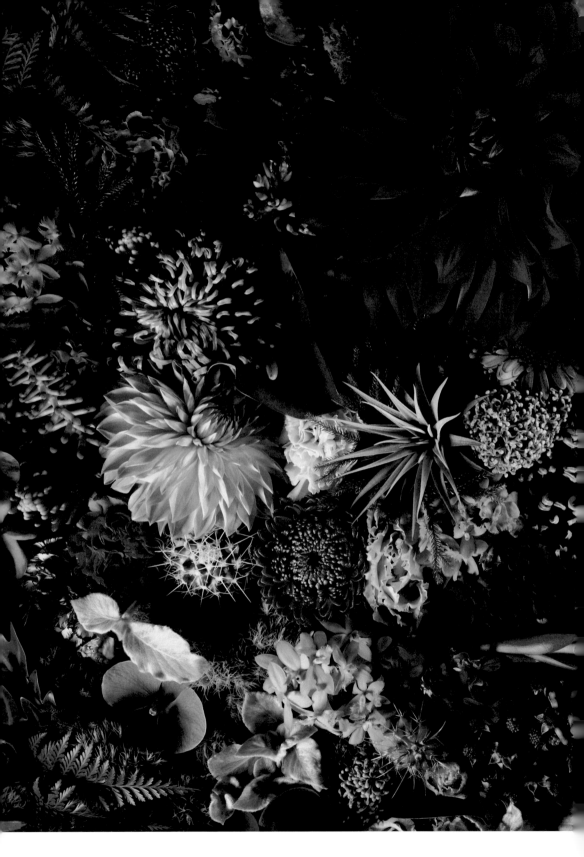

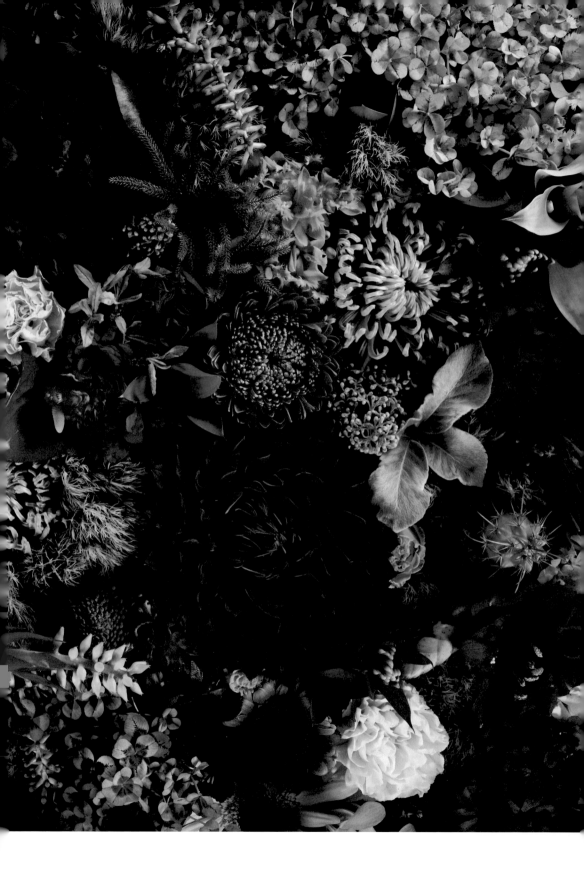

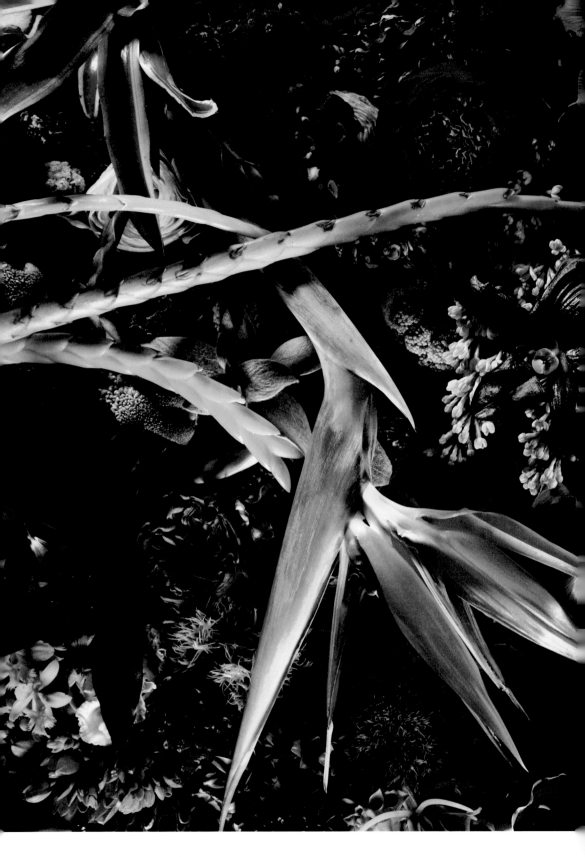

WHOLE 26

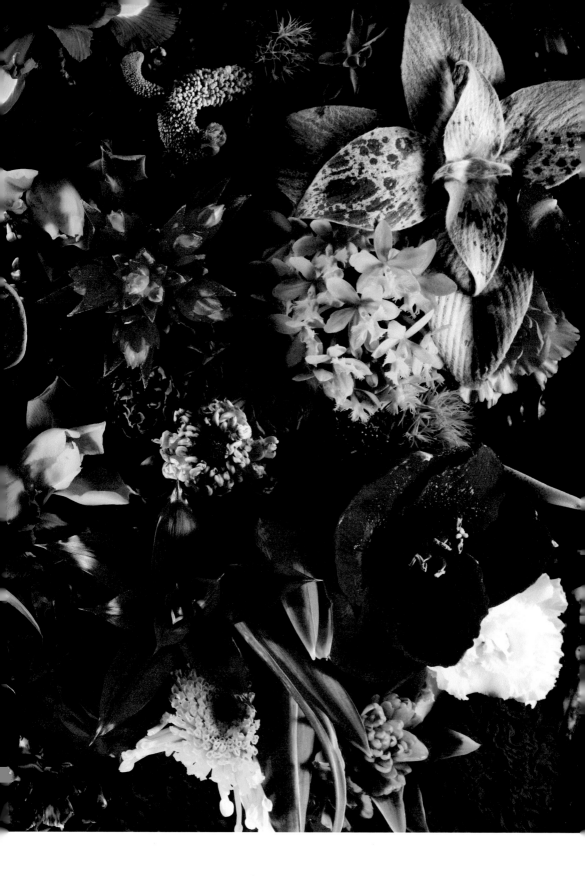

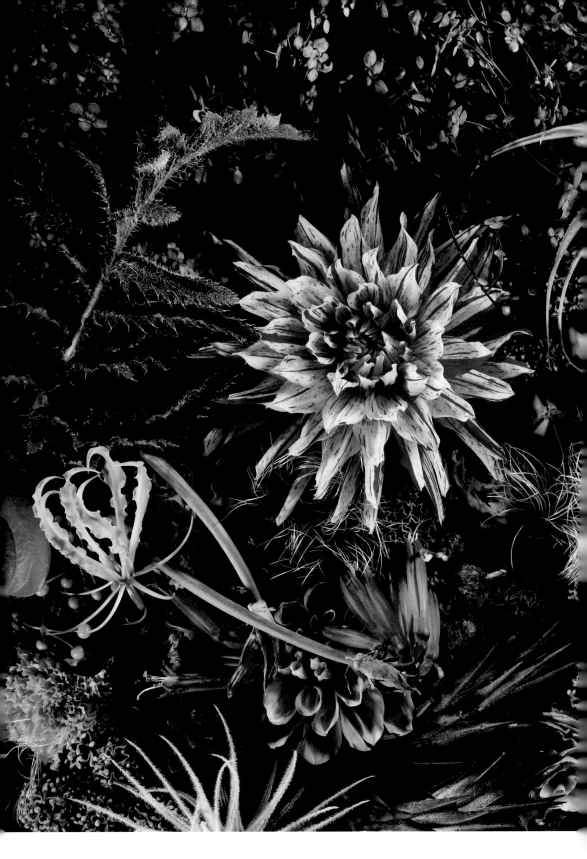

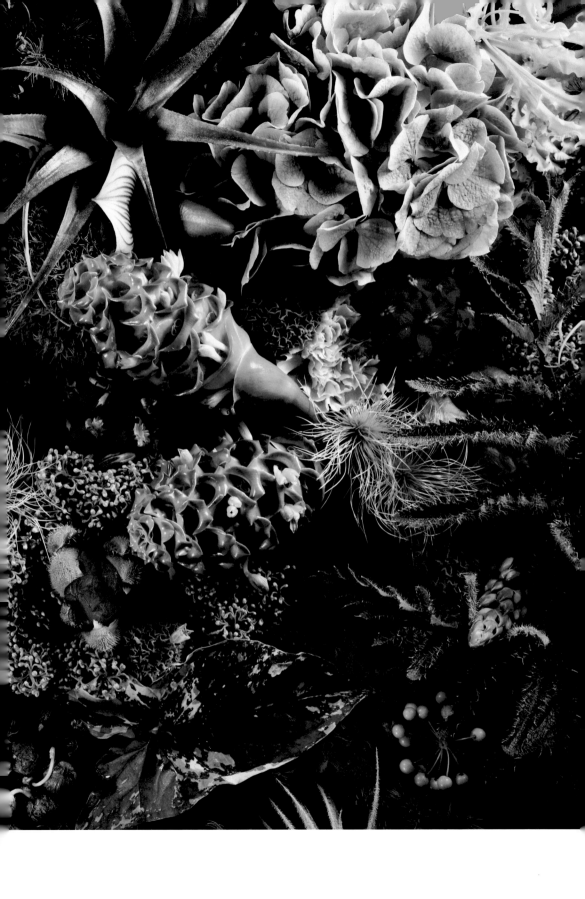

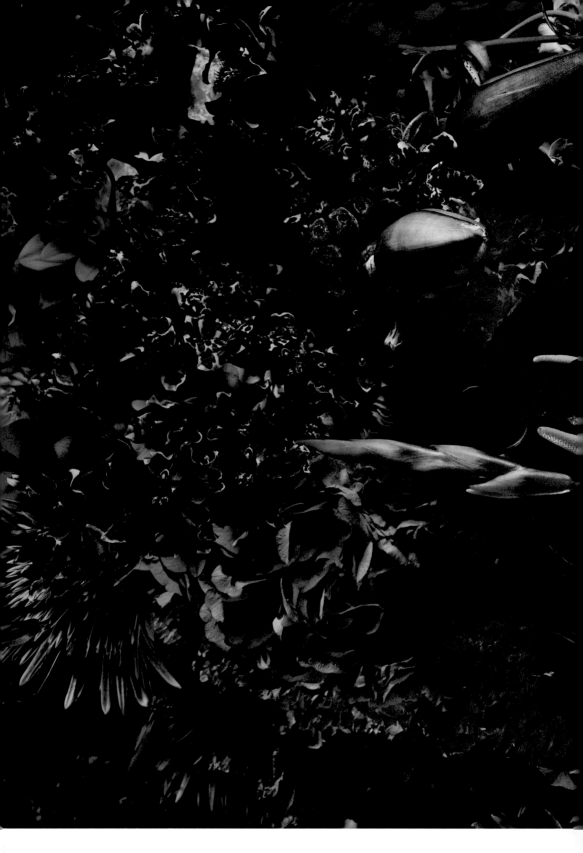

WHOLE 28

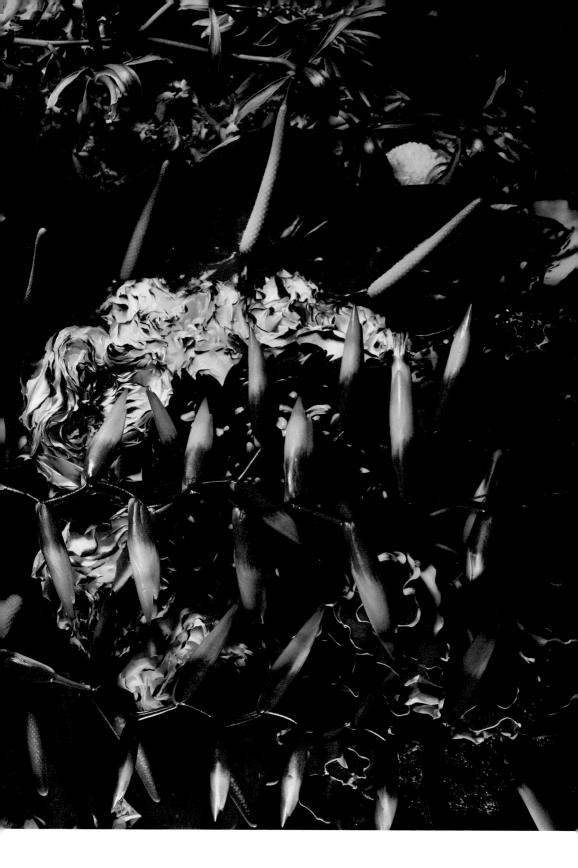

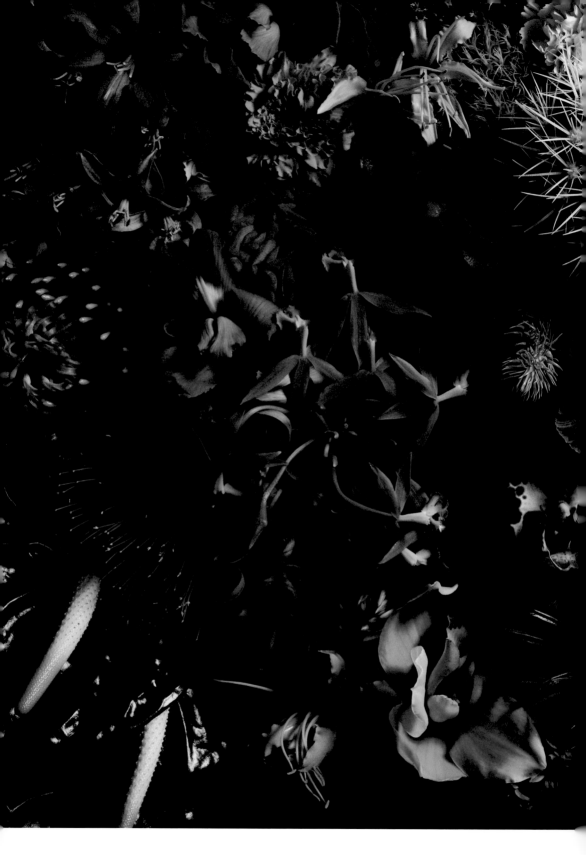

WHOLE 29

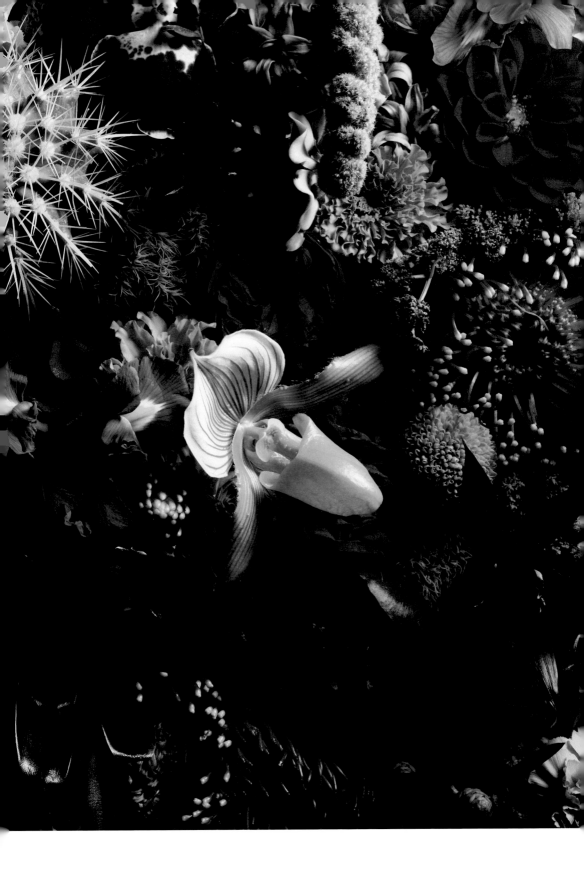

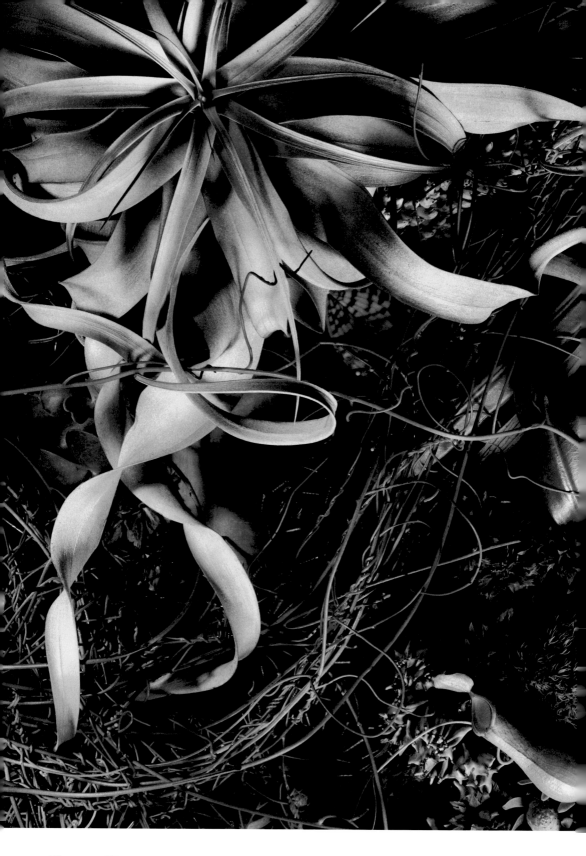

WHOLE 30

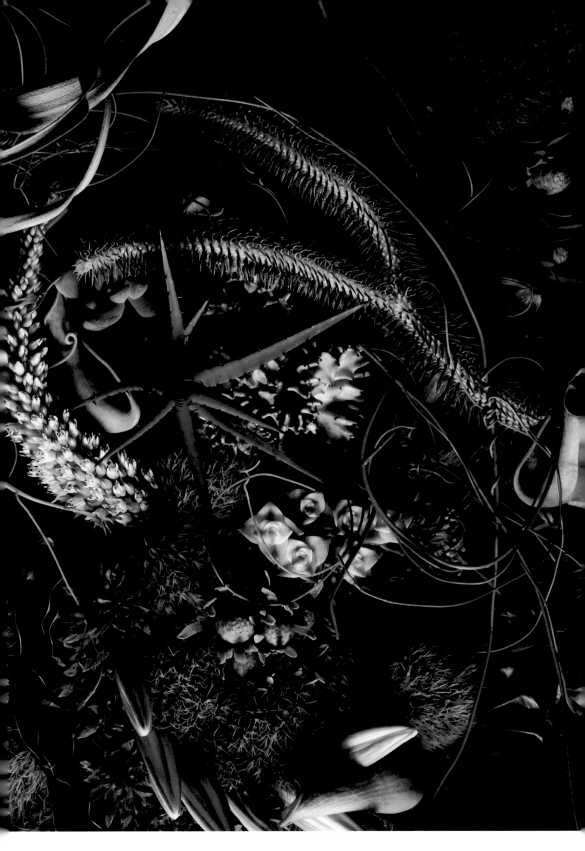

FLOCK

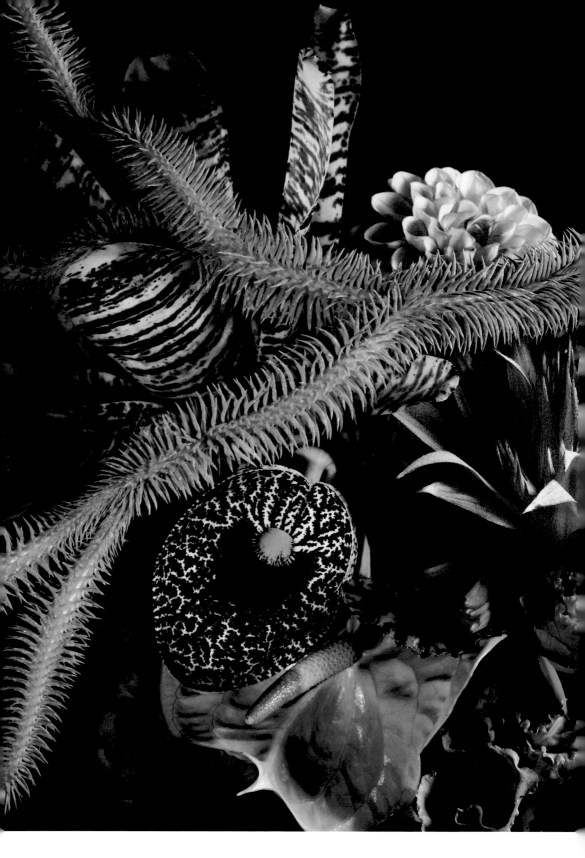

FLOCK 01

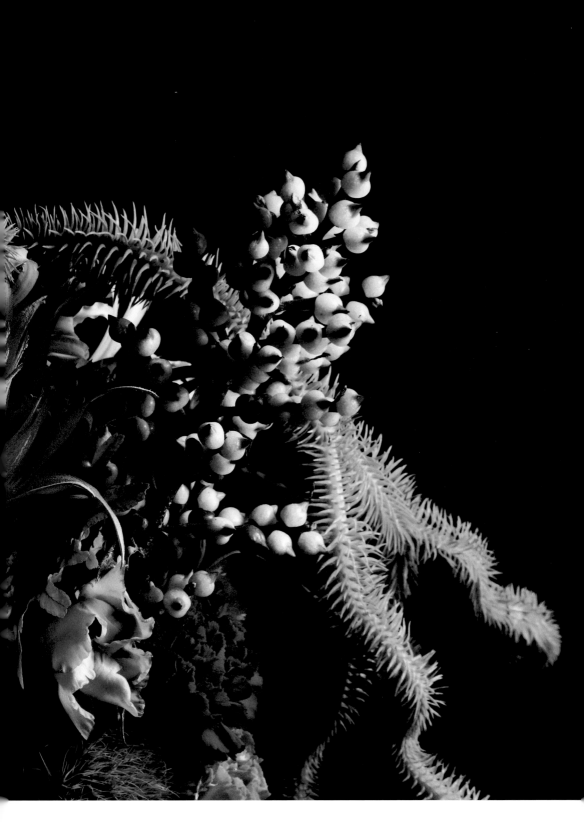

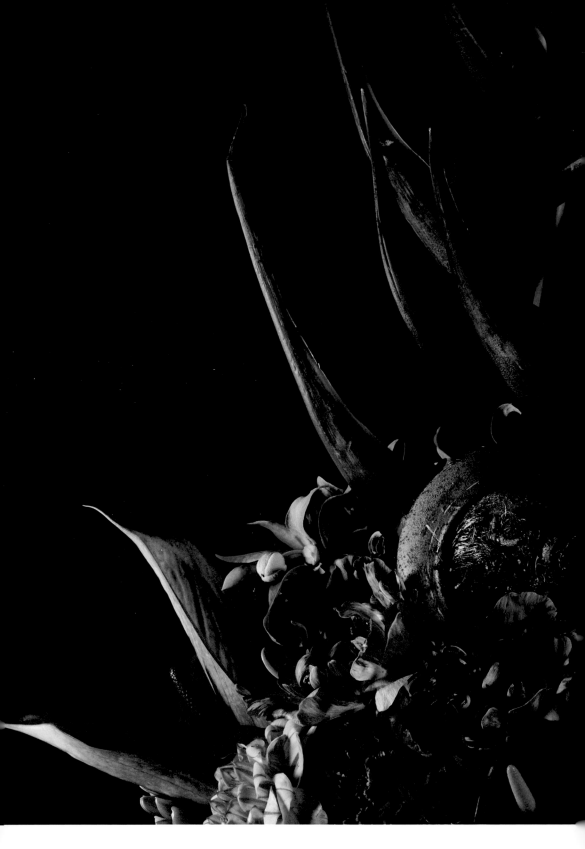

FLOCK 02

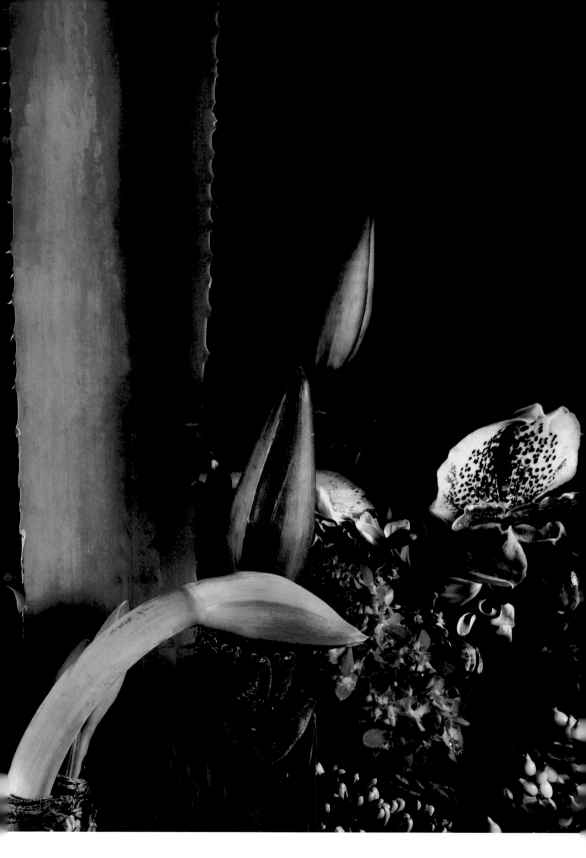

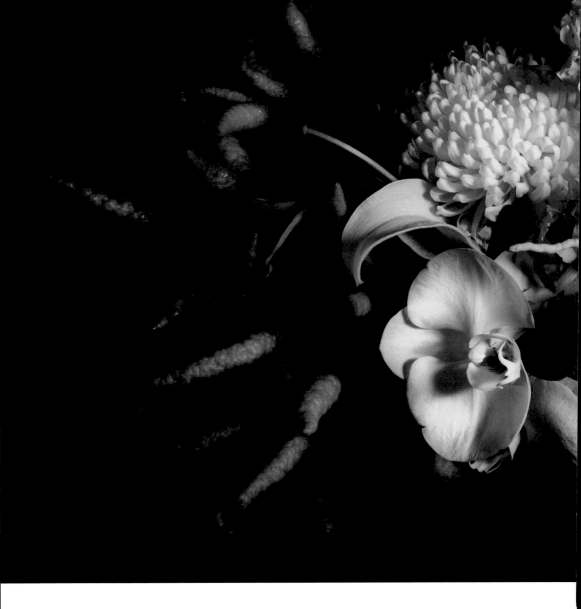

FLOCK 03

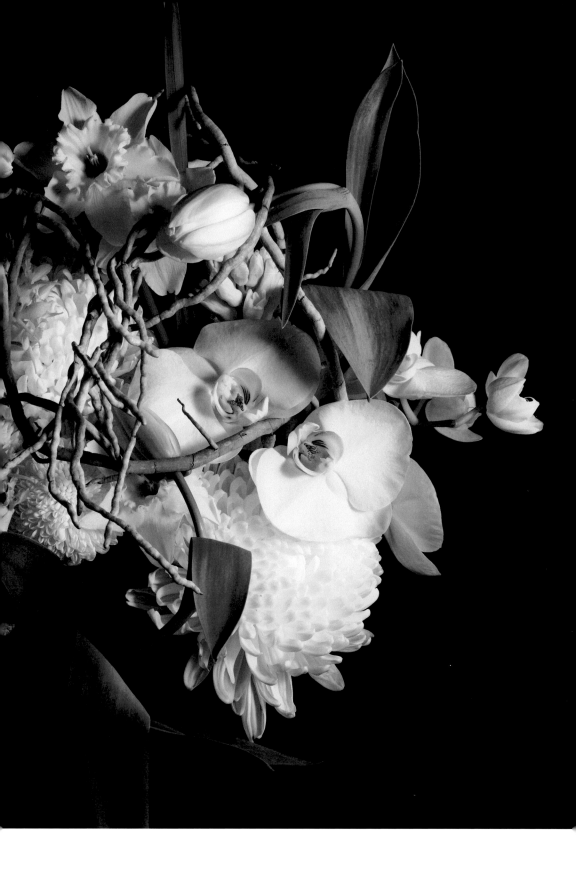

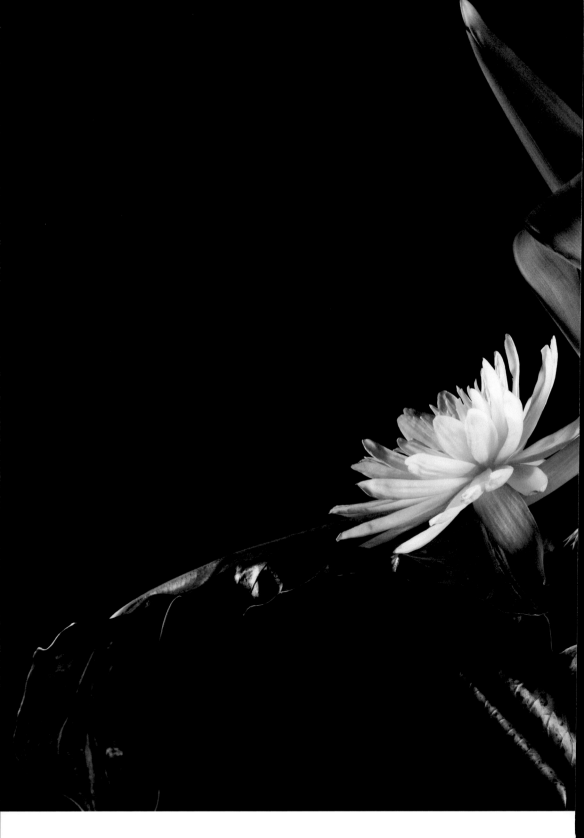

FLOCK 04

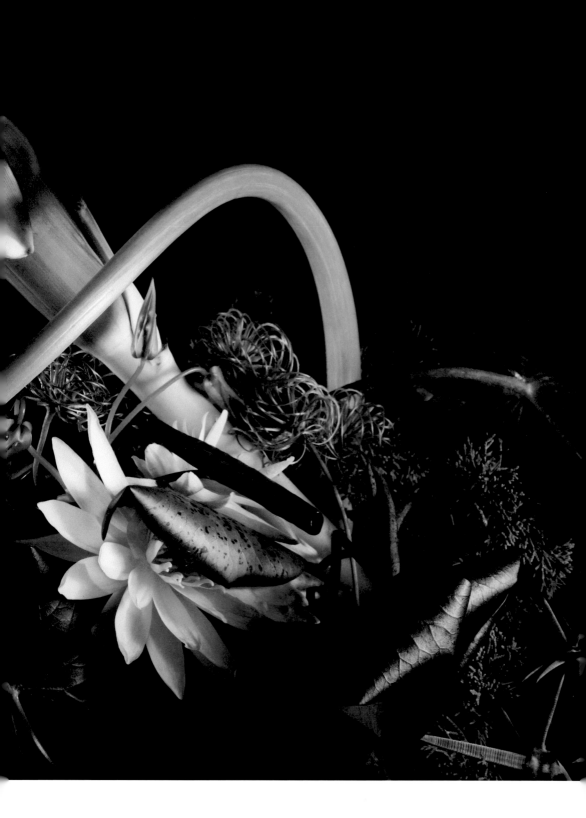

FLOCK 05

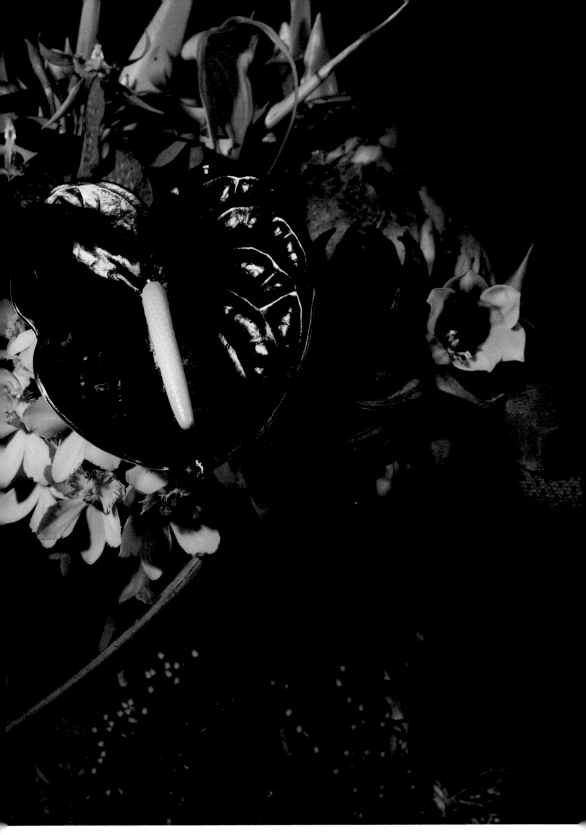

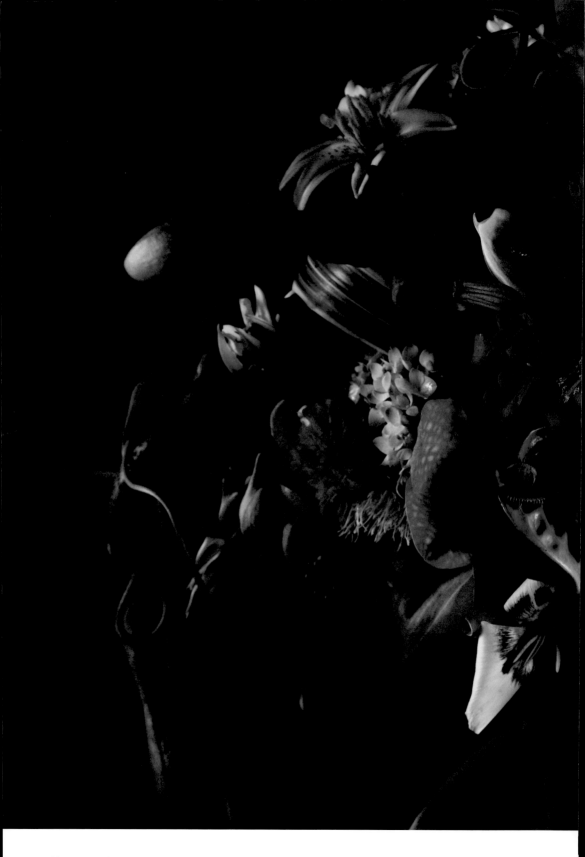

FLOCK 06

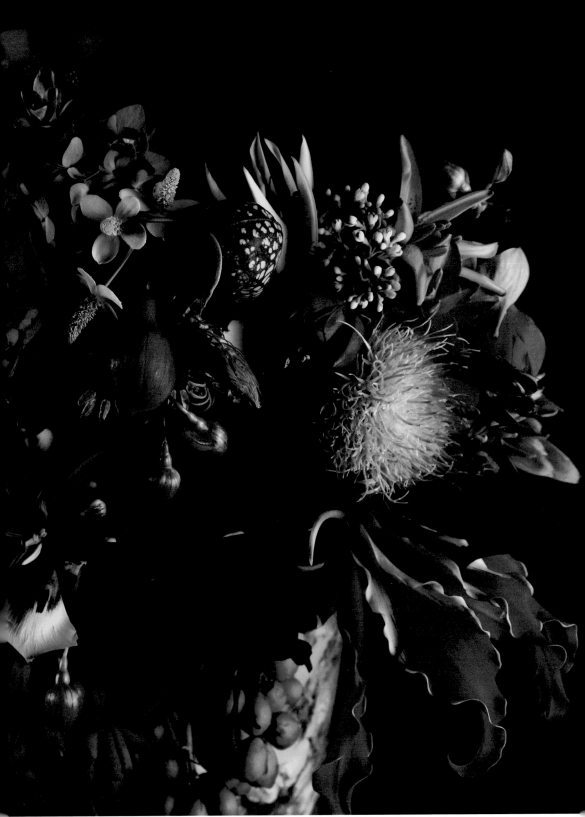

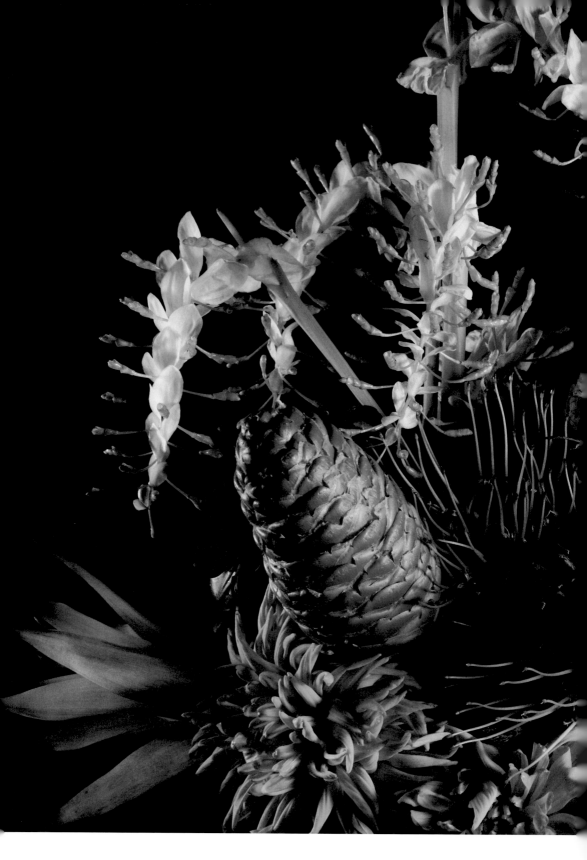

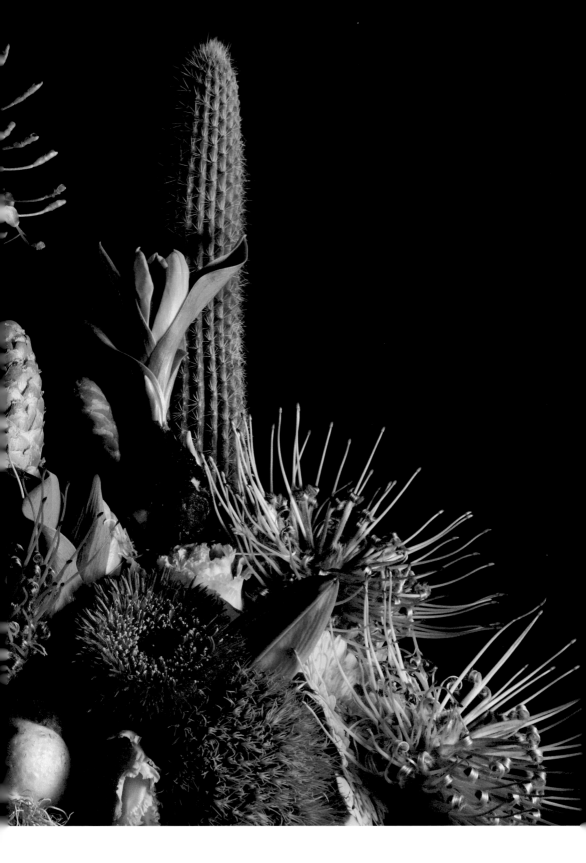

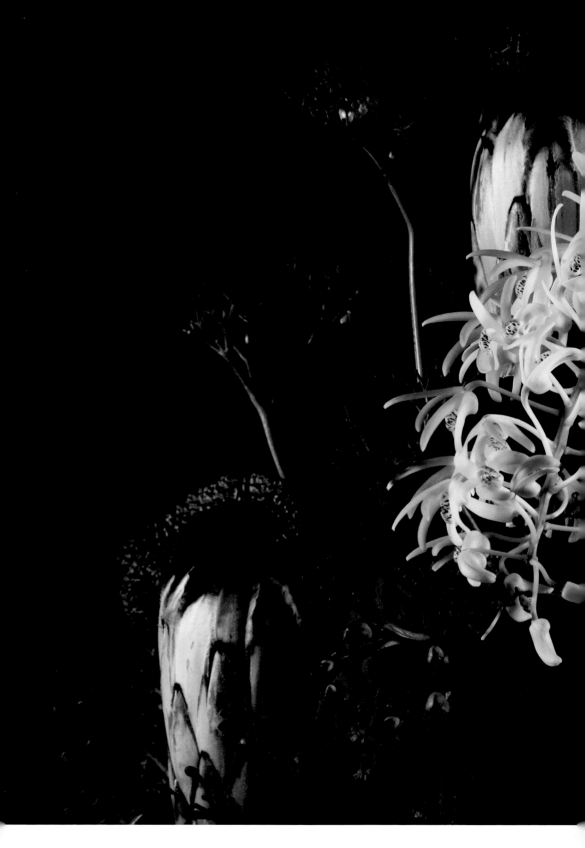

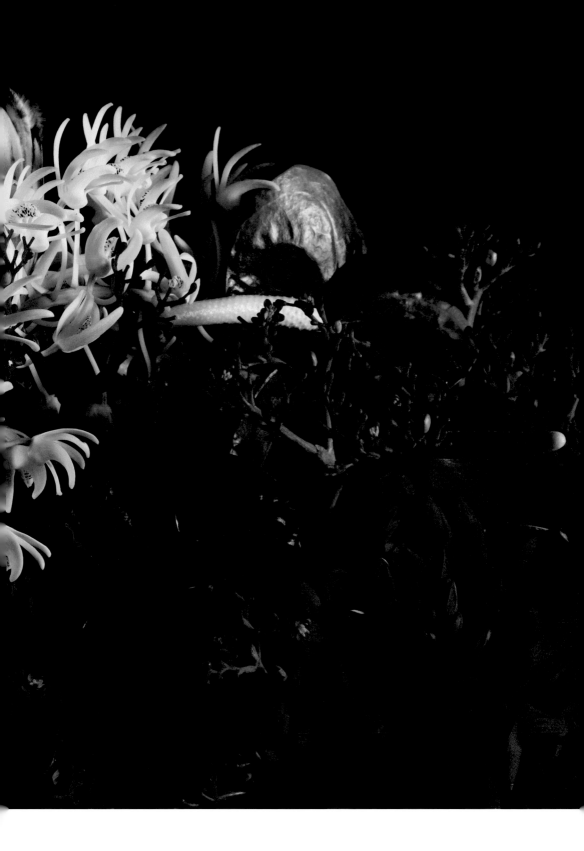

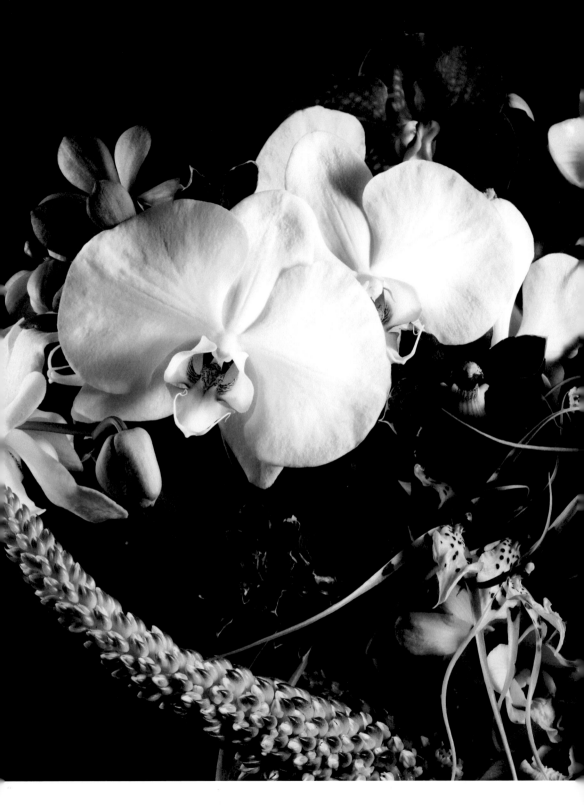

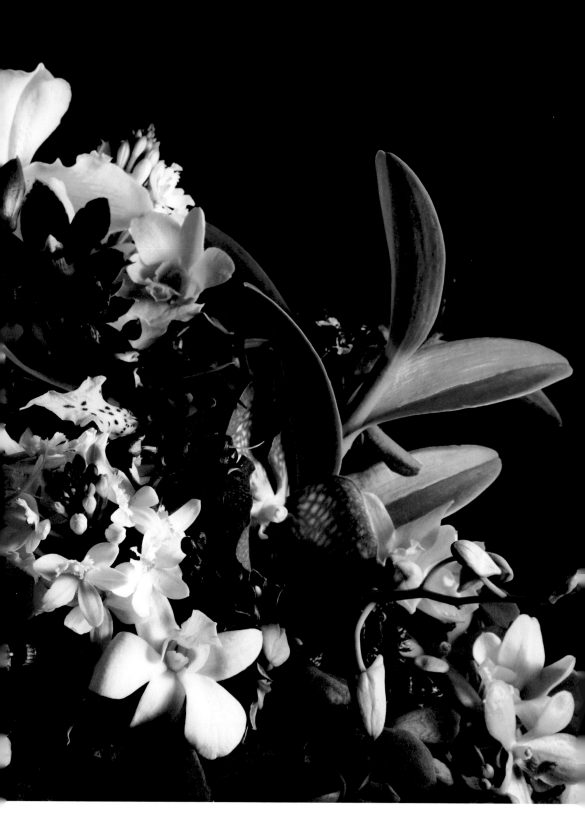

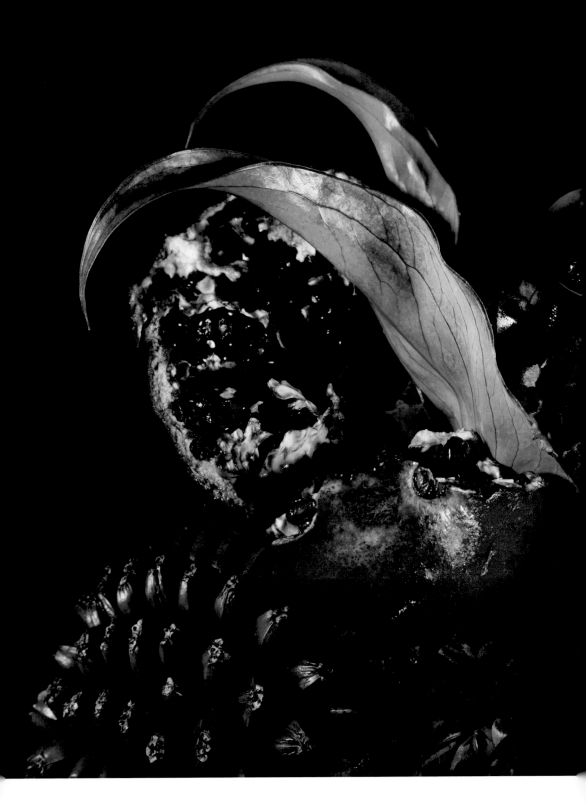

FLOCK 10

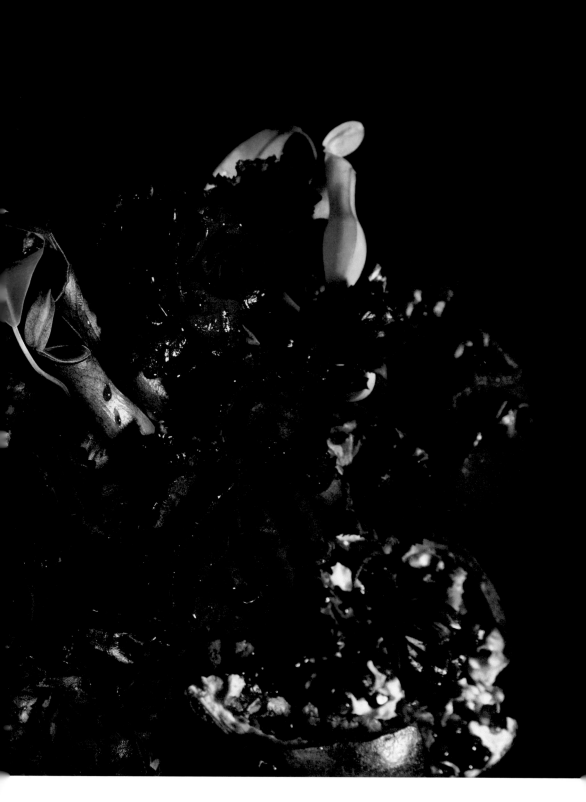

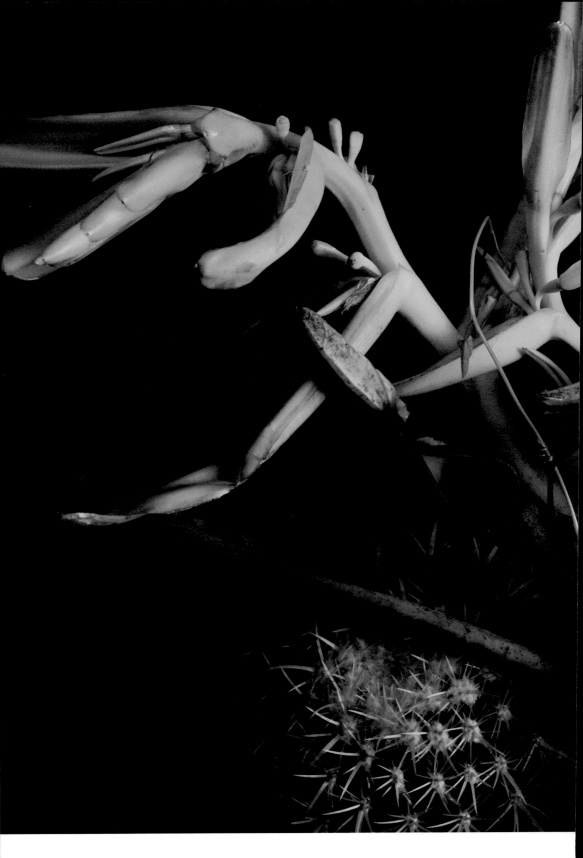

FLOCK 11

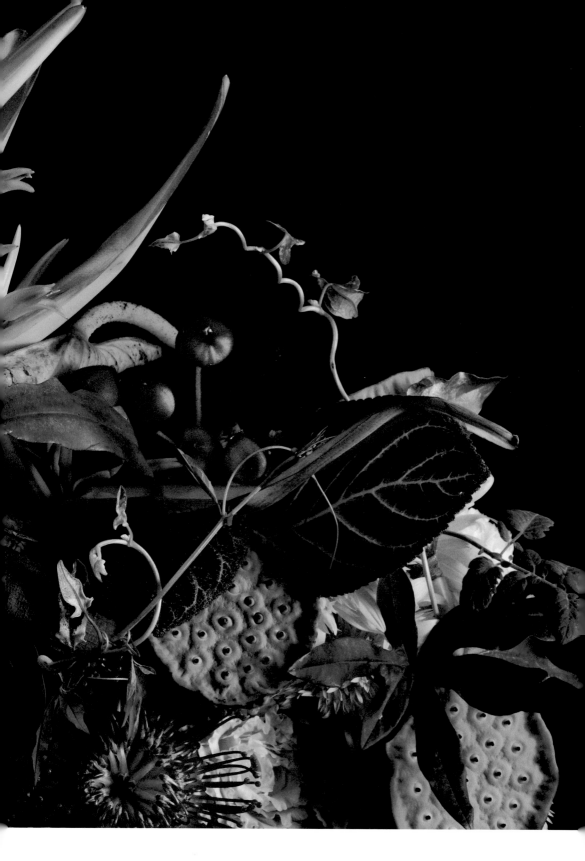

FLOCK 12

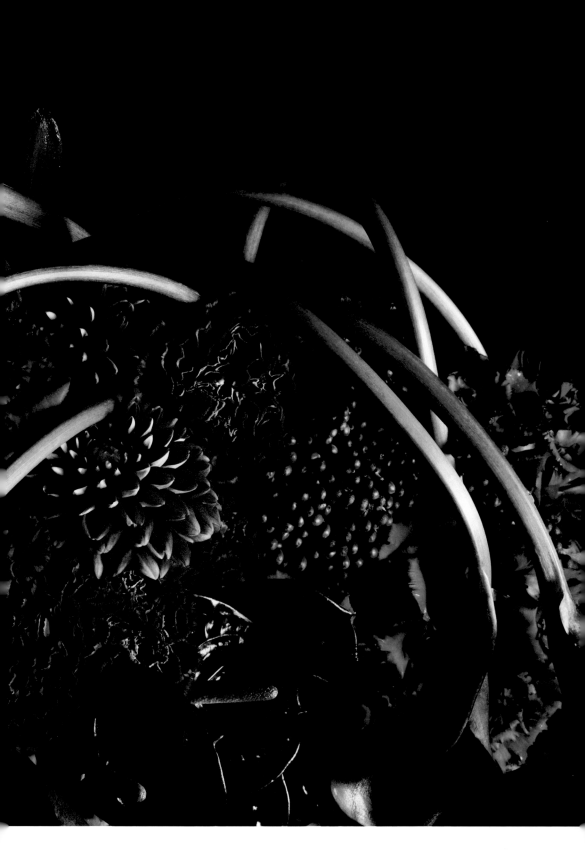

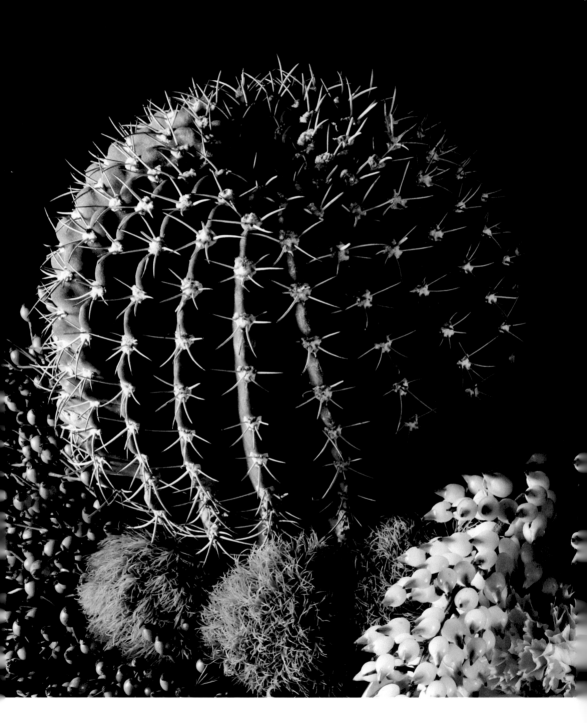

FLOCK 13

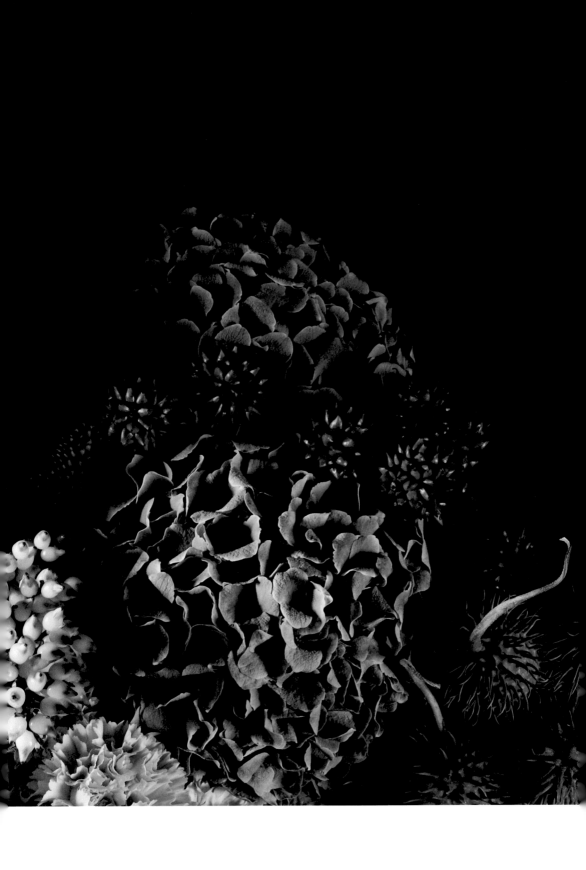

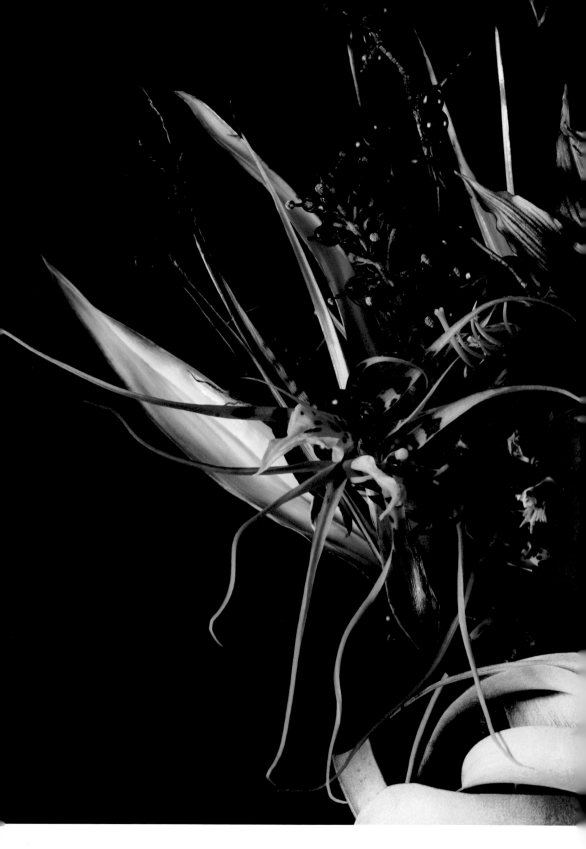

FLOCK 14

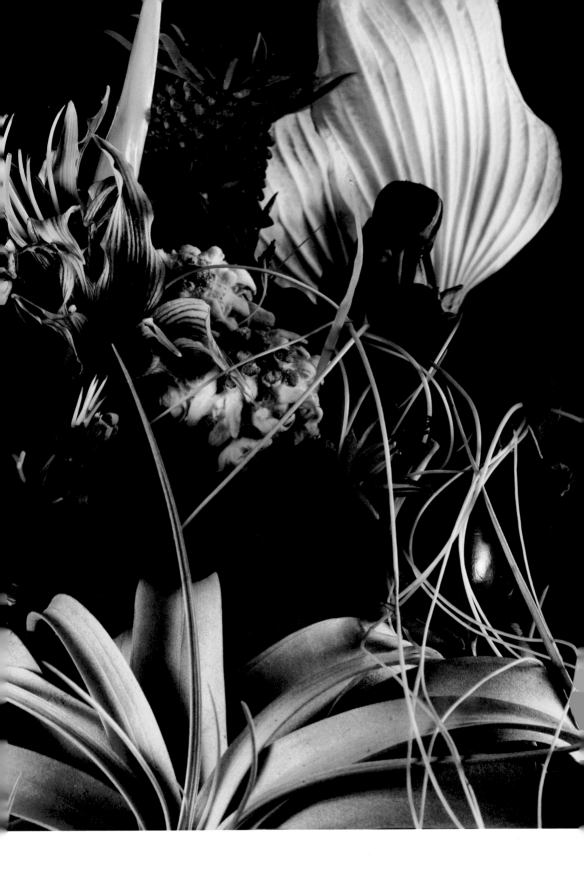

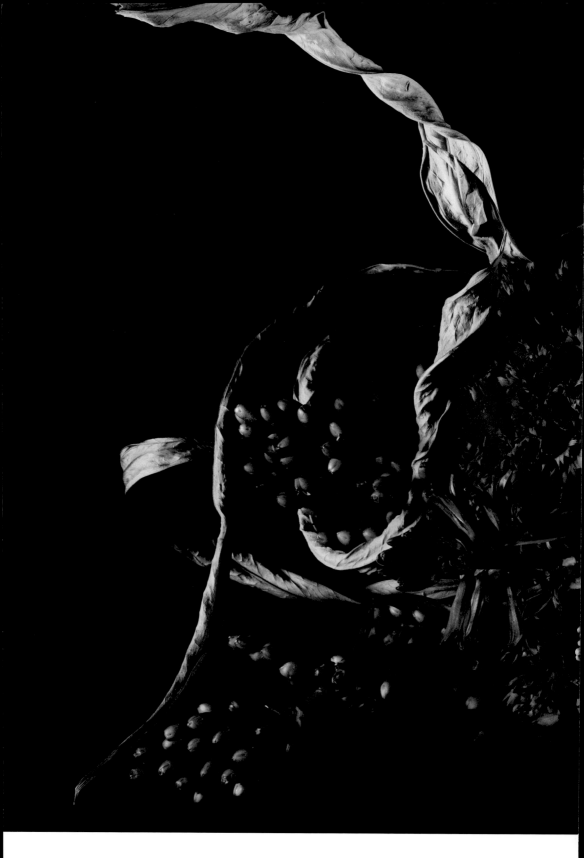

FLOCK 15

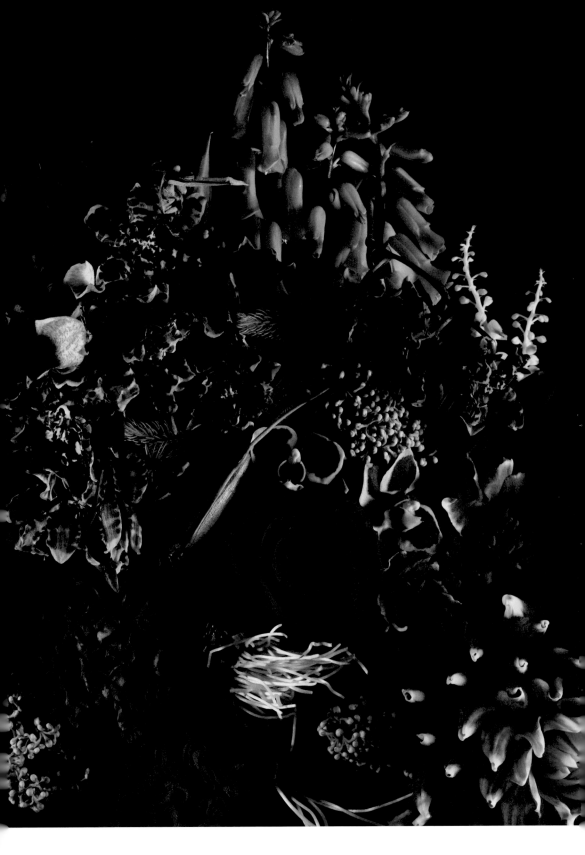

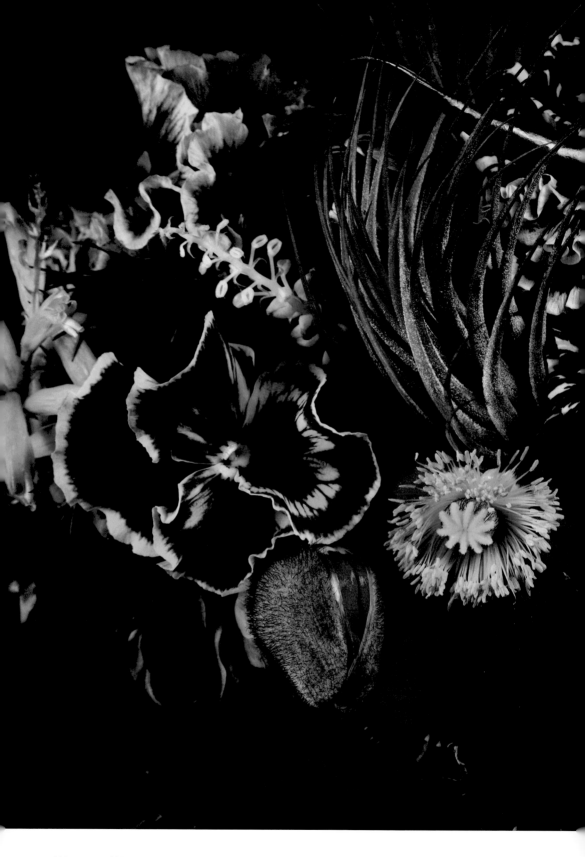

FLOCK 16

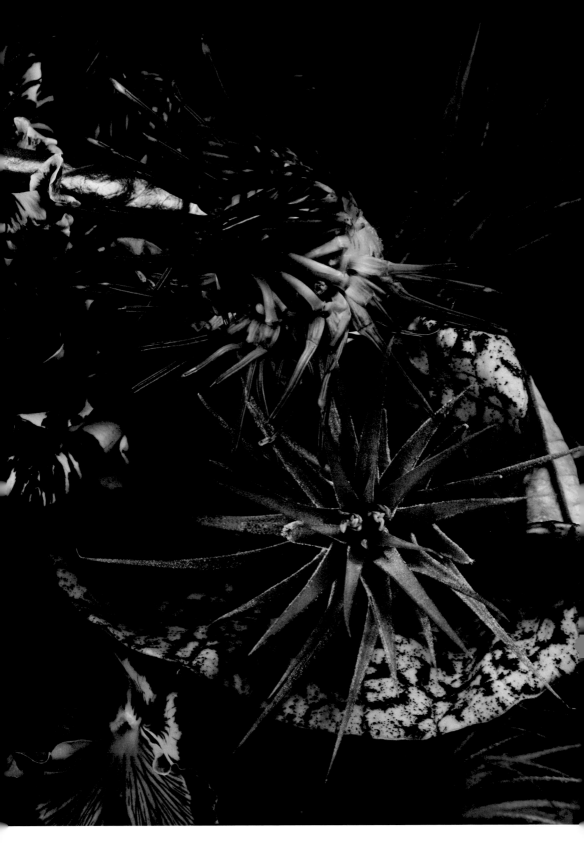

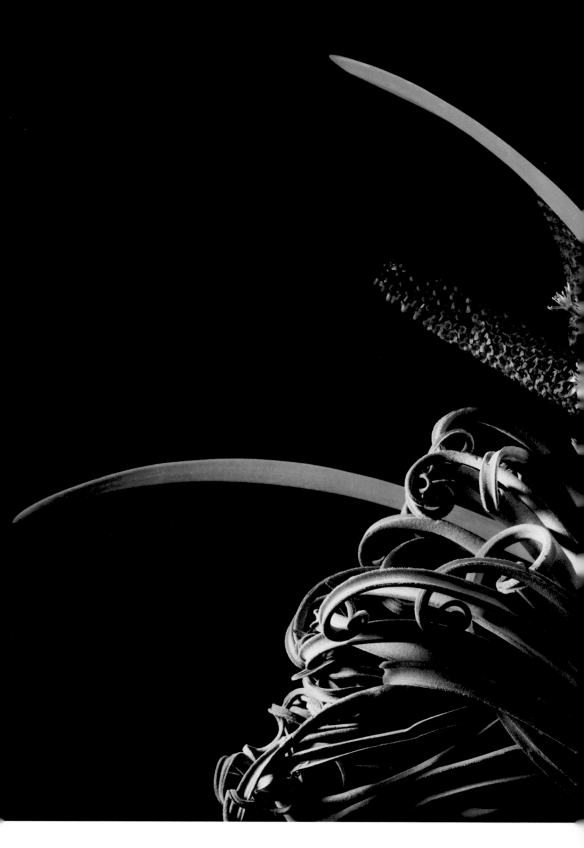

FLOCK 17

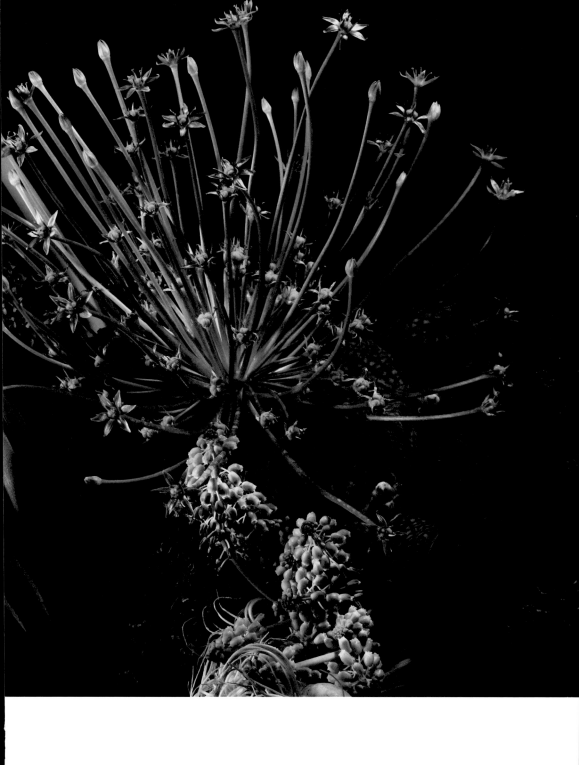

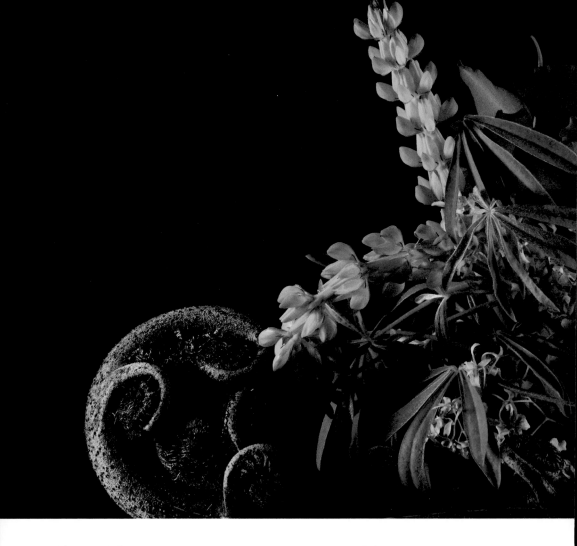

FLOCK 18

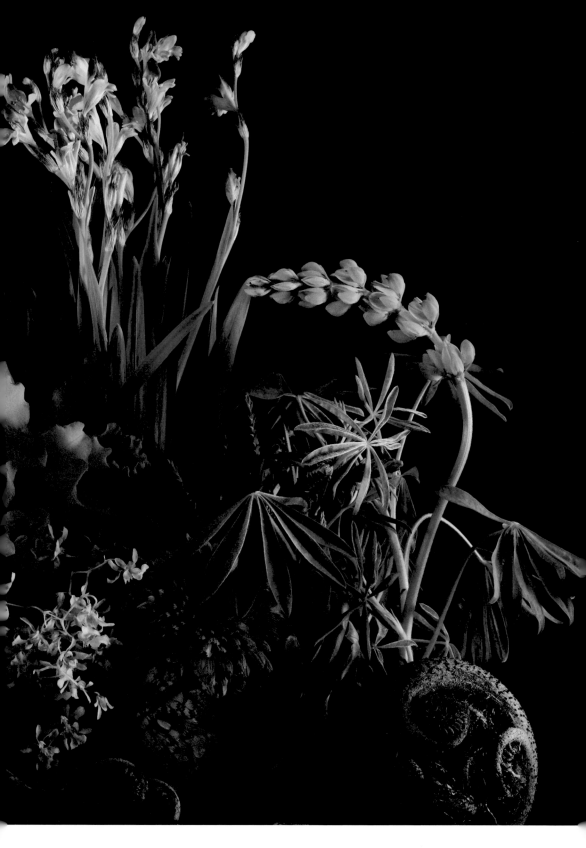

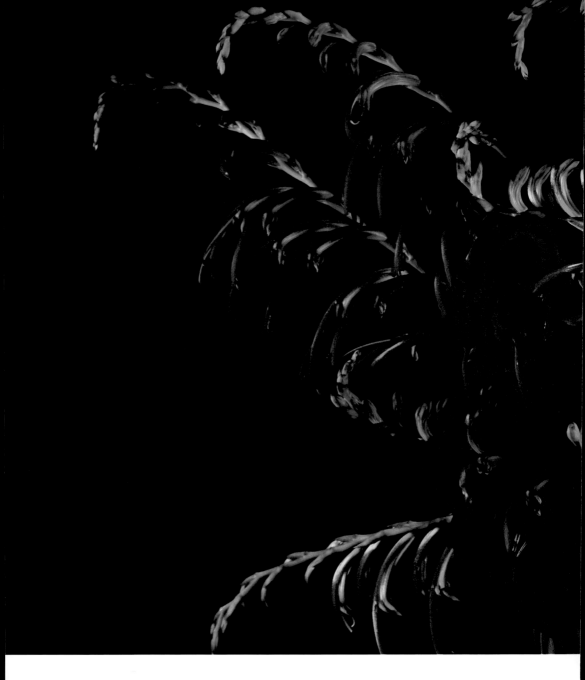

FLOCK 19

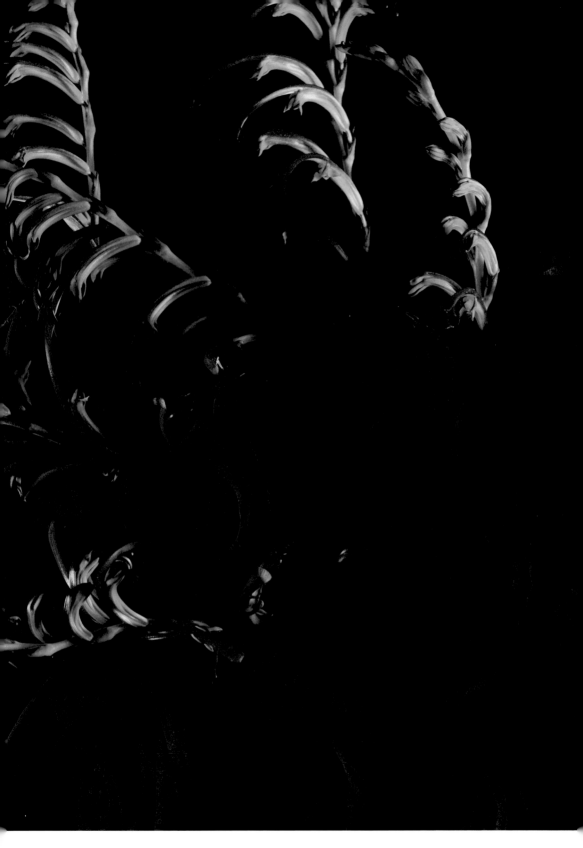

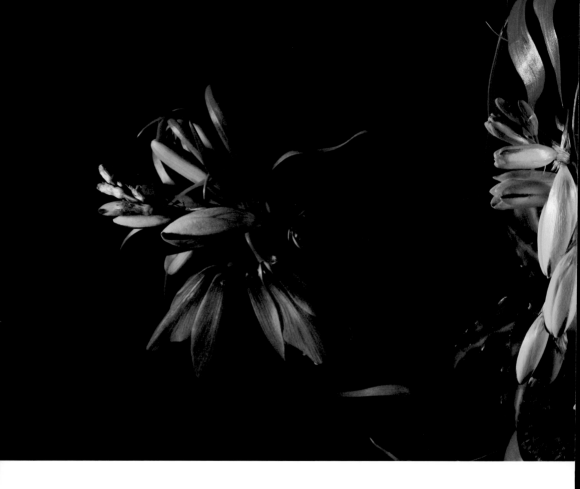

FLOCK 20

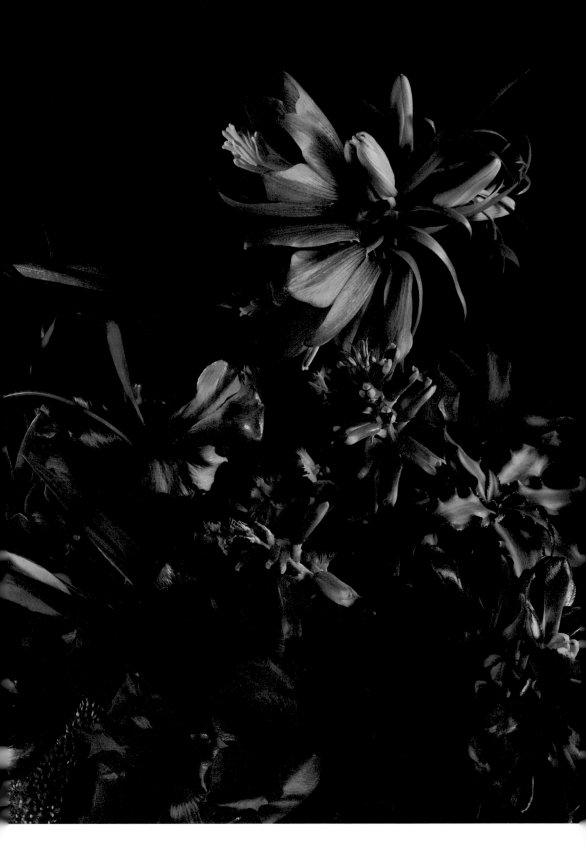

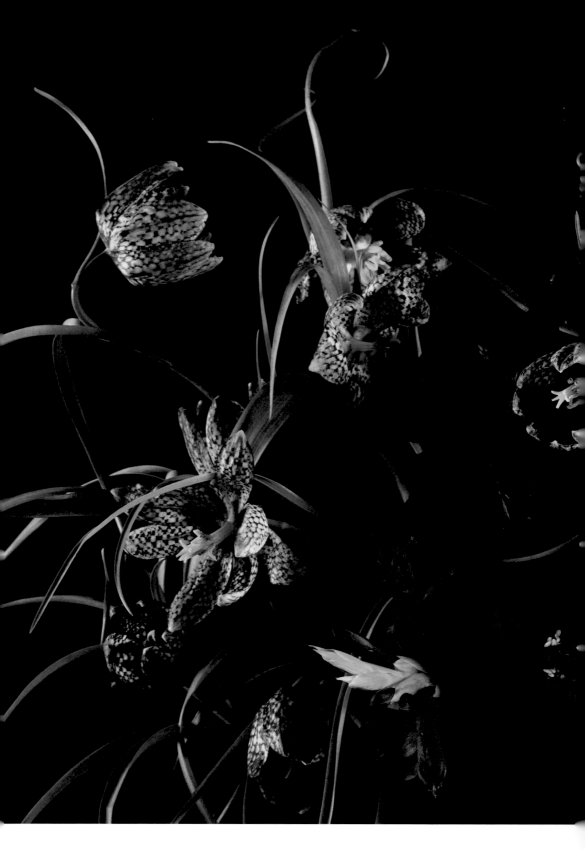

FLOCK 21

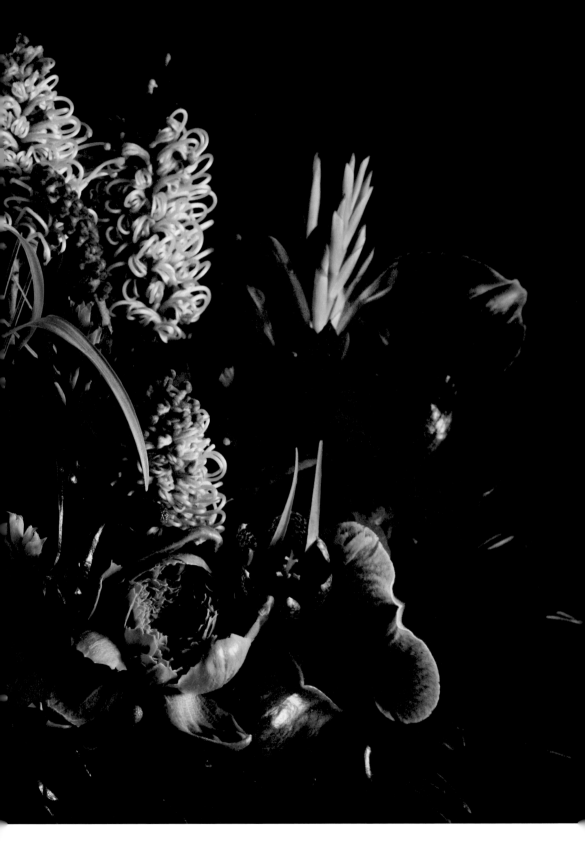

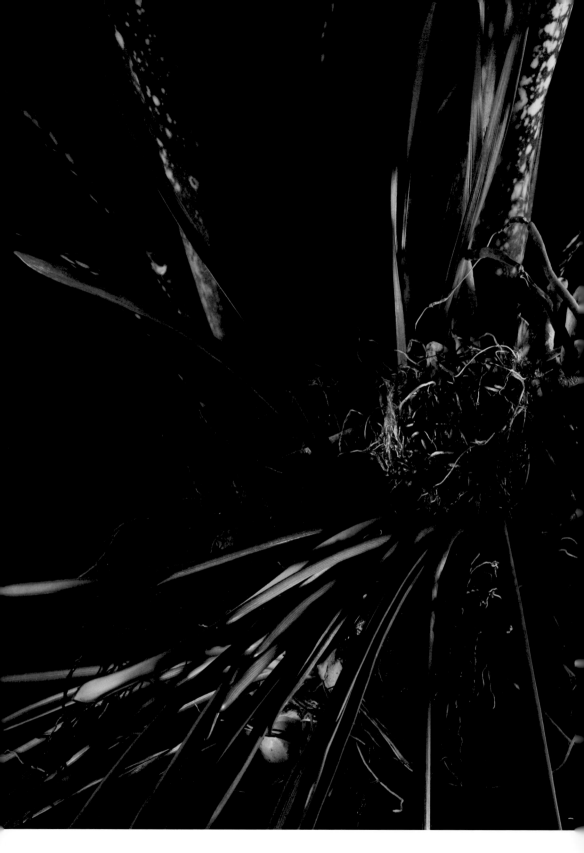

FLOCK 22

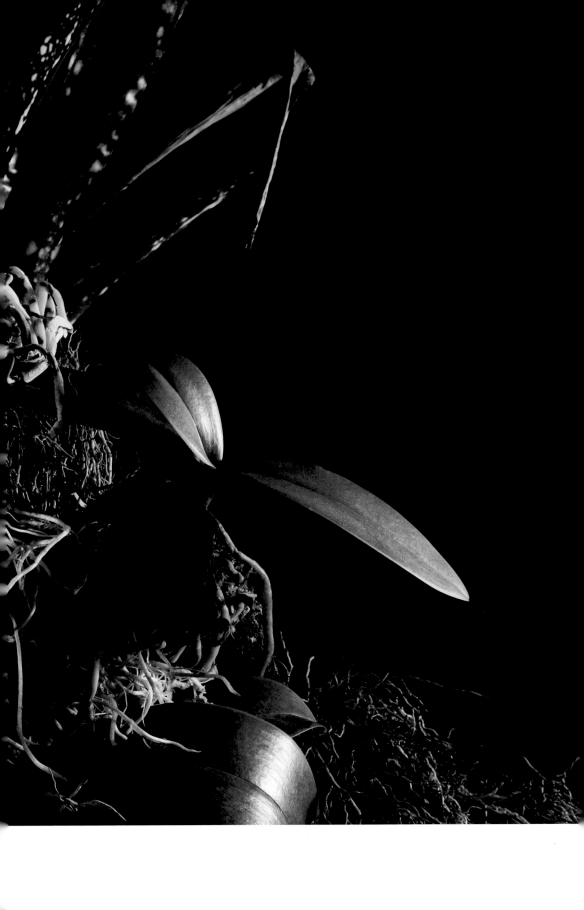

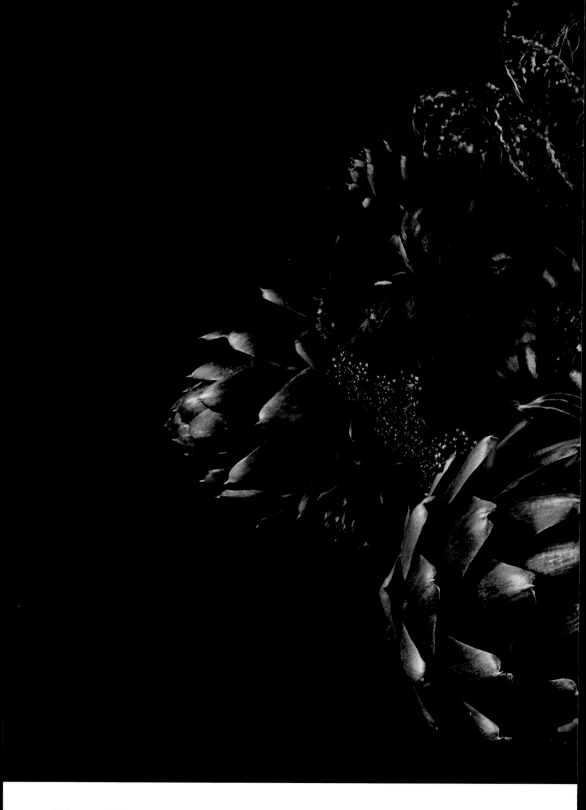

FLOCK 23

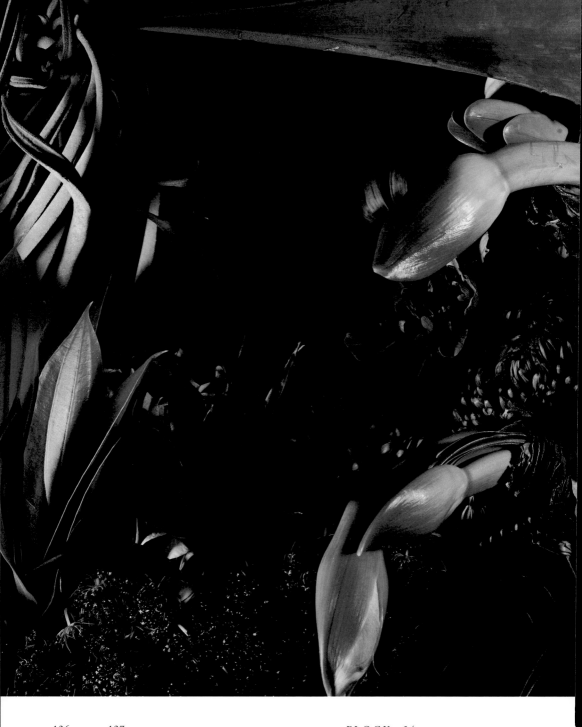

FLOCK 24

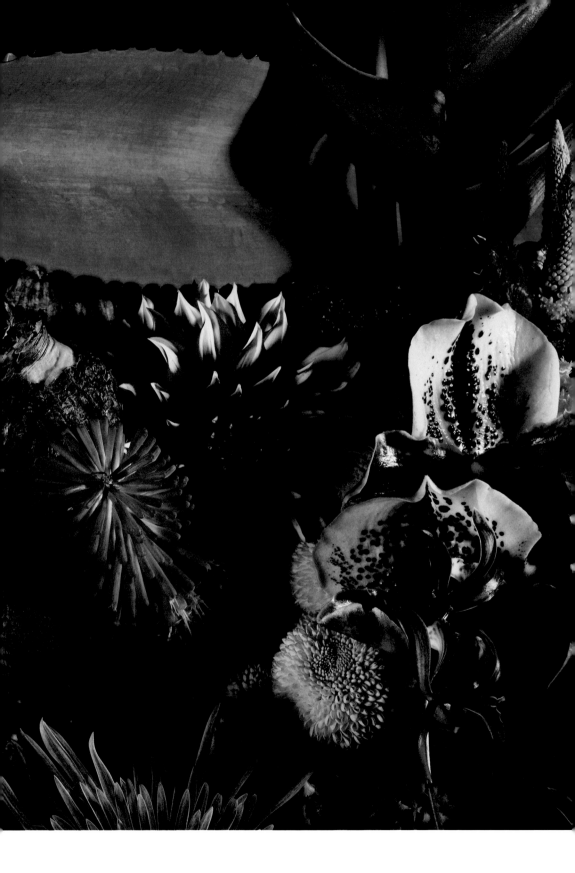

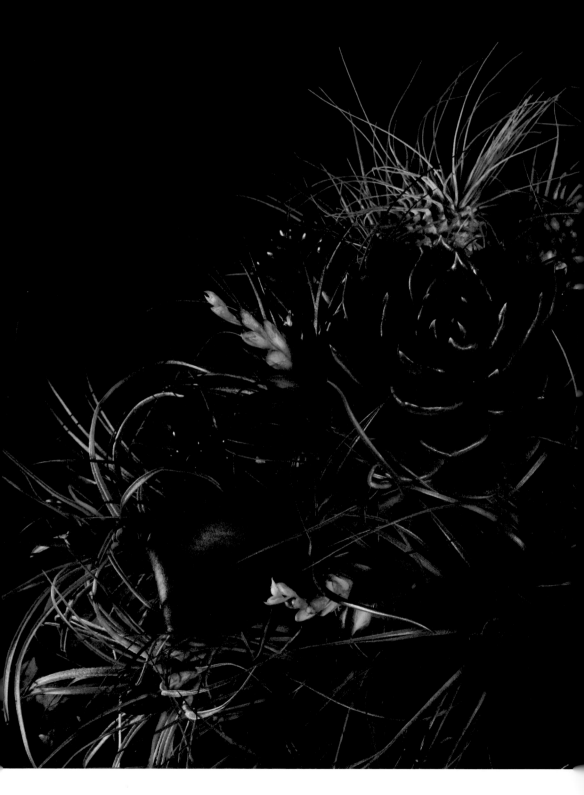

FLOCK 25

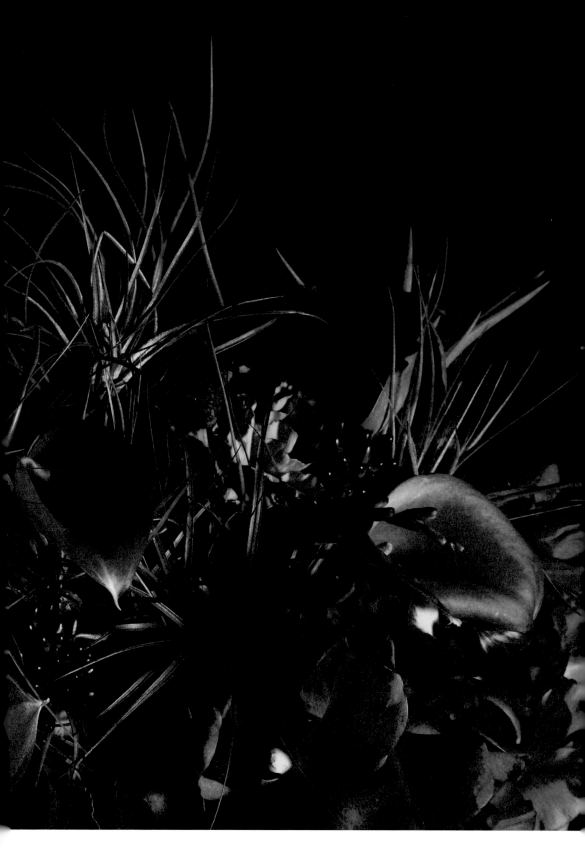

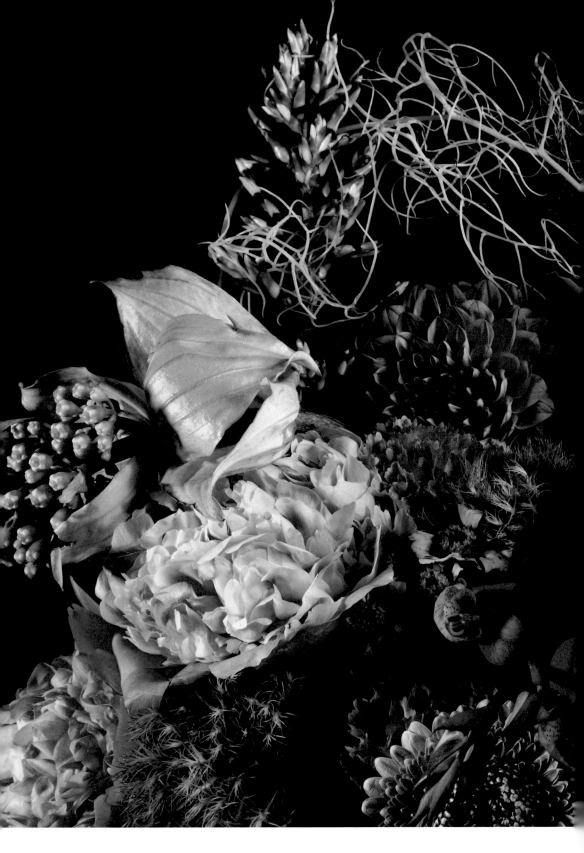

FLOCK 26

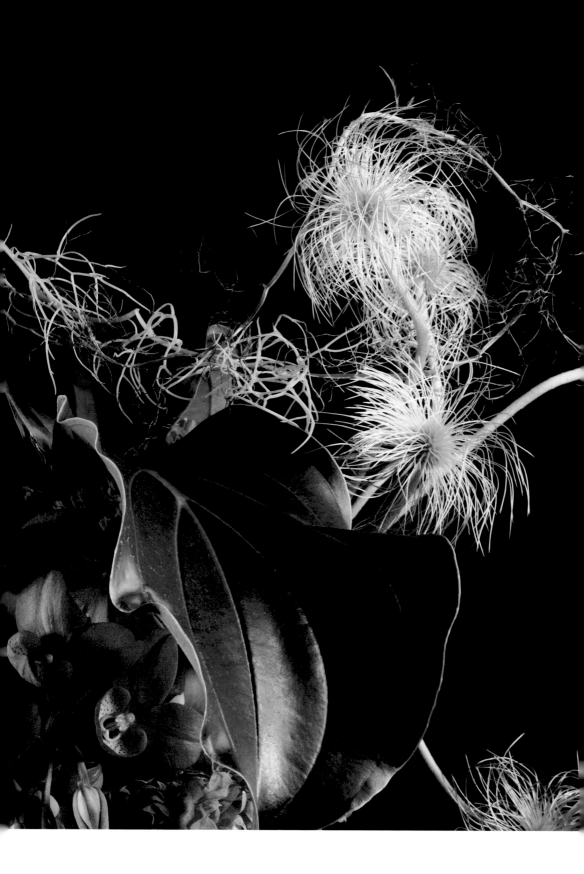

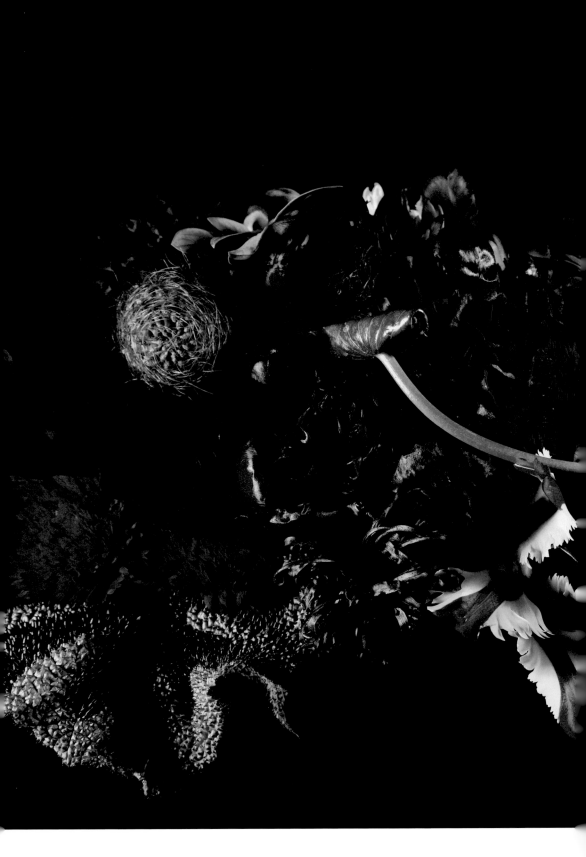

FLOCK 27

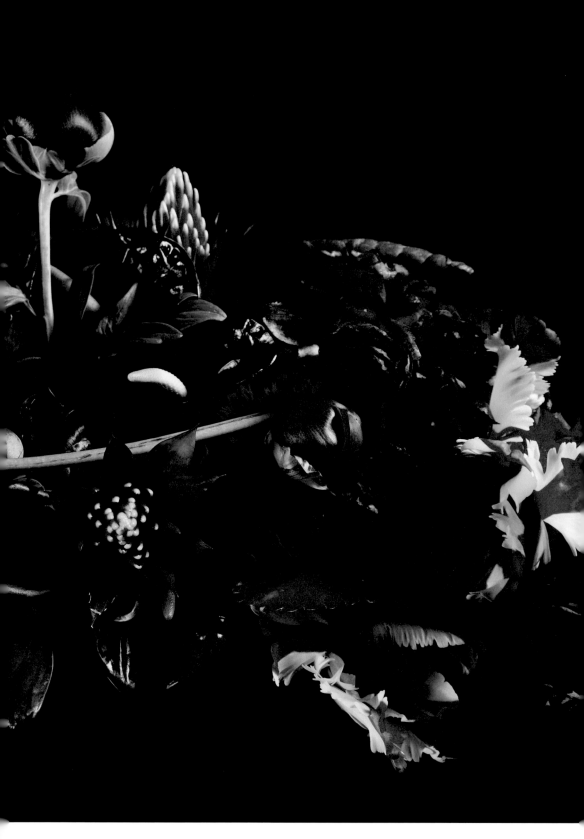

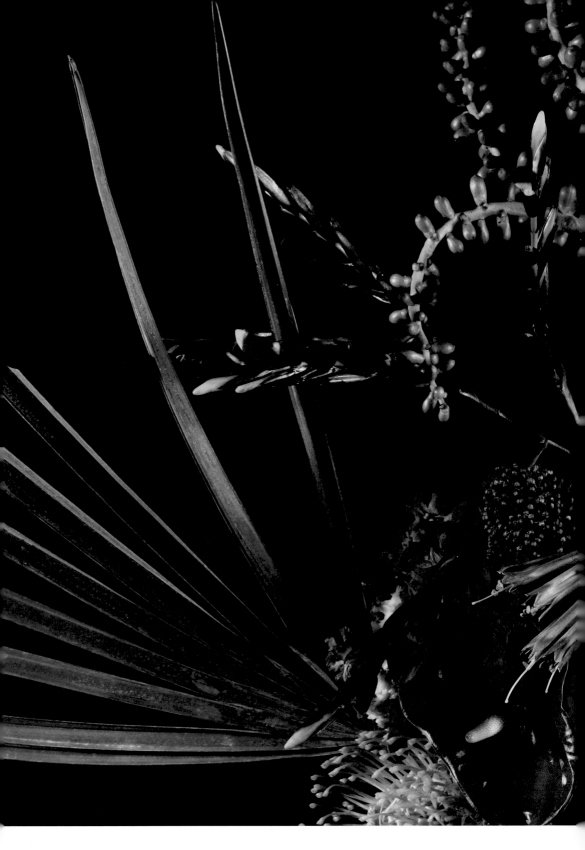

FLOCK 28

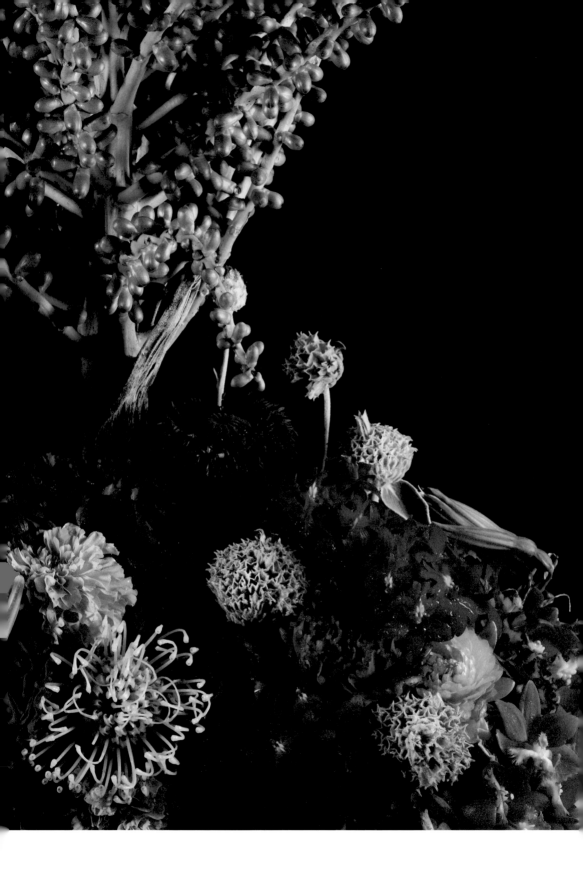

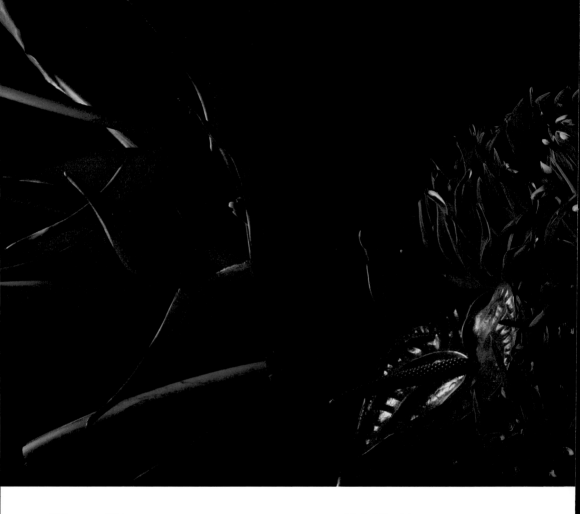

FLOCK 29

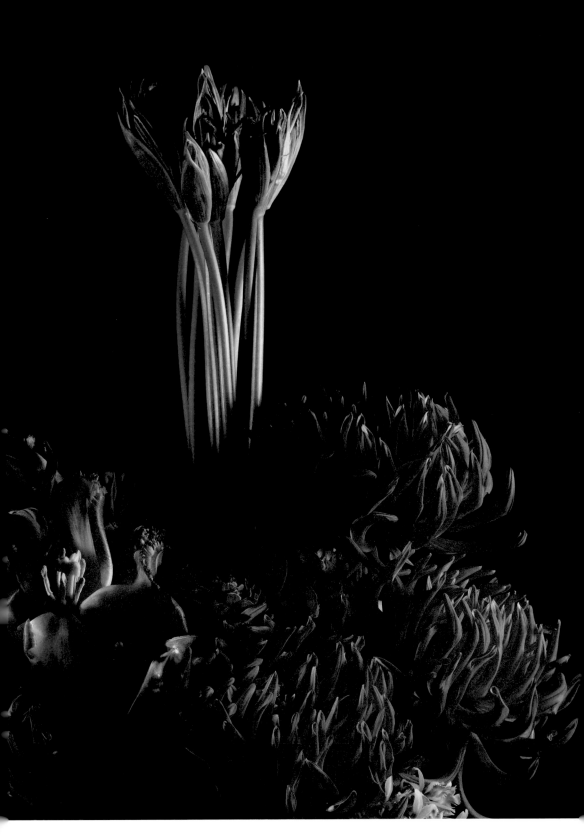

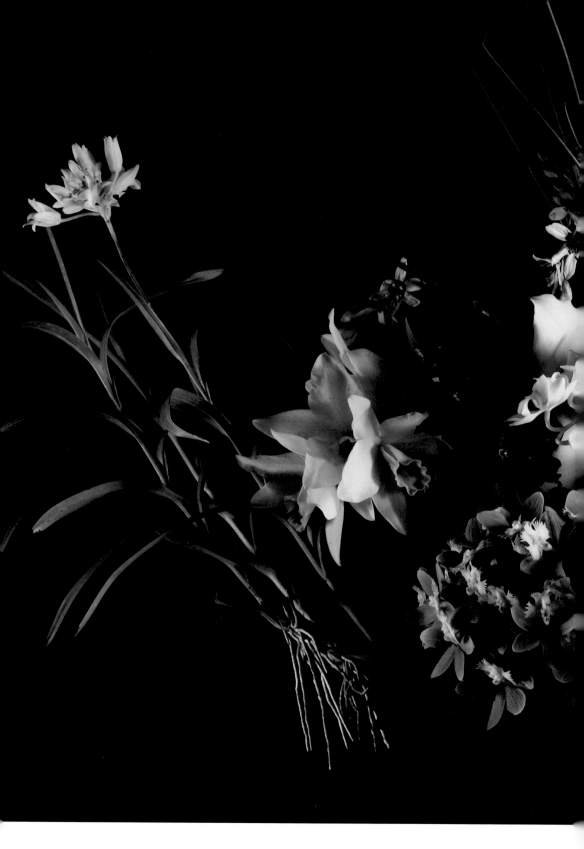

FLOCK 30

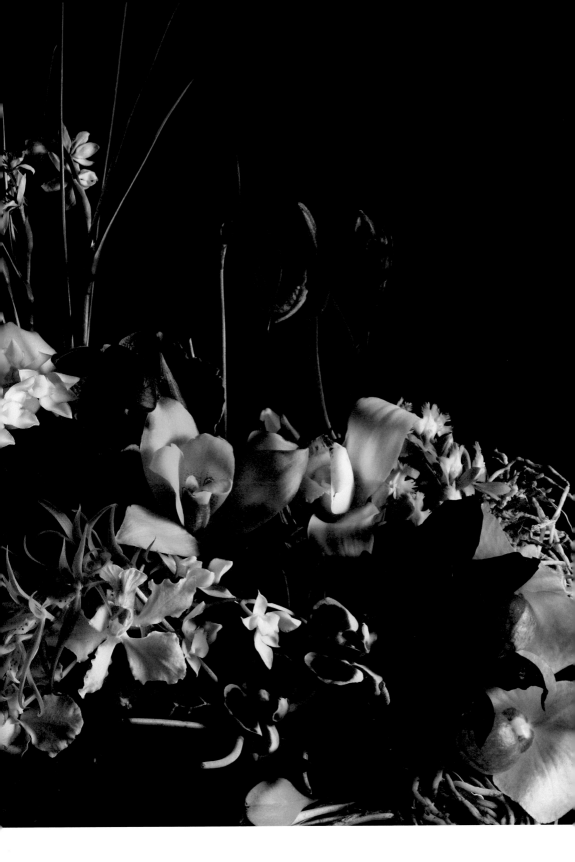

FLOCK 31

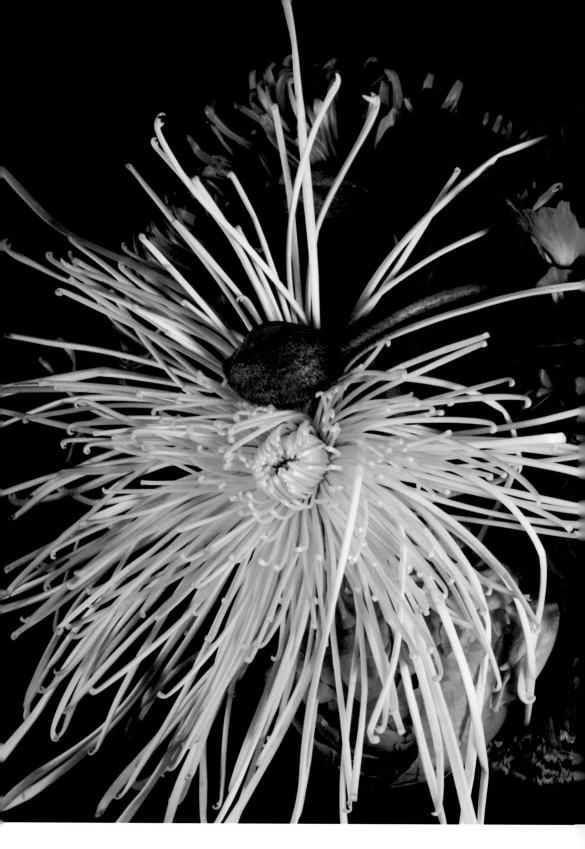

FLOCK 32

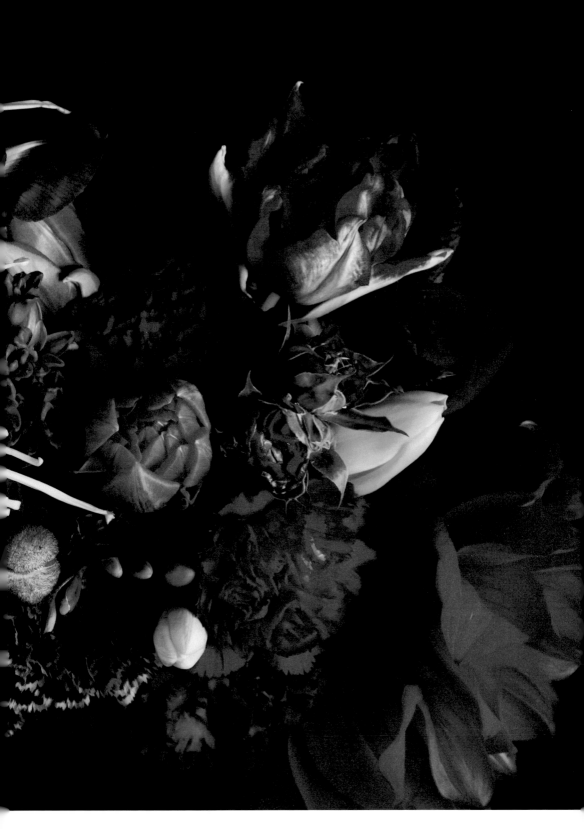

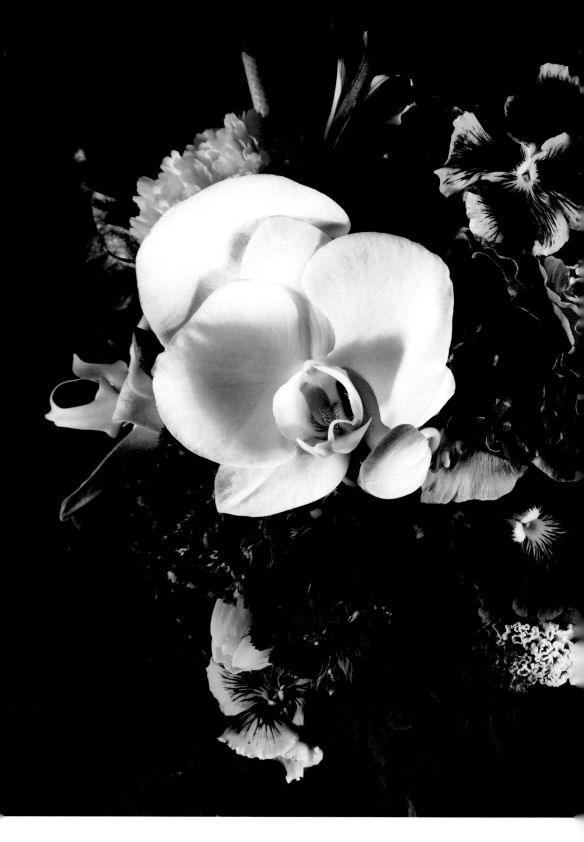

FLOCK 33

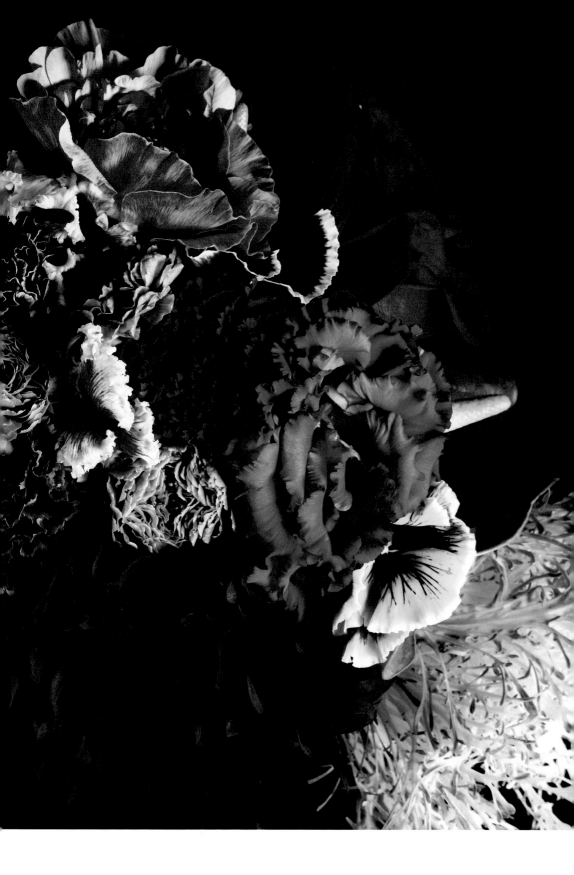

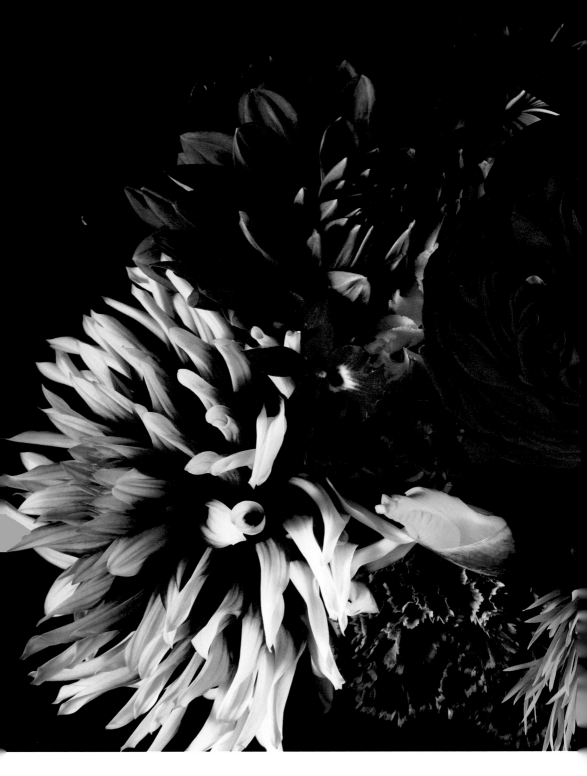

FLOCK 34

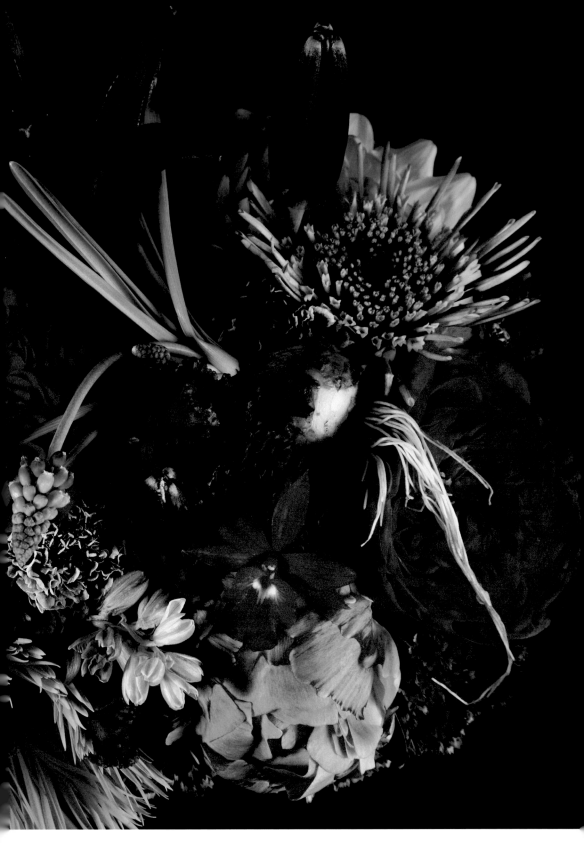

FLOCK 35

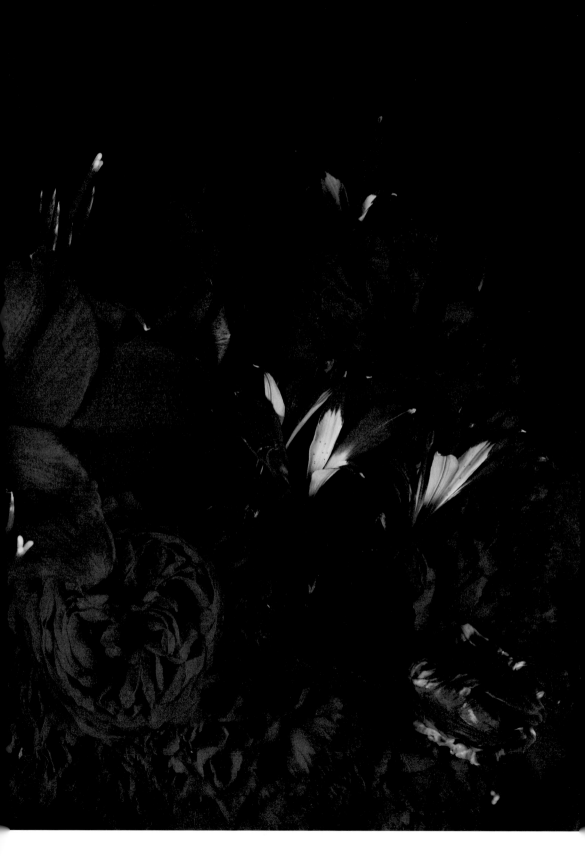

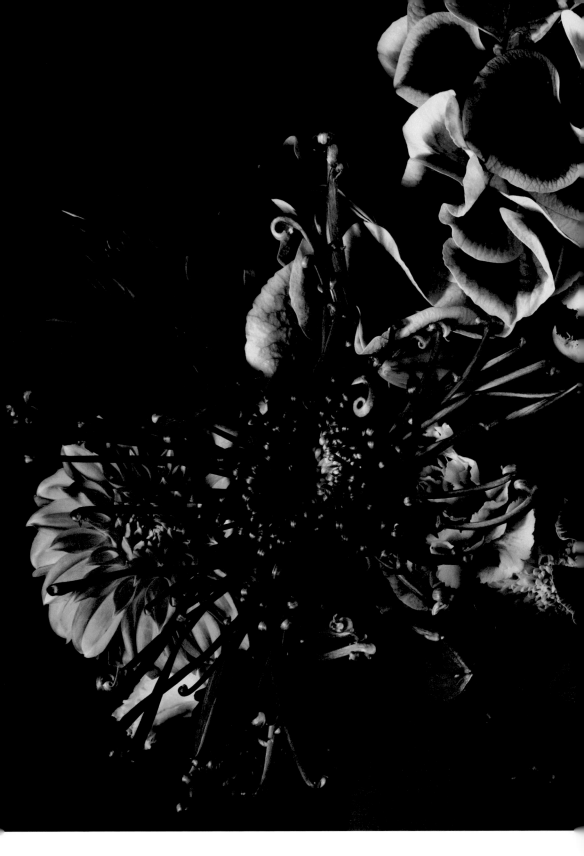

FLOCK 36

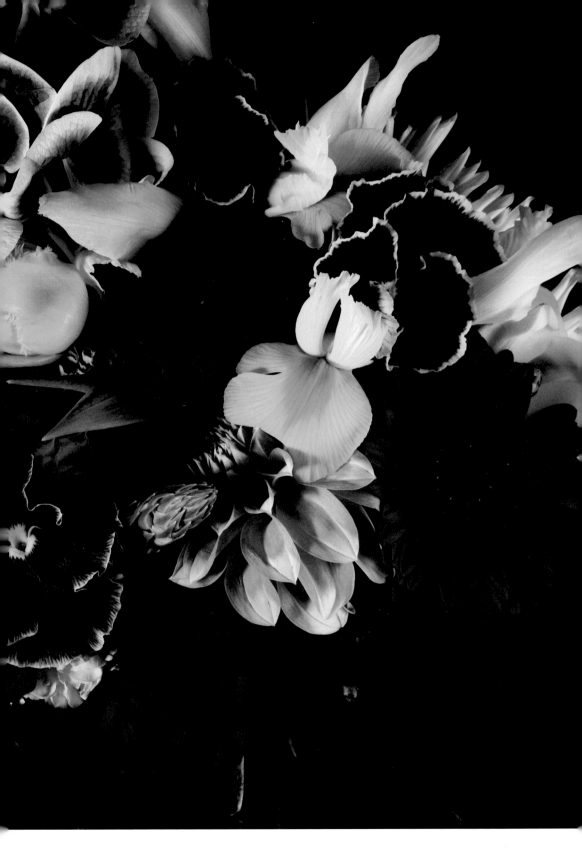

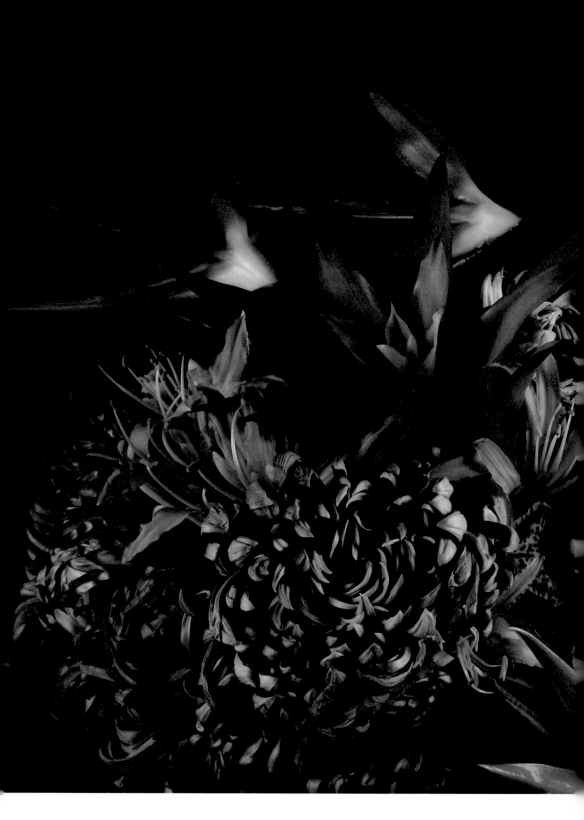

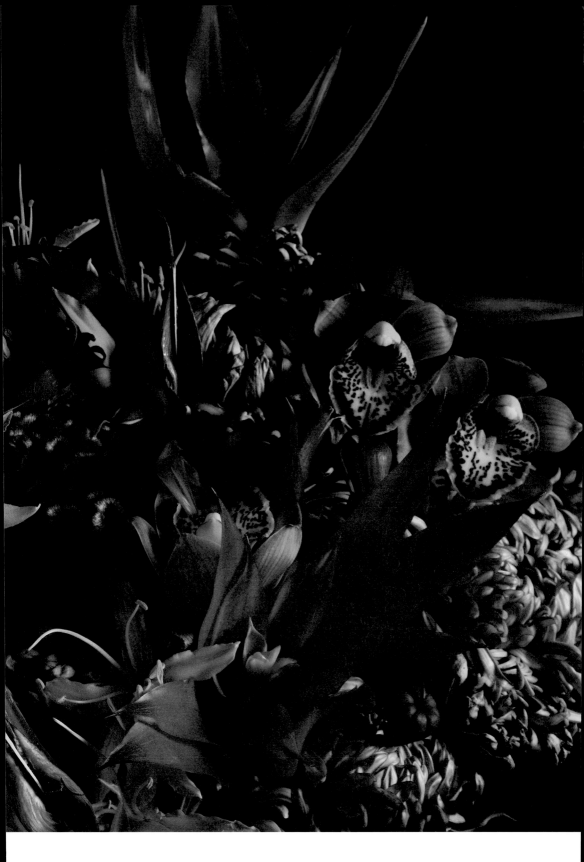

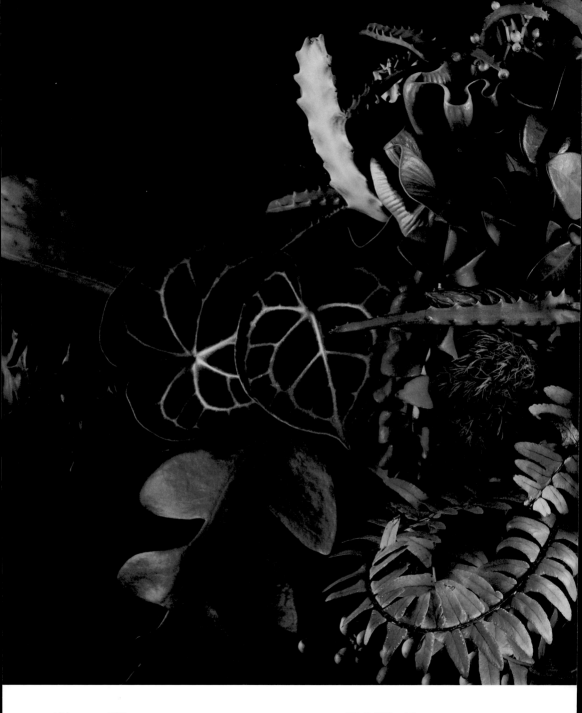

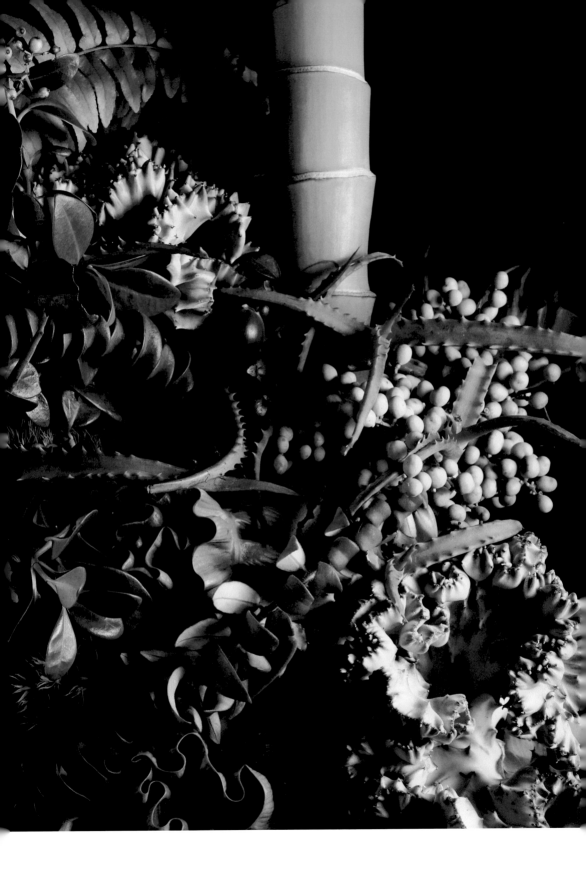

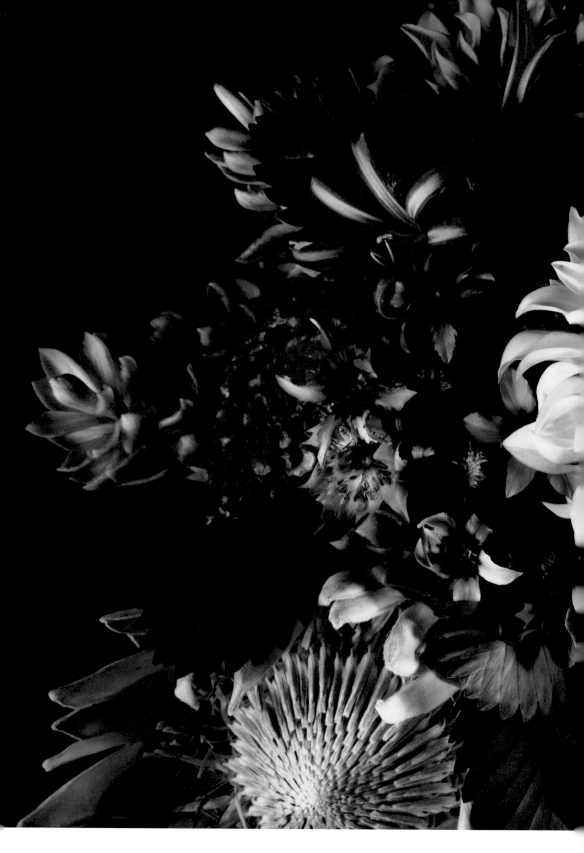

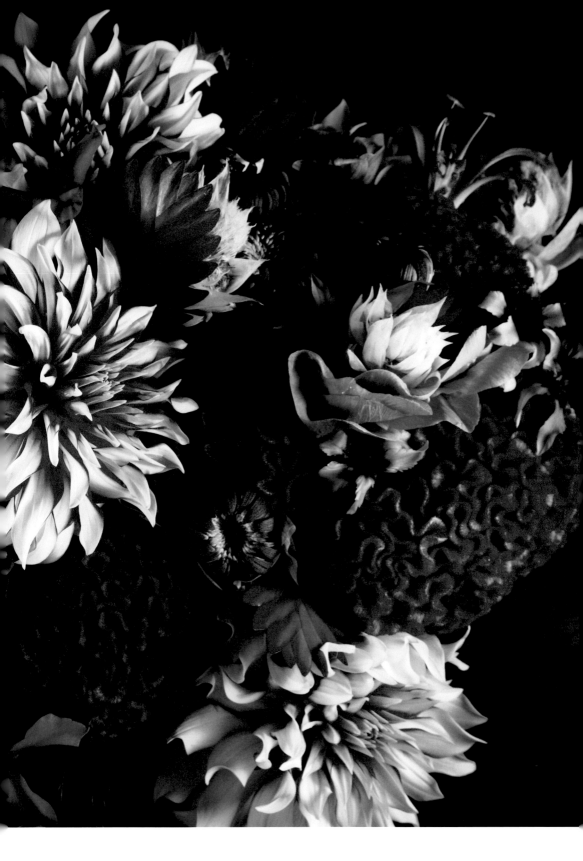

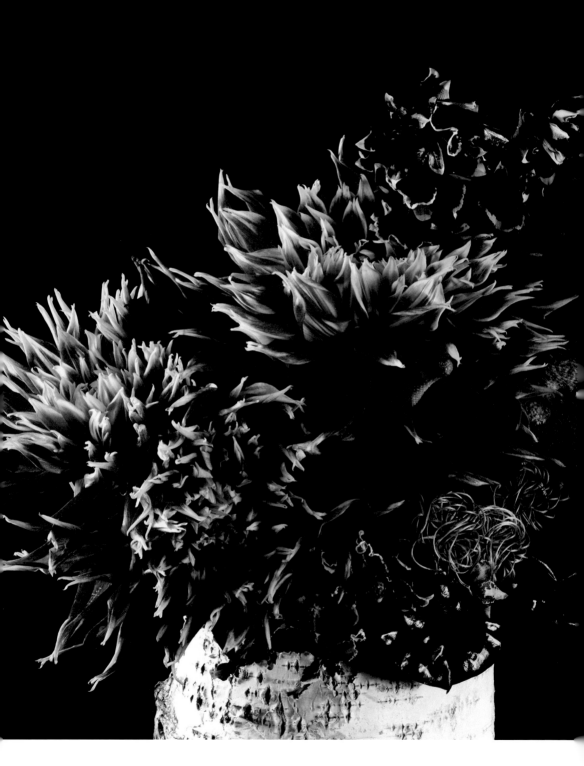

FLOCK 40

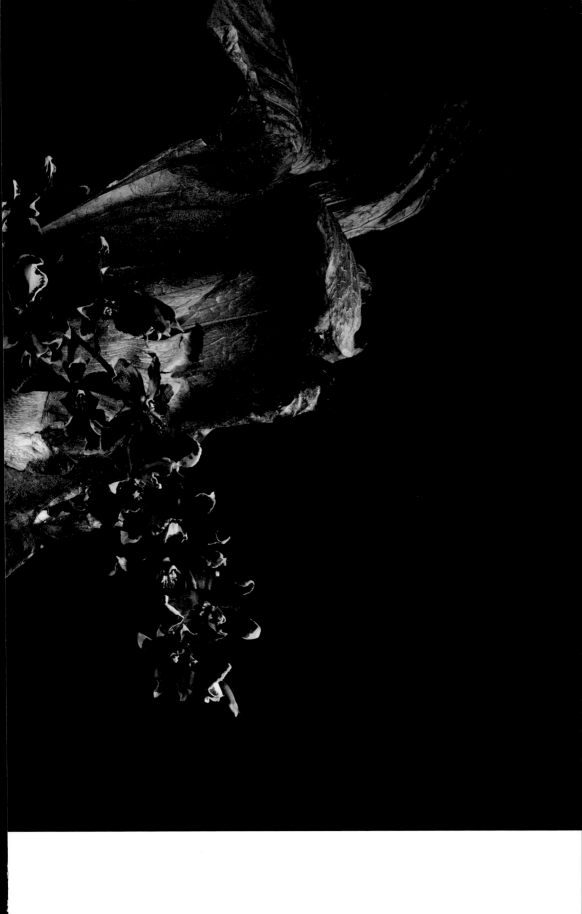

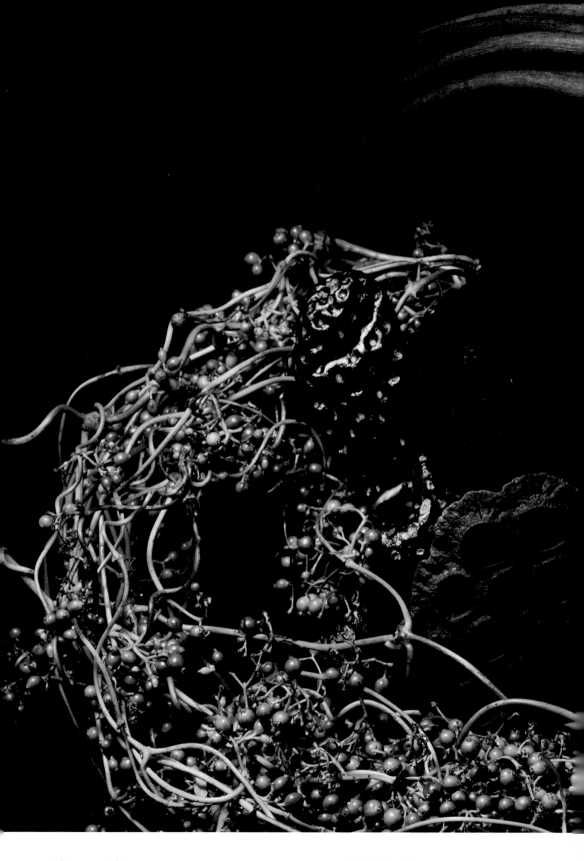

FLOCK 41

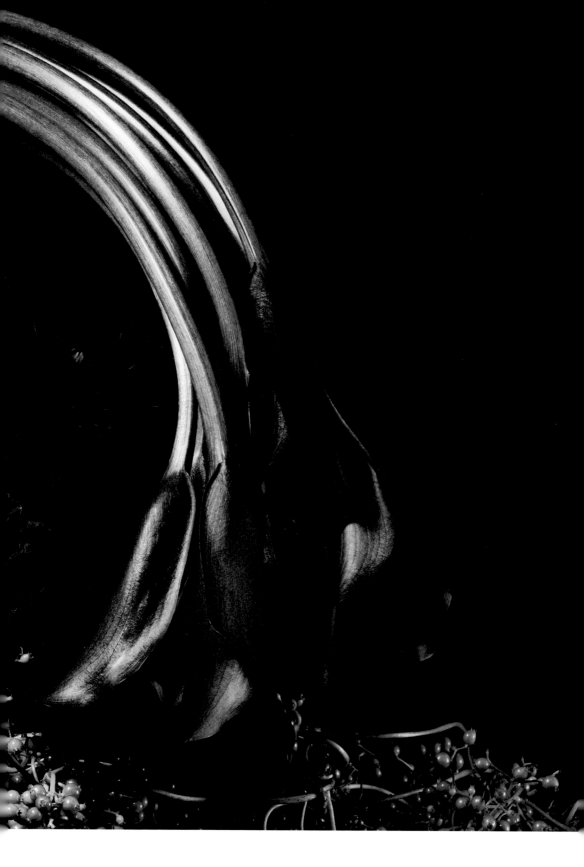

FLOCK 42

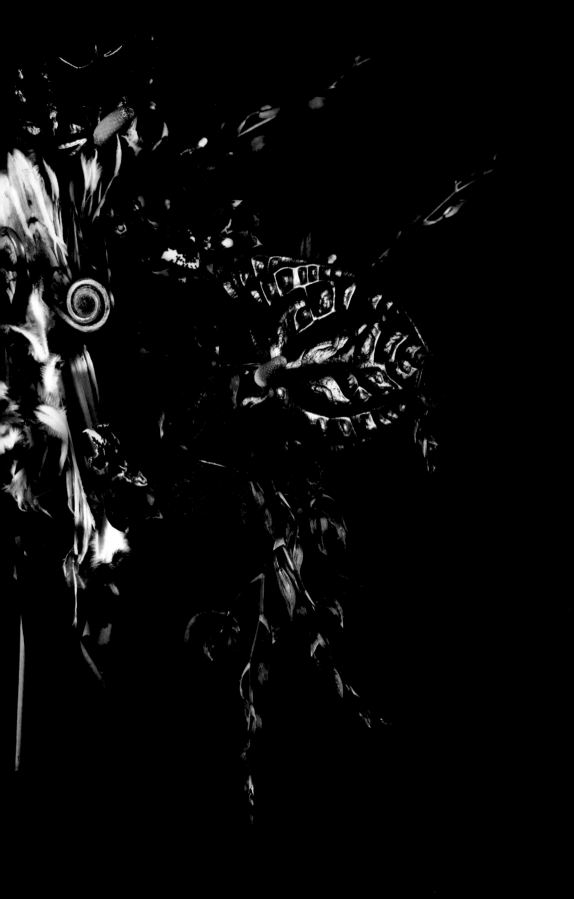

FLOCK 43

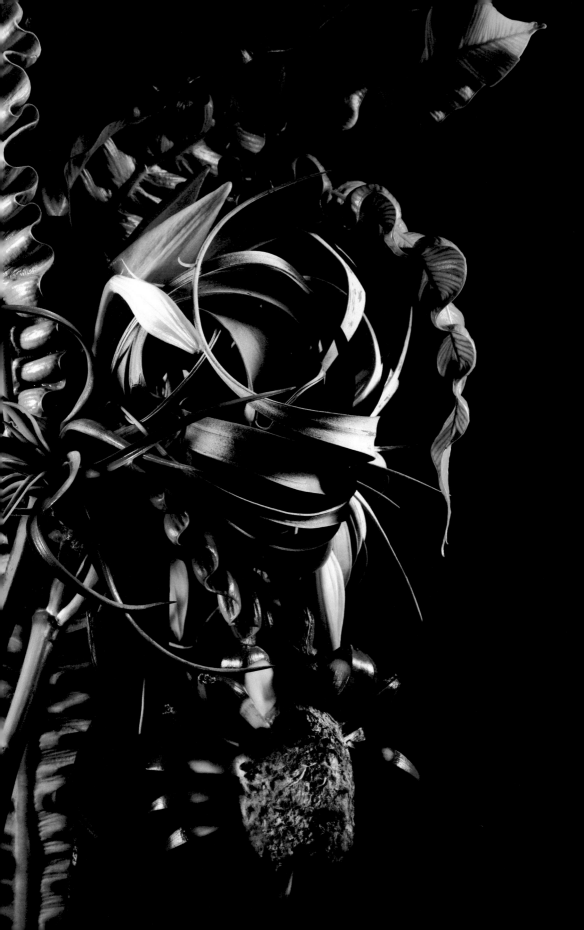

FLOCK 44

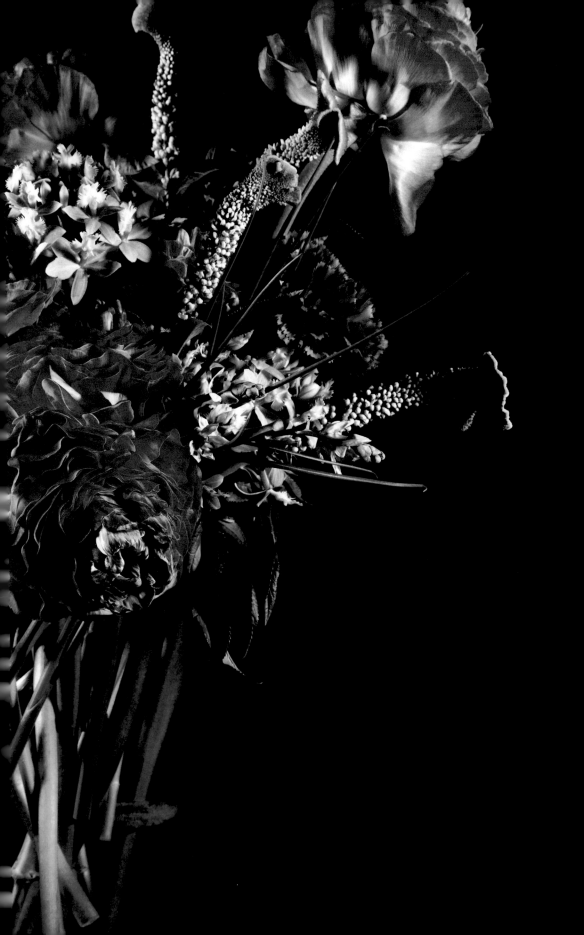

FLOCK 45

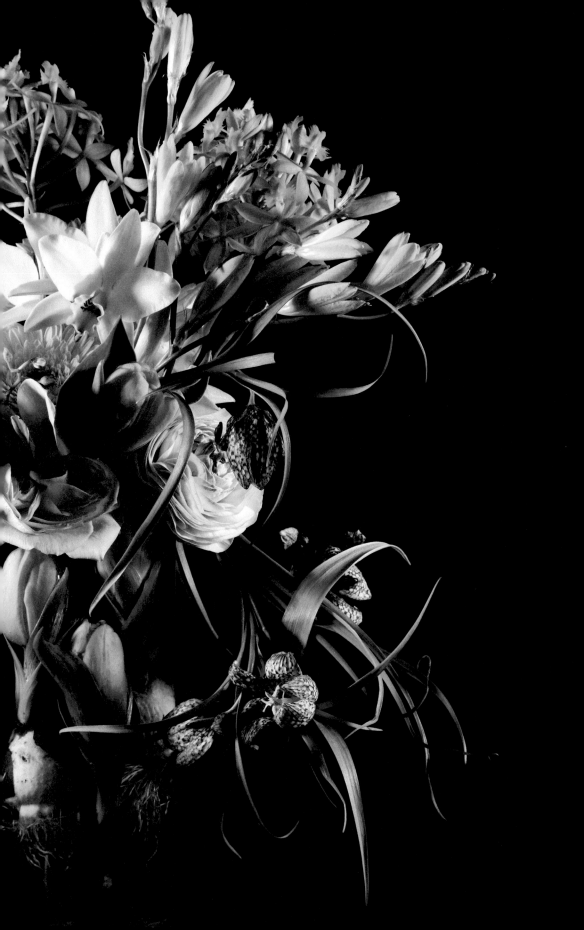

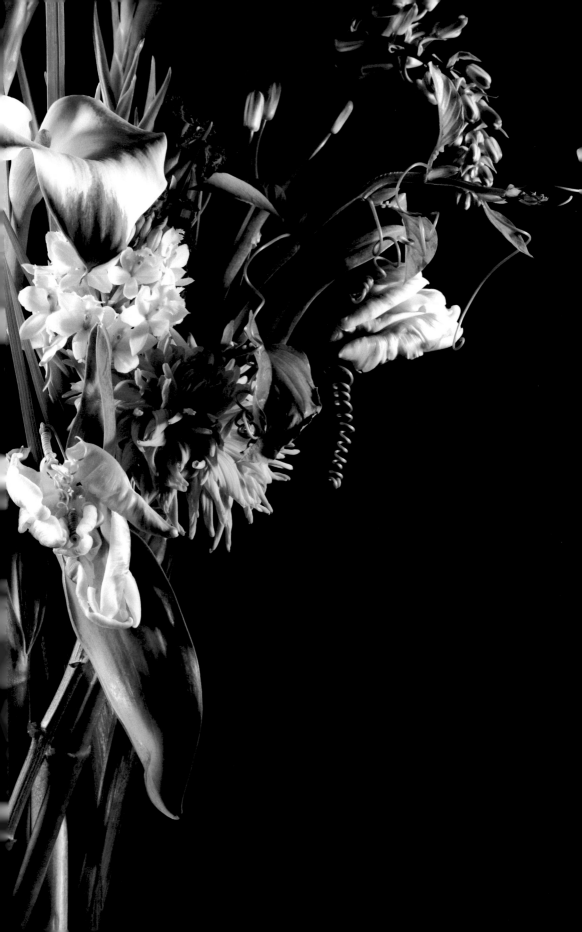

FLOCK 47

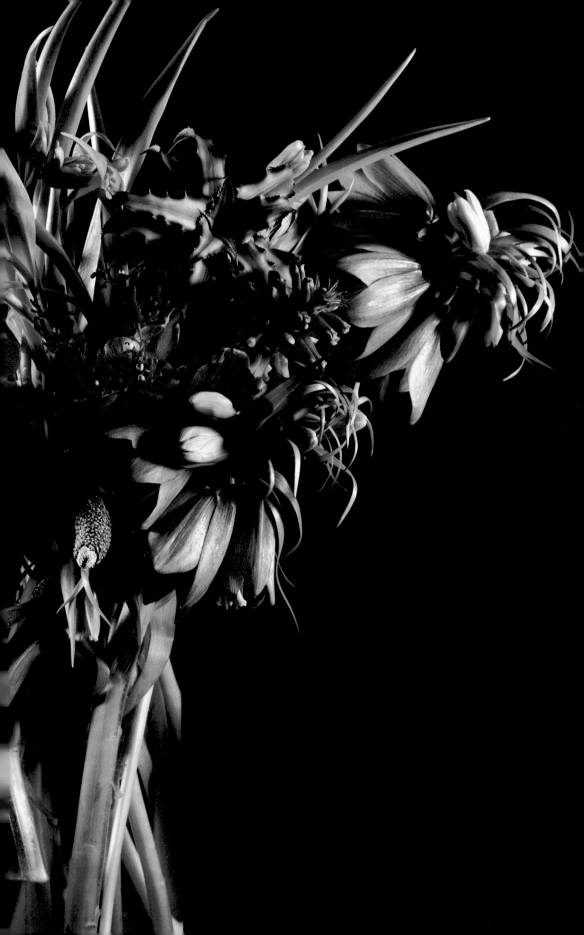

FLOCK 48

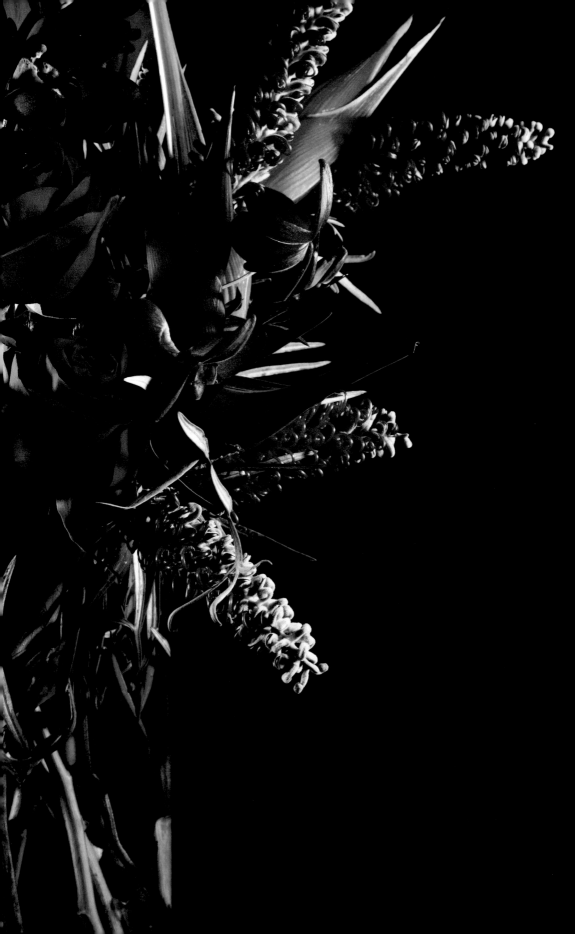

FLOCK 49

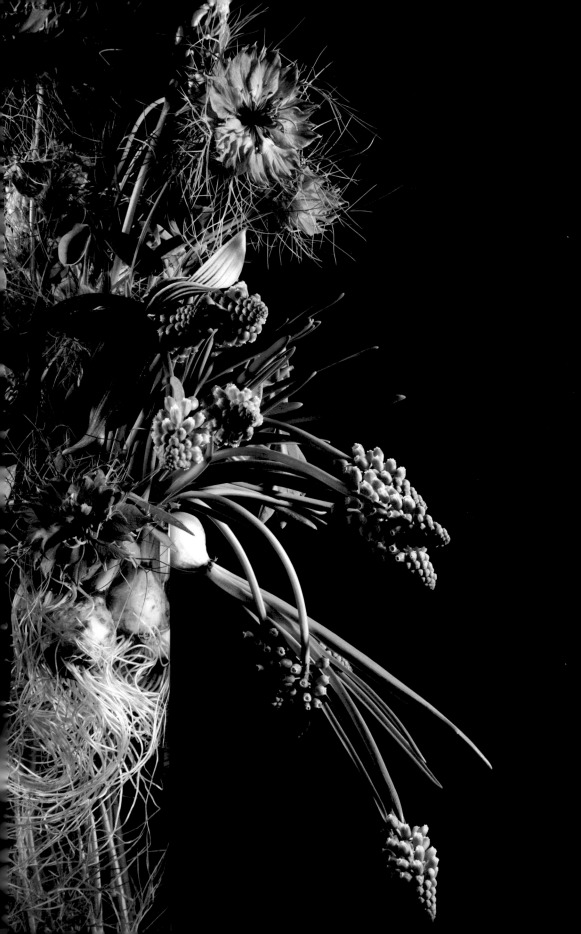

COEXISTENCE

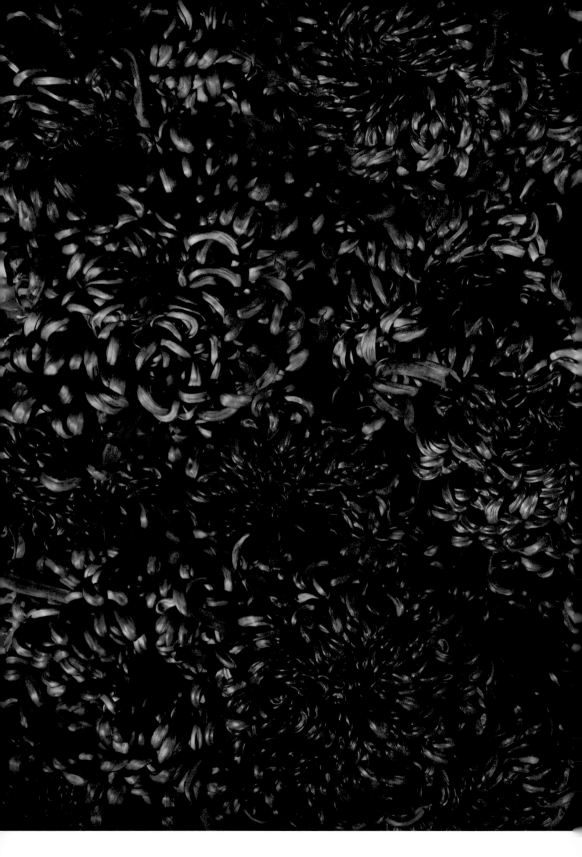

COEXISTENCE 01

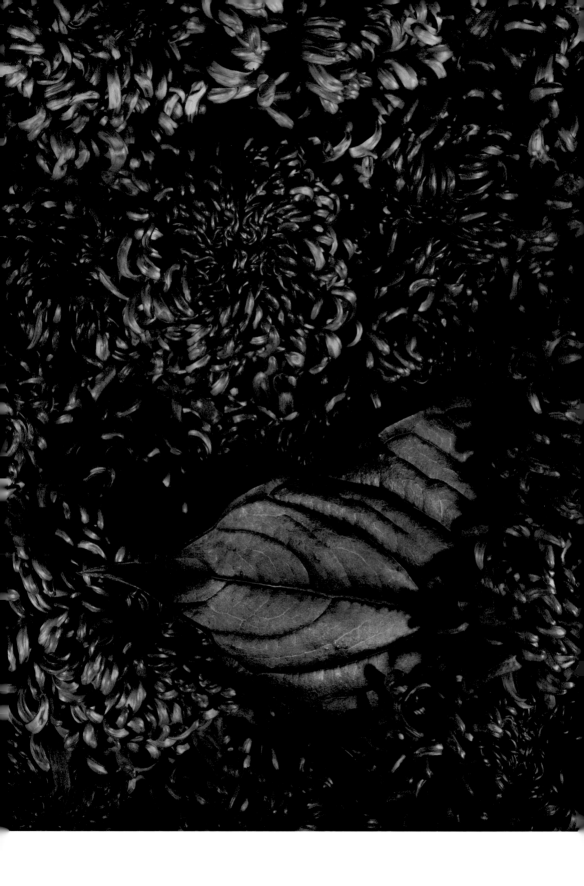

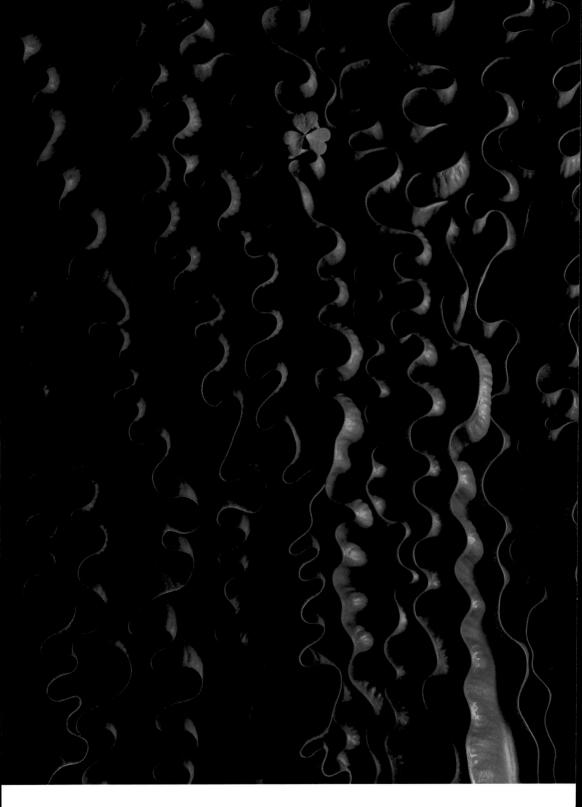

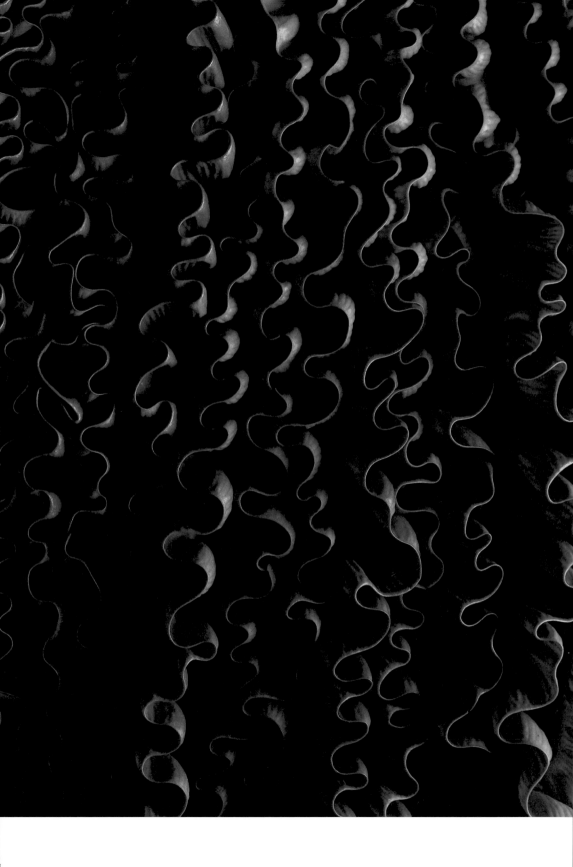

COEXISTENCE 03

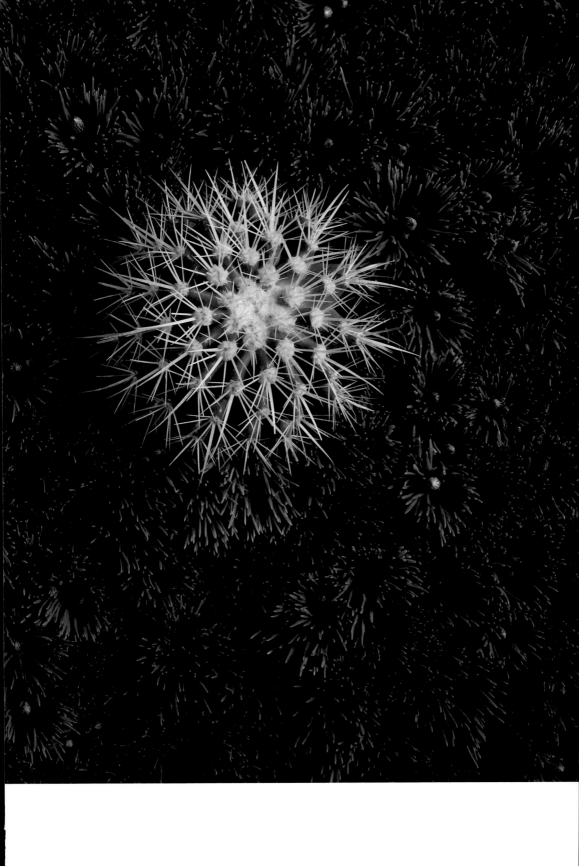

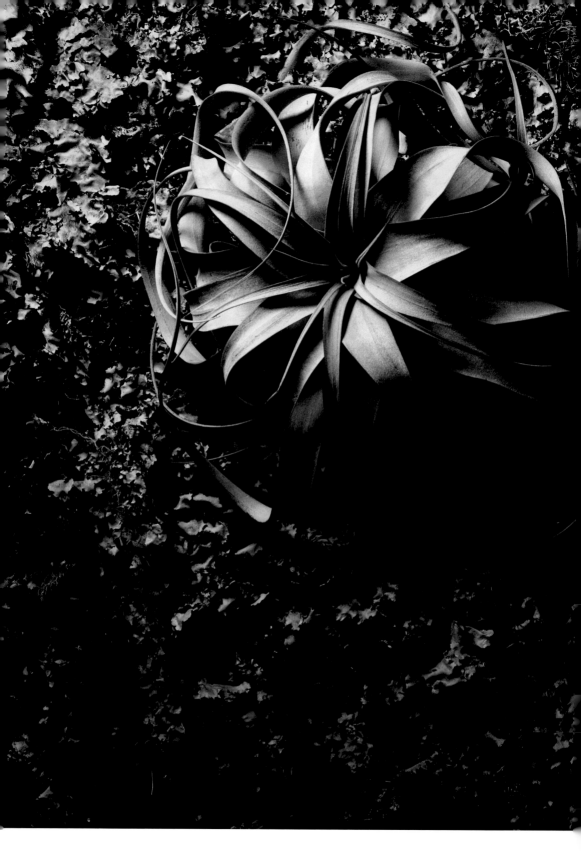

COEXISTENCE 04

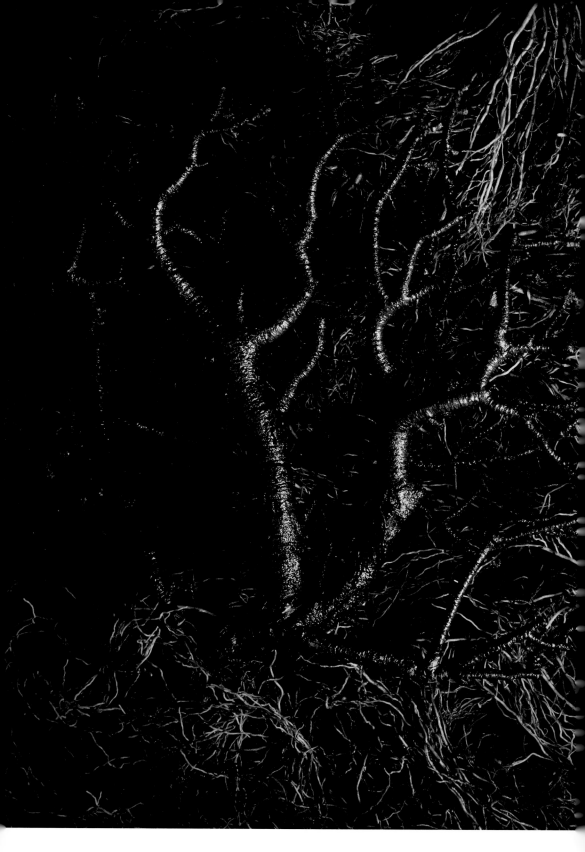

COEXISTENCE 05

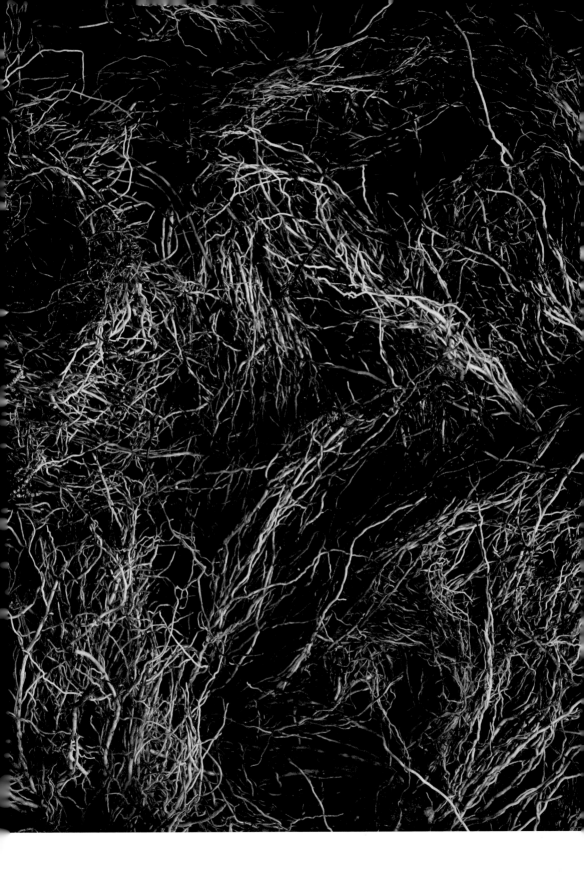

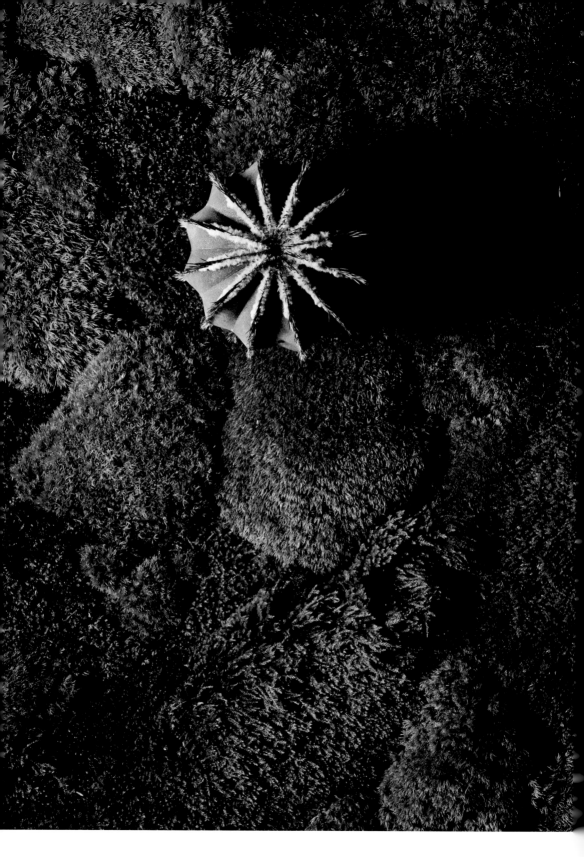

COEXISTENCE 06

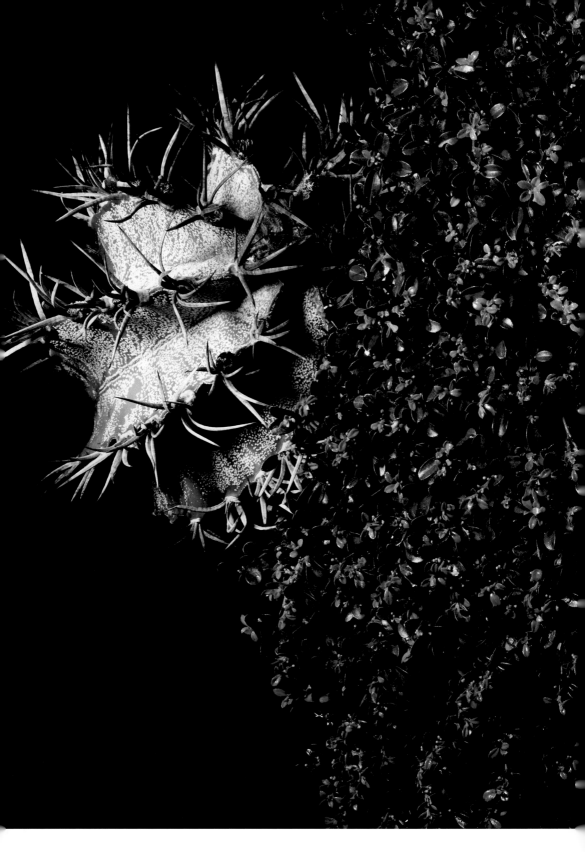

COEXISTENCE 07

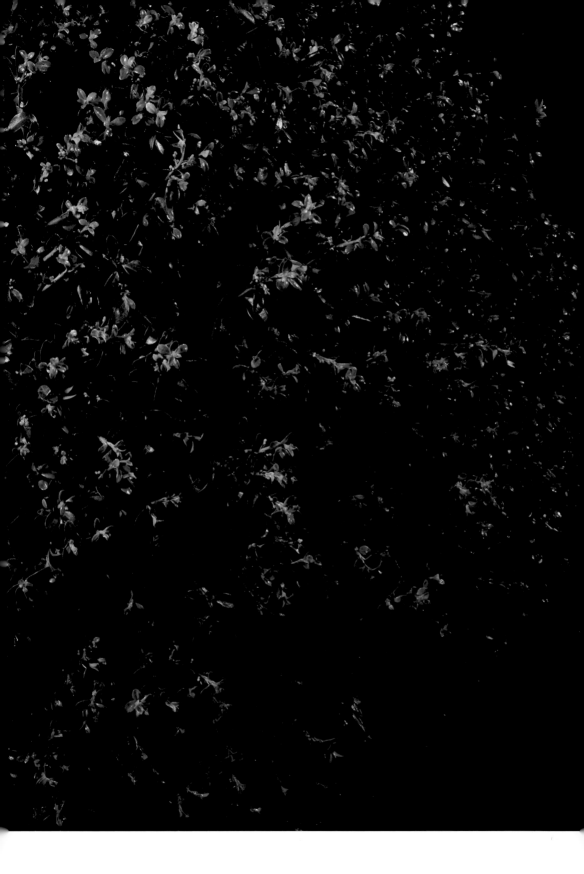

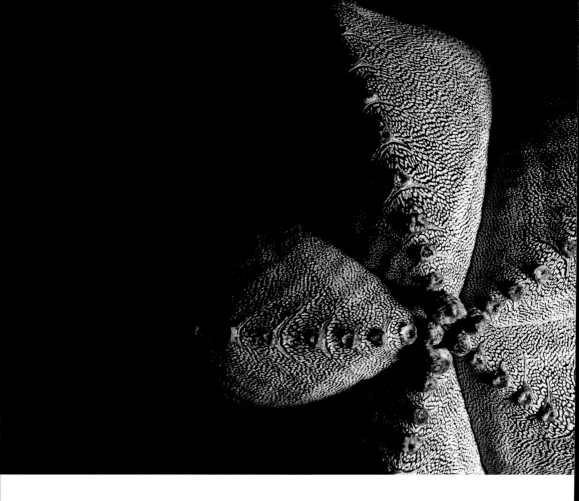

COEXISTENCE 08

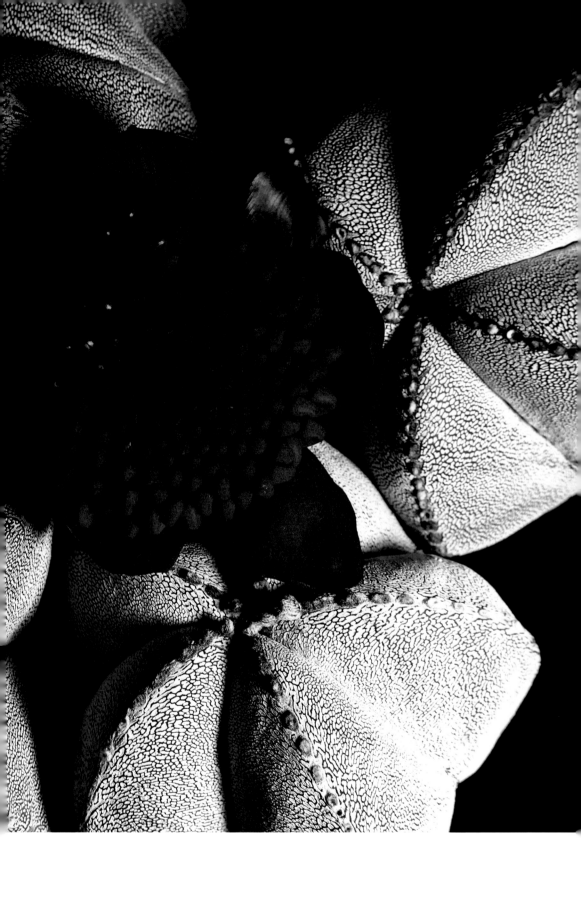

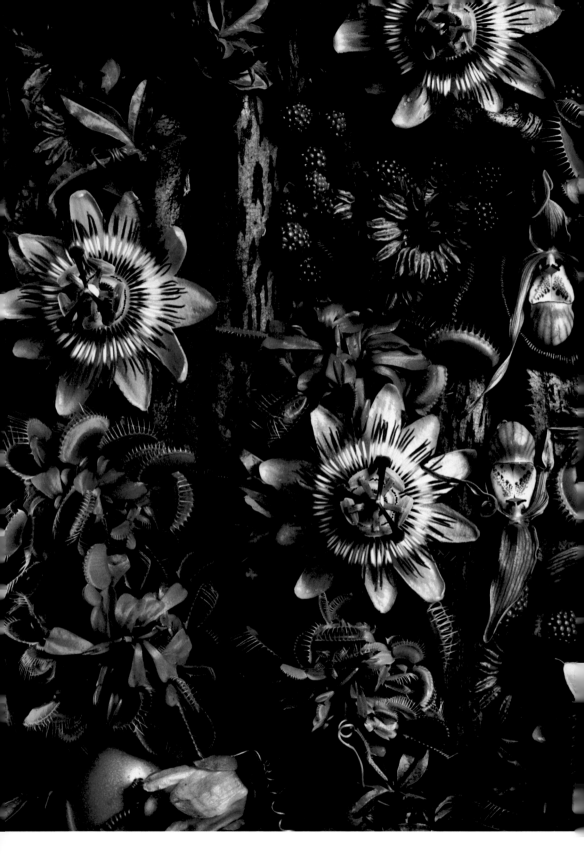

COEXISTENCE 09

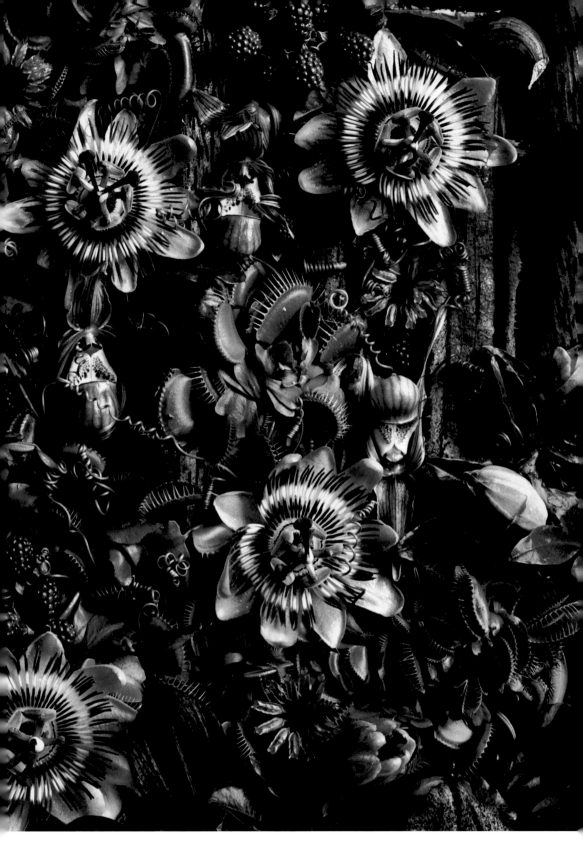

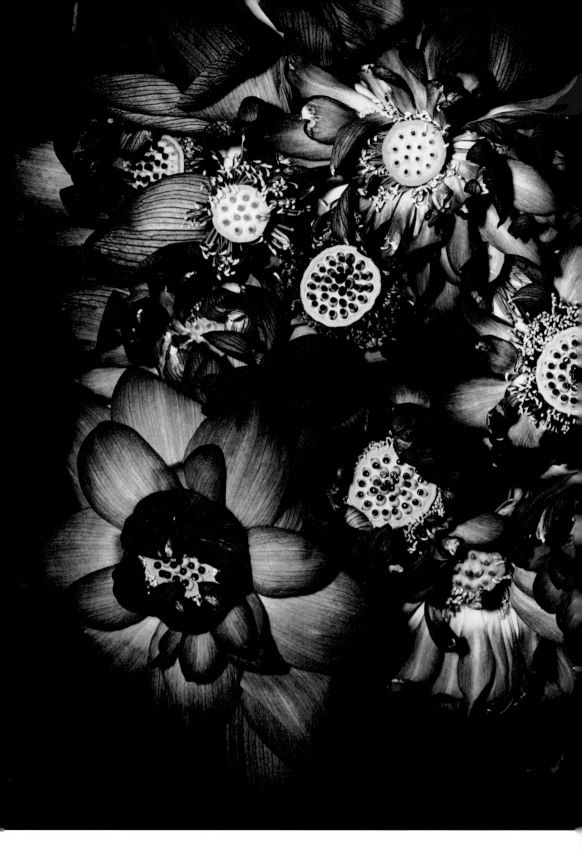

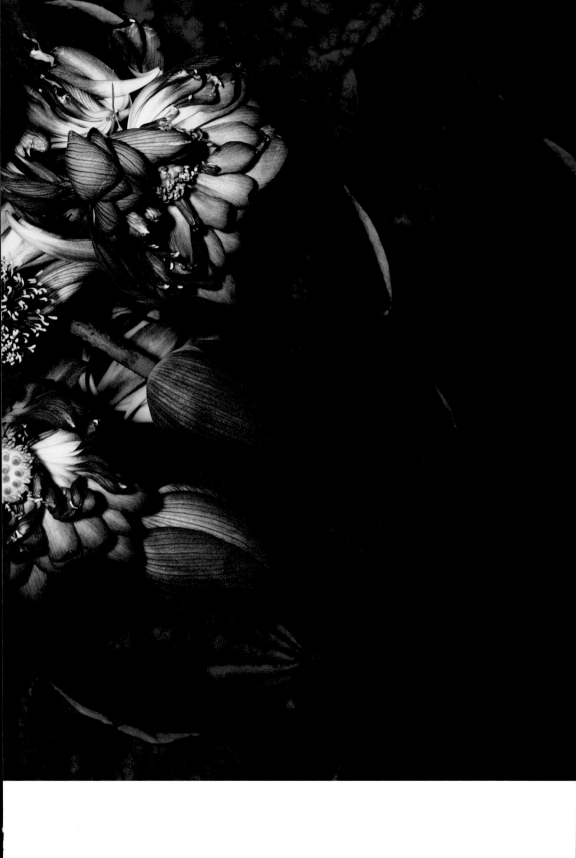

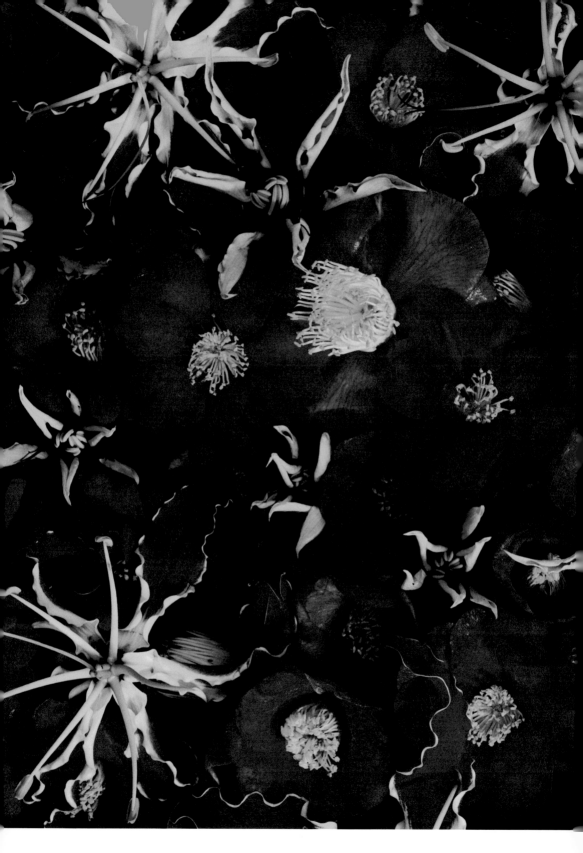

COEXISTENCE 11

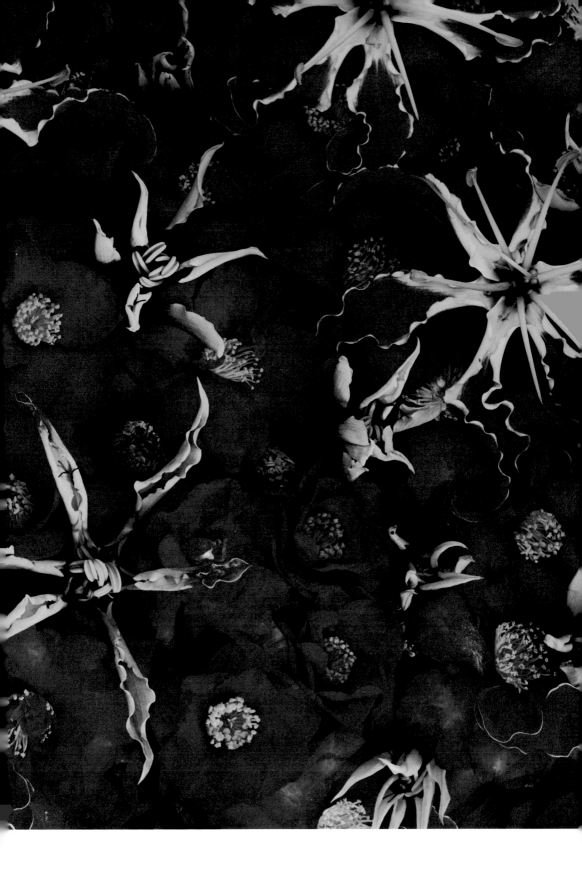

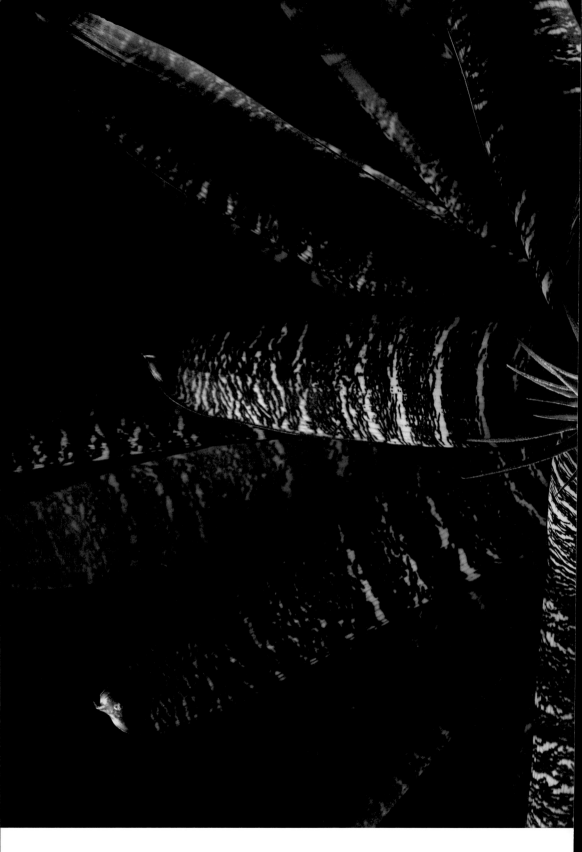

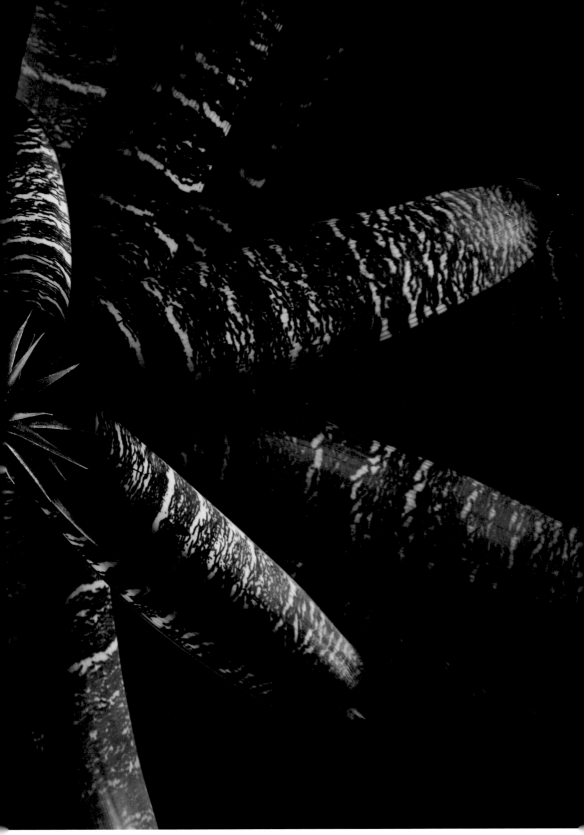

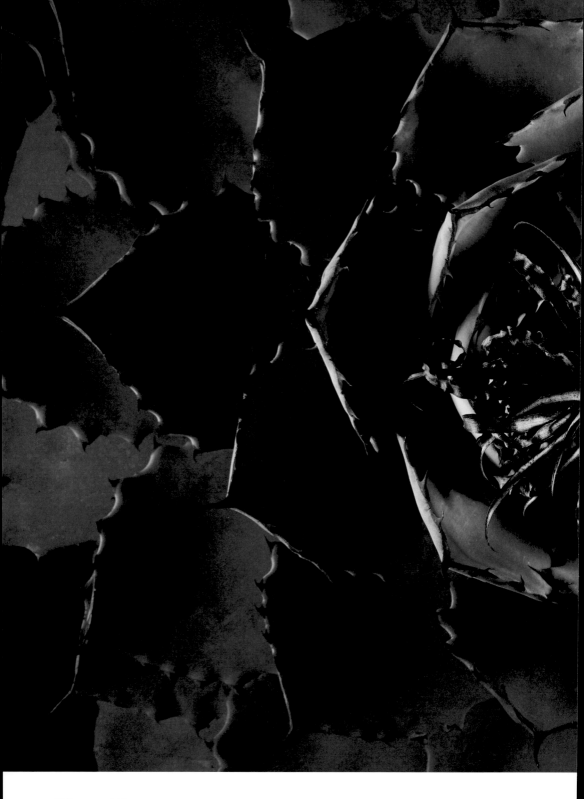

COEXISTENCE 13

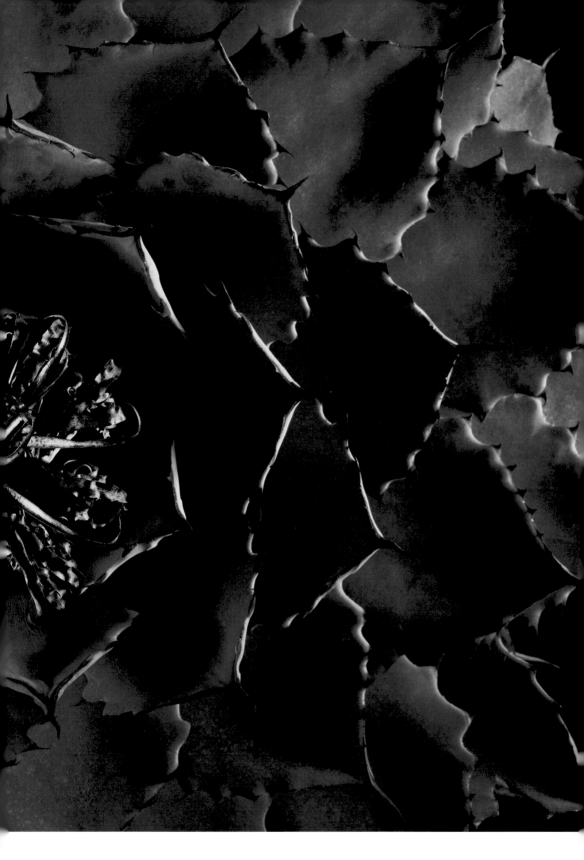

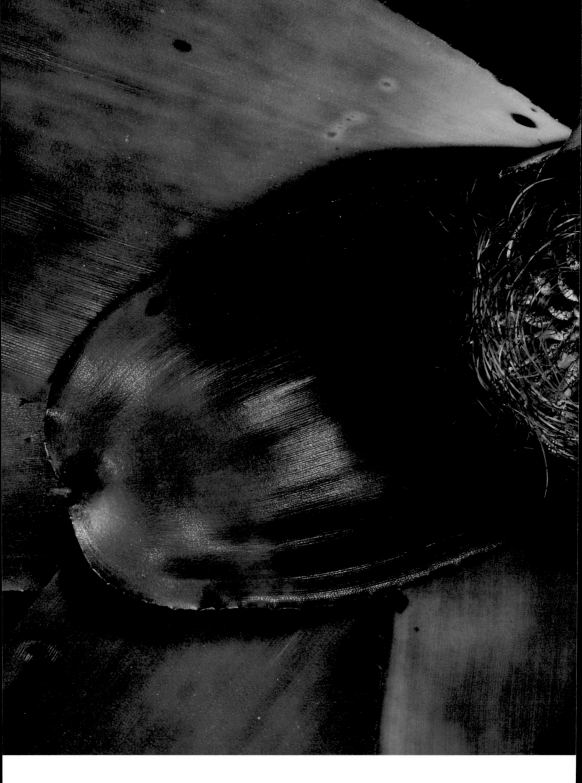

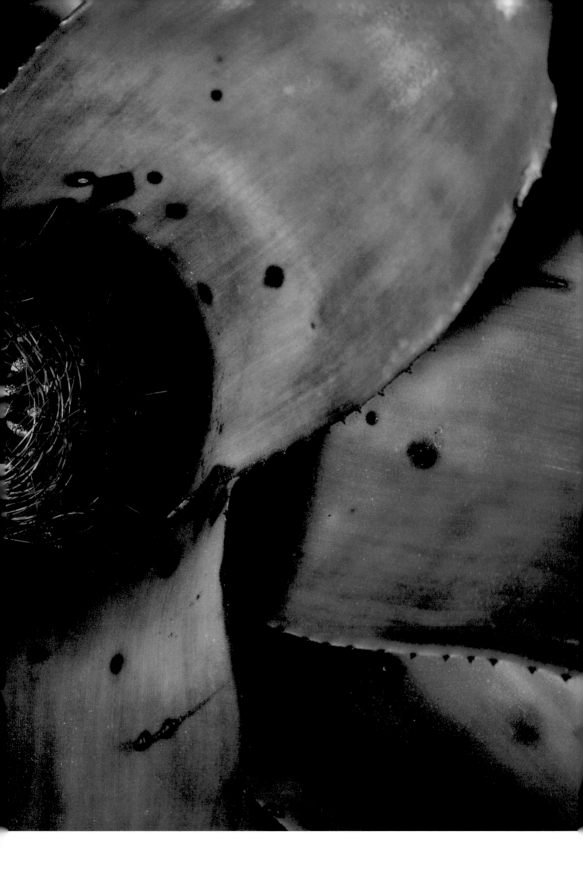

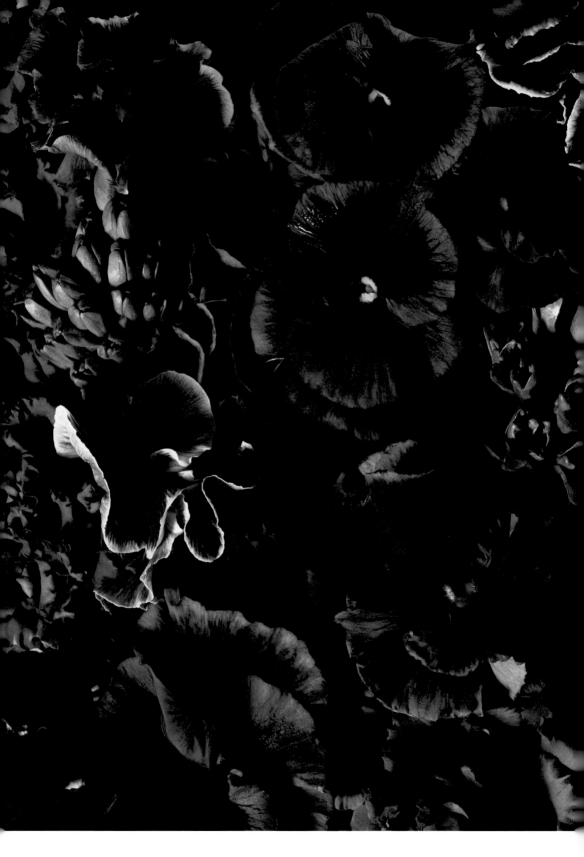

COEXISTENCE 15

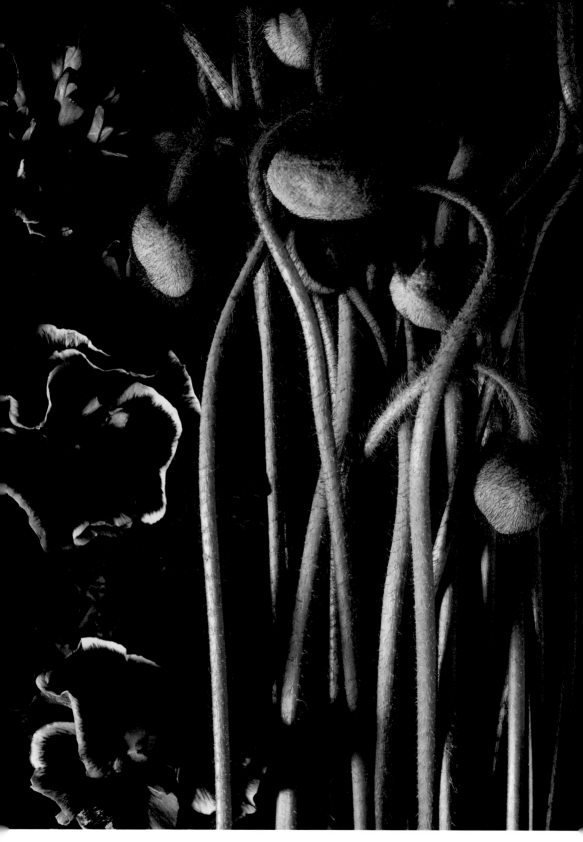

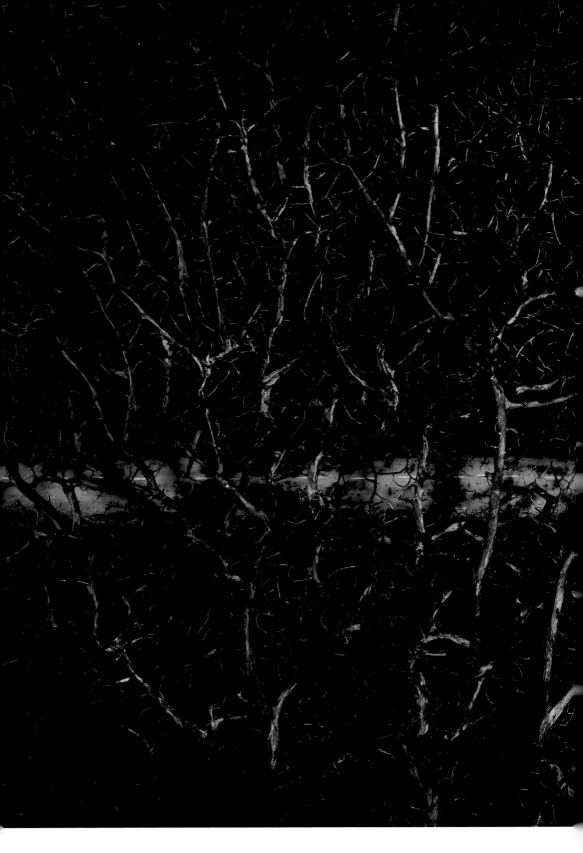

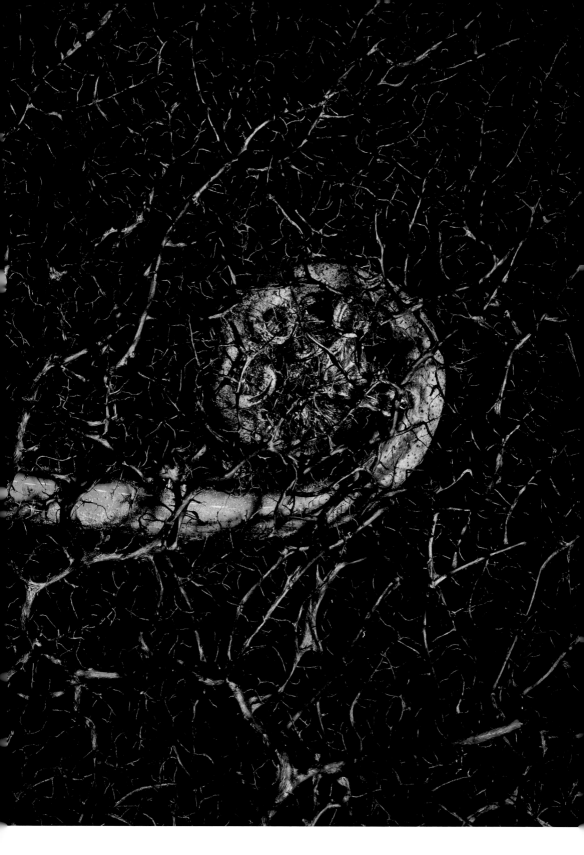

HYBRID

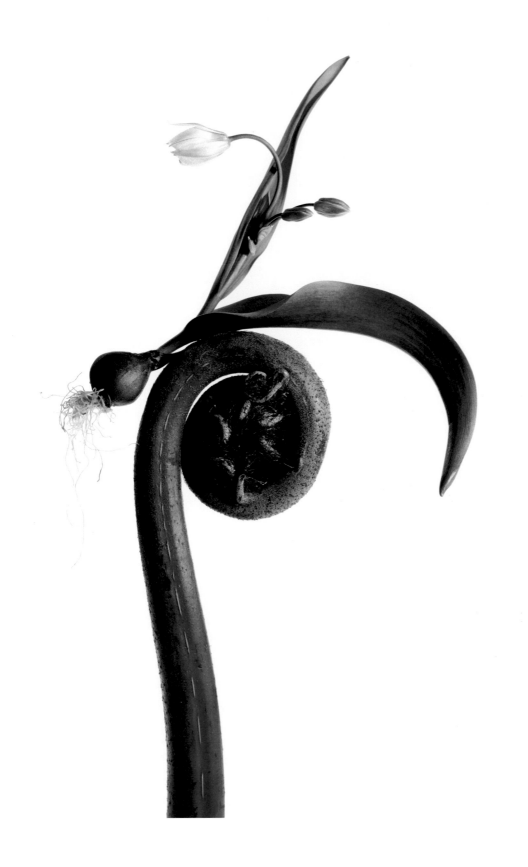

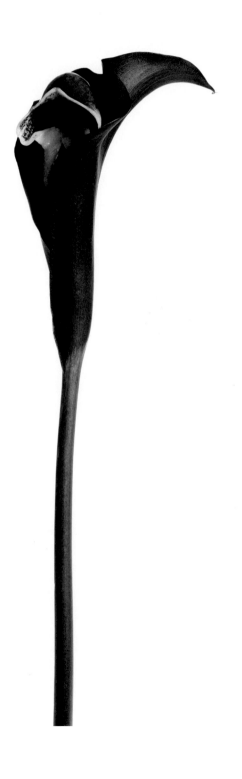

HYBRID 03

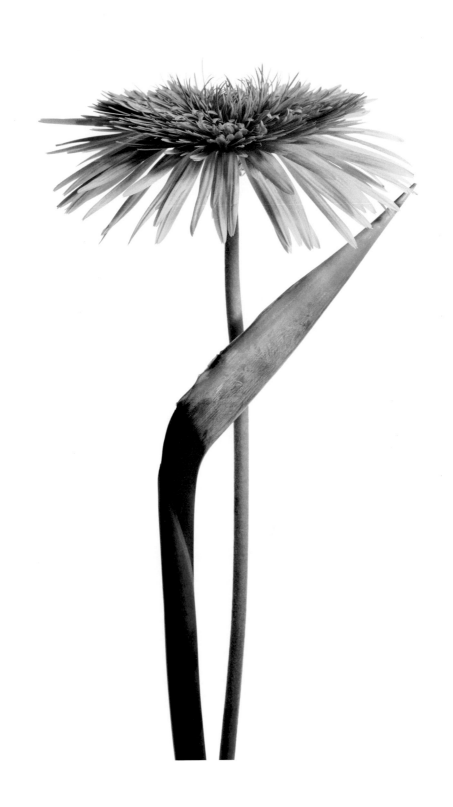

HYBRID 04

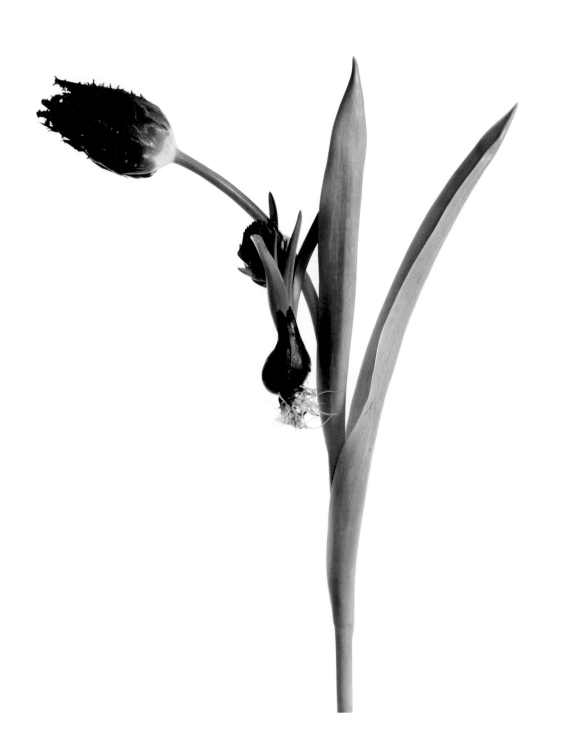

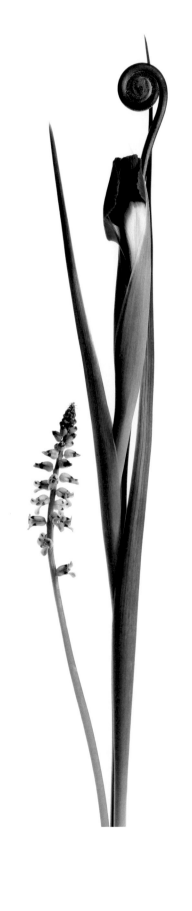

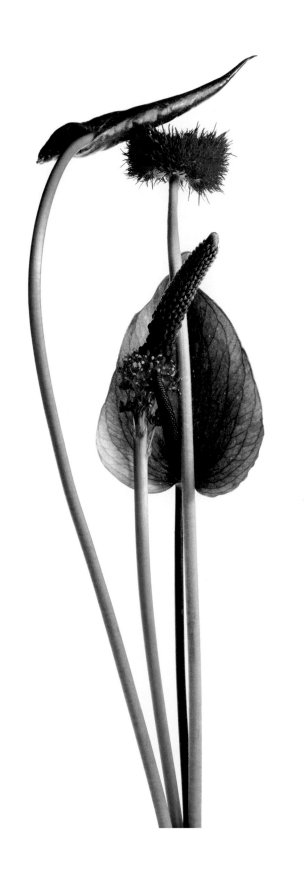

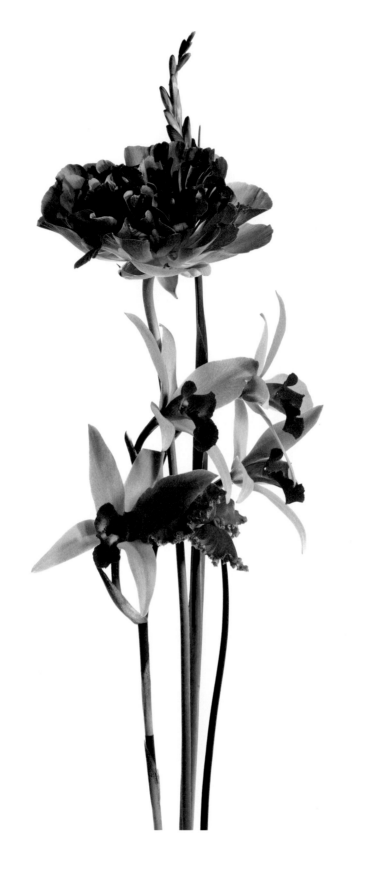

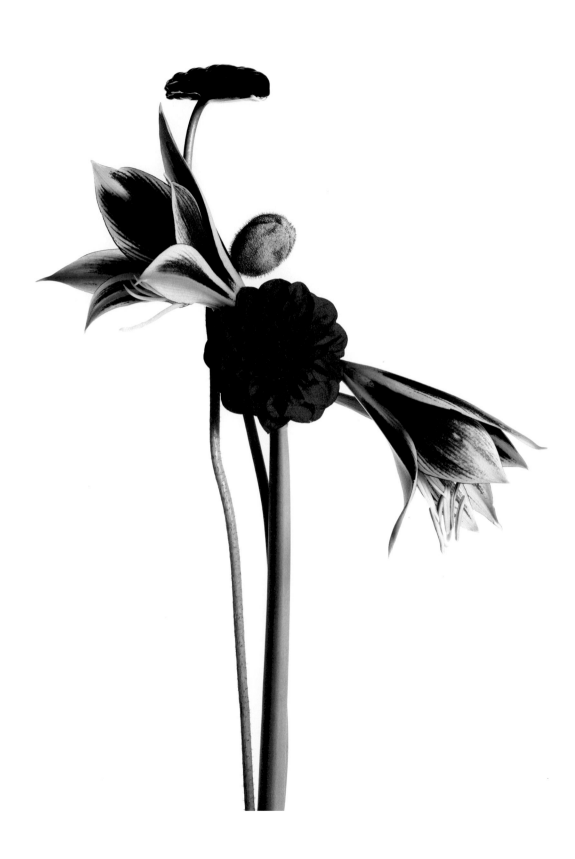

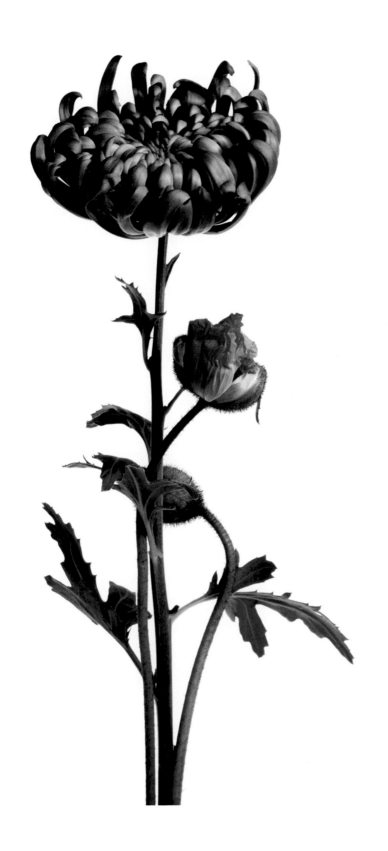

HYBRID 10

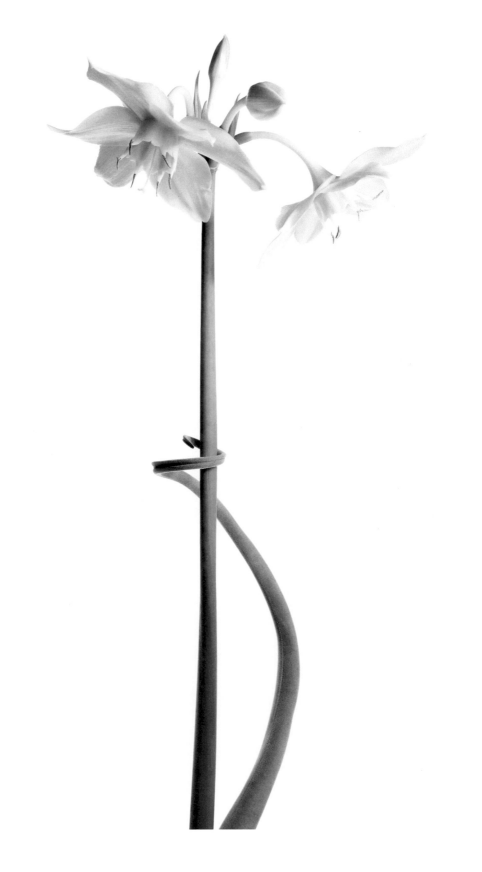

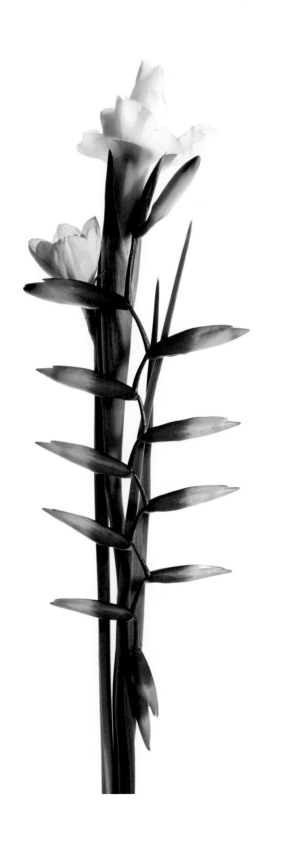

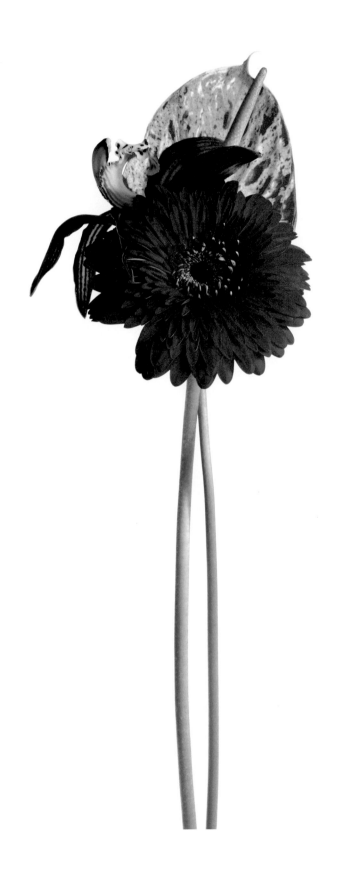

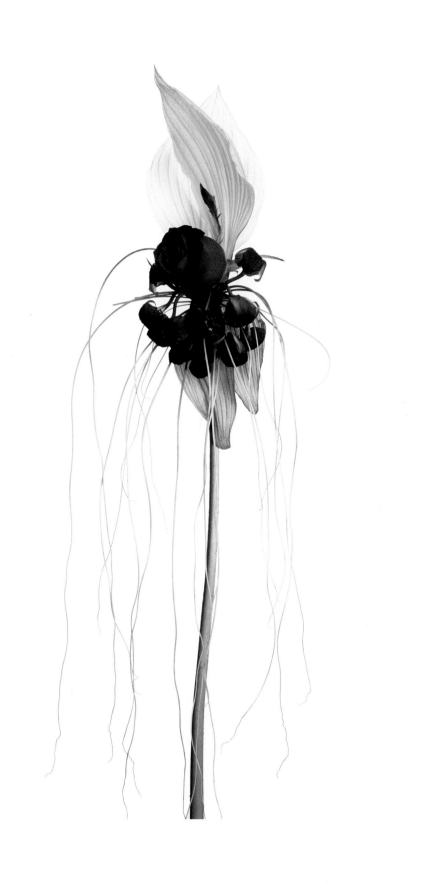

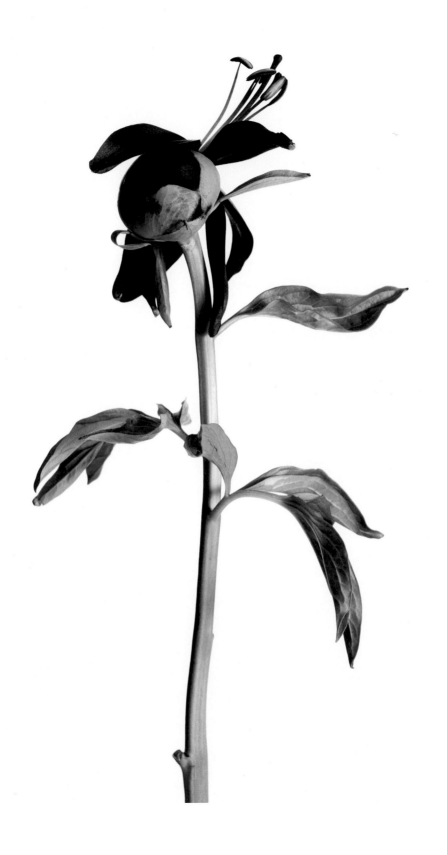

HYBRID 15

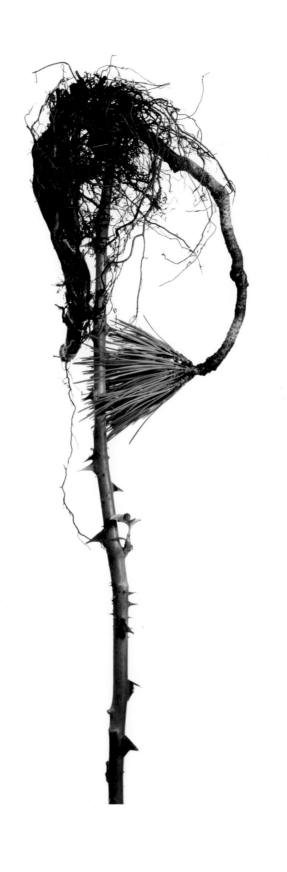

HYBRID 16

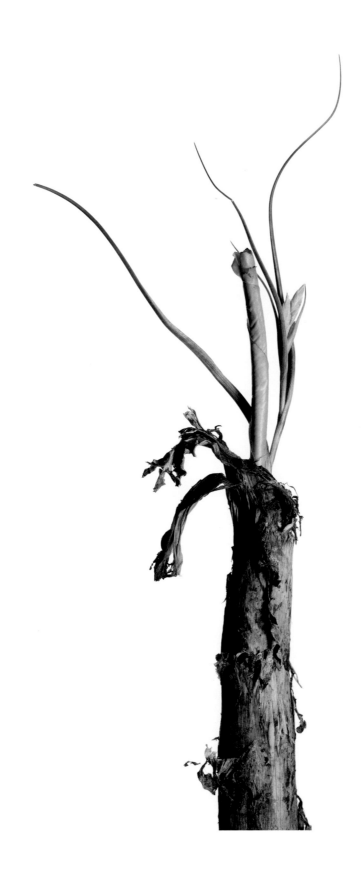

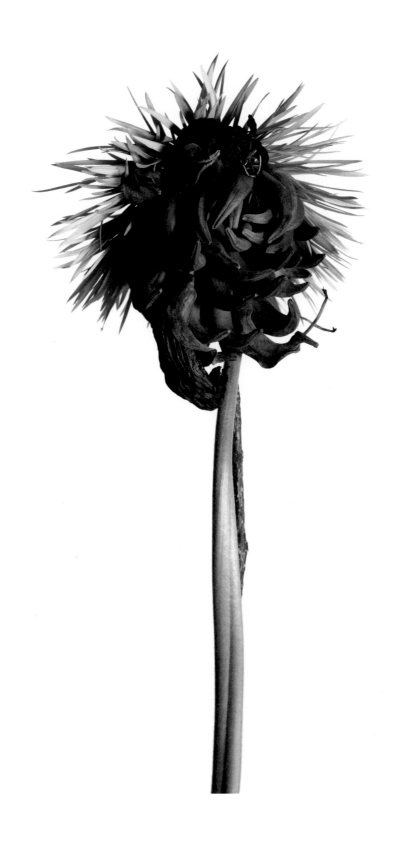

HYBRID 18

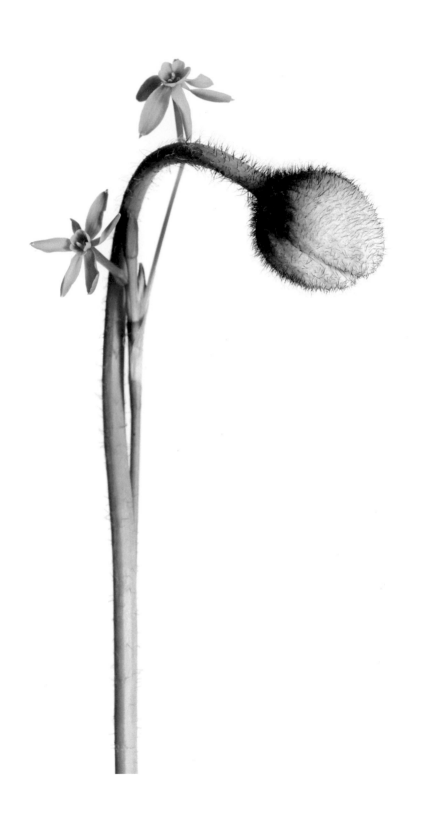

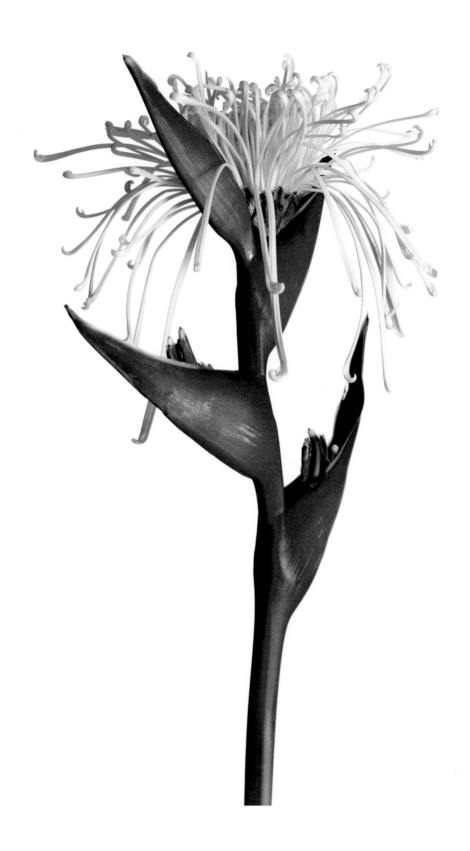

HYBRID 20

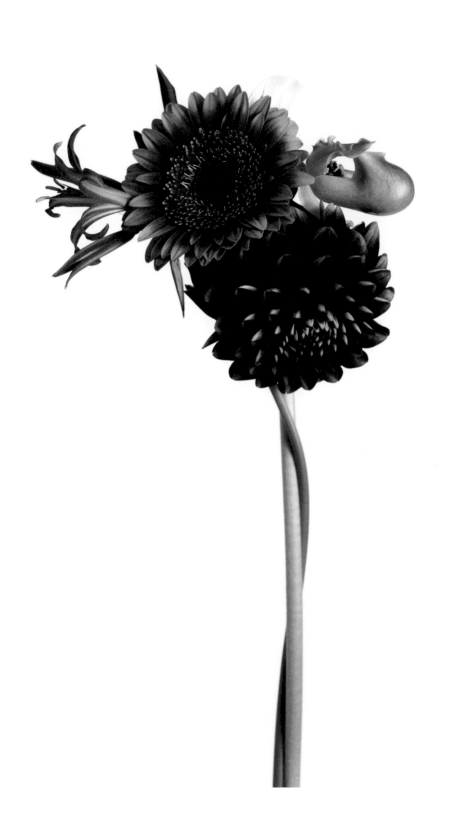

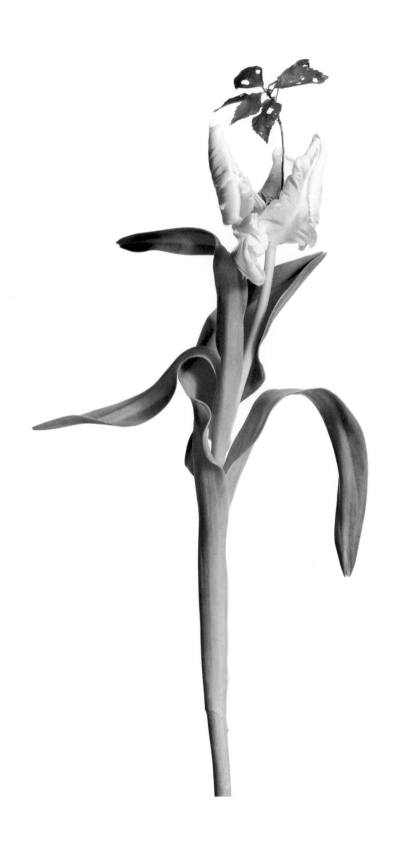

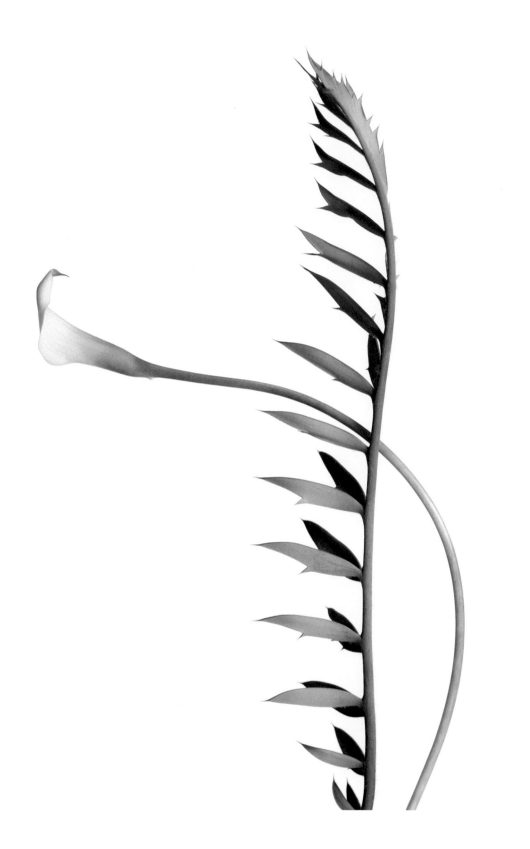

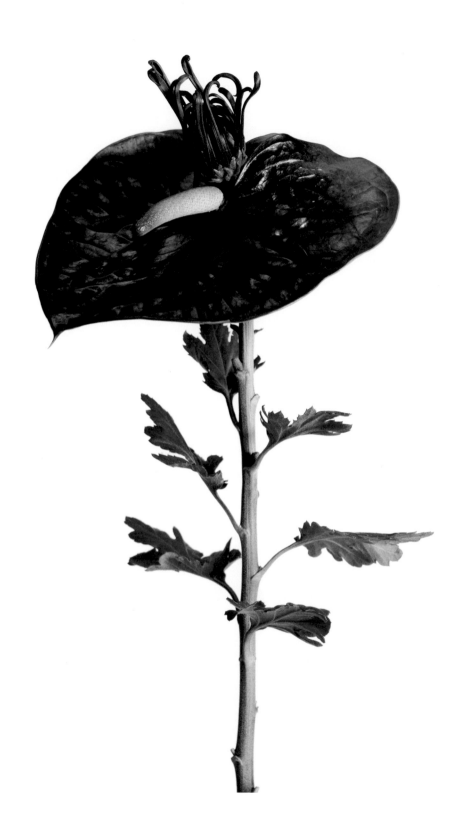

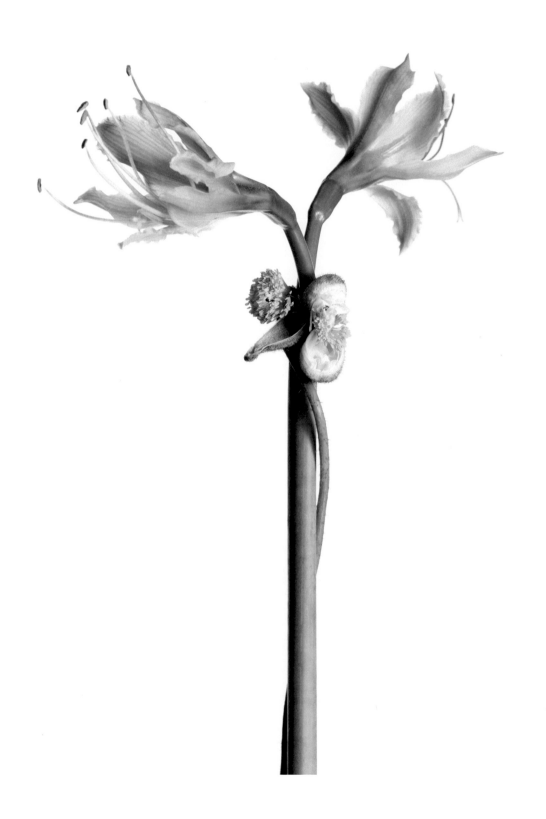

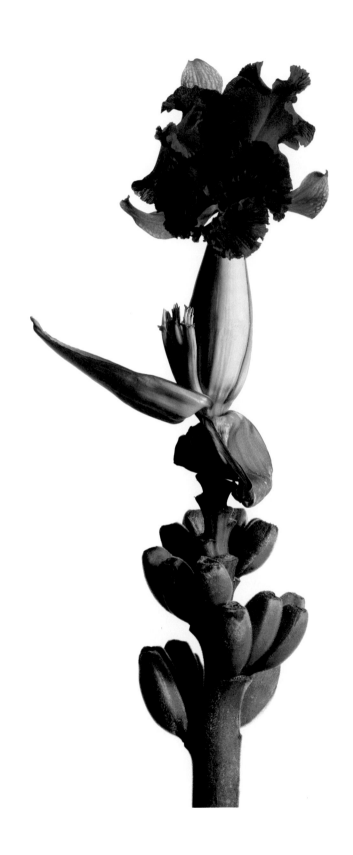

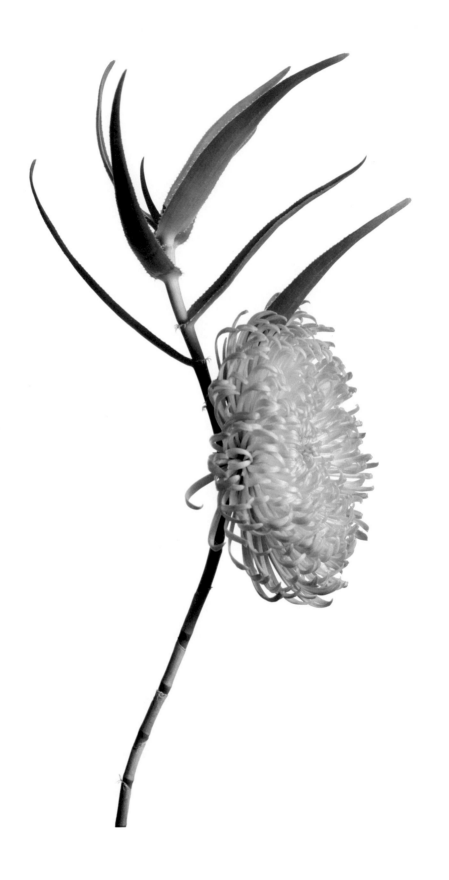

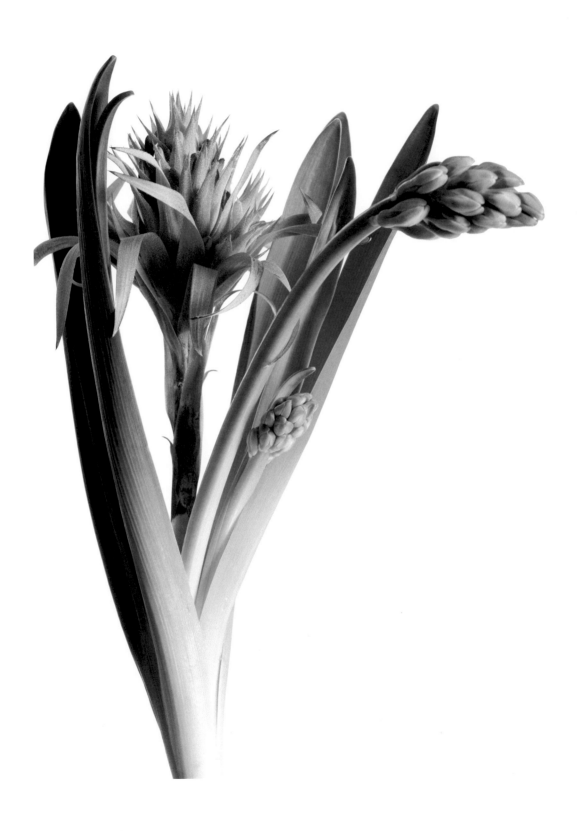

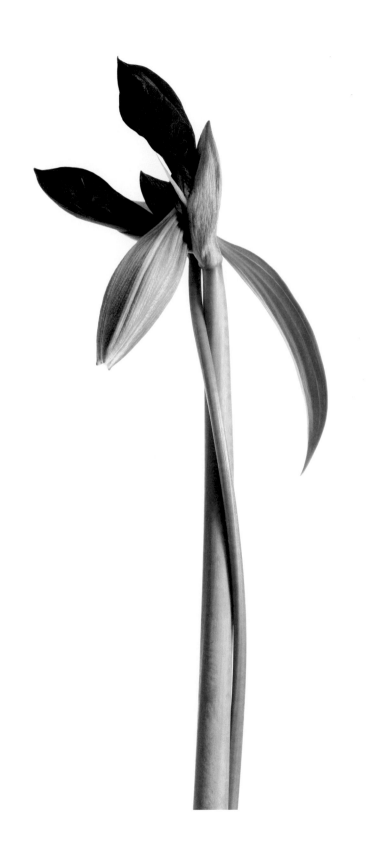

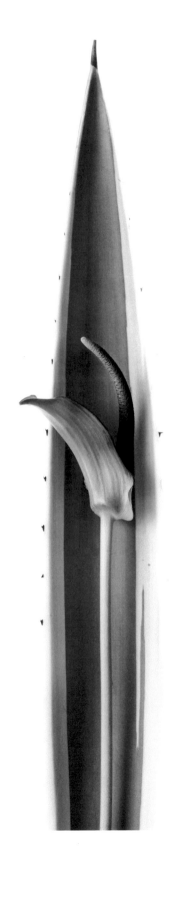

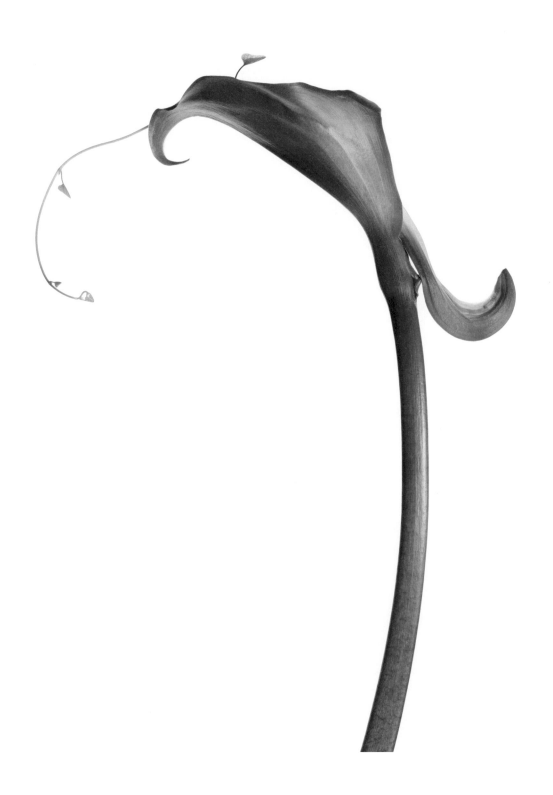

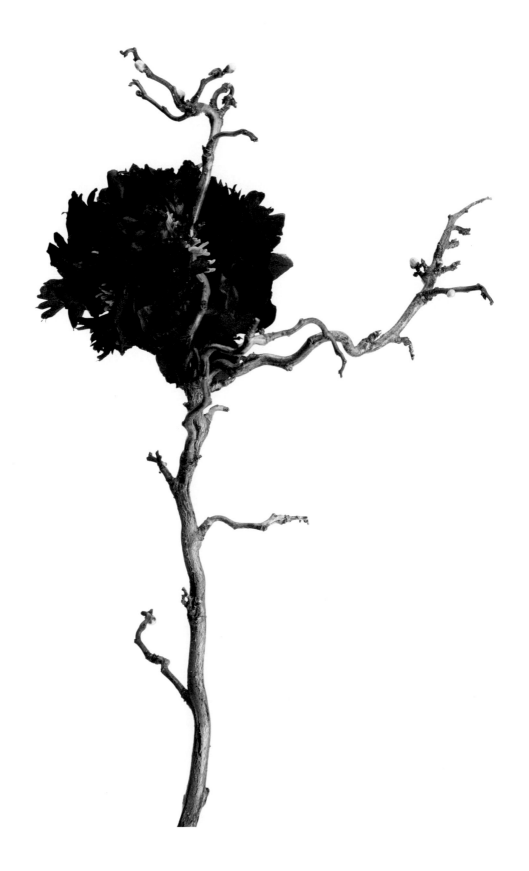

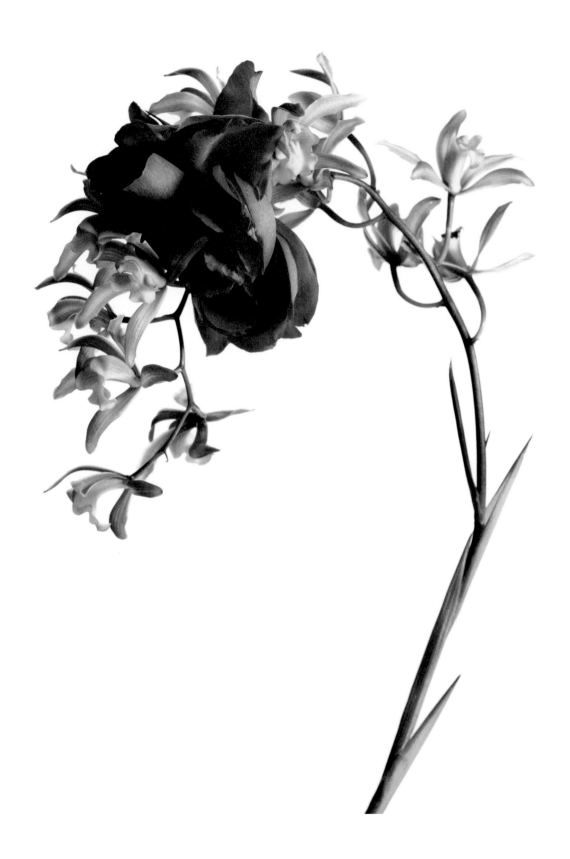

HYBRID 33

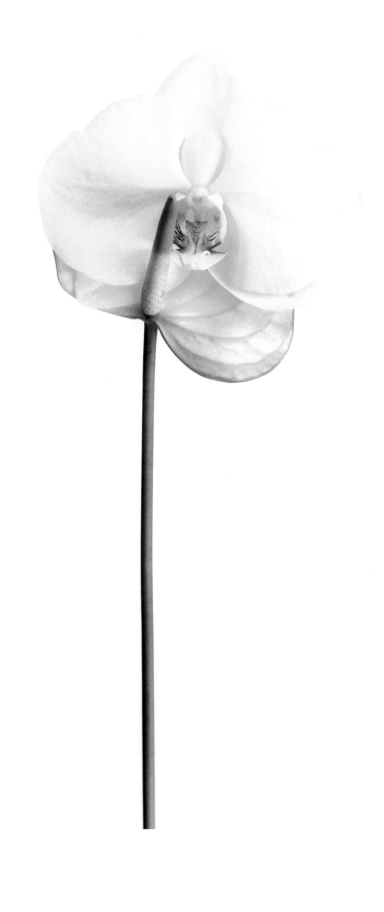

HYBRID 34

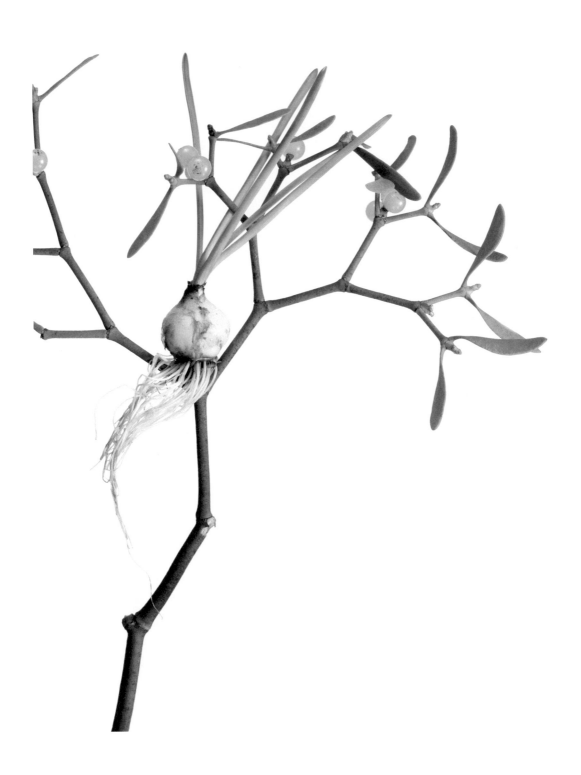

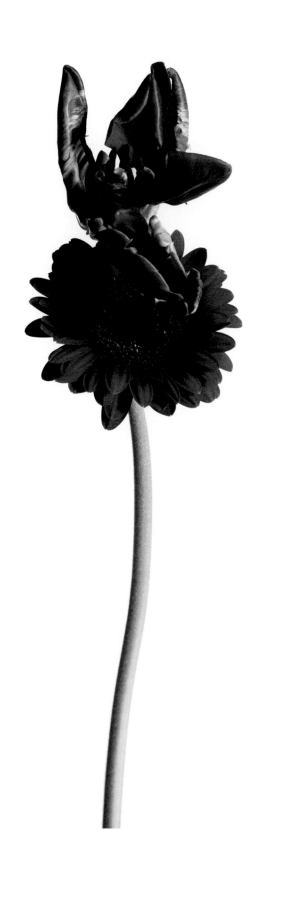

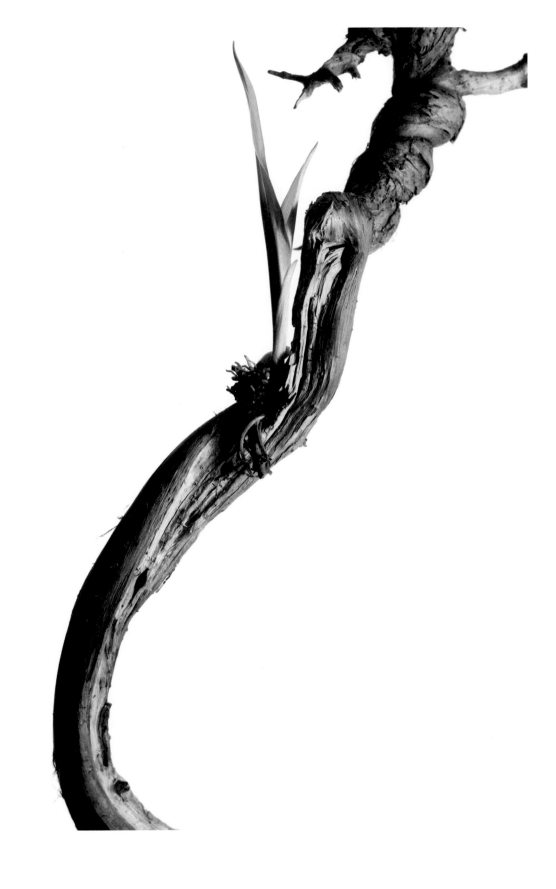

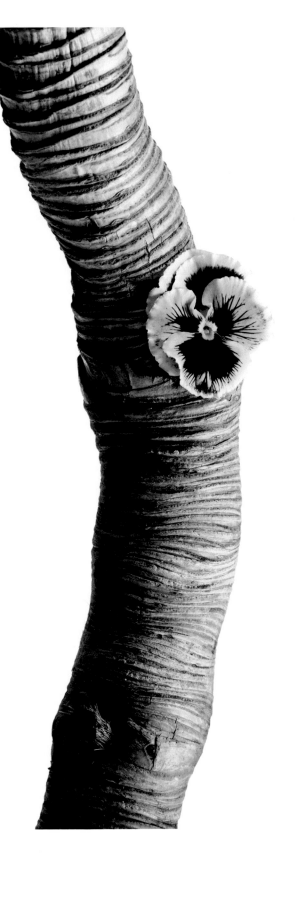

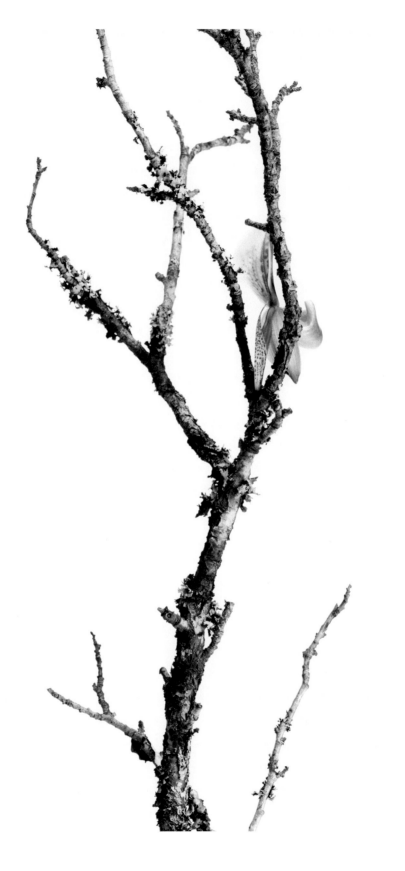

HYBRID 39

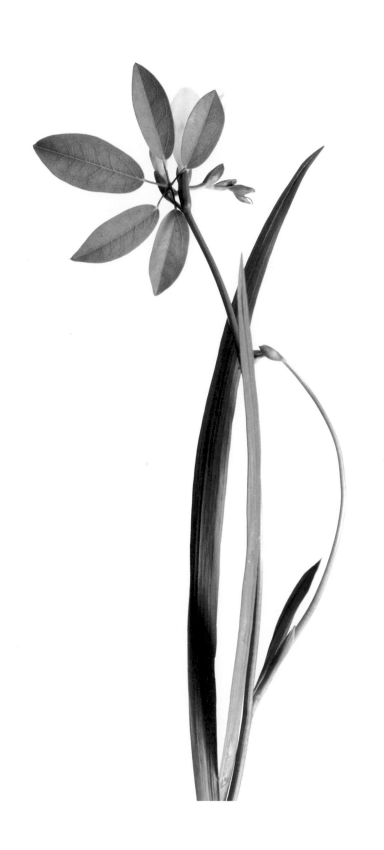

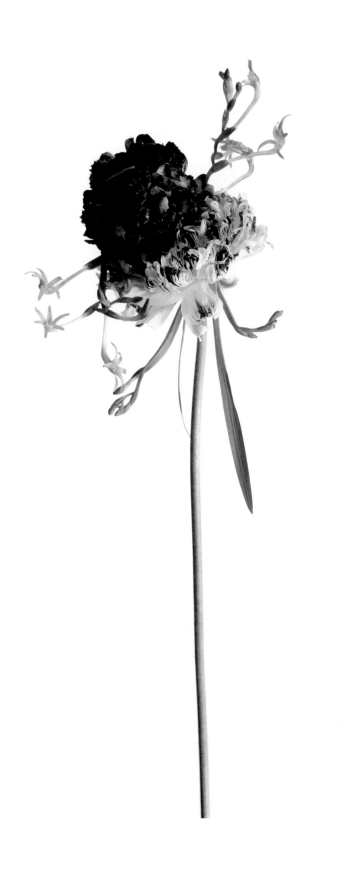

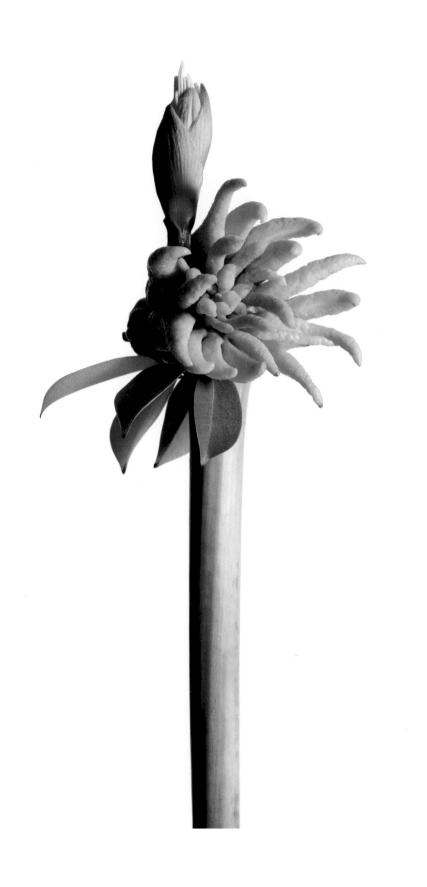

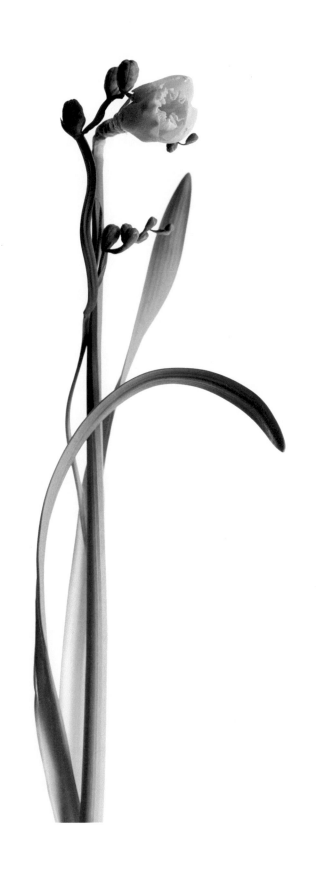

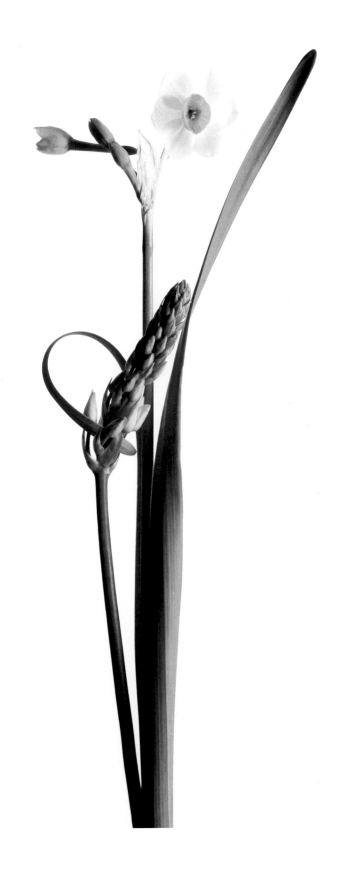

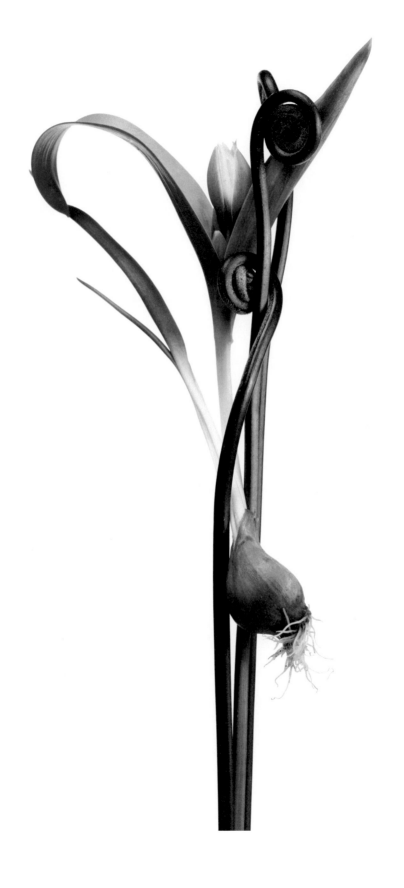

HYBRID 45

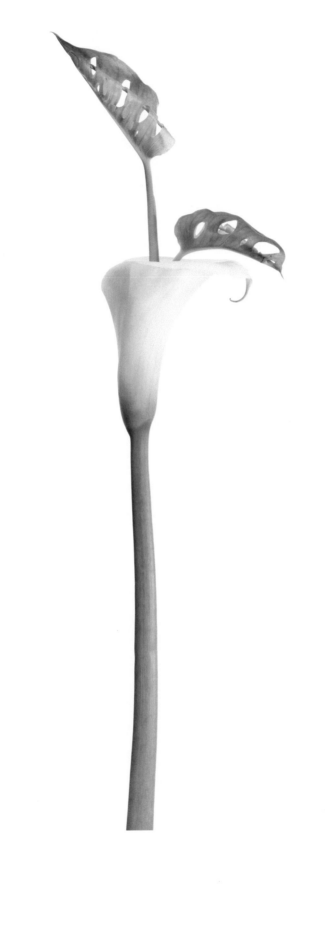

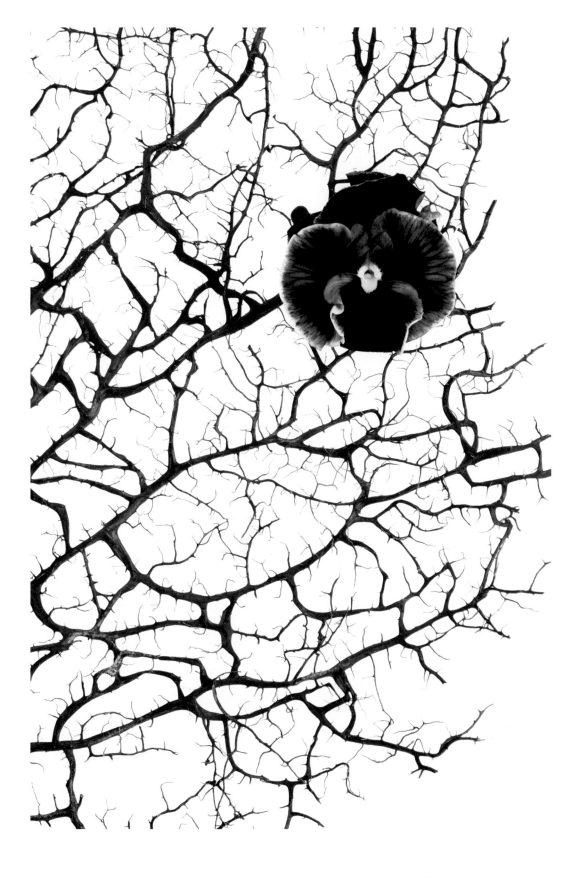

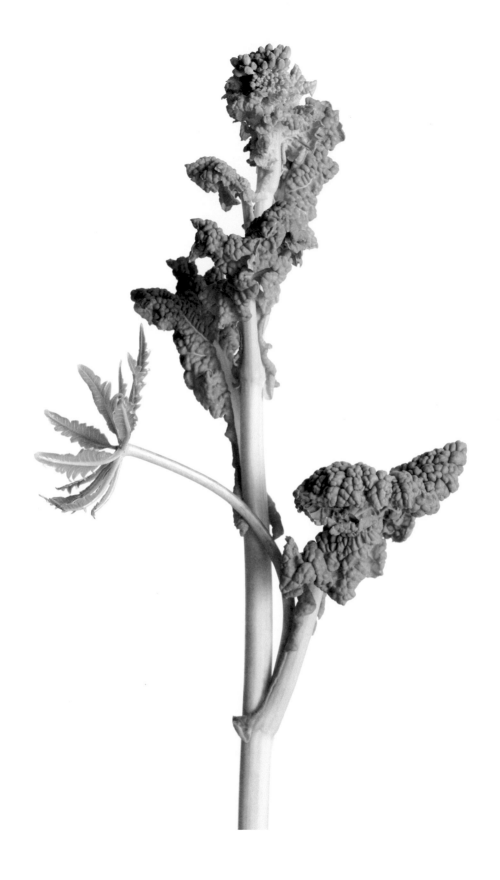

HYBRID 48

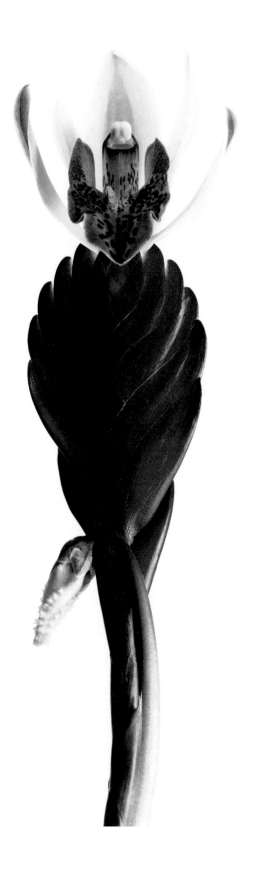

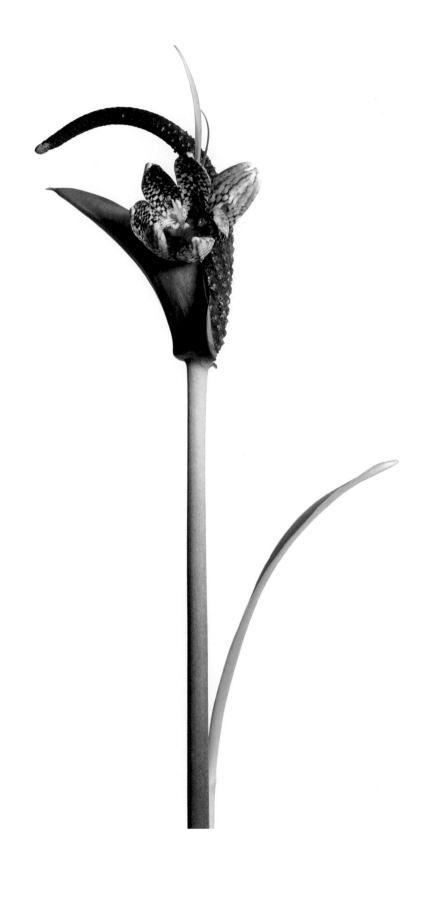

HYBRID 50

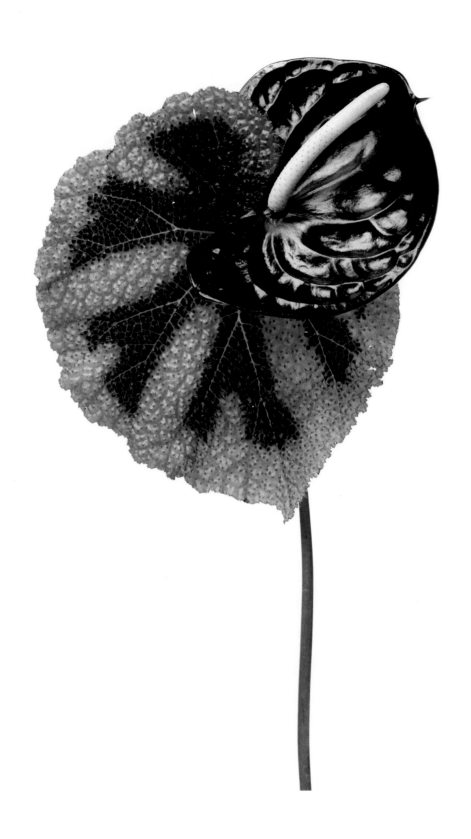

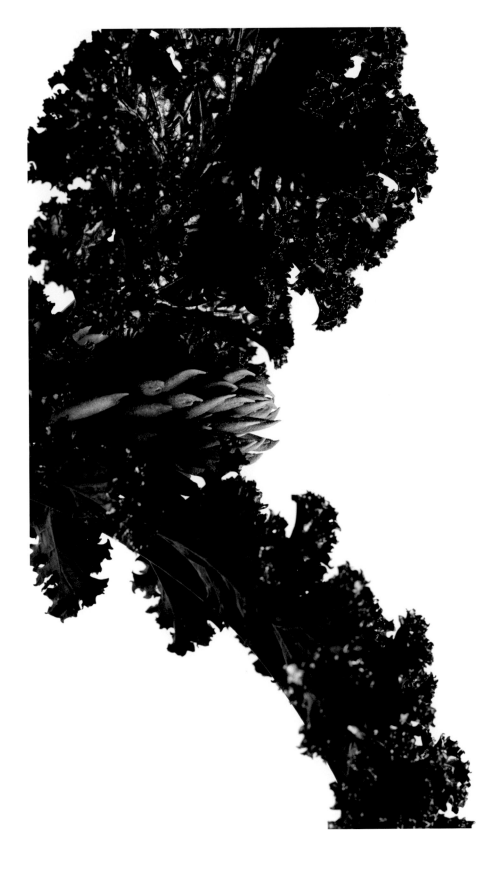

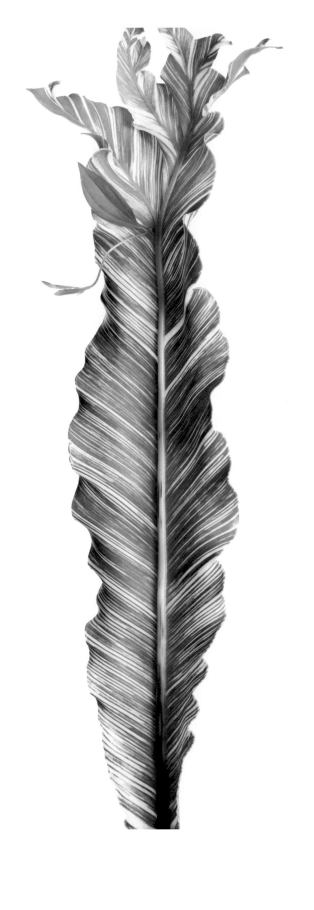

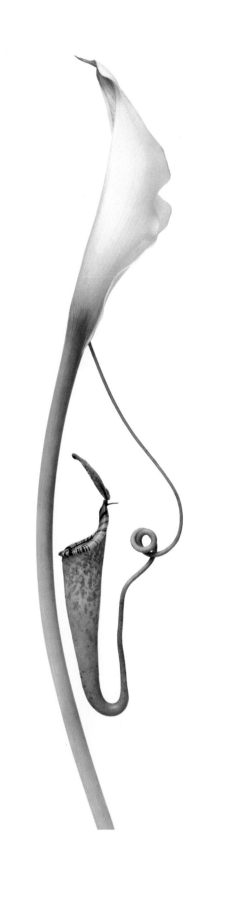

HYBRID 54

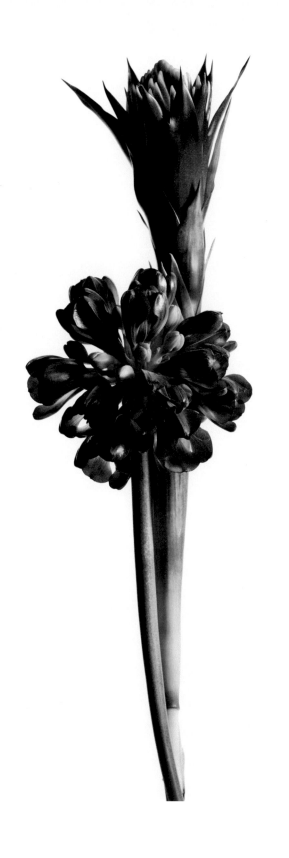

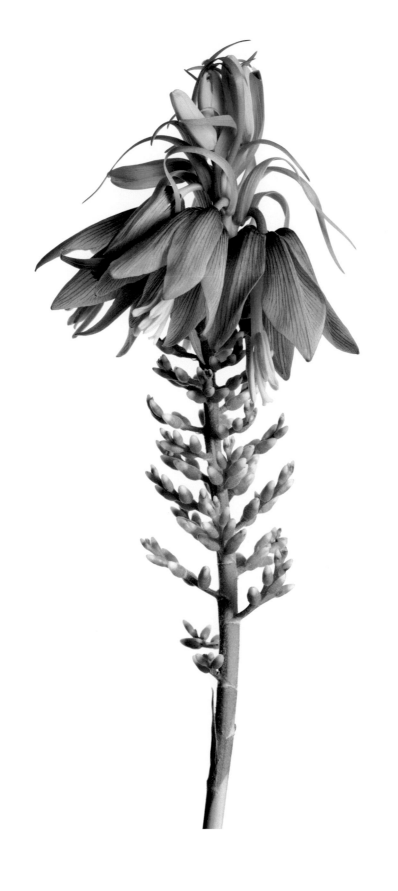

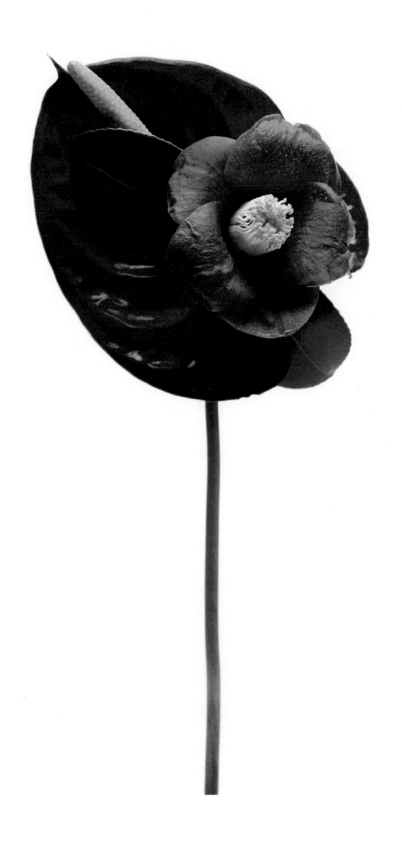

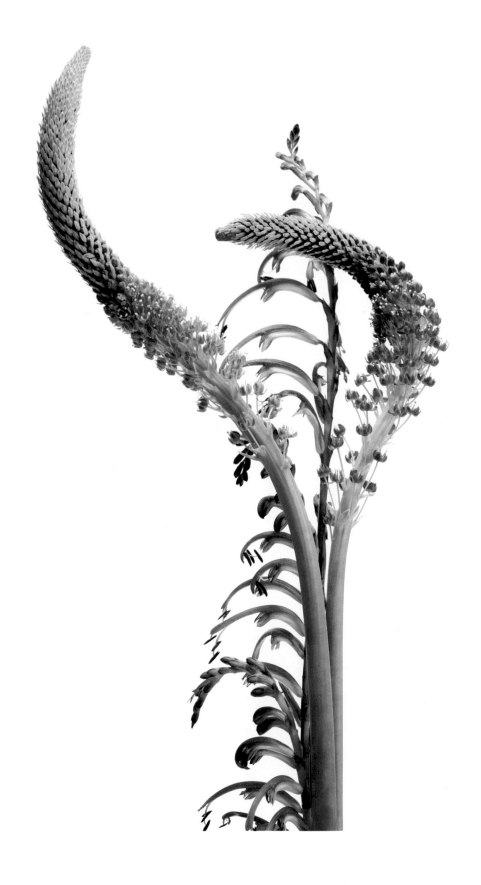

HYBRID 58

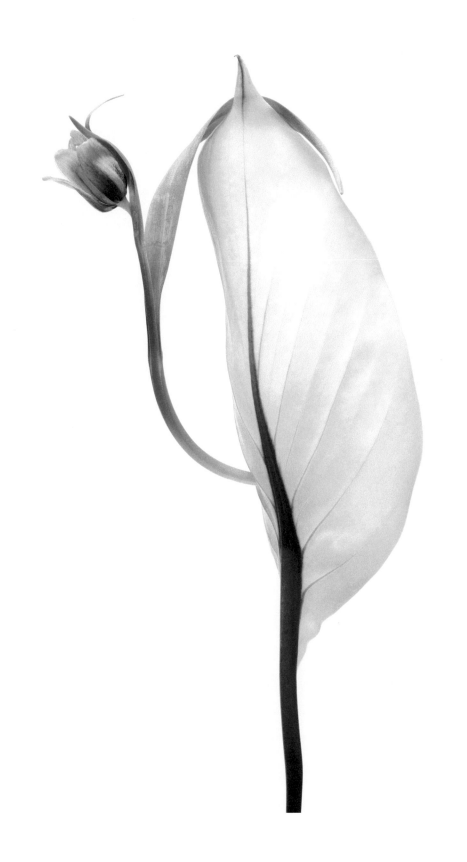

HYBRID 59

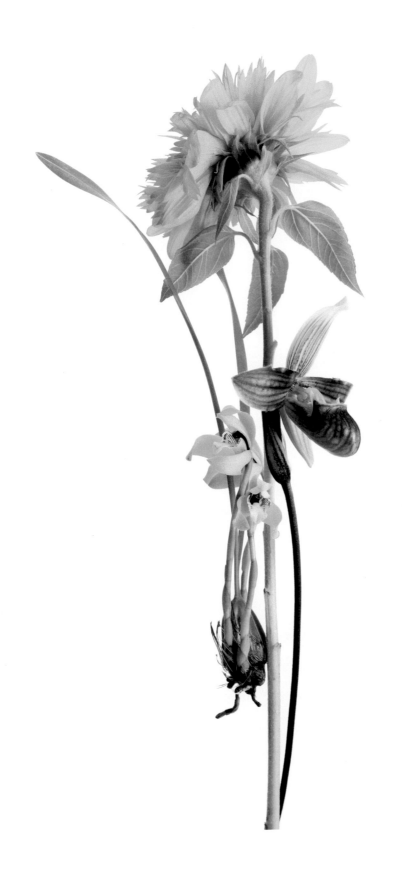

HYBRID 60

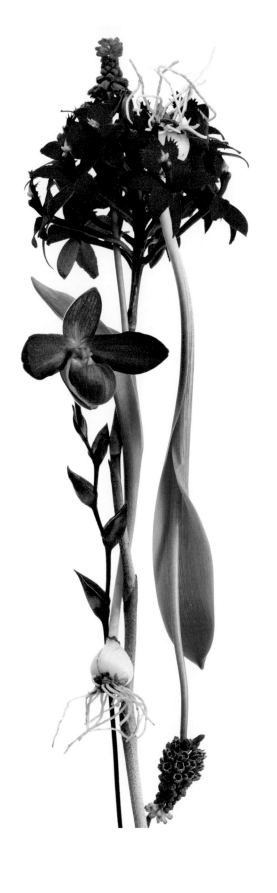

HYBRID 61

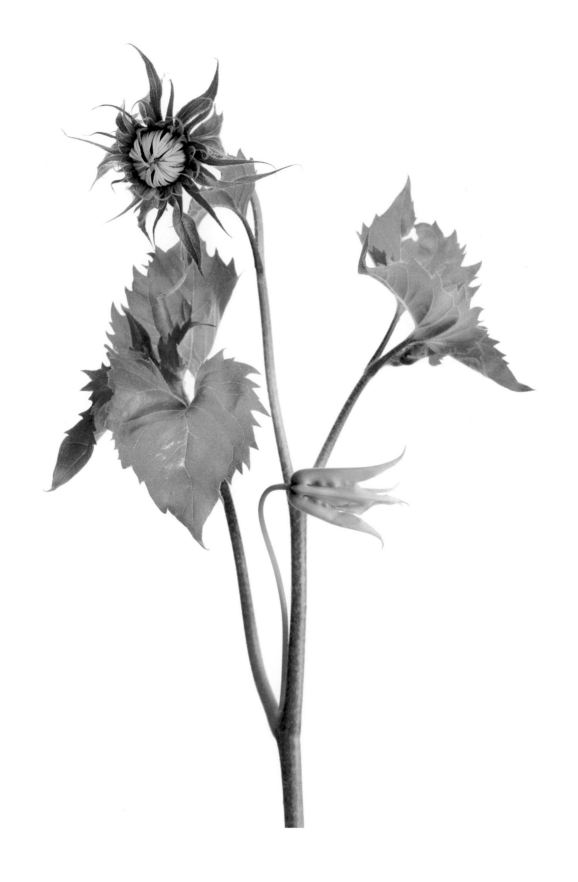

APPEARANCE

APPEARANCE 01

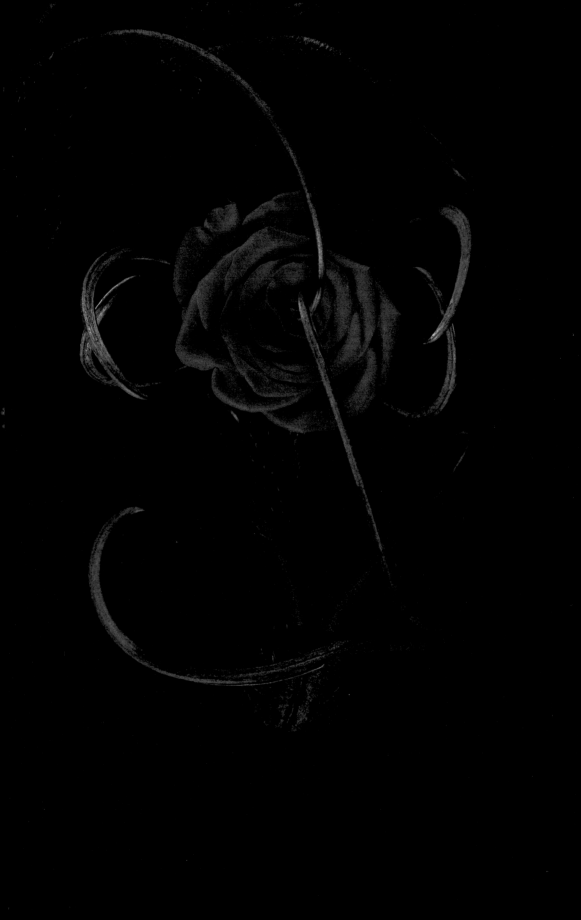

APPEARANCE 02

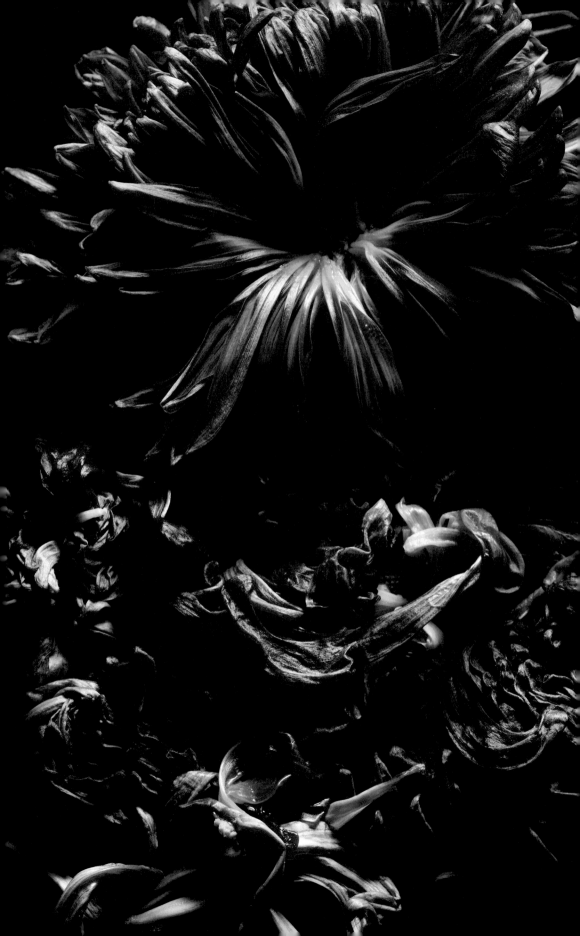

APPEARANCE 03

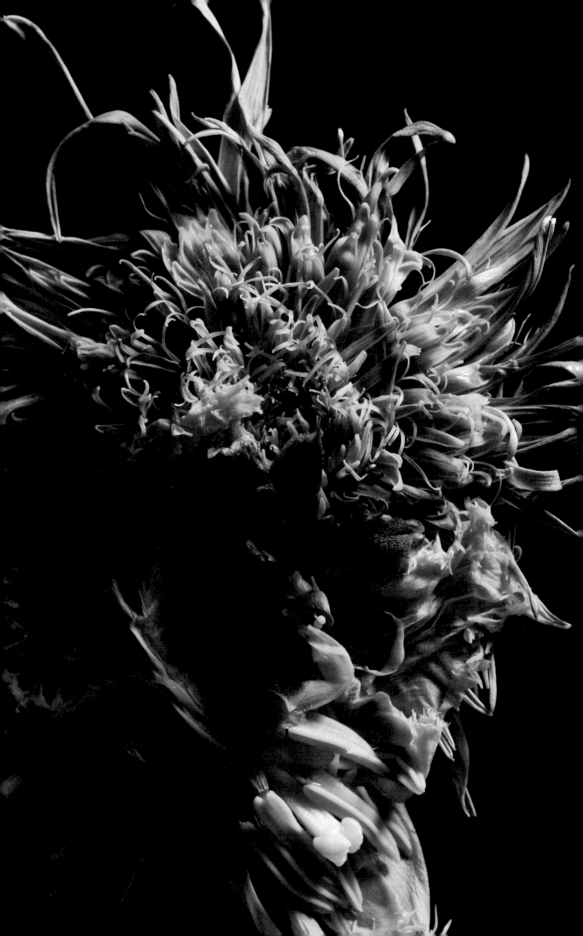

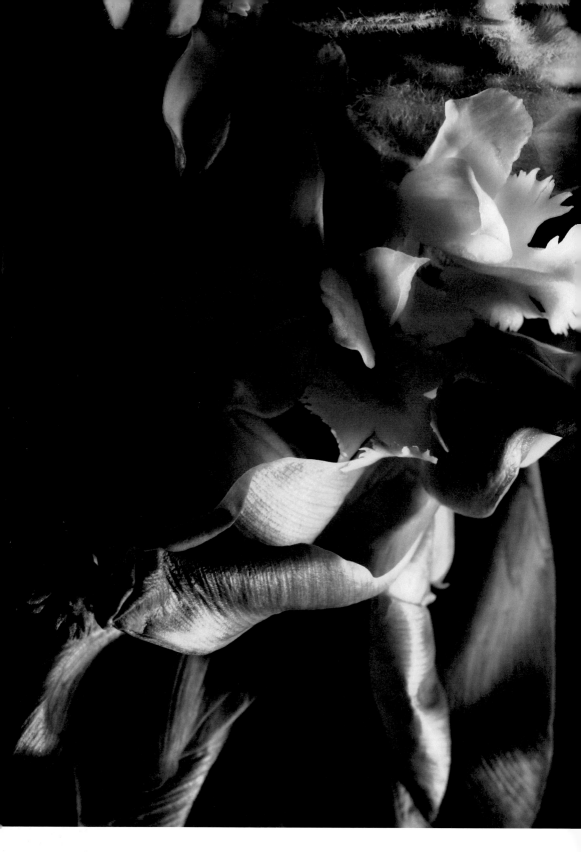

APPEARANCE 04

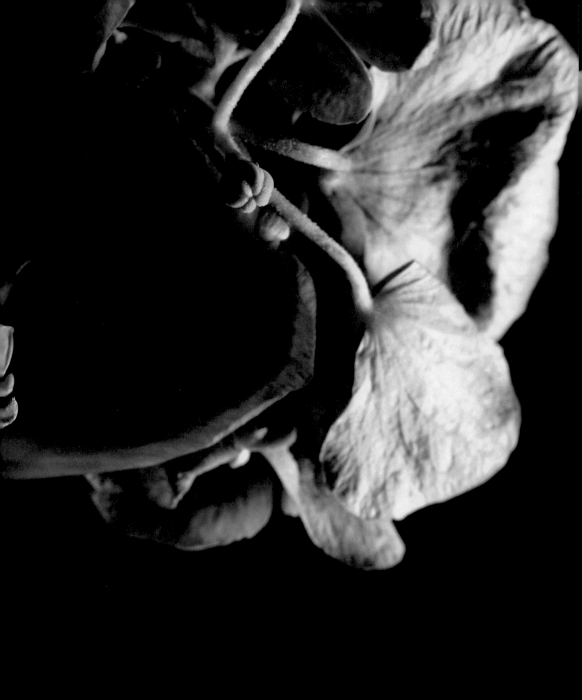

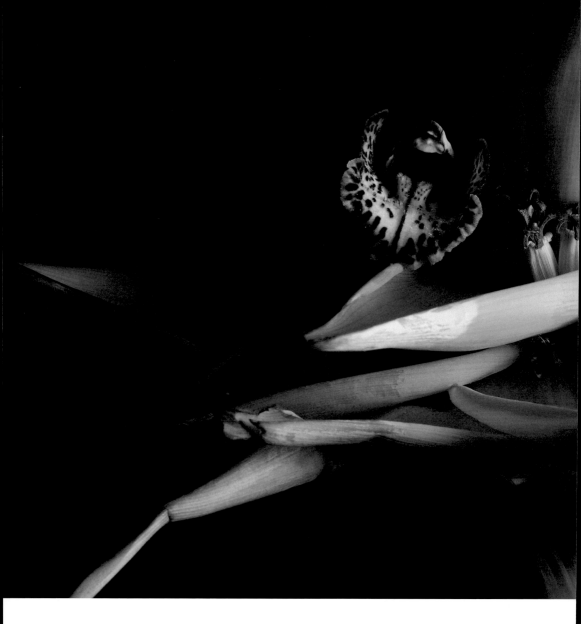

APPEARANCE 05

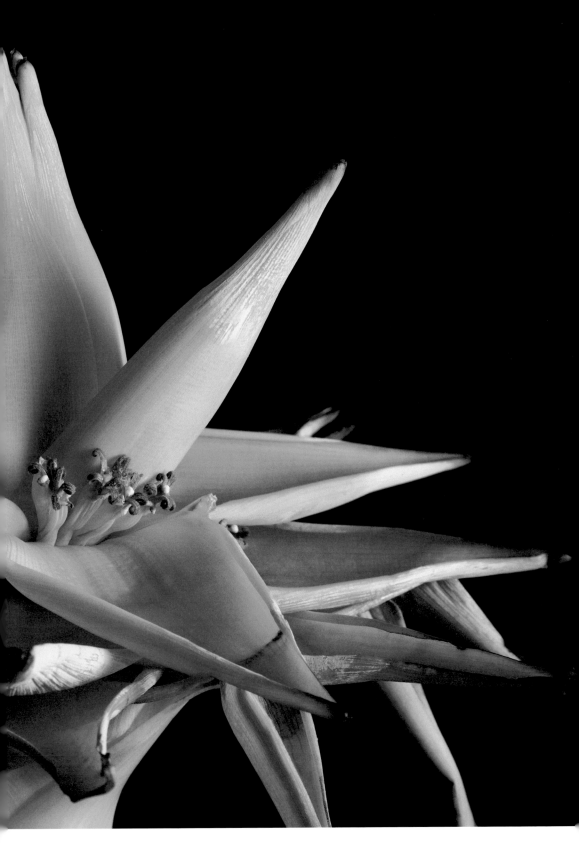

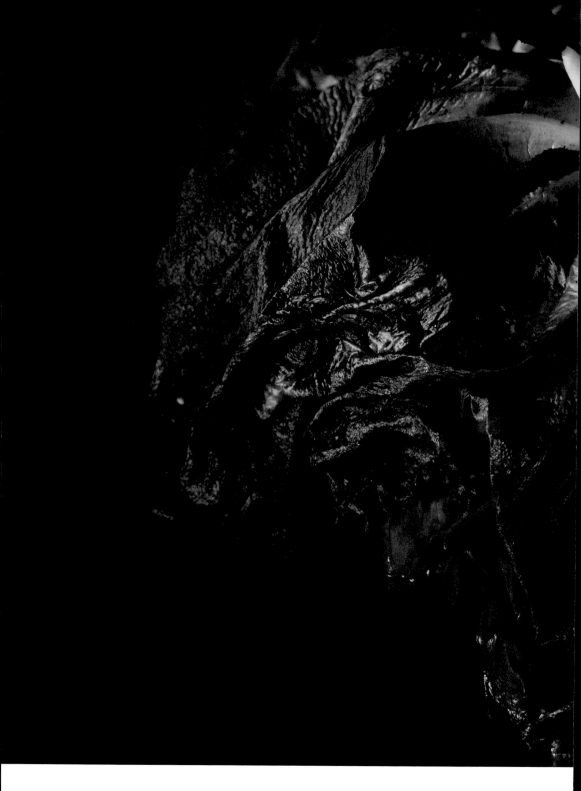

APPEARANCE 06

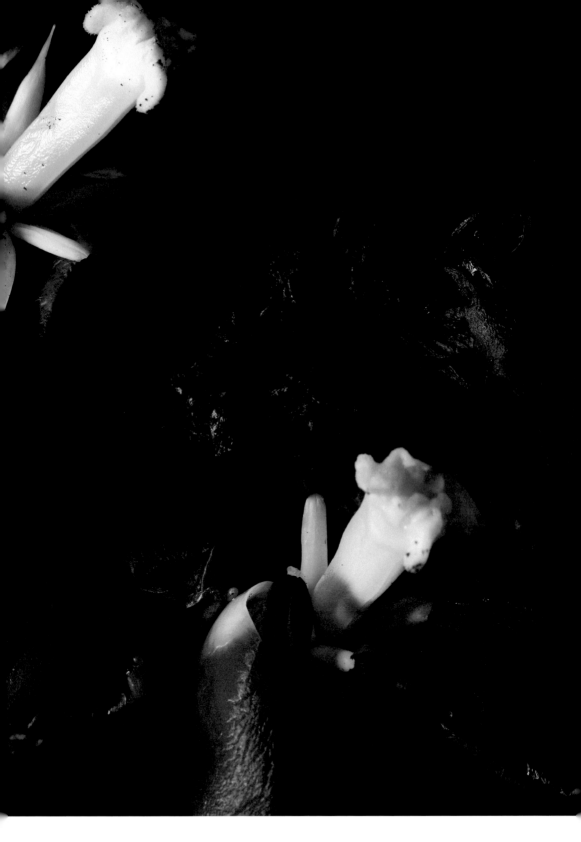

APPEARANCE 07

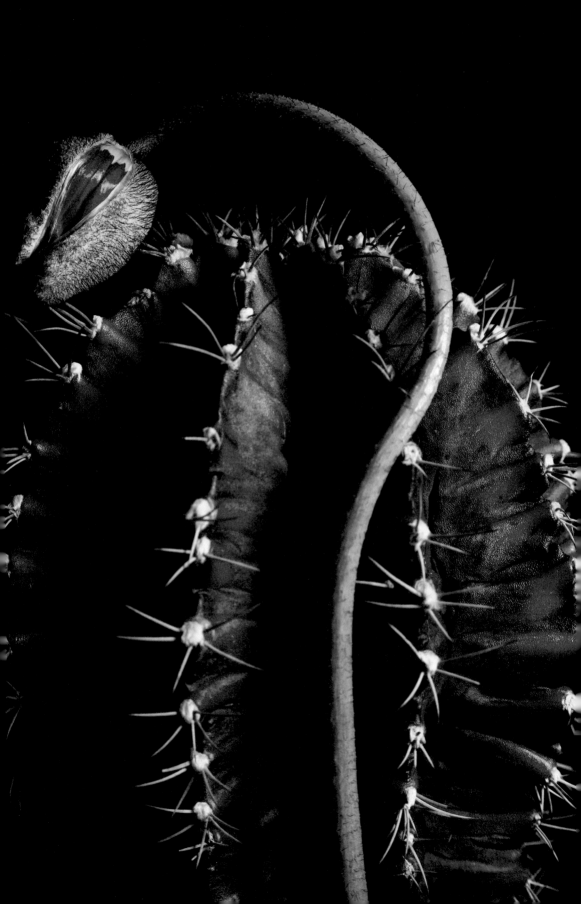

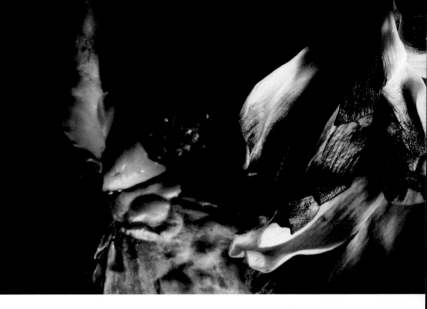

APPEARANCE 09

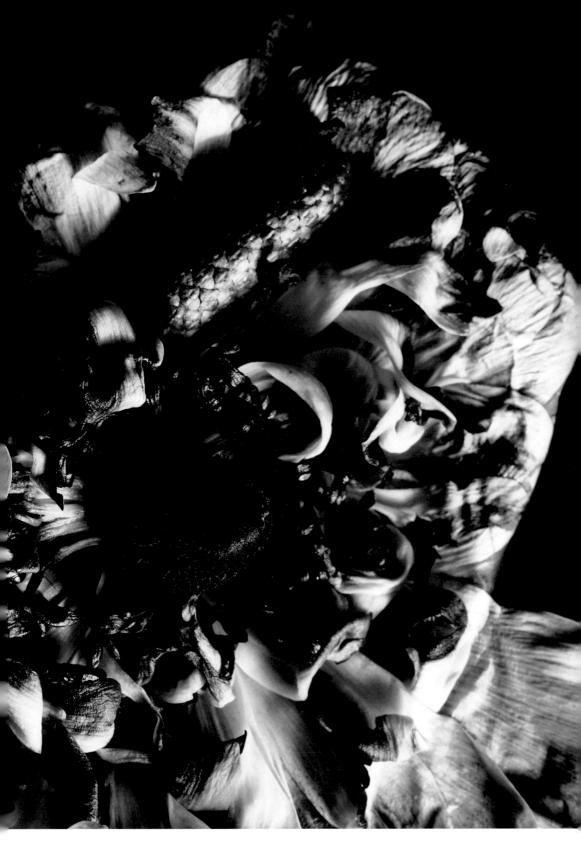

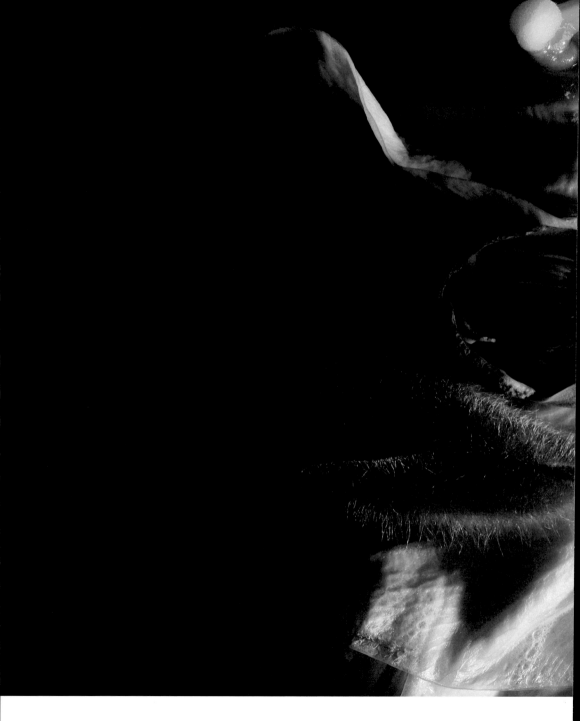

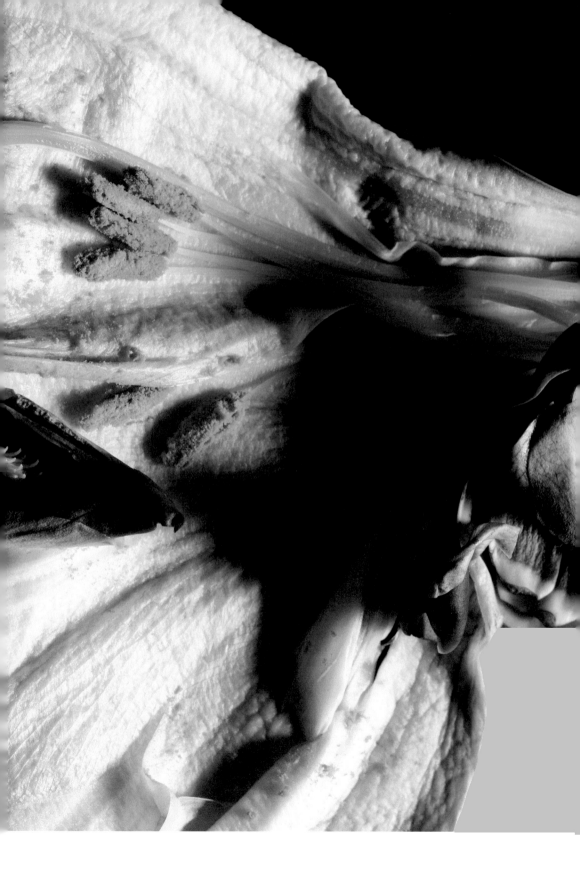

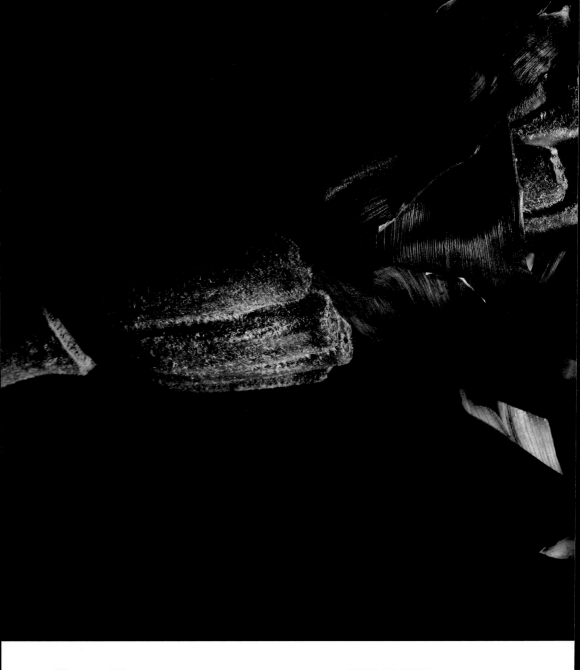

APPEARANCE 11

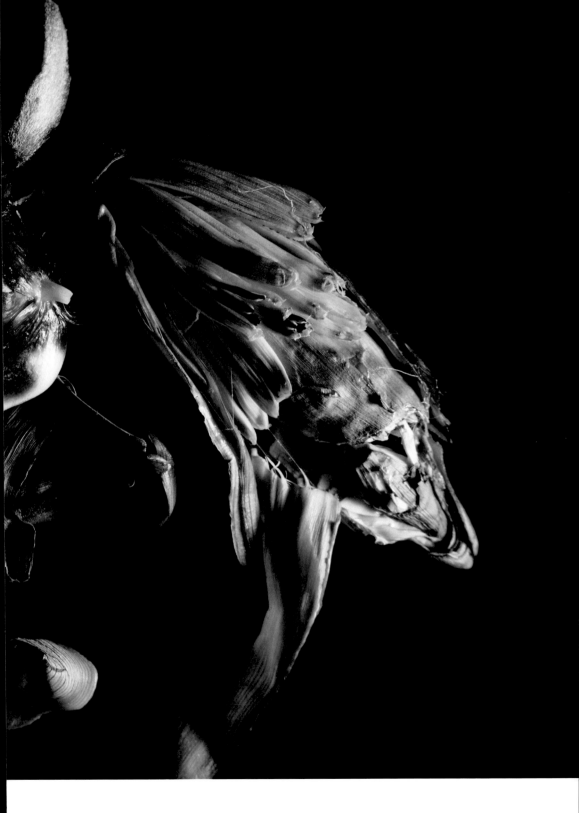

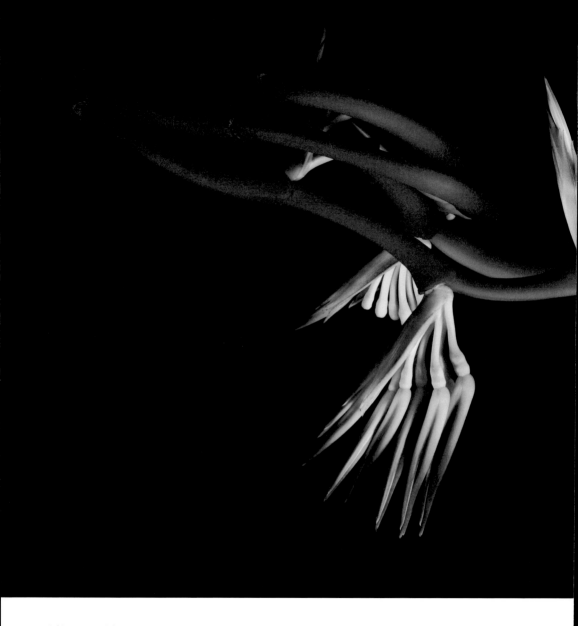

APPEARANCE 12

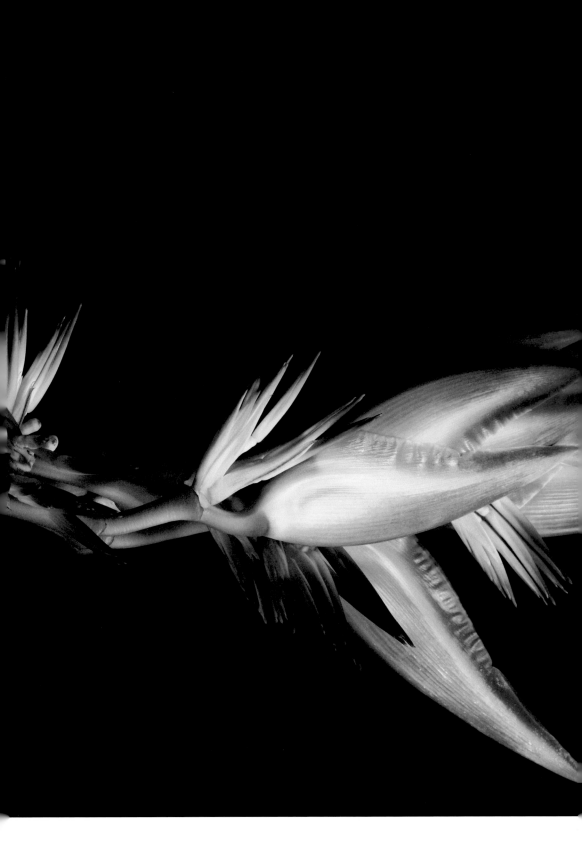

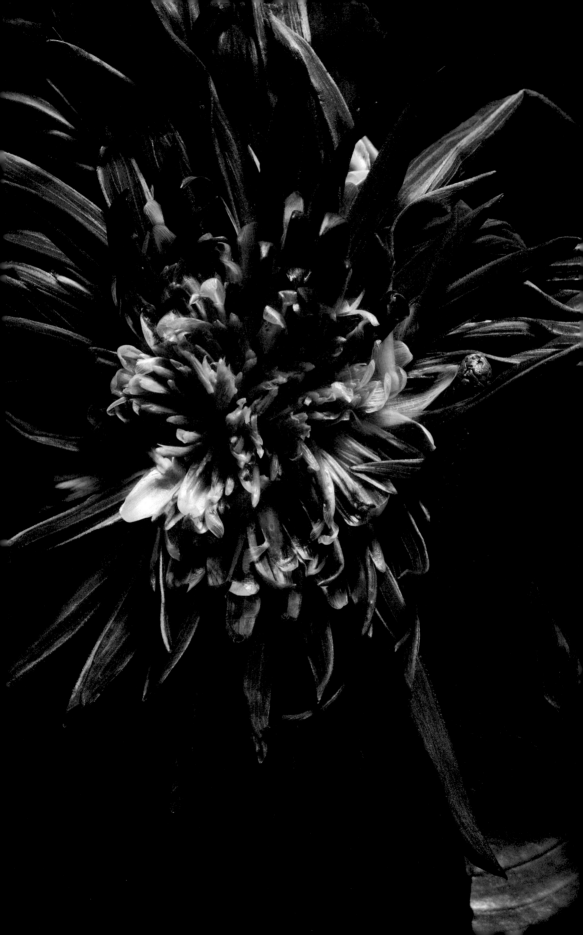

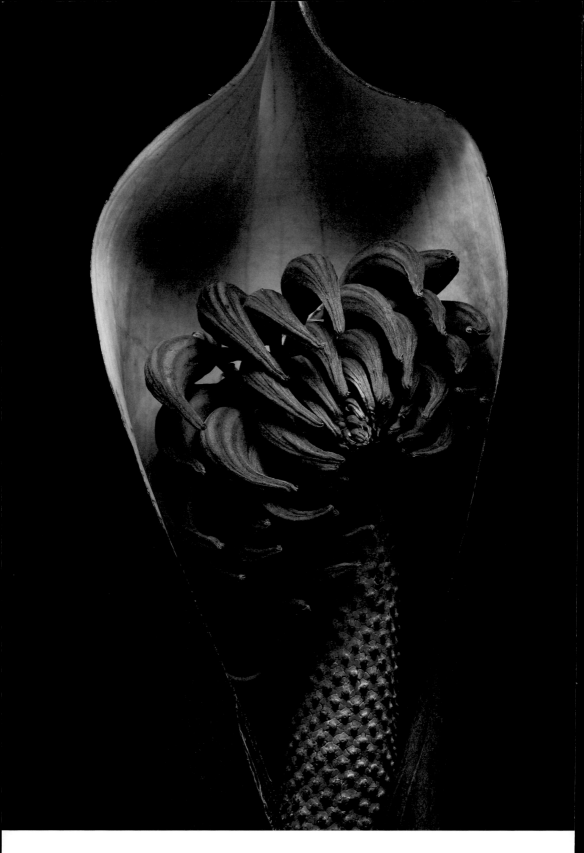

APPEARANCE 15

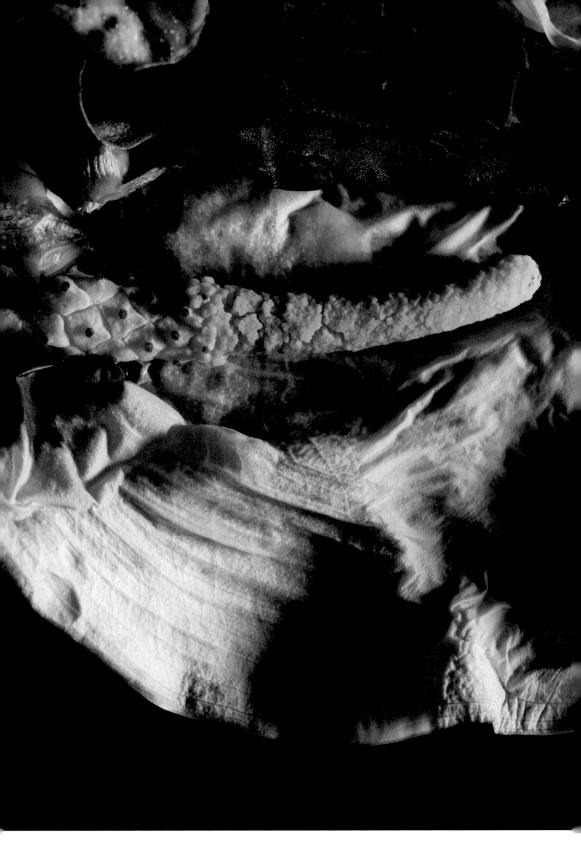

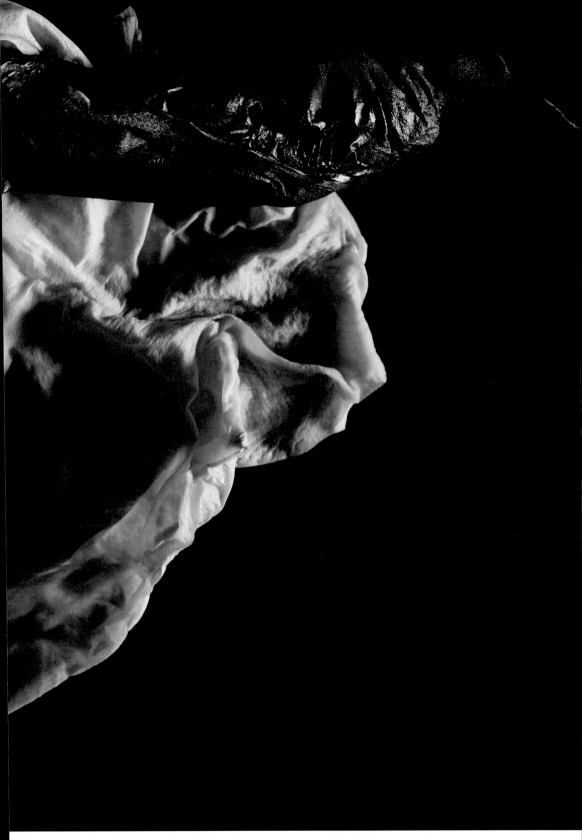

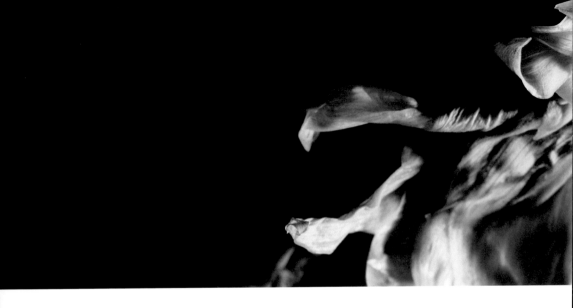

APPEARANCE 17

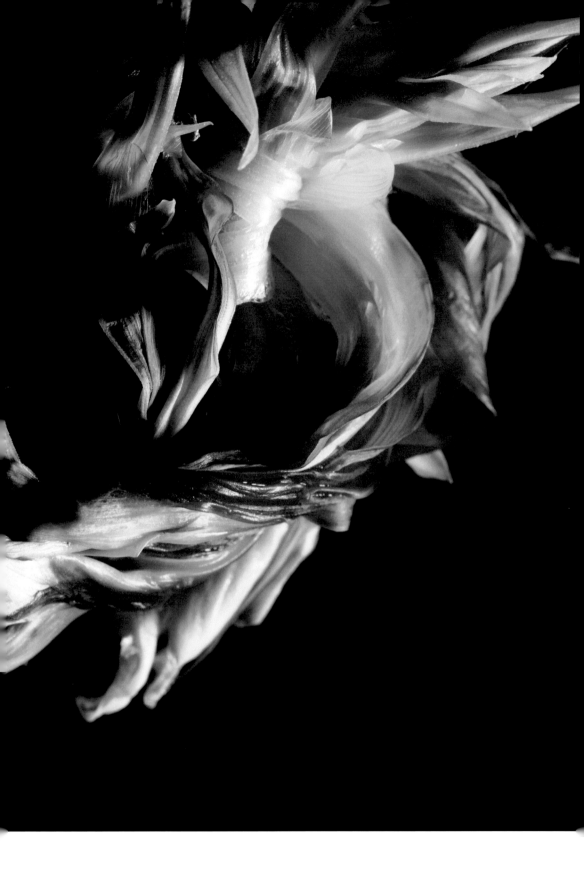

APPEARANCE 18

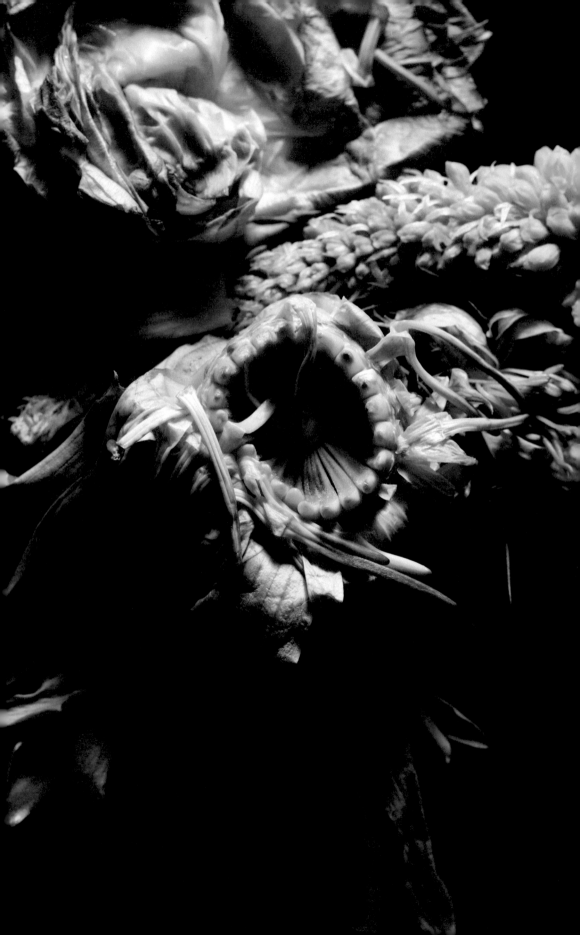

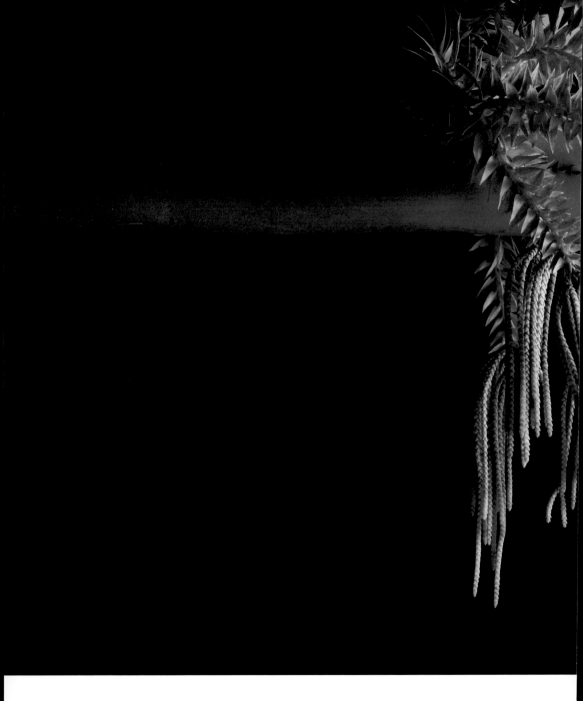

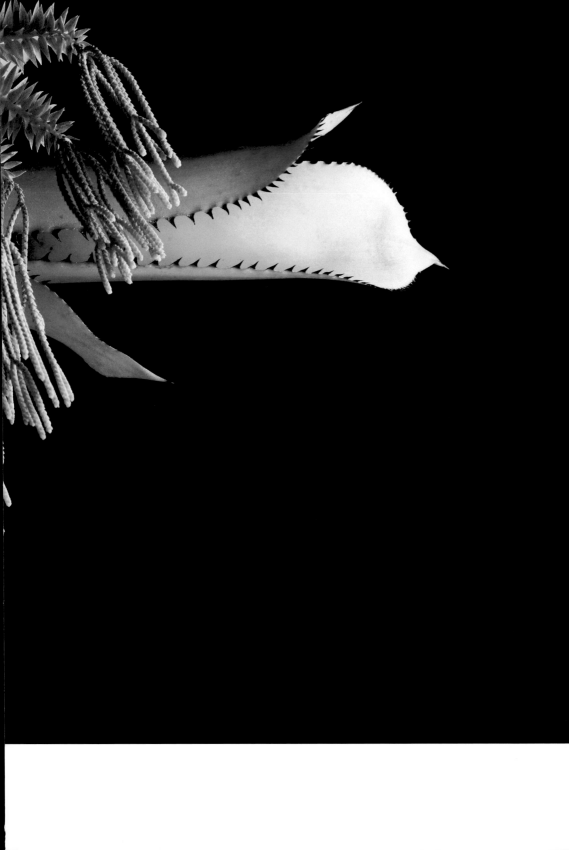

APPEARANCE 20

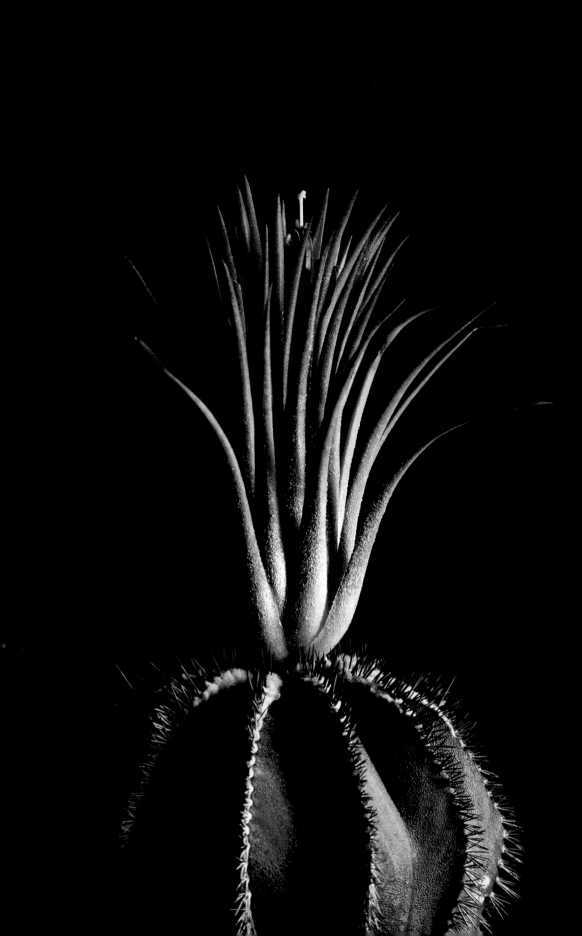

APPEARANCE 21

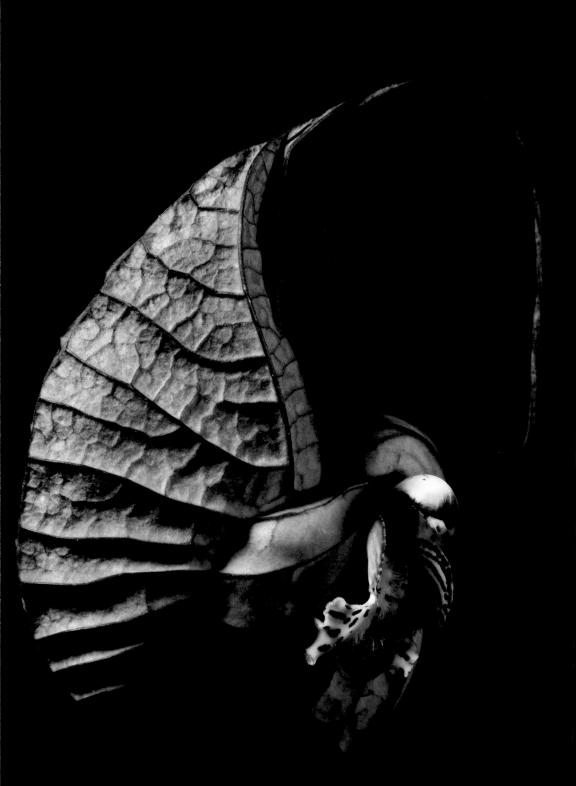

APPEARANCE 22

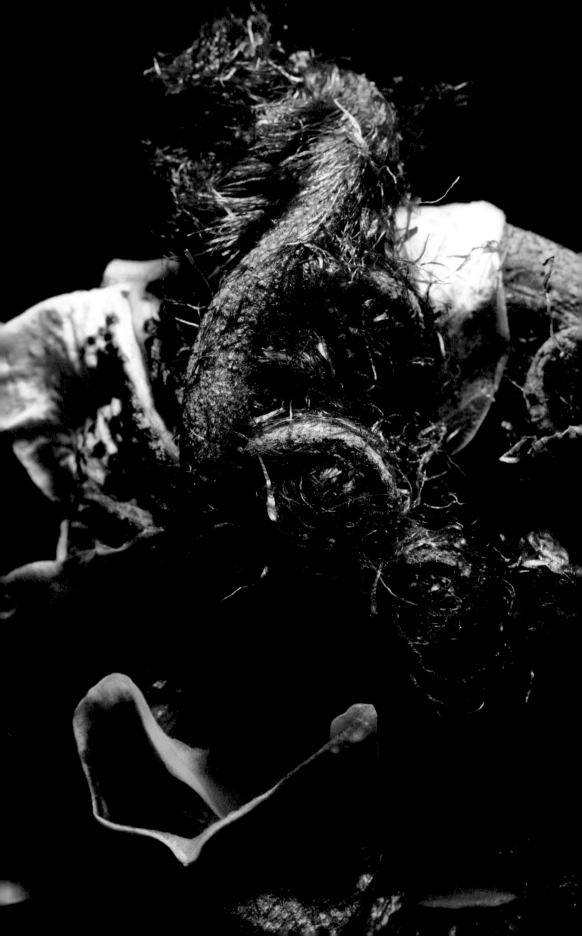

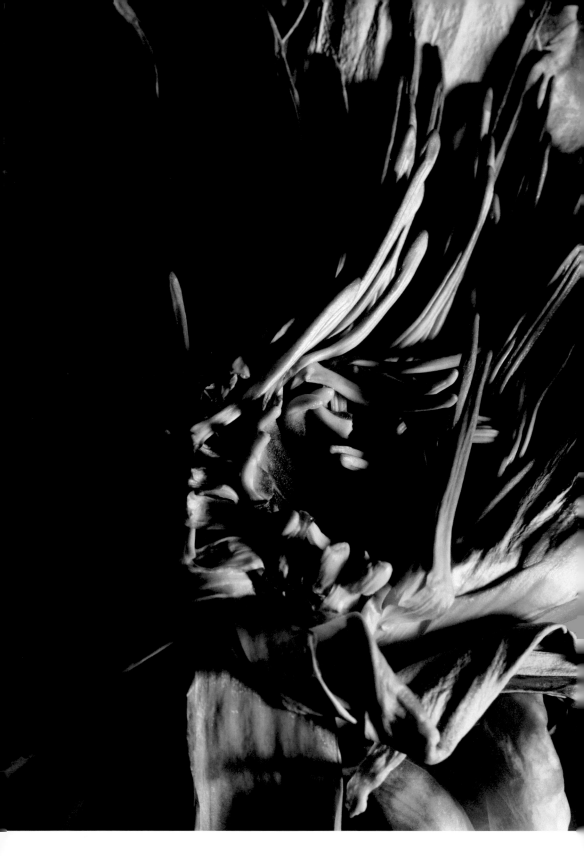

APPEARANCE 23

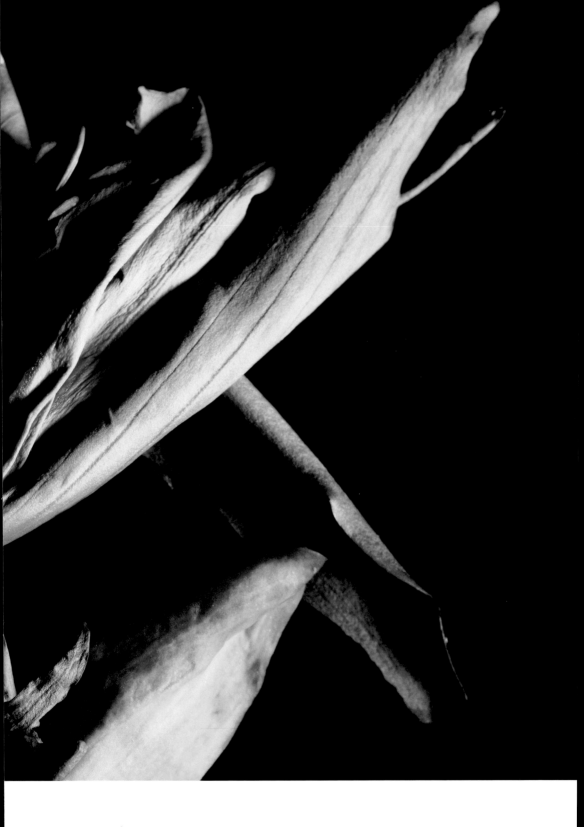

APPEARANCE 24

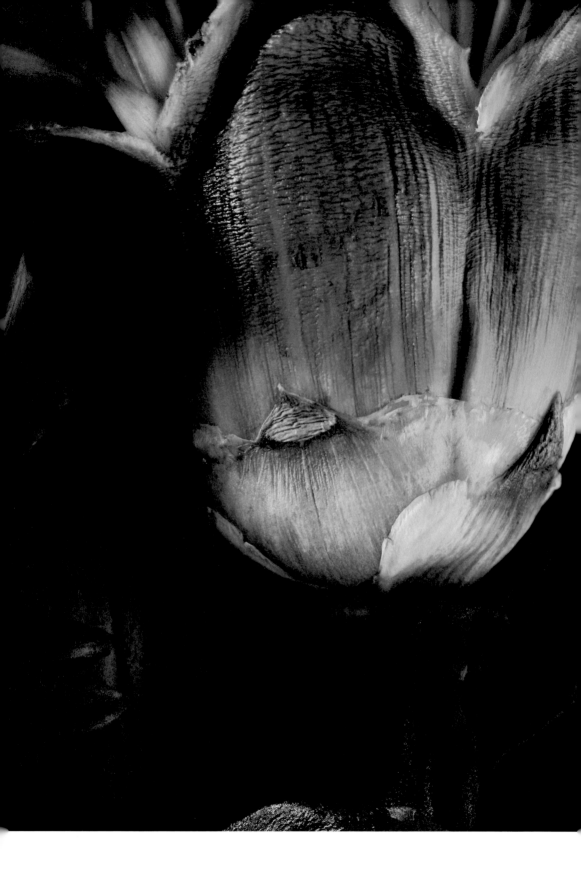

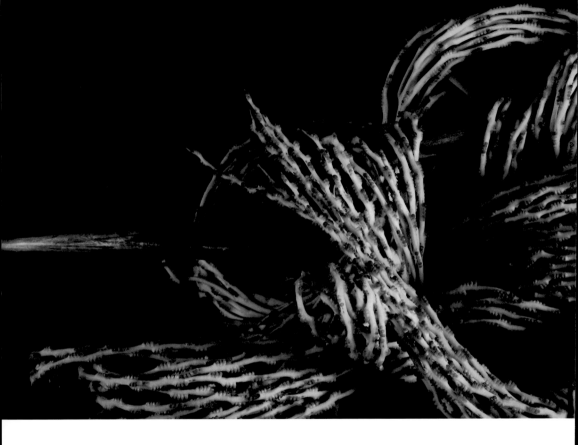

APPEARANCE 25

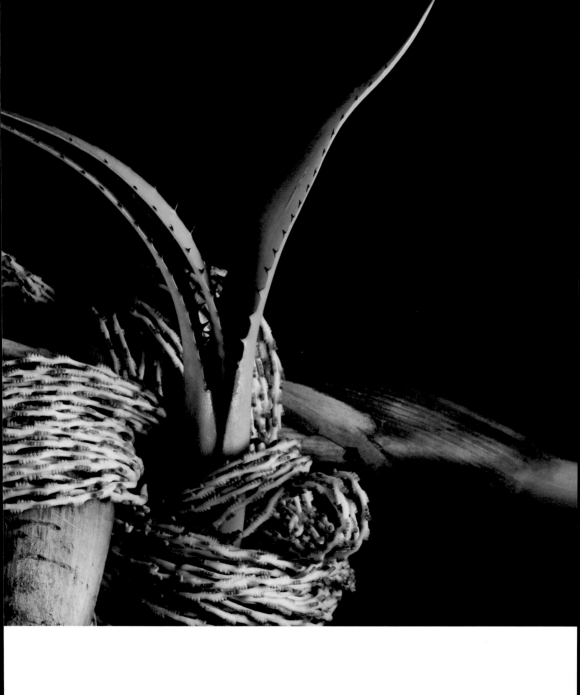

APPEARANCE 26

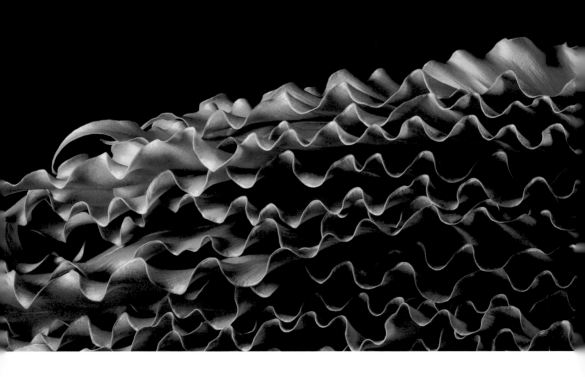

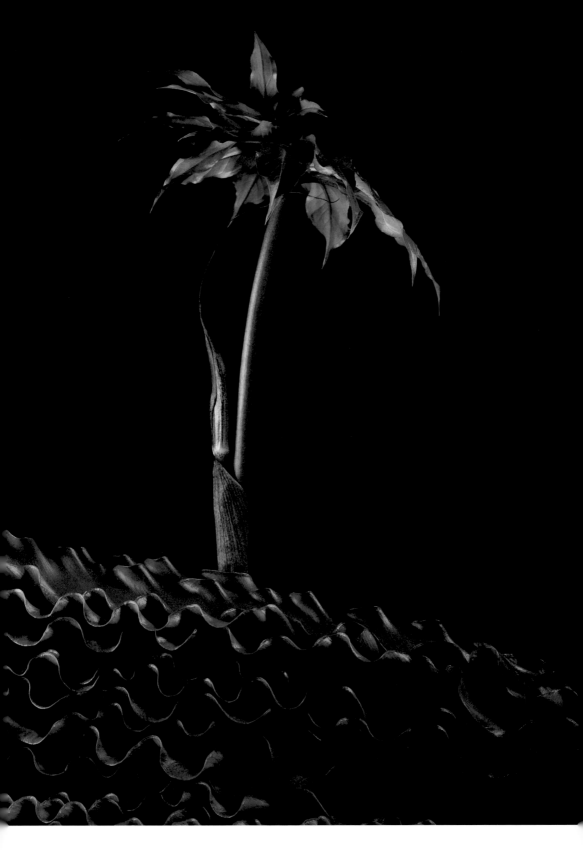

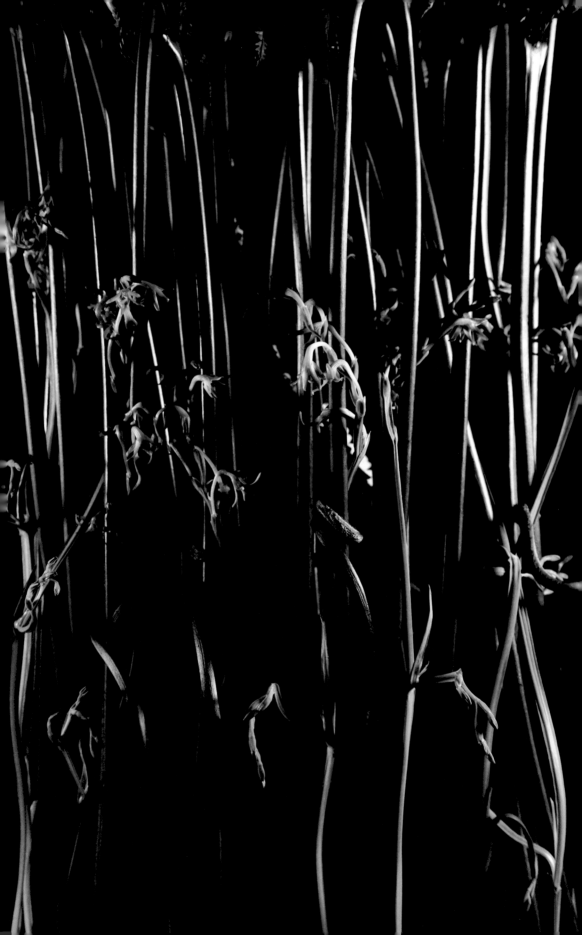

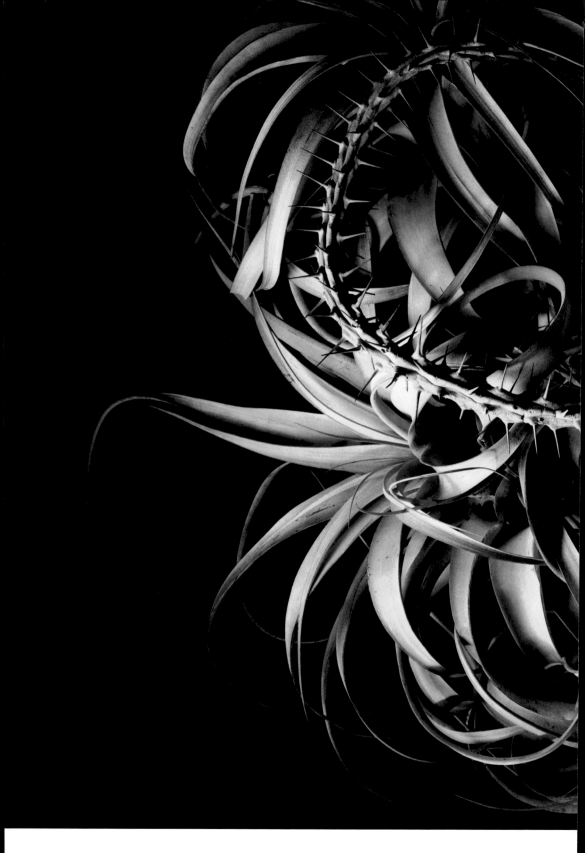

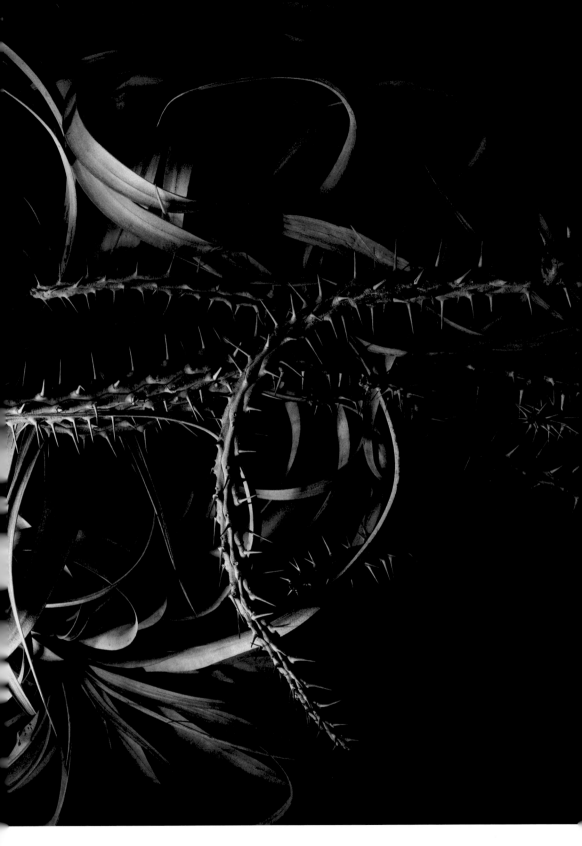

APPEARANCE 30

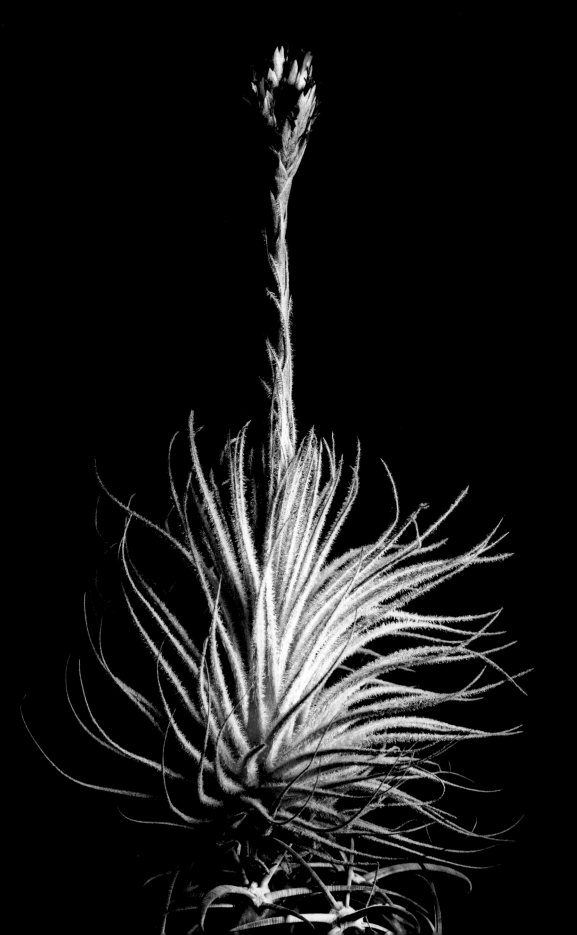

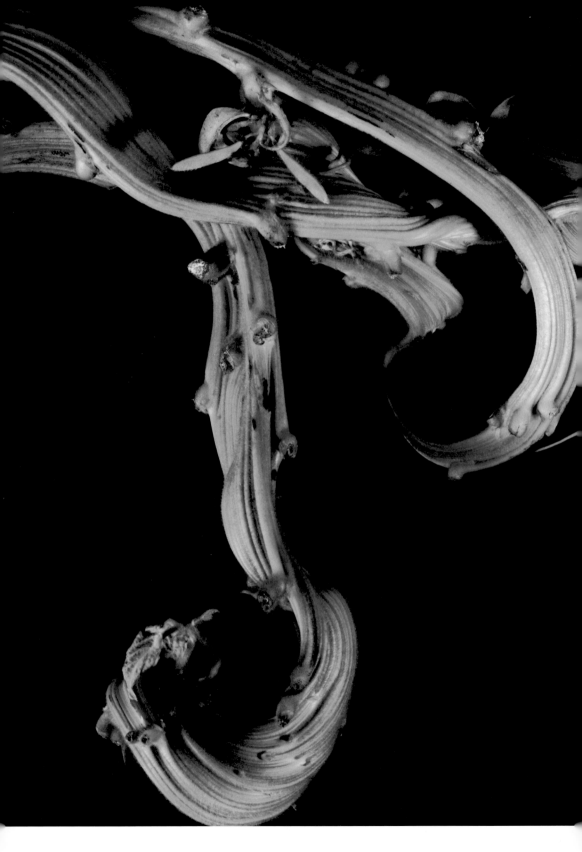

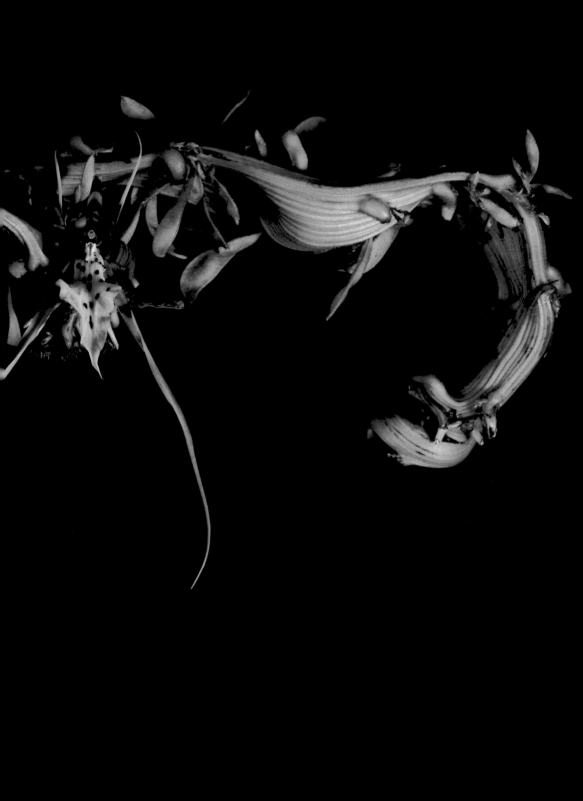

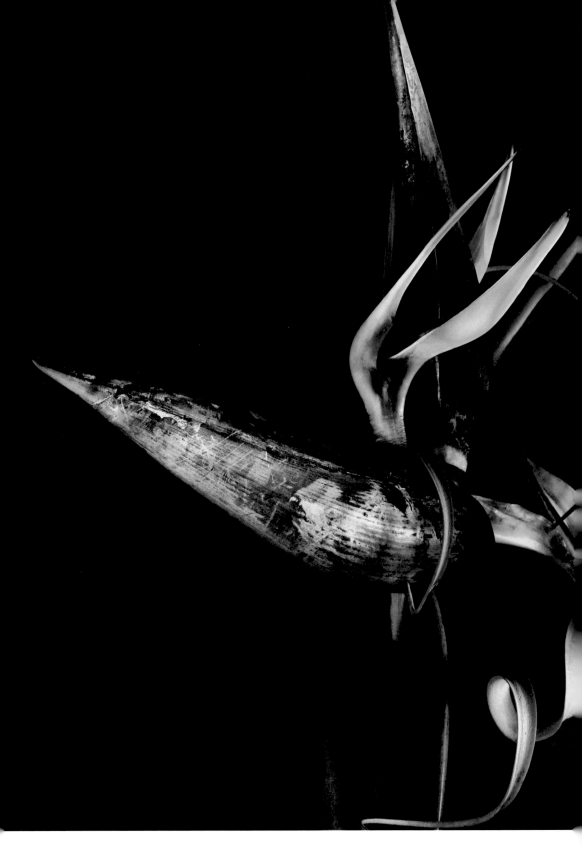

APPEARANCE 33

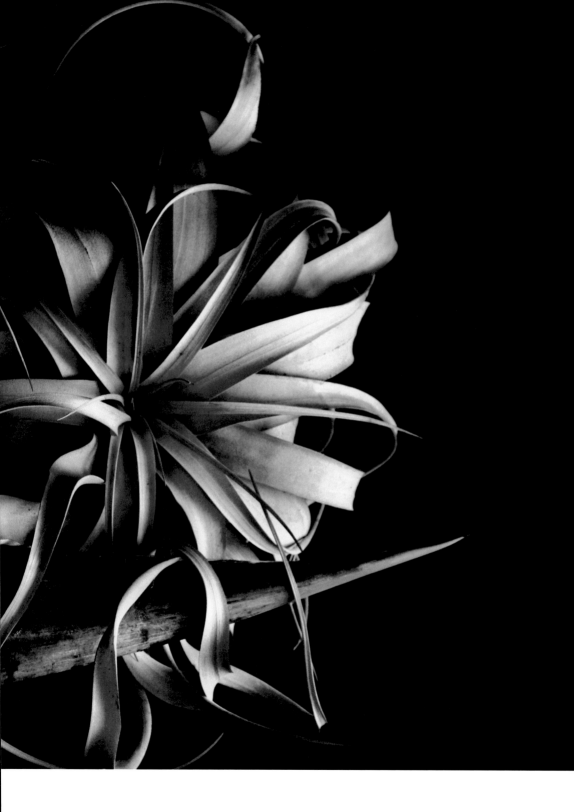

APPEARANCE 34

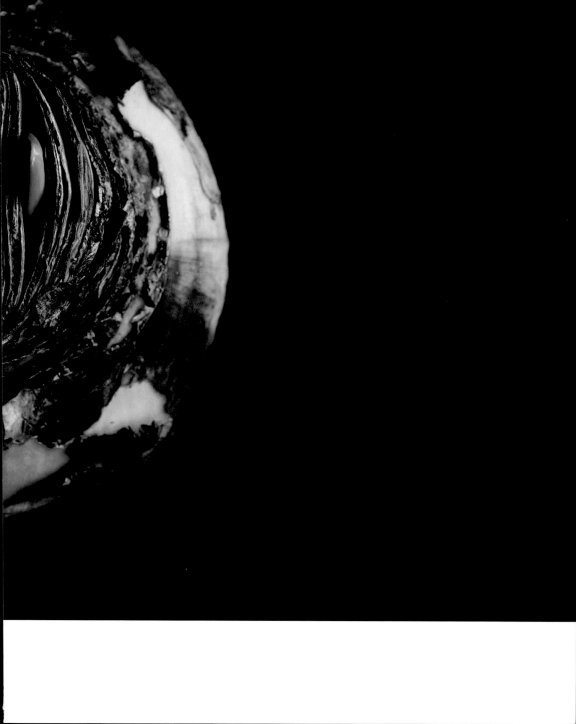

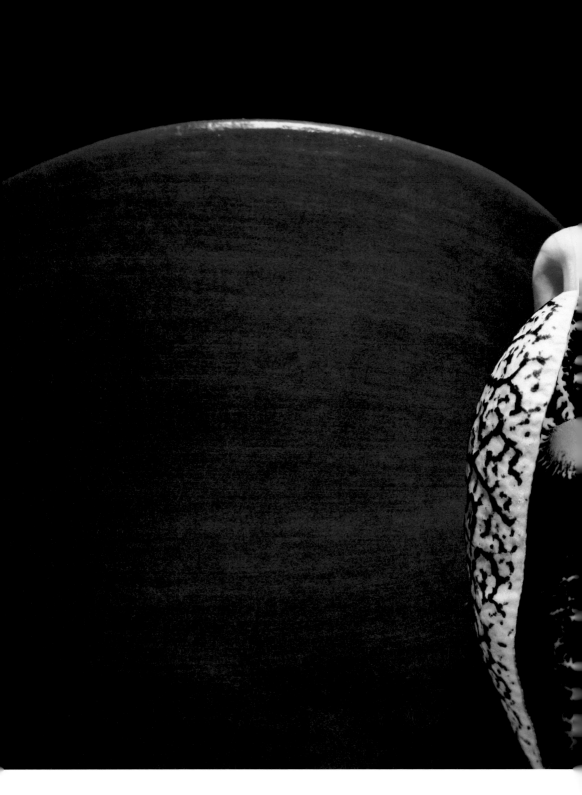

APPEARANCE 35

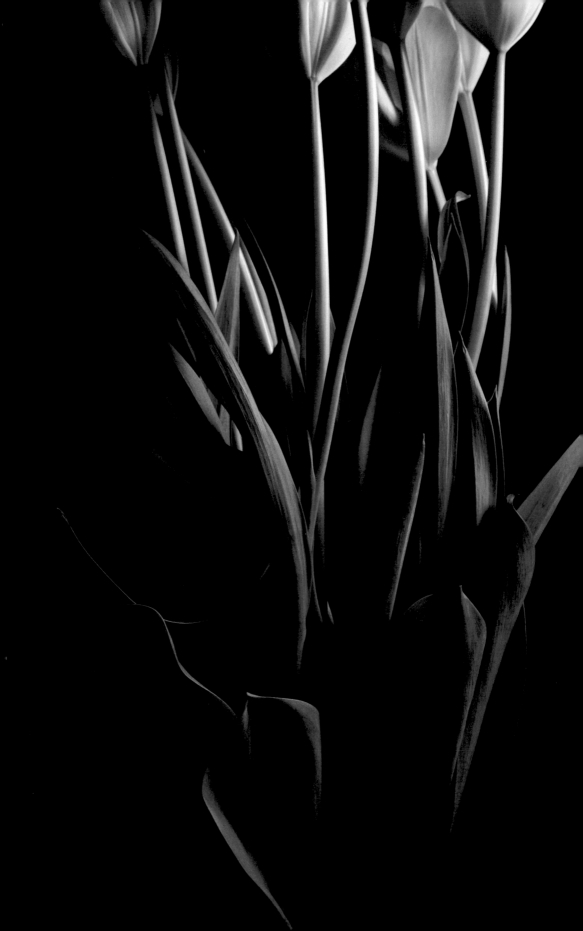

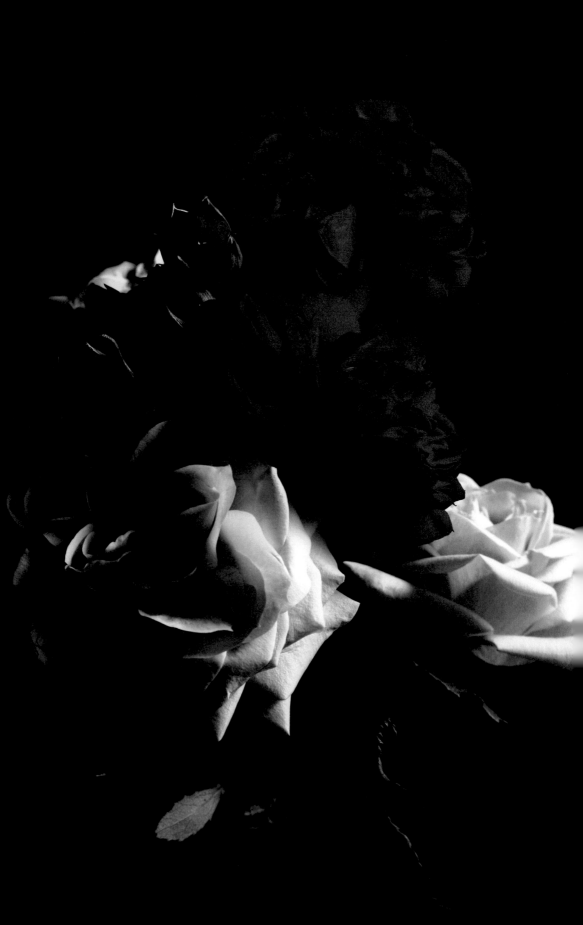

APPEARANCE 38

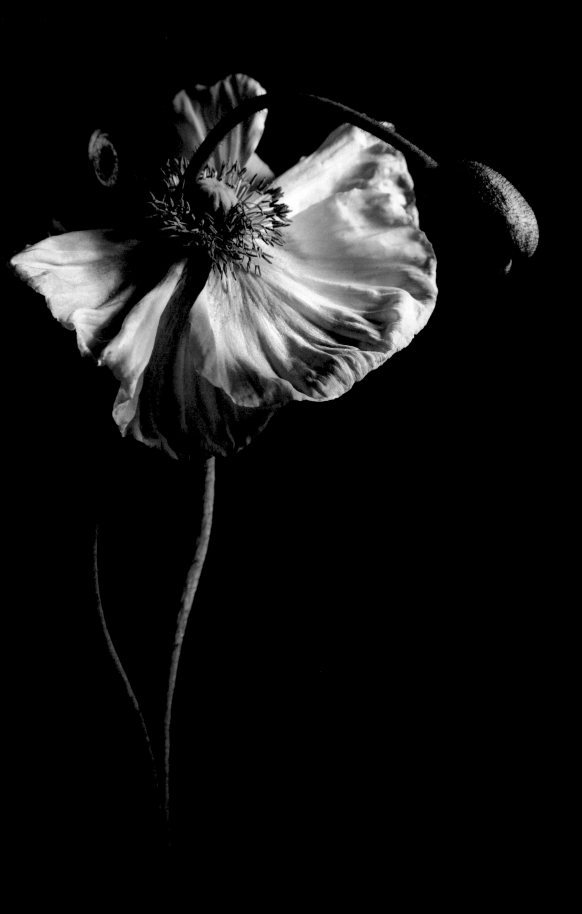

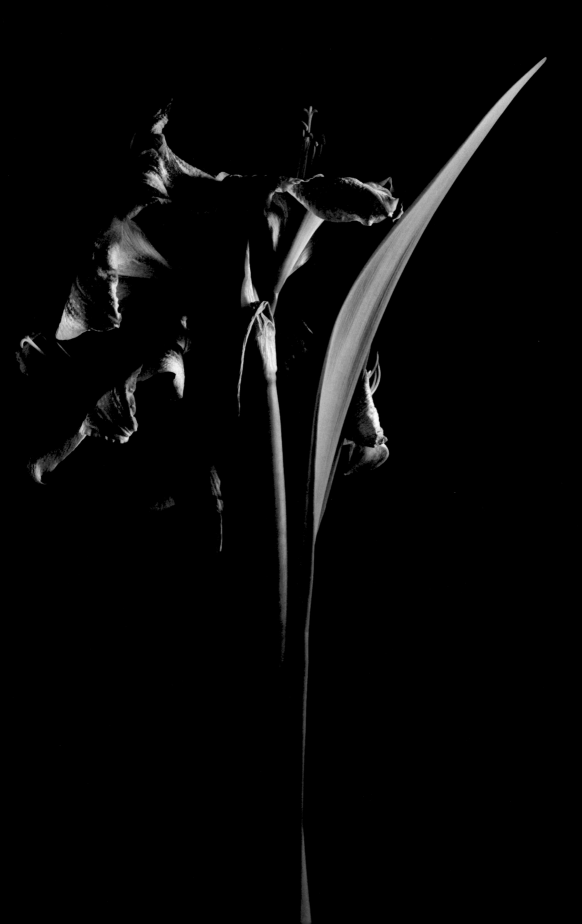

APPEARANCE 40

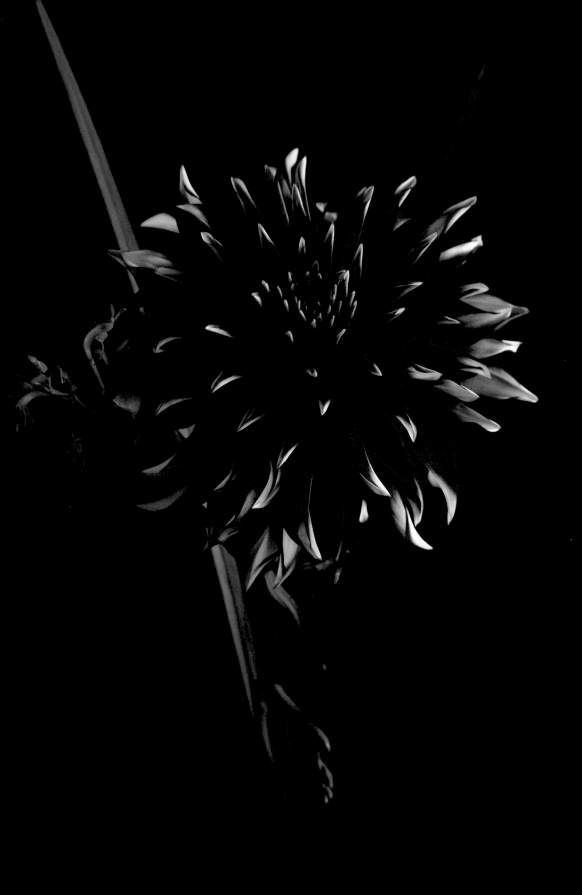

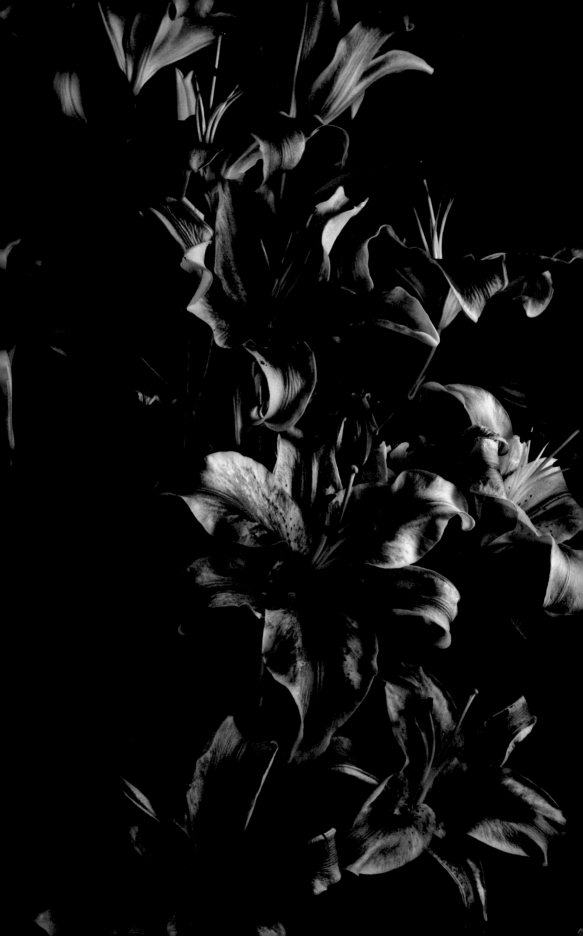

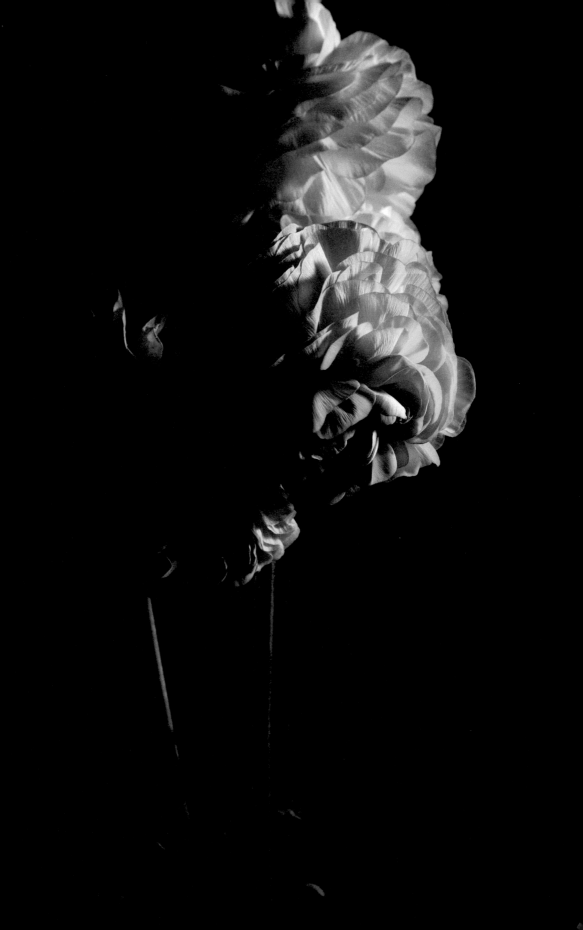

APPEARANCE 43

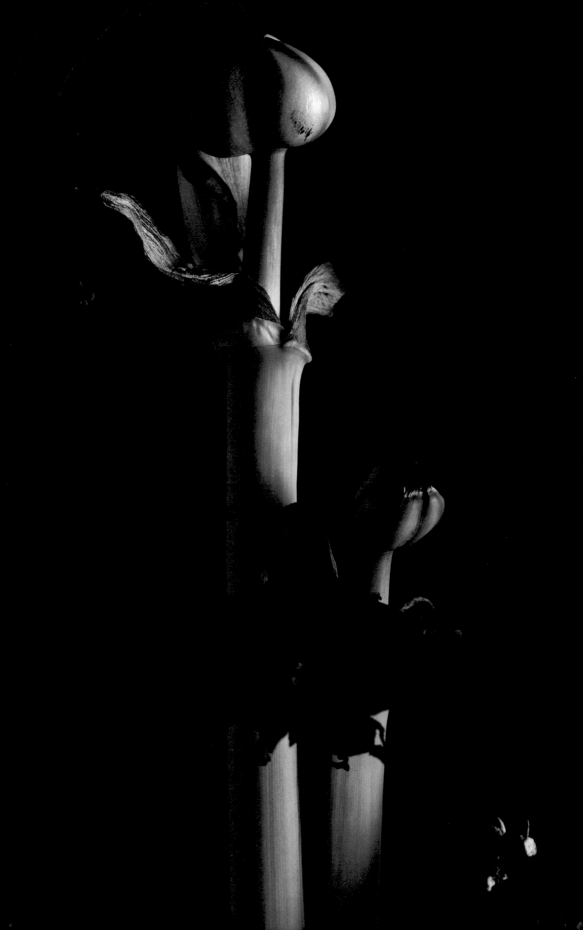

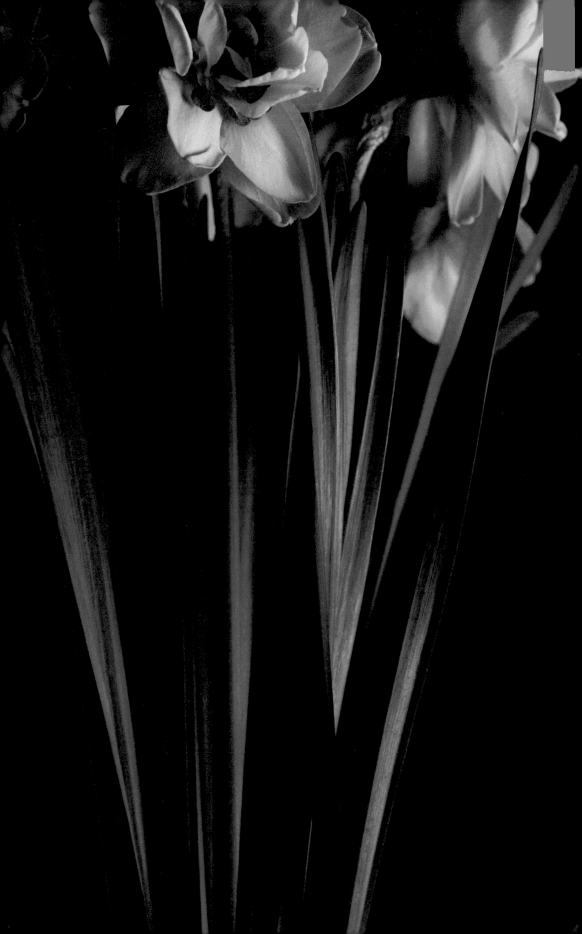

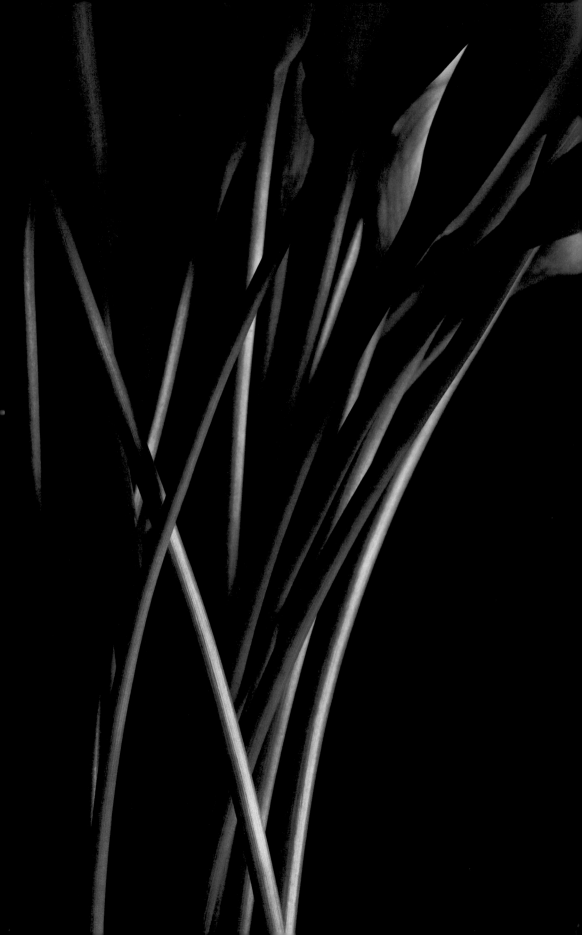

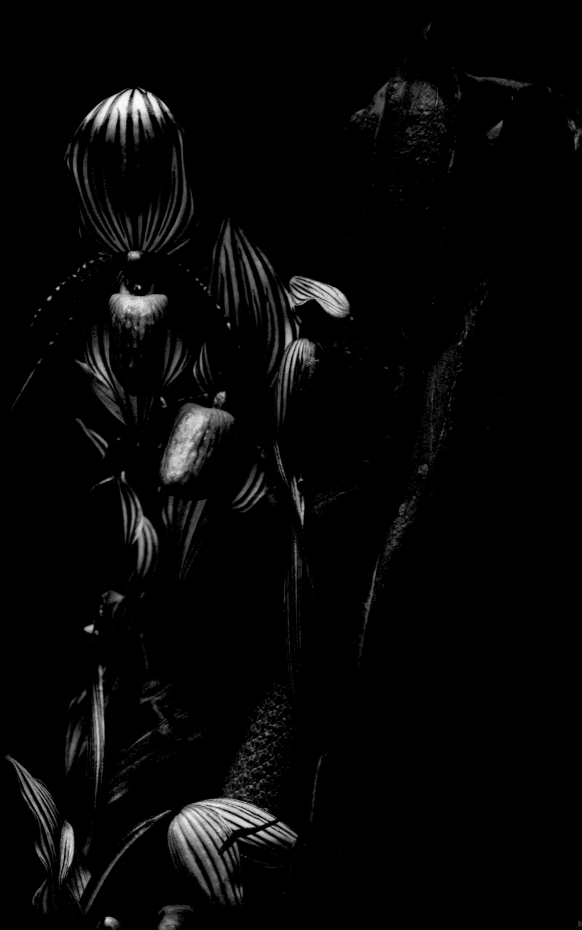

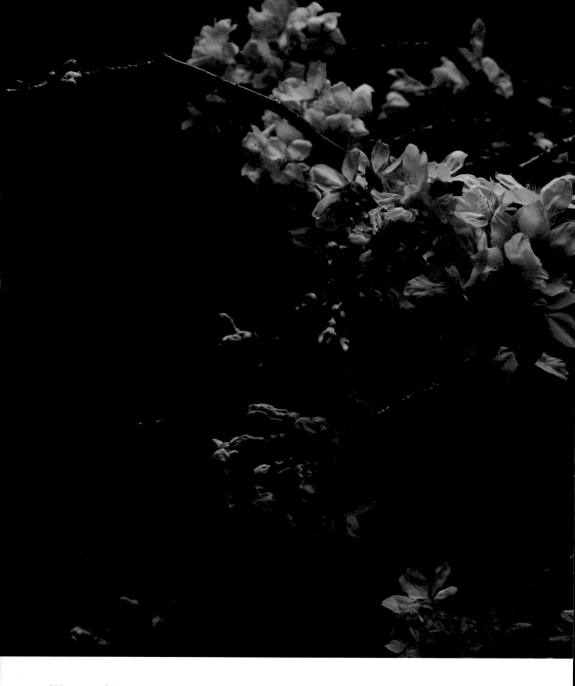

APPEARANCE 47

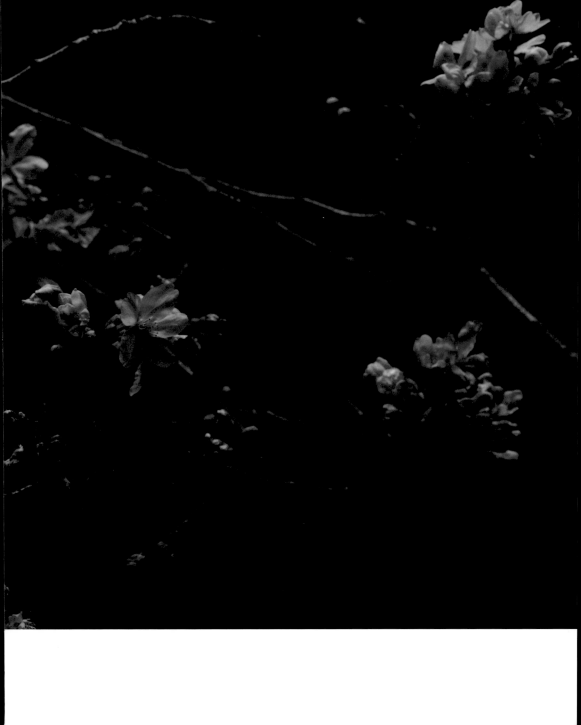

Index of Flowers

Index of Flowers by Image│WHOLE

Tokyo, April 2009–March 2012*

01 pp. 18–19

1 *Eustoma grandiflorum*
 'Voyage Blue'
 Bolero Deep Blue 'Voyage Blue'
2 *Ranunculus asiaticus* 'Angers'
 Persian Buttercup 'Angers'
3 *Lilium longiflorum* 'Hinomoto'
 Easter Lily 'Hinomoto'
4 *Dahlia* 'Sabaku'
 Dahlia 'Sabaku'
5 *Anemone coronaria* 'Mona Lisa
 Deep Blue'
 Poppy Anemone / Spanish
 Marigold 'Mona Lisa Deep Blue'
6 *Banksia baxteri* R. Br.
 Bird's-Nest Banksia
7 *Anthurium andreanum* 'Shibori'
 Anthurium 'Shibori'
8 *Leontochir ovallei*
 Lion's Claw
9 *Platycerium bifurcatum* (Cav.) C. Chr.
 Common Staghorn Fern
10 *Zygopetalum* Redvale
 'Pretty Ann'
 Zygopetalum Orchid 'Pretty Ann'
11 *Tulipa* 'Rococo'
 Tulip 'Rococo'
12 *Dianthus caryophyllus* 'Purple
 Rendezvous'
 Clove Pink 'Purple Rendezvous'
13 *Cyathea spinulosa* Wall. ex Hook.
 Large Spiny Tree Fern
14 *Dianthus caryophyllus*
 'Crazy Purple'
 Clove Pink 'Crazy Purple'
15 *Tulipa turkestanica*
 Turkestan Tulip
16 *Anthurium andreanum* 'Burgundy'
 Anthurium 'Burgundy'
17 *Dianthus caryophyllus*
 'Nobbio Violet'
 Clove Pink 'Nobbio Violet'

18 *Chrysanthemum × morifolium*
 'Pure Green'
 Chrysanth 'Pure Green'
19 *Rosa* 'Draft One'
 Rose 'Draft One'
20 *Berzelia albiflora*
 Berzelia
21 *Gerbera* 'Amulet'
 Daisy 'Amulet'
22 *Freesia refracta* 'Aladdin'
 Freesia 'Aladdin'
23 *Leucospermum cordifolium*
 'Succession'
 Pincushion 'Succession'
24 *Dahlia* 'Red Star'
 Dahlia 'Red Star'
25 *Hippeastrum papilio*
 (Ravenna) Van Scheepen
 Butterfly Amaryllis
26 *Oncidium obrizatum*
 Dancing-Lady Orchid
27 *Zantedeschia aethiopica*
 'Garnet Glow'
 Calla Lily 'Garnet Glow'
28 *Cyclamen persicum*
 'Prima Donna Gold'
 Persian Violet / Primrose
 'Prima Donna Gold'
29 *Scilla peruviana* L.
 Giant Scilla
30 *Chrysanthemum × morifolium*
 'Fuego'
 Chrysanth 'Fuego'
31 *Hydrangea macrophylla*
 'Tivoli Blue'
 French Hydrangea
 'Tivoli Blue'

* Certain plant and flower varieties and species have only existed during this
time and at this location, or their botanical names have been changed, either
from before this period or after.

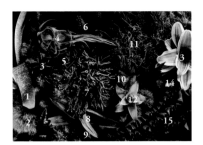

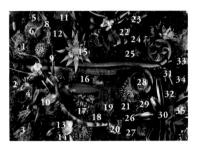

04 pp. 24–25

1 *Gerbera* 'Giant Spinner Toyotama'
Daisy 'Giant Spinner Toyotama'
2 *Oncidium altissimum* (Jacq.) Sw
Dancing-Lady Orchid 'Wild Cat'
3 *Anthurium andreanum* 'Safari'
Anthurium 'Safari'
4 *Neoregelia* 'Sunset Ball'
Neoregelia 'Sunset Ball'
5 *Epidendrum Secundum* 'Orange Ball'
Star Orchid 'Orange Ball'
6 *Dianthus caryophyllus* 'Hermès'
Clove Pink 'Hermès'
7 *Dahlia* 'Lalala'
Dahlia 'Lalala'
8 *Alanda* 'Green Tiger'
Alanda 'Green Tiger'

9 *Allium schubertii*
Ornamental Onion
10 *Phalaenopsis* 'Norika'
Moon Orchid 'Norika'
11 *Heliconia caribaea* Lam.
Wild Plantain
12 *Aechmea chantinii* (Carrière) Baker
Amazonian Zebra Plant
13 *Guzmania* 'Snow White'
Tufted Airplant 'Snow White'
14 *Tagetes erecta* 'Orange Isis'
African Marigold 'Orange Isis'
15 *Brassia* Eternal Wind 'Summer Dream'
Brassia Orchid 'Summer Dream'
16 *Aechmea fasciata* (Lindley) Baker
Silver Vase Plant / Urn Plant

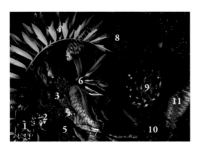

05 pp. 26–27

1 *Anthurium andreanum* 'Burgundy'
Anthurium 'Burgundy'
2 *Parmotrema tinctorum*
(Delise ex Nyl.) Hale
Umenokigoke
3 *Dianthus caryophyllus*
'Crimson Tempo'
Clove Pink 'Crimson Tempo'
4 *Encephalartos horridus* (Jacq.) Lehm.
Eastern Cape Blue Cycad
5 *Dianthus caryophyllus*
'Nobbio Hard Rock'
Clove Pink 'Nobbio Hard Rock'
6 *Doryanthes excelsa* Correa
Gymea Lily

7 *Nepenthes* 'Dicksoniana'
Tropical Pitcher Plant
'Dicksoniana'
8 *Rosa* 'Freedom'
Rose 'Freedom'
9 *Tapeinochilus ananassae*
'Indonesian Wax Ginger'
Indonesian Wax Ginger
10 *Aranthera* 'Anne Black'
Aranthera Orchid 'Anne Black'
11 *Zingiber zerumbet*
'Shampoo Ginger, Red'
Red Shampoo Ginger

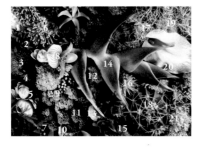

06 pp. 28–29

1 *Lilium longiflorum* 'Hinomoto'
Easter Lily 'Hinomoto'
2 *Lycopodium obscurum* L.
Stag's-Horn Clubmoss
3 *Rosa chinensis* 'Viridiflora'
Green Rose
4 *Ruscus hypophyllum* L.
Greater Butcher's Broom
5 *Lilium maculatum* 'Noble'
Mahogany Lily 'Noble'
6 *Chrysanthemum × morifolium* 'Green Shamrock'
Chrysanth 'Green Shamrock'
7 *Smilax china* L.
China Root
8 *Paphiopedilum curtisii* var. *sanderae*
'Fort Caroline'
King of Orchids 'Fort Caroline'
9 *Ornithogalum arabicum*
Star of Bethlehem
10 *Tulipa gesneriana* L.
Didier's Tulip

11 *Phlomis fruticosa* 'Green Star'
Jerusalem Sage
12 *Dianthus barbatus* 'Green Trick'
Sweet William 'Green Trick'
13 *Sarracenia flava*
Yellow Pitcher Plant
14 *Heliconia caribaea* 'Bonnie Kline'
Wild Plantain 'Bonnie Kline'
15 *Davallia tricomanoides*
Squirrel's-Foot Fern
16 *Chrysanthemum × morifolium* 'Popeye'
Chrysanth 'Popeye'
17 *Eustoma grandiflorum* 'Morino Shizuku'
Bolero Deep Blue 'Mori no Shizuku'
18 *Homalocephala texensis*
Candy Cactus
19 *Tillandsia usneoides* (L.) L.
Spanish Moss
20 *Zantedeschia aethiopica* 'Green Goddess'
Calla Lily 'Green Goddess'
21 *Viburnum* 'Snow Ball Lime'
Viburnum 'Snow Ball Lime'

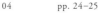

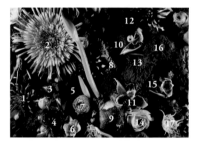

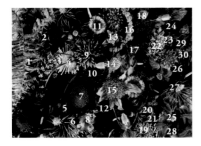

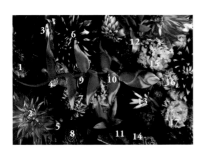

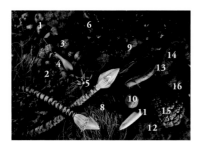

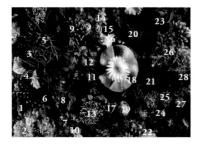

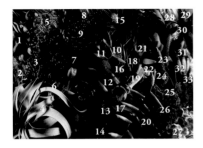

13 pp. 42–43

1 *Papaver nudicaule* L.
 Icelandic Poppy
2 *Ranunculus asiaticus* 'Charlotte'
 Persian Buttercup 'Charlotte'
3 *Colmanara* Wildcat 'Bobcat'
 Colmanara Orchid 'Bobcat'
4 *Tillandsia xerographica* Rohweder
 Shirley Temple Airplant
5 *Dahlia* 'Jazzdance'
 Dahlia 'Jazzdance'
6 *Rosa* 'X Factor'
 Rose 'X Factor'
7 *Daucus carota* var. *sativus*
 'Bordeaux'
 Carrot 'Bordeaux'
8 *Vriesea splendens*
 Flaming Sword
9 *Smilax aspera* L.
 Italian Sarsaparilla
10 *Tulipa* 'Barbatos'
 Tulipa 'Barbatos'
11 *Vriesea gigantea* Gaudichaud
 Vriesea
12 *Gerbera* 'Voldemort'
 Daisy 'Voldemort'
13 *Lachenalia mutabilis*
 Mutabilis Cape Cowslip
14 *Freesia refracta* 'Purple Rain'
 Freesia 'Purple Rain'
15 *Tillandsia stricta* Solander
 Airplant
16 *Osmunda japonica* Thunb.
 Japanese Royal Fern
17 *Anthurium andraeanum* 'Previa'
 Anthurium 'Previa'

18 *Rhipsalis cereuscula*
 Mistletoe Cactus
19 *Paphiopedilum* 'Pacific Ocean'
 King of Orchids 'Pacific Ocean'
20 *Skimmia japonica* 'Rubella'
 Japanese Skimmia 'Rubella'
21 *Vanda* 'Pachara Delight'
 Vanda 'Pachara Delight'
22 *Serruria florida* (Thunb.) Knight
 Blushing Bride
23 *Bulbinella floribunda* 'Apricot'
 Bulbinella 'Apricot'
24 *Rosa* 'Abracadabra'
 Rose 'Abracadabra'
25 *Tillandsia bulbosa* Hooker
 Bulbous Airplant
26 *Dahlia* 'Fidalgo Blacky'
 Dahlia 'Fidalgo Blacky'
27 *Hydrangea macrophylla*
 'Tivoli Pink'
 French Hydrangea 'Tivoli Pink'
28 *Anthurium andreanum* 'Shibori'
 Anthurium 'Shibori'
29 *Vanda* 'Sansai Blue'
 Vanda 'Sansai Blue'
30 *Guzmania* 'Luna'
 Tufted Airplant 'Luna'
31 *Tulipa* 'Davenport'
 Tulip 'Davenport'
32 *Musa velutina*
 Hairy Banana
33 *Eustoma grandiflorum* 'Voyage Pink'
 Bolero Deep Blue 'Voyage Pink'

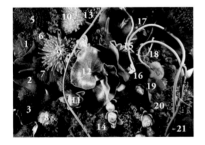

14 pp. 44–45

1 *Dianthus caryophyllus* 'Caroline'
 Clove Pink 'Caroline'
2 *Anthurium andreanum* 'President'
 Anthurium 'President'
3 *Dianthus caryophyllus*
 'Nobbio Black Heart'
 Clove Pink 'Nobbio Black Heart'
4 *Anthurium andreanum* 'Midori'
 Anthurium 'Midori'
5 *Telopea speciosissima* (Sm.) R. Br.
 Waratah
6 *Dianthus barbatus* 'Green Trick'
 Sweet William 'Green Trick'
7 *Gerbera jamesonii* 'Stanza'
 Daisy 'Stanza'
8 *Dianthus caryophyllus* 'Lemon Minami'
 Clove Pink 'Lemon Minami'
9 *Chrysanthemum* × *morifolium*
 'Green Shamrock'
 Chrysanth 'Green Shamrock'
10 *Chrysanthemum*×*morifolium* 'Zembla Lime'
 Chrysanth 'Zembla Lime'

11 *Lilium maculatum* 'Noble'
 Mahogany Lily 'Noble'
12 *Begonia venosa*
 Begonia
13 *Dahlia* 'Blue Peach'
 Dahlia 'Blue Peach'
14 *Chrysanthemum* × *morifolium*
 'Jenny Orange'
 Chrysanth 'Jenny Orange'
15 *Argyreia nervosa* (Burm. f.) Bojer
 Elephant Creeper
16 *Dianthus caryophyllus* 'Corsa'
 Clove Pink 'Corsa'
17 *Anthurium andreanum* 'Burgundy'
 Anthurium 'Burgundy'
18 *Epidendrum secundum* 'Princess'
 Star Orchid 'Princess'
19 *Vanda* 'Usha'
 Vanda 'Usha'
20 *Nigella damascena* 'Persian Jewels, Blue'
 Devil in the Bush 'Persian Jewels, Blue'
21 *Skimmia japonica* 'Rubella'
 Japanese Skimmia 'Rubella'

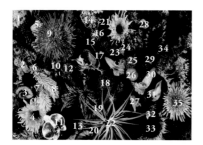

1 *Eremurus* 'Yellow Candle'
 Foxtail Lily 'Yellow Candle'
2 *Helianthus cucumerifolius* 'Asahi'
 Swamp Sneezeweed 'Asahi'
3 *Begonia rex* 'Queen of Hanover'
 Painted-Leaf Begonia
 'Queen of Hanover'
4 *Helianthus annuus*
 'Van Gogh's Sunflower'
 Common Sunflower
 'Van Gogh's Sunflower'
5 *Eustoma grandiflorum*
 'Mori no Shizuku'
 Bolero Deep Blue 'Mori no Shizuku'
6 *Tagetes erecta* 'Yellow Isis'
 African Marigold 'Yellow Isis'
7 *Dianthus barbatus* 'Green Trick'
 Sweet William 'Green Trick'
8 *Kniphofia uvaria* 'Little Maid'
 Red Hot Poker 'Little Maid'
9 *Gerbera* 'Giant Spinner Kayano'
 Daisy 'Giant Spinner Kayano'
10 *Gentiana scabra* Bunge var. *buergeri*
 (Miq.) Maxim 'Ashiro no Banshuu'
 Japanese Gentian
11 *Phalaenopsis* 'Little Mary'
 Moon Orchid 'Little Mary'
12 *Rosa* 'Exciting Meilland'
 Rose 'Exciting Meilland'
13 *Dianthus caryophyllus* 'Bloom'
 Clove Pink 'Bloom'
14 *Leucospermum cordifolium*
 'High Gold'
 Pincushion 'High Gold'
15 *Trachelium caeruleum*
 'Powder Blue'
 Throatwort 'Powder Blue'
16 *Guzmania* 'Torch'
 Tufted Airplant 'Torch'
17 *Dianthus caryophyllus* 'Master'
 Clove Pink 'Master'
18 *Leucospermum cordifolium* 'Succession'
 Pincushion 'Succession'

19 *Veronica longifolia* L.
 Longleaf Speedwell
20 *Echinops ritro* L.
 Globe Thistle
21 *Dianthus caryophyllus*
 'Nobbio Black Heart'
 Clove Pink 'Nobbio Black Heart'
22 *Tillandsia gardneri* Lindley
 Airplant
23 *Celosia argentea var. cristata*
 'Kurume New Scarlet'
 Crested Cockscomb
 'Kurume New Scarlet'
24 *Hoya carnosa*
 Wax Plant
25 *Clematis* sp. (fruit)
 Clematis
26 *Chrysanthemum × morifolium*
 'Ping Pong Golden'
 Chrysanth 'Ping Pong Golden'
27 *Musa velutina*
 Hairy Banana
28 *Disa artiste* (Watsonii × Riette)
 Disa Orchid
29 *Curcuma alismatifolia*
 'Chiang Mai Rouge'
 Siam Tulip 'Chiang Mai Rouge'
30 *Sarracenia* 'Mihara'
 Pitcher Plant 'Mihara'
31 *Anthurium andreanum*
 'Alura Pink'
 Anthurium 'Alura Pink'
32 *Aristolochia debilis*
 Dutchman's Pipe
33 *Helianthus annuus*
 'Sunrich Orange'
 Common Sunflower
 'Sunrich Orange'
34 *Tillandsia butzii* Mez.
 Butzii Airplant
35 *Gerbera*
 'Giant Spinner Toyotama'
 Daisy 'Giant Spinner Toyotama'

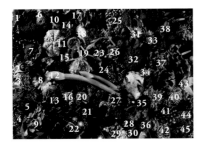

1 *Daucus carota*
Carrot

2 *Anthurium andreanum*
'Shell Green'
Anthurium 'Shell Green'

3 *Sarracenia purpurea* subsp.
purpurea f. *heterophylla*
Purple Pitcher Plant

4 *Mentha suaveolens* Ehrh.
Apple Mint

5 *Rubus fruticosus* 'Summer Green'
Bramble 'Summer Green'

6 *Rosa chinensis* 'Viridiflora'
Green Rose

7 *Citrus aurantifolia*
Key Lime

8 *Rhipsalis cereuscula*
Mistletoe Cactus

9 *Angelica pachycarpa*
'Summer Delight'
Angelica 'Summer Delight'

10 *Gloriosa superba* 'Lutea'
Flame Lily 'Lutea'

11 *Hylotelephium spectabile*
(Sweet ex Hook.)
Garden Stonecrop

12 *Polyscias filicifolia*
Panax

13 *Hordeum vulgare* f. *hexastichon*
Six-Row Barley

14 *Ribes uva-crispa* L.
Gooseberry

15 *Dianthus barbatus* 'Green Trick'
Sweet William 'Green Trick'

16 *Synurus pungens*
(Franch. et Savat.) Kitam.
Oyama-bokuchi

17 *Nepenthes mirabilis*
(Lour.) Druce
Common Swamp Pitcher Plant

18 *Canna generalis*
Orchid Canna

19 *Nigella orientalis* 'Transformer'
Devil in the Bush
'Oriental Transformer'

20 *Vaccinium virgatum* 'South Moon'
Highbush Blueberry 'South Moon'

21 *Pelargonium graveolens*
'Purple Lemonade'
Sweet-Scented Geranium
'Purple Lemonade'

22 *Fritillaria imperialis* L.
Crown Imperial Fritillary (Seed)

23 *Eremurus robustus* Regel
Foxtail Lily

24 *Lycopodium obscurum* L.
Stag's-Horn Clubmoss

25 *Cyathea spinulosa* Wall. ex Hook.
Large Spiny Tree Fern

26 *Celosia argentea* var. *cristata*
'Green Coral'
Crested Cockscomb 'Green Coral'

1 *Gloriosa superba* 'Misato Red'
Flame Lily 'Misato Red'

2 *Chrysanthemum* × *morifolium*
'Popeye'
Chrysanth 'Popeye'

3 *Anthurium andreanum* 'Mickey Mouse'
Anthurium 'Mickey Mouse'

4 *Mammillaria geminispina*
Twin-Spined Cactus, Whitey

5 *Dianthus caryophyllus*
'Nobbio Black Heart'
Clove Pink 'Nobbio Black Heart'

6 *Mokara* 'British Orange'
Mokara Orchid 'British Orange'

7 *Asplenium antiquum* 'Ruffle'
Bird's-Nest Fern 'Ruffle'

8 *Gerbera jamesonii* 'Dakar'
Daisy 'Dakar'

9 *Hydrangea macrophylla*
'Magical Coral'
French Hydrangea 'Magical Coral'

10 *Cirsium japonicum*
'Teraoka Azami'
Japanese Thistle 'Teraoka Azami'

11 *Astrophytum asterias*
Star Cactus

12 *Hippeastrum* × *hybridum*
'Red Lion'
Amaryllis 'Red Lion'

13 *Tacca chantrieri* André
Black Bat Flower

14 *Dianthus barbatus*
'Crowny Cherry Red'
Sweet William 'Crowny Cherry Red'

15 *Dianthus barbatus* 'Green Trick'
Sweet William 'Green Trick'

16 *Epidendrum secundum* 'Sakura'
Star Orchid 'Sakura'

17 *Dianthus caryophyllus*
'Matryoshka'
Clove Pink 'Matryoshka'

18 *Ranunculus asiaticus* 'M-Cream'
Persian Buttercup 'M-Cream'

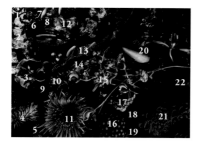

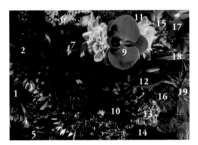

19 pp. 54–55

1 *Rosa* 'Amada'
Rose 'Amada'

2 *Anthurium andreanum* 'Burgundy'
Anthurium 'Burgundy'

3 *Tillandsia bulbosa* Hooker
Bulbous Airplant

4 *Dianthus caryophyllus*
'Nobbio Black Heart'
Clove Pink 'Nobbio Black Heart'

5 *Dahlia* 'Arabian Nights'
Dahlia 'Arabian Nights'

6 *Cynara scolymus* 'Violetto'
Globe Artichoke 'Violetto'

7 *Neoregelia marmorata*
(Baker) L. B. Smith
Neoregelia

8 *Iris germanica* 'Sea Power'
German Iris 'Sea Power'

9 *Paeonia lactiflora* 'Red Charm'
Chinese Peony 'Red Charm'

10 *Daucus carota* var. *sativus*
'Bordeaux'
Carrot 'Bordeaux'

11 *Dahlia* 'Black Butterfly'
Dahlia 'Black Butterfly'

12 *Racinaea crispa* (Baker) M. A.
Spencer & L. B. Smith
Racinaea

13 *Zantedeschia aethiopica*
'Schwarzwalder'
Calla Lily 'Schwarzwalder'

14 *Nepenthes* 'Dyeriana'
Tropical Pitcher Plant
'Dyeriana'

15 *Sinningia leucotricha*
Brazilian Edelweiss

16 *Echinochloa esculenta*
'Flake Chocolate'
Japanese Millet
'Flake Chocolate'

20 pp. 56–57

1 *Chrysanthemum* × *morifolium*
'Fuego'
Chrysanth 'Fuego'

2 *Dahlia* 'Arabian Nights'
Dahlia 'Arabian Nights'

3 *Chrysanthemum* × *morifolium*
'Classic Cocoa'
Chrysanth 'Classic Cocoa'

4 *Ranunculus asiaticus* 'Charlotte'
Persian Buttercup 'Charlotte'

5 *Medinilla magnifica* Lindl.
Malaysian Orchid

6 *Brassica oleracea* var. *botrytis* f.
botrytis
Broccoli

7 *Iris* × *hollandica* 'Blue Magic'
Dutch Iris 'Blue Magic'

8 *Dahlia* 'Kazusamangetsu'
Dahlia 'Kazusamangetsu'

9 *Phalaenopsis* 'Pinton Queen'
Moon Orchid 'Pinton Queen'

10 *Colmanara* Wildcat 'Bobcat'
Colmanara Orchid 'Bobcat'

11 *Leucospermum cordifolium*
'Succession'
Pincushion 'Succession'

12 *Anthurium andreanum*
'Tropical Red'
Anthurium 'Tropical Red'

13 *Dianthus caryophyllus*
'Antigua'
Clove Pink 'Antigua'

14 *Heliconia vellerigera*
'King Kong'
Furry Heliconia

15 *Tulipa* 'Mon Amour'
Tulip 'Mon Amour'

16 *Dianthus caryophyllus*
'Caroline'
Clove Pink 'Caroline'

17 *Disa uniflora* P. J. Bergius
Disa Orchid

18 *Vriesea simplex* 'Gigantea'
Vriesea 'Gigantea'

19 Gerbera 'Tomahawk'
Daisy 'Tomahawk'

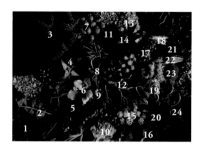

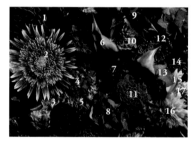

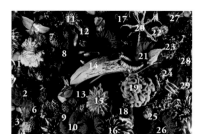

23 pp. 62–63

1 *Rosa* 'Voodoo!'
 Rose 'Voodoo!'
2 *Dahlia* 'Red Star'
 Dahlia 'Red Star'
3 *Dianthus caryophyllus*
 'Dom Pedro'
 Clove Pink 'Dom Pedro'
4 *Ranunculus asiaticus* 'Amiens'
 Persian Buttercup 'Amiens'
5 *Strobilanthes gossypinus*
 'Gold Downy'
 Strobilanthes 'Gold Downy'
6 *Dianthus caryophyllus* 'Araking'
 Clove Pink 'Araking'
7 *Scilla peruviana* L.
 Giant Scilla
8 *Neoregelia* 'Sunset Ball'
 Neoregelia 'Sunset Ball'
9 *Rosa* 'Piano'
 Rose 'Piano'
10 *Vanda* 'Pachara Delight'
 Vanda 'Pachara Delight'
11 *Lantana camara*
 Largeleaf Lantana
12 *Dianthus caryophyllus* 'Tamarind'
 Clove Pink 'Tamarind'
13 *Dianthus caryophyllus*
 'Nobbio Hard Rock'
 Clove Pink 'Nobbio Hard Rock'
14 *Nepenthes* 'Dyeriana'
 Tropical Pitcher Plant 'Dyeriana'
15 *Dahlia* 'Peach in Season'
 Dahlia 'Peach in Season'

16 *Dahlia* 'Lalala'
 Dahlia 'Lalala'
17 *Mokara* 'Buffalo Orange'
 Mokara Orchid 'Buffalo Orange'
18 *Hippeastrum* × *hybridum*
 'Red Lion'
 Amaryllis 'Red Lion'
19 *Mammillaria elongata* f. *cristata*
 Brain Cactus
20 *Gloriosa superba* 'Lutea'
 Flame Lily 'Lutea'
21 *Gerbera* 'Giorgio'
 Daisy 'Giorgio'
22 *Dendrobium phalaenopsis*
 'Chanel Green'
 Cooktown Orchid 'Chanel Green'
23 *Scabiosa atropurpurea*
 'White Picoty'
 Mourning Bride 'White Picoty'
24 *Guzmania lingulata* 'Sun Star'
 Tufted Airplant 'Sun Star'
25 *Eustoma grandiflorum*
 'Voyage Blue'
 Bolero Deep Blue 'Voyage Blue'
26 *Gerbera* 'Red Spring'
 Daisy 'Red Spring'
27 *Delphinium grandiflorum*
 'Grand Blue'
 Siberian Larkspur 'Grand Blue'
28 *Freesia refracta* 'Aladdin'
 Freesia 'Aladdin'
29 *Ornithogalum dubium*
 Sun Star

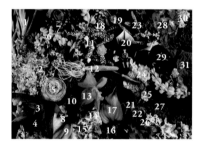

24 pp. 64–65

1 *Iris* × *hollandica* 'Blue Magic'
 Dutch Iris 'Blue Magic'
2 *Oncidium obrizatum*
 Dancing-Lady Orchid
3 *Guzmania* 'Grand Prix'
 Tufted Airplant 'Grand Prix'
4 *Eustoma grandiflorum*
 'Voyage Blue'
 Bolero Deep Blue 'Voyage Blue'
5 *Ranunculus asiaticus* 'Lille'
 Persian Buttercup 'Lille'
6 *Lupinus luteus* L.
 Marsh Lupine
7 *Freesia refracta* 'Orange Mountain'
 Freesia 'Orange Mountain'
8 *Onixotis stricta* (Burm. f.)
 Wijnands
 Rice Flower
9 *Anthurium andreanum*
 'Maxima Elegancia'
 Anthurium 'Maxima Elegancia'

10 *Jatropha podagrica* Hook.
 Buddha Belly Plant
11 *Aranda* 'Green Tiger'
 Aranda Orchid 'Green Tiger'
12 *Arisaema kiushianum* Makino
 Hime-urashimasou
13 *Rhyncattleanthe* Love Passion
 'Orange Bird'
 Rhyncattleanthe Orchid
 'Orange Bird'
14 *Eustoma grandiflorum*
 'Voyage White'
 Bolero Deep Blue 'Voyage White'
15 *Epidendrum secundum* 'Sakura'
 Star Orchid 'Sakura'
16 *Dianthus caryophyllus*
 'Nobbio Hard Rock'
 Clove Pink 'Nobbio Hard Rock'
17 *Anthurium andreanum* 'Previa'
 Anthurium 'Previa'

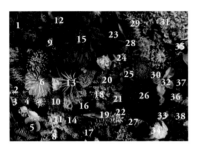

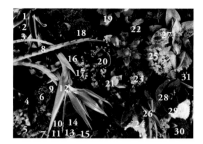

26 pp. 68–69

1 *Neoregelia* 'Fireball'
Neoregelia 'Fireball'
2 *Scabiosa atropurpurea*
'Chilli Black'
Mourning Bride 'Chilli Black'
3 *Scabiosa atropurpurea*
'Green Apple'
Mourning Bride 'Green Apple'
4 *Guzmania* 'Luna'
Tufted Airplant 'Luna'
5 *Ornithogalum dubium*
Sun Star
6 *Rosa* 'Pink Piano'
Rose 'Pink Piano'
7 *Dianthus caryophyllus*
'Orange Magic'
Clove Pink 'Orange Magic'
8 *Brocchinia reducta* Baker
Brocchinia
9 *Dianthus caryophyllus*
'Crazy Purple'
Clove Pink 'Crazy Purple'
10 *Hyacinthus orientalis* 'Delft Blue'
Garden Hyacinth 'Delft Blue'
11 *Scabiosa atropurpurea*
'Chilli Sauce'
Mourning Bride 'Chilli Sauce'
12 *Strelitzia reginae* Aiton
Orange Bird of Paradise
13 *Calathea crocata*
Eternal Flame
14 *Dianthus barbatus* 'Green Trick'
Sweet William 'Green Trick'
15 *Gloriosa superba* 'Misato Red'
Flame Lily 'Misato Red'
16 *Rheum rhabarbarum* L.
Garden Rhubarb
17 *Syringa vulgaris*
'Madame Florent Stepman'
Common Lilac
18 *Ranunculus asiaticus*
'Rainette Green'
Persian Buttercup 'Rainette Green'

19 *Iris* × *hollandica* 'Blue Magic'
Dutch Iris 'Blue Magic'
20 *Paphiopedilum callosum*
(Rchb. f.) Stein var. *vinicolor*
King of Orchids
21 *Iris* × *hollandica*
'Golden Harvest'
Dutch Iris 'Golden Harvest'
22 *Veronica longifolia*
'Smart Alien'
Longleaf Speedwell 'Smart Alien'
23 *Ranunculus asiaticus*
'Gold Coin'
Persian Buttercup 'Gold Coin'
24 *Chrysanthemum* × *morifolium*
'Yellow Vesuvio'
Chrysanth 'Yellow Vesuvio'
25 *Epidendrum secundum*
'Yellow Monkey'
Star Orchid 'Yellow Monkey'
26 *Musa liukiuensis (Matsumura)*
Makino
Ito-basho
27 *Strobilanthes gossypinus*
'Gold Downy'
Strobilanthes 'Gold Downy'
28 *Hippeastrum* × *hybridum*
'Royal Velvet'
Amaryllis 'Royal Velvet'
29 *Eustoma grandiflorum*
'Voyage Yellow'
Bolero Deep Blue 'Voyage Yellow'
30 *Dianthus caryophyllus* 'Master'
Clove Pink 'Master'
31 *Anthurium andreanum*
'Burgundy'
Anthurium 'Burgundy'

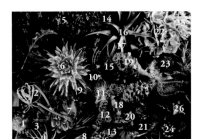

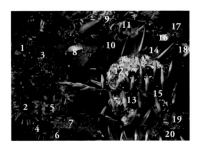

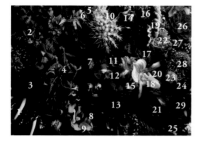

1 *Anthurium andreanum* 'Burgundy'
Anthurium 'Burgundy'
2 *Nerine bowdenii*
Cape Flower
3 *Cyperus papyrus* L.
Papyrus
4 *Epidendrum chinnabarinum*
Vermilion Epidendrum
5 *Dianthus caryophyllus* 'Prado Mint'
Clove Pink 'Prado Mint'
6 *Dianthus barbatus* 'Green Trick'
Sweet William 'Green Trick'
7 *Lycopodium squarrosum* G. Forst.
Lycopodium
8 *Peperomia ferreyrae*
Peperomia
9 *Cymbidium* 'Green Sour'
Boat Orchid 'Green Sour'
10 *Echinocactus grusonii* Hildm.
Barrel Cactus
11 *Celosia argentea* var. *cristata*
'Bombay Fire'
Crested Cockscomb 'Bombay Fire'
12 *Iris* × *hollandica* 'Blue Magic'
Dutch Iris 'Blue Magic'
13 *Neoregelia* 'Sunset Ball'
Neoregelia 'Sunset Ball'
14 *Phalaenopsis* Pink Jumbao 'Fairy'
Moon Orchid 'Fairy'
15 *Ranunculus asiaticus* 'Sivas'
Persian Buttercup 'Sivas'
16 *Hyacinthus orientalis* 'Blue Jacket'
Garden Hyacinth 'Blue Jacket'

17 *Rosa* 'Piano'
Rose 'Piano'
18 *Paphiopedilum curtisii* var.
sanderae 'Fort Caroline'
King of Orchids 'Fort Caroline'
19 *Amaranthus caudatus* 'Viridis'
Love-Lies-Bleeding 'Viridis'
20 *Dianthus caryophyllus* 'Dom Pedro'
Clove Pink 'Dom Pedro'
21 *Paeonia lactiflora* 'Red Grace'
Chinese Peony 'Red Grace'
22 *Tagetes erecta* 'Orange Isis'
African Marigold 'Orange Isis'
23 *Chrysanthemum* × *morifolium*
'Pure Green'
Chrysanth 'Pure Green'
24 *Trachelium caeruleum* 'Jade Green'
Throatwort 'Jade Green'
25 *Leucadendron laureolum*
'Safari Sunset'
Leucadendron 'Safari Sunset'
26 *Dahlia* 'Souun'
Dahlia 'Souun'
27 *Petroselinum crispum* (Mill.) Fuss
Hamburg Parsley
28 *Leucospermum cordifolium*
'Gold Dust'
Pincushion 'Gold Dust'
29 *Guzmania* 'Luna'
Tufted Airplant 'Luna'

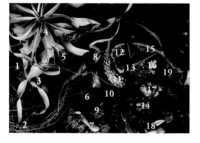

1 *Adromischus poelnitzianus*
Adromischus
2 *Rhipsalis capilliformis*
Old Man's Beard
3 *Platycerium bifurcatum* (Cav.) C. Chr.
Common Staghorn Fern
4 *Tillandsia xerographica* Rohweder
Shirley Temple Airplant
5 *Paphiopedilum barbatum*
'Tsukuba Surprise'
King of Orchids 'Tsukuba Surprise'
6 *Rosa chinensis* 'Viridiflora'
Green Rose
7 *Nepenthes rafflesiana* Jack
Raffles' Pitcher Plant
8 *Sarracenia* 'Adesugata'
Pitcher Plant 'Adesugata'
9 *Dianthus barbatus* 'Green Trick'
Sweet William 'Green Trick'
10 *Aspidistra elatior* Blume
Aspidistra / Cast-Iron Plant

11 *Orostachys japonica* (Maxim.)
A. Berger
Rock Pine
12 *Sedum* 'Alice Evans'
Stonecrop 'Alice Evans'
13 *Aloe ciliaris* Haw. var. *ciliaris*
Common Climbing Aloe
14 *Leucadendron* 'Silver Mist'
Leucadendron 'Silver Mist'
15 *Lycopodium squarrosum*
G. Forst.
Lycopodium
16 *Euphorbia lactea* ver. *variegata*
'White Ghost'
White Ghost
17 *Crassula conjuncta* f. *variegata*
String of Buttons
18 *Lilium longiflorum* 'Dusan'
Easter Lily 'Dusan'
19 *Ruscus hypophyllum* L.
Greater Butcher's Broom

Index of Flowers by Image | FLOCK

Tokyo, April 2009–March 2012

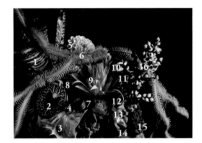

01 pp. 80–81

1 *Neoregelia* 'Turmoil'
Neoregelia 'Turmoil'

2 *Aristolochia elegans* Mast
Dutchman's Pipe

3 *Anthurium andreanum* 'Midori'
Anthurium 'Midori'

4 *Begonia bowerae* var. *nigramarga*
Eyelash Begonia

5 *Dahlia* 'Senior Ball'
Dahlia 'Senior Ball'

6 *Lycopodium squarrosum* G. Forst.
Lycopodium

7 *Lilium maculatum* 'Beatrix'
Mahogany Lily 'Beatrix'

8 *Eustoma grandiflorum* 'Voyage Blue'
Bolero Deep Blue 'Voyage Blue'

9 *Aechmea fasciata* (Lindley) Baker
Silver Vase Plant / Urn Plant

10 *Nerine sarniensis* 'Silver Light'
Guernsey Lily 'Silver Light'

11 *Scabiosa atropurpurea*
'Chilli Sauce'
Mourning Bride 'Chilli Sauce'

12 *Nephrolepis exaltata*
'Boston Fern'
Boston Fern

13 *Eustoma grandiflorum*
'Mori no Shizuku'
Bolero Deep Blue
'Mori no Shizuku'

14 *Dianthus barbatus* 'Green Trick'
Sweet William 'Green Trick'

15 *Dianthus caryophyllus*
'Moondust Princess Blue'
Clove Pink
'Moondust Princess Blue'

16 *Aechmea penduliflora*
'White Berry'
Aechmea 'White Berry'

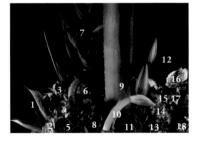

02 pp. 82–83

1 *Anthurium andreanum* 'Rapid'
Anthurium 'Rapid'

2 *Dahlia* 'Biedermannsdorf'
Dahlia 'Biedermannsdorf'

3 *Tulipa turkestanica*
Turkestan Tulip

4 *Ranunculus asiaticus* 'Charlotte'
Persian Buttercup 'Charlotte'

5 *Dianthus caryophyllus*
'Nobbio Black Heart'
Clove Pink 'Nobbio Black Heart'

6 *Cyathea spinulosa* Wall. ex Hook.
Large Spiny Tree Fern

7 *Heliconia bihai* 'Lobster Claw Tree'
Bastard Plantain 'Lobster Claw Tree'

8 *Anthurium andreanum*
'Tropical Red'
Anthurium 'Tropical Red'

9 *Agave americana* L.
Century Plant

10 *Hippeastrum* × *hybridum* 'Suzan'
Amaryllis 'Suzan'

11 *Dahlia* 'Red Star'
Dahlia 'Red Star'

12 *Musa velutina*
Hairy Banana

13 *Chrysanthemum morifolium*
'Fuego'
Chrysanth 'Fuego'

14 *Epidendrum secundum*
'Orange Ball'
Star Orchid 'Orange Ball'

15 *Colmanara* Wildcat 'Bobcat'
Colmanara Orchid 'Bobcat'

16 *Paphiopedilum*
'Satsuma Karajishi'
King of Orchids
'Satsuma Karajishi'

17 *Dahlia* 'Kazusashiranami'
Dahlia 'Kazusashiranami'

18 *Aechmea penduliflora*
'White Berry'
Aechmea 'White Berry'

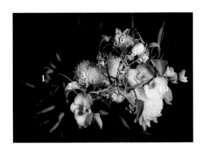

03 pp. 84–85

1 *Citrus medica* var. *sarcodactylis*
 Buddha's Hand
2 *Lilium orientalis* 'Casa Blanca'
 Oriental Lily 'Casa Blanca'
3 *Chrysanthemum × morifolium*
 'Full Bloom Mum'
 Chrysanth 'Full Bloom Mum'
4 *Epidendrum secundum* 'Snow Queen'
 Star Orchid 'Snow Queen'
5 *Chrysanthemum × morifolium*
 'Super Ping Pong'
 Chrysanth 'Super Ping Pong'

6 *Narcissus* 'Ice Follies'
 Narcissus 'Ice Follies'
7 *Vanda* 'Yano Blue'
 Vanda 'Yano Blue'
8 *Tulipa* 'White Marvel'
 Tulip 'White Marvel'
9 *Hyacinthus orientalis* 'Aiolos'
 Garden Hyacinth 'Aiolos'
10 *Phalaenopsis amabilis* Blume
 Moon Orchid

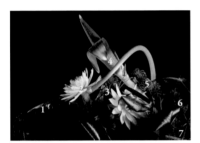

04 pp. 86–87

1 *Philodendron* 'Red Duchess'
 Philodendron 'Red Duchess'
2 *Nymphaea* 'Inner Light'
 Water Lily 'Inner Light'
3 *Gloriosa superba* 'Lutea'
 Flame Lily 'Lutea'
4 *Musa liukiuensis*
 (Matsumura) Makino
 Ito-basho

5 *Clematis* sp. (fruit)
 Clematis
6 *Juniperus chinensis* L. var.
 sargentii Henry
 Sargent Juniper
7 *Homalocephala texensis*
 Candy Cactus

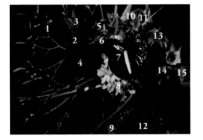

05 pp. 88–89

1 *Viscum album* L.
 European Mistletoe
2 *Cyrtosperma johnstonii*
 Arbi
3 *Zantedeschia aethiopica*
 'Hot Chocolate'
 Calla Lily 'Hot Chocolate'
4 *Dahlia* 'Black Butterfly'
 Dahlia 'Black Butterfly'
5 *Epidendrum chinnabarinum*
 Vermilion Epidendrum
6 *Vanda* 'Dark Blue'
 Vanda 'Dark Blue'
7 *Anthurium andreanum* 'Burgundy'
 Anthurium 'Burgundy'
8 *Epidendrum secundum*
 'Venus Piars'
 Star Orchid 'Venus Piars'
9 *Hyacinthus orientalis*
 'Ocean Blue'
 Garden Hyacinth 'Ocean Blue'

10 *Heliconia latispatha* (Starwiz)
 Expanded Lobster Claw
 Heliconia
11 *Masdevallia* 'Heathii'
 Masdevallia 'Heathii'
12 *Leucospermum cordifolium*
 'Gold Dust'
 Pincushion 'Gold Dust'
13 *Hipp trum × hybridum*
 'Nymph'
 Amaryllis 'Nymph'
14 *Spathodea campanulata*
 P. Beauv.
 African Tulip Tree
15 *Ranunculus asiaticus*
 'Côte Red'
 Persian Buttercup 'Côte Red'

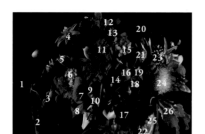

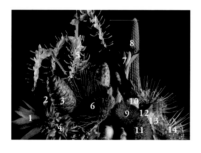

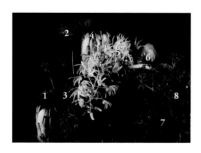

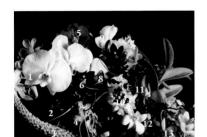

09 pp. 96–97

1 *Phalaenopsis amabilis Blume*
 Moon Orchid
2 *Colmanara Wildcat 'Bobcat'*
 Colmanara Orchid 'Bobcat'
3 *Orostachys japonica (Maxim.)*
 A. Berger
 Rock Pine
4 *Dendrobium phalaenopsis*
 'Lemon Green'
 Cooktown Orchid 'Lemon Green'
5 *Vanda 'Blue Magic'*
 Vanda 'Blue Magic'
6 *Zygopetalum Redvale*
 'Pretty Ann'
 Zygopetalum Orchid 'Pretty Ann'
7 *Brassia Eternal Wind*
 'Summer Dream'
 Brassia Orchid 'Summer Dream'

8 *Odontoglossum 'Red Lug'*
 Odontoglossum 'Red Lug'
9 *Paphiopedilum Meadow Sweet*
 'Purity'
 King of Orchids 'Purity'
10 *Epidendrum secundum*
 'White Star'
 Star Orchid 'White Star'
11 *Aranthera 'Anne Black'*
 Aranthera Orchid 'Anne Black'
12 *Dendrobium phalaenopsis*
 'Singapore White'
 Cooktown Orchid
 'Singapore White'
13 *Mokara 'Buffalo Orange'*
 Mokara Orchid 'Buffalo Orange'

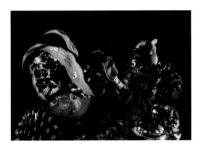

10 pp. 98–99

1 *Pandanus utilis Bory*
 Common Screwpine
2 *Punica granatum L.*
 Pomegranate
3 *Anthurium andreanum*
 'Maxima Verde'
 Anthurium 'Maxima Verde'

4 *Nepenthes tobaica Danser*
 Tropical Pitcher Plant
5 *Begonia × hiemalis 'Art Nouveau'*
 Elatior Begonia 'Art Nouveau'

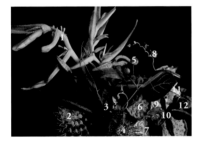

11 pp. 100–101

1 *Heliconia psittacorum ×*
 spathocircinata 'Golden Torch'
 Golden Torch Heliconia
2 *Echinocactus grusonii Hildm.*
 Barrel Cactus
3 *Nepenthes 'Rebecca Soper'*
 Tropical Pitcher Plant
 'Rebecca Soper'
4 *Leucospermum cordifolium*
 'Succession'
 Pincushion 'Succession'
5 *Pearcea hypocyrtiflora*
 (Hook. f.) Regel
 Pearcea
6 *Nelumbo nucifera Gaertn*
 Sacred Lotus

7 *Eustoma grandiflorum*
 'Mori no Shizuku'
 Bolero Deep Blue
 'Mori no Shizuku'
8 *Aristolochia baetica*
 Dutchman's Pipe
9 *Helianthus annuus*
 'Monet's Palette'
 Common Sunflower
 'Monet's Palette'
10 *Passiflora caerulea*
 'Constance Elliott'
 Passion Flower
 'Constance Elliott'
11 *Dianthus caryophyllus 'Pax'*
 Clove Pink 'Pax'
12 *Sdanum lycopercicun 'Coco'*
 Garden Tomato

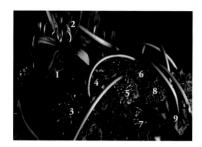

12 pp. 102–103

1 *Aeonium arboreum* 'Atropurpureum'
Purple Aeonium
2 *Doryanthes excelsa* Corrêa
Gymea Lily
3 *Chrysanthemum × morifolium* 'Pritirio'
Chrysanth 'Pritirio'
4 *Eustoma grandiflorum* 'Voyage Blue'
Bolero Deep Blue 'Voyage Blue'
5 *Dahlia* 'Jessie Rita'
Dahlia 'Jessie Rita'

6 *Dianthus caryophyllus*
'Nobbio Black Heart'
Clove Pink 'Nobbio Black Heart'
7 *Anthurium andreanum*
'Black Queen'
Anthurium 'Black Queen'
8 *Viburnum tinus* L.
Laurustinus
9 *Zantedeschia aethiopica*
'Schwarzwalder'
Calla Lily 'Schwarzwalder'

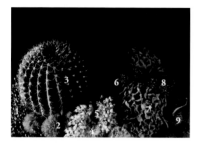

13 pp. 104–105

1 *Rosa multiflora* Thunb.
Multiflora Rose
2 *Dianthus barbatus* 'Green Trick'
Sweet William 'Green Trick'
3 *Soehrensia bruchii*
Soehrensia
4 *Dianthus caryophyllus* 'Prado Mint'
Clove Pink 'Prado Mint'
5 *Aechmea penduliflora* 'White Berry'
Aechmea 'White Berry'

6 *Chrysanthemum × morifolium*
'Pure Green'
Chrysanth 'Pure Green'
7 *Hydrangea macrophylla*
'Emerald Classic Green'
French Hydrangea
'Emerald Classic Green'
8 *Sparganium fallax*
Bur-Reed
9 *Cucumis anguria* L.
Hedgehog Gourd

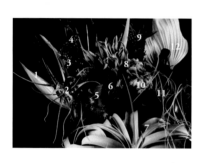

14 pp. 106–107

1 *Strelitzia augusta* Thunb.
Bird of Paradise
2 *Brassia* Eternal Wind
'Summer Dream'
Brassia Orchid 'Summer Dream'
3 *Nepenthes* 'Dyeriana'
Tropical Pitcher Plant 'Dyeriana'
4 *Ilex serrata* Thunb. ex Murray
Japanese Winterberry
5 *Odontoglossum* 'Red Lug'
Odontoglossum 'Red Lug'
6 *Rosa* 'Freedom'
Rose 'Freedom'
7 *Tillandsia xerographica* Rohweder
Shirley Temple Airplant

8 *Hippeastrum papilio* (Ravenna)
Van Scheepen
Butterfly Amaryllis
9 *Euphorbia bupleurifolia ×
susannae*
Euphorbia 'Gabitekkoumaru'
10 *Leontopodium alpinum* Cass.
Edelweiss
11 *Bessera elegans*
Coral Drops
12 *Tacca integrifolia* Ker Gawler
White Bat Flower

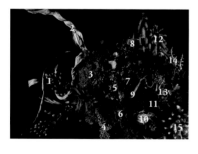

15 pp. 108–109

1 *Aechmea miniata* (Beer) hortus ex Baker
Aechmea
2 *Anthurium bakeri*
Bird's-Nest Anthurium
3 *Dianthus caryophyllus* 'Big City'
Clove Pink 'Big City'
4 *Skimmia japonica* 'Kew Green'
Japanese Skimmia 'Kew Green'
5 *Colmanara* Wildcat 'Bobcat'
Colmanara Orchid 'Bobcat'
6 *Dianthus caryophyllus* 'Dom Pedro'
Clove Pink 'Dom Pedro'
7 *Lycopodium squarrosum* G. Forst.
Lycopodium
8 *Guzmania* 'Luna'
Tufted Airplant 'Luna'

9 *Nepenthes alata* Blanco
Malaysian Pitcher Plant
10 *Hyacinthus orientalis* 'Blue Jacket'
Garden Hyacinth 'Blue Jacket'
11. *Rosa* 'Freedom'
Rose 'Freedom'
12 *Lachenalia aloides* var. *aurea*
Cape Cowslip
13 *Phalaenopsis* 'Taida Pearl'
Moon Orchid 'Taida Pearl'
14 *Lachenalia contaminata*
Angustifolia Cape Cowslip
15 *Dahlia* 'Lido'
Dahlia 'Lido'

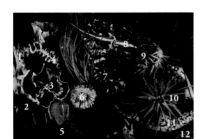

16 pp. 110–111

1 *Lachenalia viridiflora*
Turquoise Hyacinth/ Cape Cowslip
2 *Porphyrocoma lanceolata*
Scheidw. ex Hook.
Rose Pine
3 *Viola × wittrockiana*
'Moulin Frill Rouge'
Garden Pansy 'Moulin Frill Rouge'
4 *Lachenalia contaminata*
Angustifolia Cape Cowslip
5 *Dahlia* 'Black Butterfly'
Dahlia 'Black Butterfly'
6 *Papaver nudicaule* L.
Icelandic Poppy

7 *Rosa* 'Abracadabra'
Rose 'Abracadabra'
8 *Anthurium andreanum*
'Chocolate'
Anthurium 'Chocolate'
9 *Nymphaea* 'William McLane'
Water Lily 'William McLane'
10 *Tillandsia ionantha* 'Rosita'
Airplant 'Rosita'
11 *Aristolochia gigantea*
Mart. & Zucc.
Dutchman's Pipe
12 *Tillandsia tectorum* E. Morren
Roof Airplant

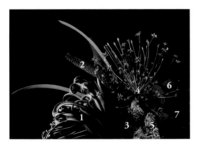

17 pp. 112–113

1 *Tillandsia duratii* Visiani
Airplant
2 *Arpophyllum giganteum* Hartw.
ex Lindl
Bottlebrush Orchid
3 *Dianthus caryophyllus*
'Nobbio Hard Rock'
Clove Pink 'Nobbio Hard Rock'

4 *Allium schubertii*
Ornamental Onion
5 *Muscari armeniacum* 'Blue Eyes'
Armenian Grape Hyacinth 'Blue Eyes'
6 *Vanda* 'Savita Blue'
Vanda 'Savita Blue'
7 *Eustoma grandiflorum*
'Voyage Blue'
Bolero Deep Blue 'Voyage Blue'

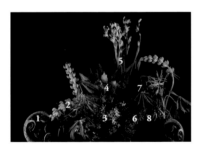

18 pp. 114–15

1 *Cyathea spinulosa* Wall. ex Hook.
Large Spiny Tree Fern
2 *Lupinus luteus* L.
Marsh Lupine
3 *Oncidium obrizatum*
Dancing-Lady Orchid
4 *Rhyncattleanthe* Love Passion
'Orange Bird'
Rhyncattleanthe Orchid
'Orange Bird'

5 *Sparaxis variegata*
Sparaxis
6 *Calendula officinalis*
'Orange Star'
Pot Marigold 'Orange Star'
7 *Dianthus caryophyllus* 'Araking'
Clove Pink 'Araking'
8 *Tulipa* 'Apricot Parrot'
Tulip 'Apricot Parrot'

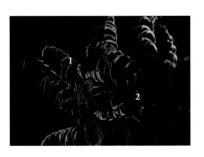

19 pp. 116–117

1 *Chasmanthe aethiopica* (L.)
N. E. Brown
African Cornflag
2 *Rosa* 'Rote Rose'
Rose 'Rote Rose'

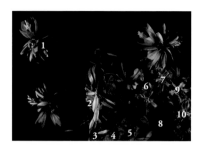

20 pp. 118–119

1 *Fritillaria imperialis* 'Rubra'
Crown Imperial Fritillary 'Rubra'
2 *Iris domestica* Goldblatt & Mabb.
Blackberry Lily
3 *Dianthus caryophyllus* 'Nobbio Black Heart'
Clove Pink 'Nobbio Black Heart'
4 *Bulbinella floribunda* 'Apricot'
Bulbinella 'Apricot'
5 *Ranunculus asiaticus* 'Lux Minoan'
Persian Buttercup 'Lux Minoan'

6 *Epidendrum secundum* 'Orange Ball'
Star Orchid 'Orange Ball'
7 *Lachenalia aloides* var. *quadricolor*
Cape Cowslip
8 *Dianthus caryophyllus* 'Deep Purple'
Clove Pink 'Deep Purple'
9 *Cryptanthus bivittatus*
Earth Star
10 *Leontochir ovallei*
Lion's Claw

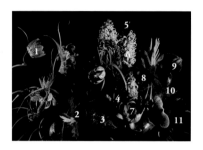

21 pp. 120–121

1 *Fritillaria meleagris* L.
Snake's Head Fritillary
2 *Watsonia marginata* (L. f.) Ker Gawl.
Fragrant Bugle Lily
3 *Epidendrum secundum* 'Violet Queen'
Star Orchid 'Violet Queen'
4 *Anthurium andreanum* 'Burgundy'
Anthurium 'Burgundy'
5 *Odontoglossum* 'Picasso Rubis'
Odontoglossum 'Picasso Rubis'
6 *Grevillea* 'Spiderman'
Grevillea Hybrid 'Spiderman'

7 *Ranunculus asiaticus* 'Pomerol'
Persian Buttercup 'Pomerol'
8 *Eustoma grandiflorum*
'Corsage Blue'
Bolero Deep Blue 'Corsage Blue'
9 *Paphiopedilum* 'Robin Hood'
King of Orchids 'Robin Hood'
10 *Rosa* 'Freedom'
Rose 'Freedom'
11 *Dahlia* 'Black Butterfly'
Dahlia 'Black Butterfly'

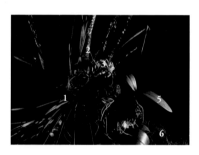

22 pp. 122–123

1 *Muscari aucheri* 'White Magic'
Common Grape Hyacinth
'White Magic'
2 *Billbergia* 'Hallelujah'
Billbergia 'Hallelujah'
3 *Epidendrum secundum*
'Snow Cocktail'
Star Orchid 'Snow Cocktail'

4 *Hyacinthus orientalis*
'City of Haarlem'
Garden Hyacinth
'City of Haarlem'
5 *Phalaenopsis amabilis* Blume
Moon Orchid
6 *Convallaria keiskei* L.
Lily of the Valley

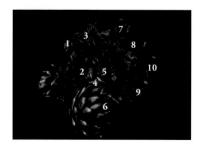

23 pp. 124–125

1 *Iris germanica* 'Dark Vader'
German Iris 'Dark Vader'
2 *Paeonia lactiflora* 'Red Grace'
Chinese Peony 'Red Grace'
3 *Racinaea crispa* (Baker) M. A.
Spencer & L. B. Smith
Racinaea
4 *Anthurium andreanum* 'Safari'
Anthurium 'Safari'
5 *Dianthus caryophyllus*
'Nobbio Black Heart'
Clove Pink 'Nobbio Black Heart'

6 *Cynara scolymus* 'Violetto'
Globe Artichoke 'Violetto'
7 *Zantedeschia aethiopica*
'Hot Chocolate'
Calla Lily 'Hot Chocolate'
8 *Helianthus annuus* 'Blood Red'
Common Sunflower 'Blood Red'
9 *Daucus carota* var. *sativus*
'Bordeaux'
Carrot 'Bordeaux'
10 *Dahlia* 'Kuroi inazuma'
Dahlia 'Kuroi Inazuma'

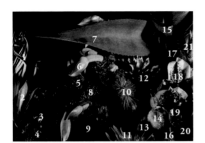

24 pp. 126–127

1 *Tillandsia duratii* Visiani
Airplant
2 *Medinilla magnifica* Lindl.
Malaysian Orchid
3 *Guzmania* 'Luna'
Tufted Airplant 'Luna'
4 *Daucus carota* var. *sativus* 'Black Night'
Carrot 'Black Night'
5 *Ranunculus asiaticus* 'Charlotte'
Persian Buttercup 'Charlotte'
6 *Hippeastrum* × *hybridum* 'Ambience'
Amaryllis 'Ambience'
7 *Agave americana* L.
Century Plant
8 *Chrysanthemum* × *morifolium* 'Tom Pearce'
Chrysanth 'Tom Pearce'
9 *Neoregelia* 'Fireball'
Neoregelia 'Fireball'
10 *Kniphofla uvaria* 'Flamenco'
Red Hot Poker 'Flamenco'
11 *Gerbera* 'Giant Spinner Izanami'
Daisy 'Giant Spinner Izanami'

12 *Dahlia* 'Lalala'
Dahlia 'Lalala'
13 *Tulipa* 'Rococo'
Tulip 'Rococo'
14 *Chrysanthemum* × *morifolium*
'Ping Pong Golden'
Chrysanth 'Ping Pong Golden'
15 *Heliconia stricta* 'Sharonii'
Dwarf Jamaica Heliconia 'Sharonii'
16 *Epidendrum secundum*
'Orange Ball'
Star Orchid 'Orange Ball'
17 *Tulipa* 'Barbatos'
Tulip 'Barbatos'
18 *Paphiopedilum* 'Satsuma Karajishi'
King of Orchids 'Satsuma Karajishi'
19 *Cymbidium tracyanum*
Tracy's Cymbidium
20 *Dianthus caryophyllus* 'Bellmouth'
Clove Pink 'Bellmouth'
21 *Bulbinella floribunda* 'Yellow Giant'
Bulbinella 'Yellow Giant'

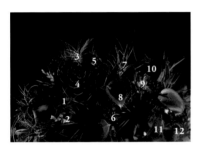

25 pp. 128–129

1 *Tillandsia filifolia*
Threadleaf Airplant
2 *Ixia* 'Castor'
African Corn Lily 'Castor'
3 *Tillandsia fuchsii* W. Till
Airplant
4 *Echeveria affinis* 'Black Knight'
Echeveria 'Black Knight'
5 *Medinilla magnifica* Lindl.
Malaysian Orchid
6 *Sedum rubrotinctum*
Jelly Bean Plant
7 *Tillandsia stricta* Solander
Airplant

8 *Zantedeschia aethiopica*
'Hot Cherry'
Calla Lily 'Hot Cherry'
9 *Dianthus caryophyllus* 'Agnese'
Clove Pink 'Agnese'
10 *Vanda* 'Robert Delight'
Vanda 'Robert Delight'
11 *Mokara* 'Calypso'
Mokara Orchid 'Calypso'
12 *Lathyrus odoratus* 'Matilda'
Sweet Pea 'Matilda'

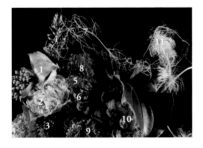

26 pp. 130–131

1 *Medinilla magnifica* Lindl.
Malaysian Orchid
2 *Paeonia lactiflora* 'Fuji'
Chinese Peony 'Fuji'
3 *Dianthus barbatus* 'Green Trick'
Sweet William 'Green Trick'
4 *Aechmea* 'Del Mar'
Living Vase
5 *Dianthus caryophyllus* 'Nora'
Clove Pink 'Nora'
6 *Tagetes patula* 'Harlequin'
French Marigold 'Harlequin'

7 *Bowiea volubilis*
Harv. & Hook. f. Harvey
Climbing Onion
8 *Dahlia* 'Micchan'
Dahlia 'Micchan'
9 *Gerbera* 'Bokito'
Daisy 'Bokito'
10 *Disa artiste* (Watsonii × Riette)
Disa Orchid
11 *Clematis* sp. (fruit)
Clematis

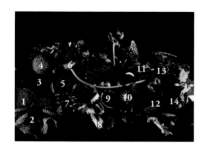

27 pp. 132–133

1 *Dianthus caryophyllus* 'Master'
Clove Pink 'Master'
2 *Begonia masoniana* 'Iron Cross'
Begonia 'Iron Cross'
3 *Dahlia* 'Black Butterfly'
Dahlia 'Black Butterfly'
4 *Dolichothele camptotricha*
Bird's-Nest Cactus
5 *Paeonia lactiflora* 'Red Grace'
Chinese Peony 'Red Grace'
6 *Anthurium andreanum* 'Tera'
Anthurium 'Tera'
7 *Racinaea crispa* (Baker) M. A.
Spencer & L. B. Smith
Racinaea

8 *Tulipa* 'Flaming Parrot'
Tulip 'Flaming Parrot'
9 *Zantedeschia aethiopica*
'Hot Chocolate'
Calla Lily 'Hot Chocolate'
10 *Guzmania* 'Torch'
Tufted Airplant 'Torch'
11 *Anthurium andreanum* 'Burgundy'
Anthurium 'Burgundy'
12 *Vriesea carinata* 'Christiane'
Vriesea 'Christiane'
13 *Begonia × hiemalis* 'Art Deco'
Elatior Begonia 'Art Deco'
14 *Rosa* 'Red Intuition'
Rose 'Red Intuition'

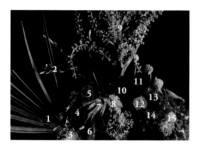

28 pp. 134–135

1 *Bismarckia nobilis*
Hildebrandt & H. Wendl.
Bismarck Palm
2 *Vriesea* 'Purple Pendant'
Vriesea 'Purple Pendant'
3 *Leucospermum cordifolium*
'High Gold'
Pincushion 'High Gold'
4 *Dianthus caryophyllus* 'Master'
Japanese Skimmia 'Rubella'
5 *Skimmia japonica* 'Rubella'
Clove Pink 'Master'
6 *Anthurium andreanum* 'Elan'
Anthurium 'Elan'
7 *Cyrtanthus herrei*
(F. M. Leight.) R. A. Dyer
Firecracker Flower
8 *Tagetes erecta* 'Orange Isis'
African Marigold 'Orange Isis'

9 *Arenga engleri*
Formosa Palm
10 *Eustoma grandiflorum*
'Voyage Blue'
Bolero Deep Blue 'Voyage Blue'
11 *Papaver orientale*
Oriental Poppy
12 *Phlomis fruticosa* 'Green Star'
Jerusalem Sage
13 *Epidendrum secundum* 'Fireball'
Star Orchid 'Fireball'
14 *Dianthus caryophyllus*
'Tiepolo Fucsia'
Clove Pink 'Tiepolo Fucsia'
15 *Dahlia* 'Tsukimisou'
Dahlia 'Tsukimisou'

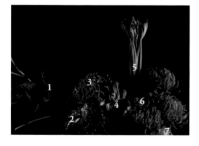

29 pp. 136–137

1 *Heliconia bihai* 'Lobster Claw Tree'
Bastard Plantain
'Lobster Claw Tree'
2 *Anthurium andreanum* 'Sirion'
Anthurium 'Sirion'
3 *Dahlia* 'Jane'
Dahlia 'Jane'
4 *Tulipa* 'Huis Ten Bosch'
Tulip 'Huis Ten Bosch'

5 *Nerine bowdenii* 'Ras van Roon'
Cape Flower 'Ras van Roon'
6 *Ranunculus asiaticus* 'Rennes'
Persian Buttercup 'Rennes'
7 *Epidendrum secundum* 'Sakura'
Star Orchid 'Sakura'

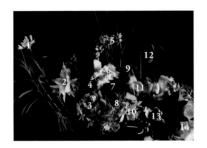

30 pp. 138–139

1 *Neobenthamia gracilis*
 Graceful Neobenthamia
2 *Cattleya lueddemanniana*
 Fairyland 'Sara'
 Cattleya Orchid 'Sara'
3 *Epidendrum secundum*
 'Pink Chandelier'
 Star Orchid 'Pink Chandelier'
4 *Wilsonara* Blazing Lustre
 'Night Ruby'
 Wilsonara 'Night Ruby'
5 *Onixotis stricta* (Burm. f.) Wijnands
 Rice Flower
6 *Osmoglossum pulchellum*
 Lily of the Valley Orchid
7 *Dahlia* 'Black Butterfly'
 Dahlia 'Black Butterfly'

8 *Brassica* 'Orange Delight'
 Brassica Orchid 'Orange Delight'
9 *Phragmipedium*
 'Elizabeth March'
 Phragmipedium Orchid
 'Elizabeth March'
10 *Papilionanthe teres* (Roxb.)
 Schltr.
 Terete Leaf Papilionanthe
11 *Lycaste* 'Yellow Submarine'
 Lycaste Orchid
 'Yellow Submarine'
12 *Masdevallia coccinea*
 Masdevallia
13 *Phalaenopsis* 'Taida Pearl'
 Moon Orchid 'Taida Pearl'
14 *Paphiopedilum delenatii*
 King of Orchids

31 pp. 140–141

1 *Dahlia* 'Agitato'
 Dahlia 'Agitato'
2 *Hippeastrum* × *hybridum*
 'Red Lion'
 Amaryllis 'Red Lion'
3 *Tulipa* 'Rococo'
 Tulip 'Rococo'

4 *Rosa* 'Freedom'
 Rose 'Freedom'
5 *Dianthus caryophyllus*
 'Dom Pedro'
 Clove Pink 'Dom Pedro'

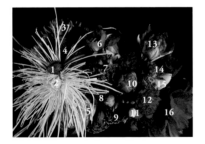

32 pp. 142–143

1 *Papaver nudicaule* L.
 Icelandic Poppy
2 *Chrysanthemum* × *morifolium*
 'Ito-hachi'
 Chrysanth 'Ito-hachi'
3 *Chrysanthemum* × *morifolium*
 'Green Shamrock'
 Chrysanth 'Green Shamrock'
4 *Dahlia* 'Red Star'
 Dahlia 'Red Star'
5 *Paeonia lactiflora* 'Fuji'
 Chinese Peony 'Fuji'
6 *Iris* × *hollandica* 'Blue Magic'
 Dutch Iris 'Blue Magic'
7 *Hyacinthus orientalis* 'Delft Blue'
 Garden Hyacinth 'Delft Blue'
8 *Rosa* 'Rote Rose'
 Rose 'Rote Rose'

9 *Dianthus caryophyllus*
 'Nobbio Burgundy'
 Clove Pink 'Nobbio Burgundy'
10 *Tulipa* 'Orange Princess'
 Tulip 'Orange Princess'
11 *Freesia refracta* 'Aladdin'
 Freesia 'Aladdin'
12 *Dianthus caryophyllus*
 'Francisco'
 Clove Pink 'Francisco'
13 *Tulipa* 'Flash Point'
 Tulip 'Flash Point'
14 *Rosa* 'Exciting Meilland'
 Rose 'Exciting Meilland'
15 *Tulipa* 'Yellow King'
 Tulip 'Yellow King'
16 *Dahlia* 'Zessho'
 Dahlia 'Zessho'

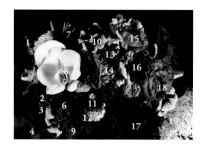

33 pp. 144–145

1 *Anthurium andreanum* 'Jewel'
Anthurium 'Jewel'
2 *Dianthus caryophyllus*
'Nobbio Violet'
Clove Pink 'Nobbio Violet'
3 *Gerbera* 'Madness'
Daisy 'Madness'
4 *Hippeastrum × hybridum*
'Red Lion'
Amaryllis 'Red Lion'
5 *Dianthus caryophyllus* 'Kiro'
Clove Pink 'Kiro'
6 *Dianthus barbatus*
'Baron Breanthus'
Sweet William 'Baron Breanthus'
7 *Alstroemeria* 'Rouge Prista'
Peruvian Lily 'Rouge Prista'
8 *Phalaenopsis* 'Victory White'
Moon Orchid 'Victory White'
9 *Rosa* 'Freedom'
Rose 'Freedom'
10 *Viola × wittrockiana*
'Moulin Frill Rouge'
Garden Pansy 'Moulin Frill Rouge'

11 *Viola × wittrockiana*
'Frizzle Sizzle Blue'
Garden Pansy 'Frizzle Sizzle Blue'
12 *Cyclamen persicum*
'Prima Donna Gold'
Persian Violet /
Primrose 'Prima Donna Gold'
13 *Scabiosa atropurpurea*
'Andalucía'
Mourning Bride 'Andalucía'
14 *Ranunculus asiaticus* 'Fréjus'
Persian Buttercup 'Fréjus'
15 *Ranunculus asiaticus* 'Charlotte'
Persian Buttercup 'Charlotte'
16 *Dianthus caryophyllus* 'Nelson'
Clove Pink 'Nelson'
17 *Dahlia* 'Black Butterfly'
Dahlia 'Black Butterfly'
18 *Eustoma grandiflorum*
'Voyage Blue'
Bolero Deep Blue 'Voyage Blue'
19 *Brassica oleracea* L. var.
acephala DC. f. *tricolor* Hort
Kale

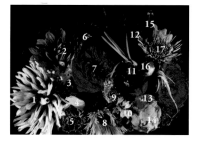

34 pp. 146–147

1 *Dahlia* 'Enbu'
Dahlia 'Enbu'
2 *Dahlia* 'Matador'
Dahlia 'Matador'
3 *Eustoma grandiflorum*
'Corsage Blue'
Bolero Deep Blue 'Corsage Blue'
4 *Iris × hollandica* 'Golden Beauty'
Dutch Iris 'Golden Beauty'
5 *Dianthus caryophyllus*
'Nobbio Burgundy'
Clove Pink 'Nobbio Burgundy'
6 *Gerbera* 'Pink Snow'
Daisy 'Pink Snow'
7 *Rosa* 'Pink Piano'
Rose 'Pink Piano'
8 *Gerbera* 'Tomahawk'
Daisy 'Tomahawk'
9 *Scabiosa atropurpurea*
'Andalucía'
Mourning Bride 'Andalucía'

10 *Delphinium grandiflorum*
'Grand Blue'
Siberian Larkspur 'Grand Blue'
11 *Cyclamen persicum*
'Royal Moon Dress'
Persian Violet /
Primrose 'Royal Moon Dress'
12 *Dahlia* 'Hama Suiren'
Dahlia 'Hama Suiren'
13 *Barkeria skinneri*
Skinner's Barkeria
14 *Paeonia lactiflora*
'Koto no Hikari'
Chinese Peony 'Koto no Hikari'
15 *Lilium maculatum*
'Dimension'
Mahogany Lily 'Dimension'
16 *Muscari aucheri* 'Blue Magic'
Common Grape Hyacinth
'Blue Magic'
17 *Chrysanthemum × morifolium*
'Annecy Orange'
Chrysanth 'Annecy Orange'

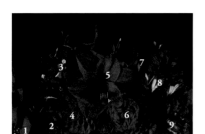

35 pp. 148–149

1 *Euphorbia pulcherrima* 'Premium Red'
Poinsettia 'Premium Red'
2 *Dianthus caryophyllus* 'Dom Pedro'
Clove Pink 'Dom Pedro'
3 *Burrageara* 'Living Fire'
Burrageara Orchid 'Living Fire'
4 *Dahlia* 'Nekkyuu'
Dahlia 'Nekkyuu'
5 *Hippeastrum × hybridum* 'Red Lion'
Amaryllis 'Red Lion'

6 *Rosa* 'Piano'
Rose 'Piano'
7 *Anemone coronaria* 'Mona Lisa Scarlet'
Poppy Anemone / Spanish Marigold 'Mona Lisa Scarlet'
8 *Alstroemeria* 'Rouge Prista'
Peruvian Lily 'Rouge Prista'
9 *Tulipa* 'Rococo'
Tulip 'Rococo'

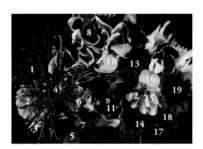

36 pp. 150–151

1 *Dahlia* 'Agitato'
Dahlia 'Agitato'
2 *Dahlia* 'Blue Peach'
Dahlia 'Blue Peach'
3 *Eustoma grandiflorum* 'Kikoushi'
Bolero Deep Blue 'Kikoushi'
4 *Chrysanthemum × morifolium* 'Ito-kagaribi'
Chrysanth 'Ito-kagaribi'
5 *Euphorbia pulcherrima* 'Novia'
Poinsettia 'Novia'
6 *Dianthus caryophyllus* 'Bellissimo'
Clove Pink 'Bellissimo'
7 *Hippeastrum × hybridum* 'Red Lion'
Amaryllis 'Red Lion'
8 *Hydrangea macrophylla* 'Tivoli Blue'
French Hydrangea 'Tivoli Blue'
9 *Chrysanthemum × morifolium* 'Seichiro'
Chrysanth 'Seichiro'
10 *Tulipa* 'Hamilton'
Tulip 'Hamilton'

11 *Viola × wittrockiana* 'Oluki Blue Shade'
Garden Pansy 'Oluki Blue Shade'
12 *Ornithogalum* 'Mt. Fuji'
Star of Bethlehem 'Mt. Fuji'
13 *Ranunculus asiaticus* 'Morocco'
Persian Buttercup 'Morocco'
14 *Dianthus caryophyllus* 'Dom Pedro'
Clove Pink 'Dom Pedro'
15 *Dahlia* 'Peach in Season'
Dahlia 'Peach in Season'
16 *Iris × hollandica* 'Apollo'
Dutch Iris 'Apollo'
17 *Lilium maculatum* 'Dimension'
Mahogany Lily 'Dimension'
18 *Chrysanthemum × morifolium* 'Pantheon'
Chrysanth 'Pantheon'
19 *Gerbera* 'Voldemort'
Daisy 'Voldemort'

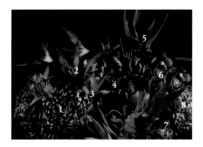

37 pp. 152–153

1 *Chrysanthemum × morifolium* 'Fuego'
Chrysanth 'Fuego'
2 *Guzmania* 'Orangeade'
Tufted Airplant 'Orangeade'
3 *Lycoris aurea* (L'Hér.) Herb.
Golden Spider Lily
4 *Celosia argentea* var. *cristata* 'Brown Beauty'
Silver Cockscomb 'Brown Beauty'
5 *Strelitzia reginae* 'Orange Prince'
Orange Bird of Paradise 'Orange Prince'

6 *Cymbidium* Enzan Forest 'Majolica'
Boat Orchid 'Majolica'
7 *Clematis addisonii* 'King'
Addison's Leather Flower 'King'
8 *Chrysanthemum × morifolium* 'Classic Cocoa'
Chrysanth 'Classic Cocoa'

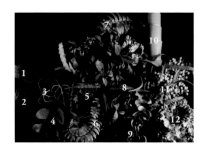

38 pp. 154–155

1 *Albizia julibrissin* Durazz.
Silk Tree

2 *Asplenium* 'Dragon'
Dragon Tail Fern

3 *Anthurium crystallium* Lind. & Andr
Anthurium

4 *Cryptocereus anthonyanu*
Ric Rac Cactus

5 *Dianthus barbatus* 'Green Trick'
Sweet William 'Green Trick'

6 *Nephrolepis auriculata* 'Cristata'
Sword Fern 'Cristata'

7 *Psychotria serpens* L.
Creeping Psychotria

8 *Aloe arborescens* Mill.
Candelabra Aloe

9 *Asplenium nidus* 'Emerald Wave'
Hawaii Bird's-Nest Fern
'Emerald Wave'

10 *Mascarena verschaffeltii* L. H.
Bailey
Bottle Palm

11 *Ligustrum japonicum*
Japanese Privet

12 *Euphorbia lactea* var. *variegata*
'White Ghost'
White Ghost

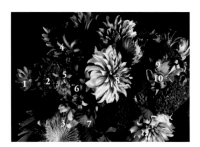

39 pp. 156–157

1 *Alpinia purpurata*
Red Ginger 'Pink Ginger'

2 *Celosia argentea* var. *cristata*
'Rose Beauty'
Crested Cockscomb 'Rose Beauty'

3 *Protea cynaroides*
King Protea

4 *Nerine sarniensis* 'Rose Princess'
Guernsey Lily 'Rose Princess'

5 *Leucocoryne* 'Caravelle'
Glory of the Sun

6 *Chrysanthemum* × *morifolium*
'Sienna'
Chrysanth 'Sienna'

7 *Tillandsia cyanea*
Airplant

8 *Dahlia* 'Lalala'
Dahlia 'Lalala'

9 *Serruria florida* (Thunb.) Knight
Blushing Bride

10 *Anemone coronaria* 'Mona Lisa
Lavender Shade'
Poppy Anemone /
Spanish Marigold 'Mona Lisa
Lavender Shade'

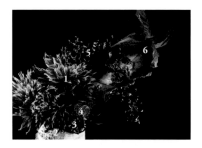

40 pp. 158–159

1 *Dahlia* 'Mallorca'
Dahlia 'Mallorca'

2 *Betula platyphylla* var. *japonica*
(Miq.) H. Hara
Asian White Birch

3 *Anthurium andreanum*
'Burgundy'
Anthurium 'Burgundy'

4 *Clematis* sp. (fruit)
Clematis

5 *Colmanara* Wildcat 'Bobcat'
Colmanara Orchid 'Bobcat'

6 *Platycerium bifurcatum*
(Cav.) C. Chr.
Common Staghorn Fern

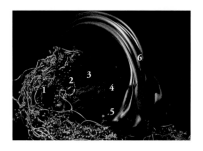

41 pp. 160–161

1 *Paederia scandens* (Lour.) Merr.
var. *mairei* (Lev.) Hara.
Skunk Vine

2 *Arisaema urashima* Hara
Urashimasou

3 *Dahlia* 'Jessie Rita'
Dahlia 'Jessie Rita'

4 *Rosa* 'Black Baccara'
Rose 'Black Baccara'

5 *Nelumbo nucifera* Gaertn
Sacred Lotus

6 *Zantedeschia aethiopica*
'Hot Chocolate'
Calla Lily 'Hot Chocolate'

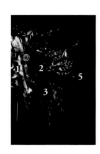

42 p. 163

1 *Protea neriifolia* 'White Mink'
 Oleanderleaf protea
 'White Mink'
2 *Osmunda japonica* Thunb.
 Japanese Royal Fern
3 *Vuylstekeara cambria* 'Plush'
 Vuylstekeara 'Plush'
4 *Colmanara* Wildcat 'Bobcat'
 Colmanara Orchid 'Bobcat'
5 *Anthurium andreanum*
 'Black Queen'
 Anthurium 'Burgundy'

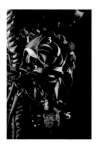

43 p. 165

1 *Asplenium nidus*
 'Emerald Wave'
 Hawaii Bird's-Nest Fern
 'Emerald Wave'
2 *Tillandsia stricta* Solander
 Airplant
3 *Lilium longiflorum* 'Hinomoto'
 Easter Lily 'Hinomoto'
4 *Tillandsia xerographica*
 Rohweder
 Shirley Temple Airplant
5 *Pandanus utilis* Bory
 Common Screwpine

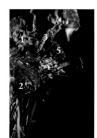

44 p. 167

1 *Epidendrum secundum* 'Sakura'
 Star Orchid 'Sakura'
2 *Ranunculus asiaticus*
 'Rainette Green'
 Persian Buttercup
 'Rainette Green'
3 *Veronica longifolia*
 'Smart Alien'
 Longleaf Speedwell
 'Smart Alien'
4 *Onixotis stricta* (Burm. f.)
 Wijnands
 Rice Flower
5 *Dianthus caryophyllus*
 'Nobbio Violet'
 Clove Pink 'Nobbio Violet'

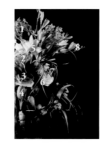

45 p. 169

1 *Epidendrum secundum*
 'Star Valley'
 Star Orchid 'Star Valley'
2 *Gerbera* 'Titi'
 Daisy 'Titi'
3 *Narcissus*
 'Yellow Cheerfulness'
 Narcissus
 'Yellow Cheerfulness'
4 *Tulipa batalinii* 'Bright Gem'
 Miscellaneous Tulip
 'Bright Gem'
5 *Cattleya lueddemanniana*
 Fairyland 'Sara'
 Cattleya Orchid 'Sara'
6 *Ranunculus asiaticus* 'M-Gold'
 Persian Buttercup 'M-Gold'
7 *Fritillaria meleagris* L.
 Snake's Head Fritillary
8 *Iris domestica* Goldblatt &
 Mabb.
 Blackberry Lily

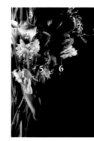

46 p. 171

1 *Tulipa* 'Super Parrot'
 Tulip 'Super Parrot'
2 *Zantedeschia aethiopica*
 'Green Goddess'
 Calla Lily 'Green Goddess'
3 *Gladiolus* 'Sophie'
 Gladiolus 'Sophie'
4 *Epidendrum secundum*
 'White Star'
 Star Orchid 'White Star'
5 *Chrysanthemum* × *morifolium*
 'Popeye'
 Chrysanth 'Popeye'
6 *Passiflora caerulea* 'Clear Sky'
 Passion Flower 'Clear Sky'
7 *Albuca nelsonii*
 Nelson's Slime Lily

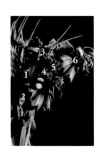

47 p. 173

1 *Jatropha podagrica* Hook.
 Buddha Belly Plant
2 *Anthurium* 'Jungle Bush'
 Anthurium 'Jungle Bush'
3 *Cryptanthus bivittatus*
 Earth Star
4 *Ranunculus asiaticus*
 'Lux Minoan'
 Persian Buttercup 'Lux Minoan'
5 *Lachenalia aloides* var.
 quadricolor
 Cape Cowslip
6 *Fritillaria imperialis* 'Rubra'
 Crown Imperial Fritillary 'Rubra'

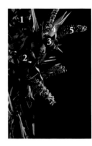

48 p. 175

1 *Cymbidium* Kiwi Midnight
 'Geyserland'
 Boat Orchid 'Geyserland'
2 *Rosa* 'Freedom'
 Rose 'Freedom'
3 *Phragmipedium* 'Andean Fire'
 Phragmipedium Orchid
 'Andean Fire'
4 *Heliconia caribaea* Lam.
 Wild Plantain
5 *Grevillea* 'Robyn Gordon'
 Red Silky Oak

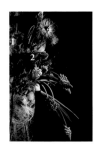

49 p. 177

1 *Lupinus angustifolius*
 Marsh Lupine
2 *Paphiopedilum callosum*
 (Rchb. f.) Stein
 King of Orchids
3 *Muscari aucheri* 'Blue Magic'
 Common Grape Hyacinth
 'Blue Magic'
4 *Nigella damascena* 'Persian
 Jewels, Blue'
 Devil in the Bush 'Persian
 Jewels, Blue'

Index of Flowers by Image | COEXISTENCE

Tokyo, April 2009–March 2012

01 pp. 180–181
—
1 *Chrysanthemum × morifolium*
 'Classic Curly'
 Chrysanth 'Classic Curly'
2 *Anthurium chamberlainianum*
 Anthurium 'Rom's Red'

02 pp. 182–183
—
1 *Trifolium repens* 'Tint Veil'
 White Clover 'Tint Veil'
2 *Asplenium nidus* 'Emerald Wave'
 Hawaii Bird's-Nest Fern
 'Emerald Wave'

03 pp. 184–185
—
1 *Pinus* 'Hakuju'
 Pine 'Hakuju'
2 *Echinocactus grusonii* Hildm.
 Barrel Cactus

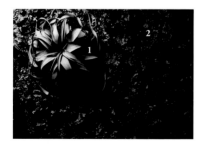

04 pp. 186–187
—
1 *Tillandsia xerographica* Rohweder
 Shirley Temple Airplant
2 *Parmotrema tinctorum*
 (Delise ex Nyl.) Hale
 Umenokigoke

05 pp. 188–189

1 *Pinus parviflora* Sieb. & Zucc.
 Japanese White Pine
2 *Convallaria keiskei* L.
 Lily of the Valley

06 pp. 190–191

1 *Uebelmannia pectinifera* Buining
 Uebelmannia
2 *Leucobryum juniperoideum* (Brid.)
 Muell. Hal
 Smaller White-Moss

07 pp. 192–193

1 *Astrophytum capricorne* var.
 crassispinum f. *majus*
 Astrophytum
2 *Ilex crenata* Thunb. f. *bullata*
 Rehder
 Japanese Holly

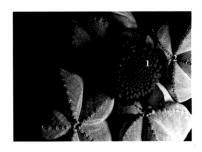

08 pp. 194–195

1 *Telopea speciosissima* (Sm.) R. Br.
 Waratah
2 *Astrophytum myriostigma* Lem.
 Bishop's Cap

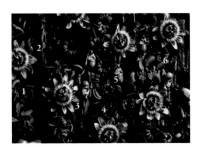

09 pp. 196–197

1 *Dionaea muscipula* Sol. ex J. Ellis
 Venus Flytrap
2 *Nepenthes* 'Dyeriana'
 Tropical Pitcher Plant 'Dyeriana'
3 *Passiflora caerulea* 'Clear Sky'
 Passion Flower 'Clear Sky'
4 *Rubus fruticosus* 'Summer Green'
 Bramble 'Summer Green'

5 *Phragmipedium caricinum*
 (Lindl. & Paxton) Rolfe
 Phragmipedium Orchid
 (caricinum)
6 *Coptis japonica* var. *dissecta*
 Cutleaf Japanese Coptis

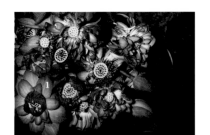

10 pp. 198–199

1 *Nelumbo nucifera* 'Shokkouren'
 Sacred Lotus 'Shokkouren'

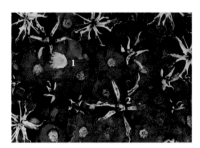

11 pp. 200–201

1 *Camellia japonica* L.
 Japanese Camellia
2 *Gloriosa superba* 'Misato Red'
 Flame Lily 'Misato Red'

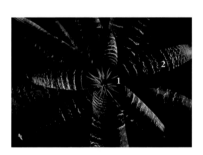

12 pp. 202–203

1 *Tillandsia ionantha* 'Rosita'
 Airplant 'Rosita'
2 *Vriesea forsteriana* 'Red Chestnut'
 Vriesea 'Red Chestnut'

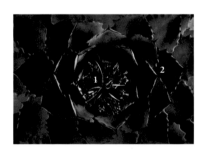

13 pp. 204–205

1 *Racinaea crispa* (Baker) M. A.
 Spencer & L. B. Smith
 Racinaea
2 *Agave isthmensis*
 Dwarf Butterfly Agave

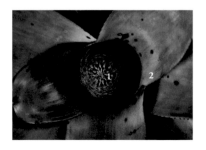

14 pp. 206–207

1 *Dolichothele camptotricha*
 Bird's-Nest Cactus
2 *Neoregelia* 'Voodoo Doll'
 Neoregelia 'Voodoo Doll'

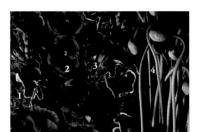

15 pp. 208–209

1 *Eustoma grandiflorum* 'Voyage Blue'
 Bolero Deep Blue 'Voyage Blue'
2 *Viola × wittrockiana* 'Oluki Blue Shade'
 Garden Pansy 'Oluki Blue Shade'
3 *Hyacinthus orientalis* 'Blue Jacket'
 Garden Hyacinth 'Blue Jacket'
4 *Papaver undicaule* L.
 Icelandic Poppy

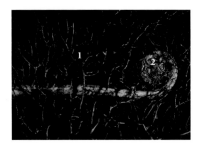

16 pp. 210–211

1 *Codium fragile* (Suringar) Hariot
 Codium
2 *Cyathea spinulosa* Wall. ex Hook.
 Large Spiny Tree Fern

Index of Flowers by Image | HYBRID

Tokyo, April 2009–March 2012

01 p. 215

1 *Tulipa turkestanica*
Turkestan Tulip
2 *Cyathea spinulosa*
Wall. ex Hook.
Large Spiny Tree Fern

05 p. 223

1 *Osmunda japonica* Thunb.
Japanese Royal Fern
2 *Iris × hollandica* 'Blue Magic'
Dutch Iris 'Blue Magic'
3 *Lachenalia mutabilis*
Mutabilis Cape Cowslip

02 p. 217

1 *Paphiopedilum* Swing Boot
'Hanakage'
King of Orchids 'Hanakage'
2 *Zantedeschia aethiopica*
'Hot Chocolate'
Calla Lily 'Hot Chocolate'

06 p. 225

1 *Anthurium andreanum*
'Burgundy'
Anthurium 'Burgundy'
2 *Gerbera* 'Magic Ball'
Daisy 'Magic Ball'
3 *Bulbinella floribunda* 'Apricot'
Bulbinella 'Apricot'
4 *Anthurium andreanum*
'Maxima Verde'
Anthurium 'Maxima Verde'

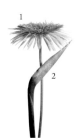

03 p. 219

1 *Gerbera* 'Giant Spinner
Toyotama'
Daisy 'Giant Spinner
Toyotama'
2 *Strelitzia reginae*
'Orange Prince'
Orange Bird of Paradise
'Orange Prince'

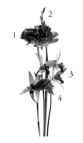

07 p. 227

1 *Ranunculus asiaticus* 'Charlotte'
Persian Buttercup 'Charlotte'
2 *Ixia* 'Castor'
African Corn Lily 'Castor'
3 *Cattleya* Santa Barbara 'Sunset'
Cattleya Orchid 'Sunset'
4 *Cyclamen persicum* 'Wedding Dress'
Persian Violet /
Primrose 'Wedding Dress'

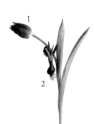

04 p. 221

1 *Tulipa* 'Barbatos'
Tulip 'Barbatos'
2 *Tulipa humilis* var. *pulchella*
f. *plena* 'Tête-à-Tête'
Tulip 'Tête-à-Tête'

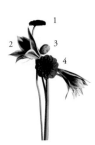

08 p. 229

1 *Anthurium andreanum* 'Black Queen'
Anthurium 'Black Queen'
2 *Hippeastrum papilio* (Ravenna)
Van Scheepen
Butterfly Amaryllis
3 *Papaver nudicaule* L.
Icelandic Poppy
4 *Dahlia* 'Red Star'
Dahlia 'Red Star'

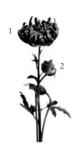

09 p. 231

1 *Chrysanthemum* × *morifolium*
 'Fuego'
 Chrysanth 'Fuego'
2 *Papaver nudicaule* L.
 Icelandic Poppy

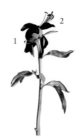

14 p. 241

1 *Paeonia lactiflora* 'Red Grace'
 Chinese Peony 'Red Grace'
2 *Lilium maculatum* 'Dimension'
 Mahogany Lily 'Dimension'

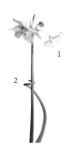

10 p. 233

1 *Eucharis grandiflora*
 Amazon Lily
2 *Tillandsia duratii* Visiani
 Airplant

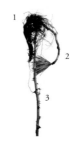

15 p. 243

1 *Juniperus chinensis* L. var.
 sargentii Henry
 Sargent Juniper
2 *Pinus thunbergii* Parl.
 Japanese Black Pine
3 *Rosa* 'Rote Rose'
 Rose 'Rote Rose'

11 p. 235

1 *Iris* × *hollandica* 'Apollo'
 Dutch Iris 'Apollo'
2 *Narcissus* 'Glenfarclas'
 Narcissus 'Glenfarclas'
3 *Vriesea simplex* 'Gigantea'
 Vriesea 'Gigantea'

16 p. 245

1 *Tillandsia butzii* Mez.
 Butzii Airplant
2 *Musa liukiuensis*
 (Matsumura) Makino
 Ito-basho

12 p. 237

1 *Anthurium andreanum*
 'Shibori'
 Anthurium 'Shibori'
2 *Cymbidium iridioides* D. Don.
 Cymbidium
3 *Gerbera* 'Cadillac'
 Daisy 'Cadillac'

17 p. 247

1 *Gerbera* 'Tomahawk'
 Daisy 'Tomahawk'
2 *Spathodea campanulata*
 P. Beauv.
 African Tulip Tree

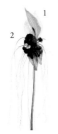

13 p. 239

1 *Tacca integrifolia*
 Ker Gawler
 White Bat Flower
2 *Rosa* 'Freedom'
 Rose 'Freedom'

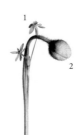

18 p. 249

1 *Narcissus* 'Autumn Jewel'
 Narcissus 'Autumn Jewel'
2 *Papaver nudicaule* L.
 Icelandic Poppy

19	p. 251

1 *Chrysanthemum* × *morifolium*
 'Ito-hachi'
 Chrysanth 'Ito-hachi'
2 *Heliconia humilis* Jacq.
 Lobster Claw Heliconia

24	p. 261

1 *Hippeastrum calyptrata*
 Green-Flowered Amaryllis
2 *Papaver nudicaule* L.
 Icelandic Poppy

20	p. 253

1 *Nerine bowdenii*
 'Ras van Roon'
 Cape Flower 'Ras van Roon'
2 *Gerbera* 'Rembrandt'
 Daisy 'Rembrandt'
3 *Paphiopedilum spicerianum*
 Spicer's Paphiopedilum
4 *Dahlia* 'Jessie Rita'
 Dahlia 'Jessie Rita'

25	p. 263

1 *Cattleya* Bonanza 'Cornucopia'
 Cattleya Orchid 'Cornucopia'
2 *Musa velutina*
 Hairy Banana

21	p. 255

1 *Galinsoga quadriradiata*
 Ruiz & Pav.
 Fringed Quickweed
2 *Tulipa* 'Super Parrot'
 Tulip 'Super Parrot'

26	p. 265

1 *Aloe ciliaris* Haw. var. *ciliaris*
 Common Climbing Aloe
2 *Chrysanthemum* × *morifolium*
 'Anastasia Green'
 Chrysanth 'Anastasia Green'

22	p. 257

1 *Zantedeschia aethiopica*
 'Crystal Blush'
 Calla Lily 'Crystal Blush'
2 *Encephalartos horridus*
 (Jacq.) Lehm.
 Eastern Cape Blue Cycad

27	p. 267

1 *Aechmea fasciata* (Lindley)
 Baker
 Silver Vase Plant / Urn Plant
2 *Hyacinthus orientalis* 'Carnegie'
 Garden Hyacinth 'Carnegie'

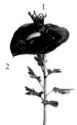

23	p. 259

1 *Chrysanthemum* × *morifolium*
 'Akarikyuu'
 Chrysanth 'Akarikyuu'
2 *Anthurium andreanum*
 'Black Queen'
 Anthurium 'Black Queen'

28	p. 269

1 *Hippeastrum* × *hybridum*
 'Red Lion'
 Amaryllis 'Red Lion'
2 *Lilium orientalis* 'Sorbonne'
 Oriental Lily 'Sorbonne'
3 *Lilium longiflorum* 'Hinomoto'
 Easter Lily 'Hinomoto'

29 p. 271

1 *Agave americana* 'Variegata'
Century Plant 'Variegata'
2 *Anthurium* 'Arrow'
Anthurium 'Arrow'

34 p. 281

1 *Muscari armeniacum* Leichtlin
Armenian Grape Hyacinth
2 *Viscum album* L.
European Mistletoe

30 p. 273

1 *Aristolochia gigantea* Mart.
& Zucc.
Dutchman's Pipe
2 *Zantedeschia aethiopica*
'Green Goddess'
Calla Lily 'Green Goddess'

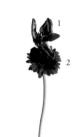

35 p. 283

1 *Tulipa* 'Rococo'
Tulip 'Rococo'
2 *Gerbera* 'Suri'
Daisy 'Suri'

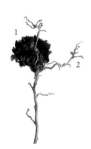

31 p. 275

1 *Paeonia lactiflora* 'Red Charm'
Chinese Peony 'Red Charm'
2 *Prunus mume* 'Unryuubai'
Japanese Apricot 'Unryuubai'

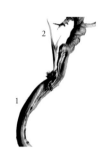

36 p. 285

1 *Juniperus chinensis* L. var.
sargentii Henry
Sargent Juniper
2 *Convallaria keiskei* L.
Lily of the Valley

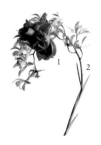

32 p. 277

1 *Rosa* 'Yves Piaget'
Rose 'Yves Piaget'
2 *Cymbidium floribundum*
Lindl.
Golden-Edged Orchid

37 p. 287

1 *Viola* × *wittrockiana*
'Frizzle Sizzle Yellow'
Garden Pansy 'Frizzle Sizzle
Yellow'
2 *Pandanus utilis* Bory
Common Screwpine

33 p. 279

1 *Anthurium andreanum*
'Snowy'
Anthurium 'Snowy'
2 *Phalaenopsis* 'Diamond Star'
Moon Orchid 'Diamond Star'

38 p. 289

1 *Prunus mume* 'Akebono'
Japanese Apricot 'Akebono'
2 *Paphiopedilum* Leeanum
Lawrence
King of Orchids
3 *Parmotrema tinctorum*
(Delise ex Nyl.) Hale
Umenokigoke

39 p. 291

1 *Akebia × pentaphylla*
 (Makino) Makino
 Five-Leaf Akebia
2 *Freesia enkelbloemig*
 'Elegance'
 Freesia 'Elegance'

44 p. 301

1 *Tulipa polychroma*
 Tulip Polychroma
2 *Osmunda japonica* Thunb.
 Japanese Royal Fern

40 p. 293

1 *Ranunculus asiaticus*
 'Morocco, Amizmiz'
 Persian Buttercup
 'Morocco, Amizmiz'
2 *Ranunculus asiaticus*
 'Morocco, Tantan'
 Persian Buttercup 'Morocco, Tantan'
3 *Freesia viridis*
 Freesia

45 p. 303

1 *Monstera friedrichsthalii*
 Fredericka Starlite
2 *Zantedeschia aethiopica*
 'Wedding March'
 Calla Lily 'Wedding March'

41 p. 295

1 *Hippeastrum × hybridum*
 'Christmas Gift'
 Amaryllis 'Christmas Gift'
2 *Citrus medica* var. *sarcodactylis*
 Buddha's Hand
3 *Akebia × pentaphylla*
 (Makino) Makino
 Five-Leaf Akebia

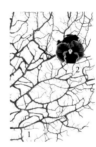

46 p. 305

1 *Codium fragile* (Suringar)
 Hariot
 Codium
2 *Viola × wittrockiana*
 'Frizzle Sizzle Blue'
 Garden Pansy
 'Frizzle Sizzle Blue'

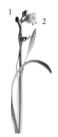

42 p. 297

1 *Freesia refracta* 'Excellent'
 Freesia 'Excellent'
2 *Narcissus* 'Fortune'
 Narcissus 'Fortune'

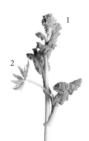

47 p. 307

1 *Brassica rapa* L. var.
 nippo-oleifera
 Wild Turnip
2 *Schefflera elegantissima*
 (Veitch ex Masters)
 Lowry & Frodin
 Aralia

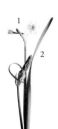

43 p. 299

1 *Narcissus tazetta* var. *chinensis*
 Japanese Narcissus
2 *Ornithogalum* 'Mt. Fuji'
 Star of Bethlehem 'Mt. Fuji'

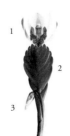

48 p. 309

1 *Cymbidium* 'Queen'
 Boat Orchid 'Queen'
2 *Vriesea carinata* 'Christiane'
 Vriesea 'Christiane'
3 *Cyclamen persicum* 'Victoria'
 Persian Violet / Primrose
 'Victoria'

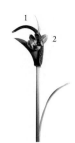

49 p. 311

1 *Anthurium* 'Arrow'
Anthurium 'Arrow'
2 *Fritillaria meleagris* L.
Snake's Head Fritillary

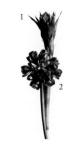

54 p. 321

1 *Guzmania* 'Torch'
Tufted Airplant 'Torch'
2 *Leontochir ovallei*
Lion's Claw

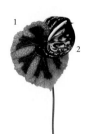

50 p. 313

1 *Begonia masoniana*
'Iron Cross'
Begonia 'Iron Cross'
2 *Anthurium andreanum*
'Burgundy'
Anthurium 'Burgundy'

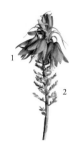

55 p. 323

1 *Fritillaria imperialis* 'Rubra'
Crown Imperial Fritillary
'Rubra'
2 *Aechmea penduliflora*
'Orange Berry'
Aechmea 'Orange Berry'

51 p. 315

1 *Brassica oleracea* L. var.
acephala DC. 'Dressy Afro'
Kale
2 *Erythrina speciosa* Andrews
Tiger's Claw

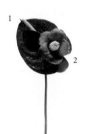

56 p. 325

1 *Anthurium andreanum*
'Tropical Red'
Anthurium 'Tropical Red'
2 *Camellia japonica* L.
Japanese Camellia

52 p. 317

1 *Asplenium antiquum*
'Dear Mirage'
Bird's-Nest Fern
'Dear Mirage'
2 *Stemona japonica*
(Blume) Miq.
Japanese Stemona

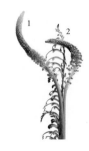

57 p. 327

1 *Bulbinella floribunda* 'Apricot'
Bulbinella 'Apricot'
2 *Chasmanthe aethiopica*
(L.) N. E. Brown
African Cornflag

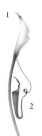

53 p. 319

1 *Zantedeschia aethiopica*
'Crystal Blush'
Calla Lily 'Crystal Blush'
2 *Nepenthes rafflesiana* Jack
Raffles' Pitcher Plant

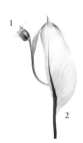

58 p. 329

1 *Fritillaria hermonis* subsp.
amana
Fritillaria
2 *Spathiphyllum* 'Merry'
Peace Lily 'Merry'

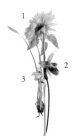

59 p. 331

1 *Helianthus annuus*
 'Touhokuyae'
 Common Sunflower
 'Touhokuyae'
2 *Paphiopedilum tonsum*
 (Rchb. f.) Pfitzer
 Bald Paphiopedilum
3 *Maxillaria picta* Hook.
 Painted Maxillaria Orchid

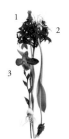

60 p. 333

1 *Muscari latifolium*
 Bicolor Grape Hyacinth
2 *Epidendrum secundum*
 'Fireball'
 Star Orchid 'Fireball'
3 *Phragmipedium* 'Andean Fire'
 Phragmipedium Orchid
 'Andean Fire'

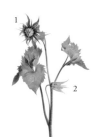

61 p. 335

1 *Helianthus annuus* 'Jade'
 Common Sunflower 'Jade'
2 *Gloriosa superba* 'Lutea'
 Flame Lily 'Lutea'

01 *p. 339*
—
1 *Proboscidea louisianica*
 (Mill.) Thell.
 Ram's Horn
2 *Rosa 'Rote Rose'*
 Rose 'Rote Rose'

02 *p. 341*
—
1 *Chrysanthemum × morifolium*
 'Fuego'
 Chrysanth 'Fuego'
2 *Anthurium andreanum*
 'Burgundy'
 Anthurium 'Burgundy'
3 *Dahlia 'Black Butterfly'*
 Dahlia 'Black Butterfly'
4 *Lilium longiflorum 'Hinomoto'*
 Easter Lily 'Hinomoto'

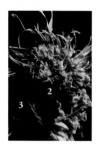

03 *p. 343*
—
1 *Gerbeara 'Giant Spinner*
 Toyotama'
 Daisy 'Giant Spinner
 Toyotama'
2 *Colmanara Wildcat 'Bobcat'*
 Colmanara Orchid 'Bobcat'
3 *Tulipa 'Mon Amour'*
 Tulip 'Mon Amour'

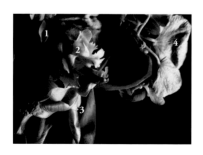

04 *pp. 344–345*
—
1 *Oxypetalum caeruleum*
 'Blue Star'
 Tweedia 'Blue Star'
2 *Epidendrum Princess Valley*
 'White Castle'
 Star Orchid 'White Castle'

3 *Iris × hollandica 'Blue Magic'*
 Dutch Iris 'Blue Magic'
4 *Hydrangea macrophylla*
 'Challenge Blue'
 French Hydrangea
 'Challenge Blue'

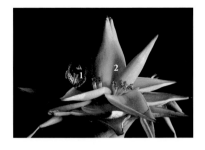

05 *pp. 346–347*

1 *Cymbidium Enzan Forest*
 'Majolica'
 Boat Orchid 'Majolica'
2 *Musella lasiocarpa*
 Chinese Dwarf Banana

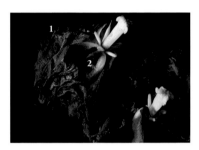

06 *pp. 348–349*

1 *Dahlia 'Holly Houston'*
 Dahlia 'Holly Houston'
2 *Tulipa 'Hollywood'*
 Tulip 'Hollywood'

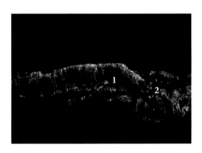

07 *pp. 350–351*

1 *Quercus suber L.*
 Cork Oak
2 *Colmanara Wildcat 'Bobcat'*
 Colmanara Orchid 'Bobcat'

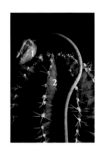

08 *p. 353*

1 *Papaver nudicaule L.*
 Icelandic Poppy
2 *Gymnocalycium mihanovichii*
 f. variegata
 Ruby Ball

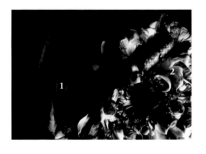

09 *pp. 354–355*

1 *Anthurium andreanum 'Previa'*
 Anthurium 'Previa'
2 *Ranunculus asiaticus 'Charlotte'*
 Persian Buttercup 'Charlotte'

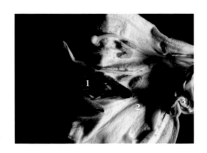

10 pp. 356–357

1 *Magnolia heptapeta*
 White Magnolia
2 *Lilium longiflorum* 'Hinomoto'
 Easter Lily 'Hinomoto'
3 *Alpinia zerumbet* (Pers.) B. L. Burtt & R.
 M. Smith
 Light Galangal

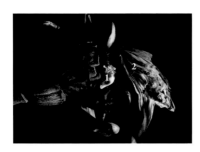

11 pp. 358–359

1 *Phalaenopsis* 'Everspring'
 Moon Orchid 'Everspring'
2 *Musa nana* Lour
 Dwarf Banana

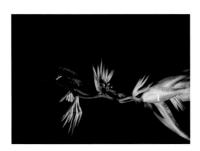

12 pp. 360–361

1 *Heliconia chartacea* 'Sexy Pink'
 Pink Flamingo

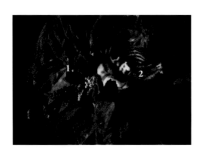

13 pp. 362–363

1 *Rosa* 'Piano'
 Rose 'Piano'
2 *Cymbidium* 'Gâteau Chocolat'
 Boat Orchid 'Gâteau Chocolat'

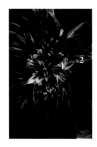

14 p. 365

1 *Dahlia* 'Kuroi Inazuma'
 Dahlia 'Kuroi Inazuma'
2 *Anthurium andreanum* 'Fiorino'
 Anthurium 'Fiorino'

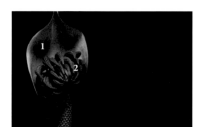

15 pp. 366–367

1 *Cyrtosperma merkusii*
 Pulaka
2 *Spathodea campanulata* P. Beauv.
 African Tulip Tree

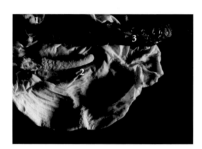

16 pp. 368–369

1 *Cymbidium* Happy Barry 'Sailor Moon'
 Boat Orchid 'Sailor Moon'
2 *Zantedeschia aethiopica* 'Gold Finger'
 Calla Lily 'Gold Finger'
3 *Anthurium bakeri*
 Bird's-Nest Anthurium

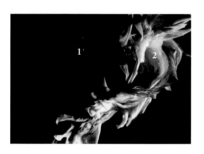

17 pp. 370–371

1 *Hyacinthus orientalis* 'Pink Pearl'
 Garden Hyacinth 'Pink Pearl'
2 *Dahlia* 'Amy K'
 Dahlia 'Amy K'

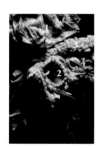

18 p. 373

1 *Tulipa* 'Orange Princess'
 Tulip 'Orange Princess'
2 *Nymphaea* 'Tina'
 Water Lily 'Tina'
3 *Eremurus bungei*
 Foxtail Lily
4 *Nigella damascena*
 'Blue Istanbul'
 Devil in the Bush 'Blue Istanbul'

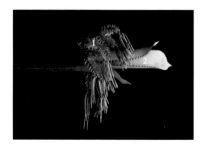

19 pp. 374–375

1 *Lycopodium phregmarioides*
 Lycopodium
2 *Aechmea purpureorosea* (Hooker) Wawra
 Aechmea

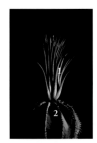

20 p. 377

1 *Tillandsia ionantha*
'Conehead'
Airplant 'Conehead'
2 *Uebelmannia pectinifera*
Buining
Uebelmannia

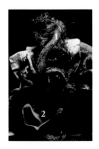

21 p. 379

1 *Aristolochia gigantea*
Mart. & Zucc.
Dutchman's Pipe
2 *Cymbidium* Enzan Knuckle
'Paulista'
Boat Orchid 'Paulista'

22 p. 381

1 *Cyathea spinulosa*
Wall. ex. Hook.
Large Spiny Tree Fern
2 *Paphiopedilum* Micmac
'Washington'
King of Orchids 'Washington'

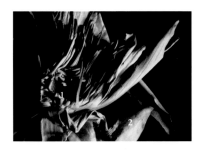

23 pp. 382–383

1 *Nymphaea* 'Enchantment'
Water Lily 'Enchantment'
2 *Rhyncattleanthe* Love Passion 'Orange Bird'
Rhyncattleanthe Orchid 'Orange Bird'

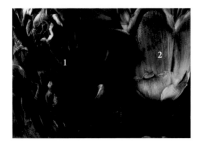

24 pp. 384–385

1 *Dahlia* 'Zorro'
Dahlia 'Zorro'
2 *Dianthus caryophyllus* 'Moondust'
Clove Pink 'Moondust'

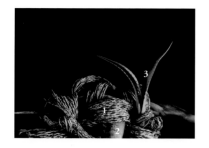

25 pp. 386–387

1 *Mascarena verschaffeltii* L. H. Bailey
Bottle Palm
2 *Strelitzia augusta* Thunb.
Bird of Paradise
3 *Aechmea purpureorosea* (Hooker) Wawra
Aechmea

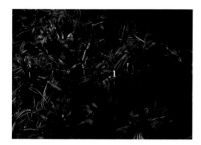

26 pp. 388–389

1 *Lycoris radiata* (L'Hér.) Herb.
Red Spider Lily

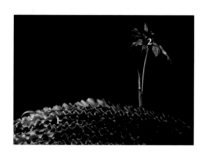

27 pp. 390–391

1 *Asplenium antiquum* 'Ruffle'
Bird's-Nest Fern 'Ruffle'
2 *Arisaema kiushianum* Makino
Hime-urashimasou

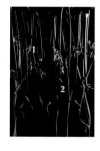

28 p. 393

1 *Osmunda japonica* Thunb.
Japanese Royal Fern
2 *Freesia viridis*
Freesia

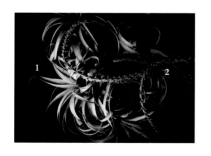

29 pp. 394–395

1 *Tillandsia xerographica* Rohweder
Shirley Temple Airplant
2 *Alluaudia procera* (Drake) Drake
Madagascan Ocotillo

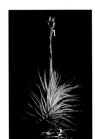

30 p. 397

1 *Tillandsia tectorum* E. Morren
 Roof Airplant
2 *Ferocactus latispinus*
 (Haworth) Britton & Rose
 Devil's Tongue Barrel

31 p. 399

1 *Paeonia lactiflora* 'Paula Fay'
 Chinese Peony 'Paula Fay'
2 *Anthurium andreanum*
 'Castor'
 Anthurium 'Castor'
3 *Anthurium chamberlanianum*
 Anthurium 'Rom's Red'

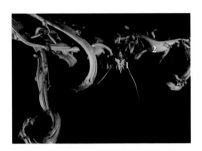

32 pp. 400–401

1 *Brassia* Eternal Wind 'Summer Dream'
 Brassia Orchid 'Summer Dream'
2 *Glycine* max (L.) Merr.
 Soybean

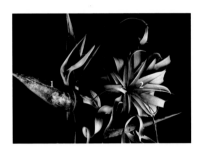

33 pp. 402–403

1 *Strelitzia nicolai* Regel & K. Koch
 White Bird of Paradise
2 *Tillandsia xerographica* Rohweder
 Shirley Temple Airplant

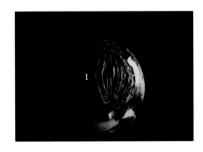

34 pp. 404–405

1 *Hippeastrum* × *hybridum* 'Double Dragon'
 Amaryllis 'Double Dragon'

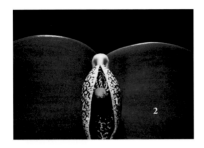

35 pp. 406–407

1 *Aristolochia elegans* Mast
 Dutchman's Pipe
2 *Massonia depressa*
 Hedgehog Lily

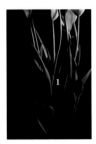

36 p. 409

1 *Tulipa* 'White Dream'
 Tulip 'White Dream'

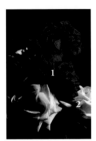

37 p. 411

1 *Rosa* 'Duke of Edinburgh'
 Rose 'Duke of Edinburgh'
2 *Rosa* 'Titanic'
 Rose 'Titanic'

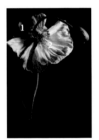

38 p. 413

1 *Osmunda japonica* Thunb.
 Japanese Royal Fern
2 *Papaver nudicaule* L.
 Icelandic Poppy

39 p. 415

1 *Hippeastrum* × *hybridum*
 'Apple Blossom'
 Amaryllis 'Apple Blossom'

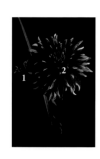

40 p. 417
—
1 *Freesia viridis*
 Freesia
2 *Dahlia* 'Lalala'
 Dahlia 'Lalala'

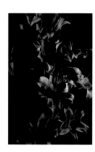

41 p. 419
—
1 *Lilium orientalis* 'Sorbonne'
 Oriental Lily 'Sorbonne'

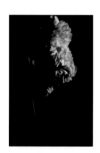

42 p. 421
—
1 *Ranunculus asiaticus*
 'Belfort'
 Persian Buttercup 'Belfort'

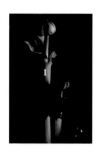

43 p. 423
—
1 *Hippeastrum* × *hybridum*
 'Royal Velvet'
 Amaryllis 'Royal Velvet'

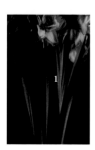

44 p. 425
—
1 *Narcissus* 'Tahiti'
 Narcissus 'Tahiti'

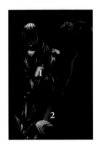

45 p. 427

1 *Zantedeschia aethiopica*
'Silk Road'
Calla Lily 'Silk Road'

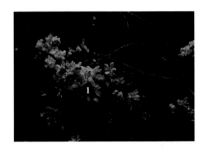

46 p. 429

1 *Paphiopedilum* 'St. Swithin'
King of Orchids
'St. Swithin'
2 *Cyrtosperma johnstonii*
Arbi

47 pp. 430–431

1 *Cerasus × yedoensis* (Matsum.)
A. V. Vassil. 'Somei-yoshino'
Flowering Cherries
'Somei-yoshino'

Index of Flowers by Name

H·I·J

N · O · P

V · W · Y · Z

Acknowledgments
and Biographies

Acknowledgments

The completion of this book was made possible by the combined efforts of many individuals, organizations, and collectives. In particular, we, the authors and the editor, would like to express our respect and gratitude to the following:

Kenya Hara and Kaoru Matsuno created a design that drew out the charm of the work to greatly advance the book's primary focus and objective. Chen Fangju delicately designed the enormous list of flower names. Kenya Hara also introduced us to his long-time friend, Lars Müller, with whose publishing house, Lars Müller Publishers, the English-language edition of this book was realized. We are thrilled that Lars' insightful and well-considered advice, as well as his editorial and design philosophy, were incorporated into this book. Michael Ammann, editor at Lars Müller Publishers, was a highly reliable counterpart during the intense production. Seigensha's Hideki Yasuda, Yoko Yasuda, Sosuke Tanaka, Ayako Kanzaki, Chikako Kaneda, along with the entire sales team, supported the making of this book. At the printing house SumM Color, Katsumi Matsui, Kazuo Yoshida, and printing director Masuo Taniguchi produced a remarkably high degree of precision in the printing. The Ministry of Agriculture, Forestry and Fisheries and the Japan Flower Promotion Center Foundation provided invaluable information for the preparation of this book's introduction. Thanks to Ivan Vartanian, who translated the introduction, and Mariko Yanagida, who provided sage translation advice, and Jonathan Fox, who copyedited the English version. The list of flower names was overseen by AMBC (see p. 511), who tirelessly labored day and night toward its completion. In its initial stage, the preparation of the list involved the assistance of Hisashi

Kaneko of Floral Collection. Thanks also to VOGT Landscape, Zurich, for their advice on the English version of the list. Lastly, we would like to extend our humble gratitude to all those who generously contributed to the preparation of this book. And to all the flowers that are in bloom in this book, and all the withered plants that are not included too, we express our greatest respect.

Makoto Azuma, Shunsuke Shiinoki, and Kyoko Wada, June 2012

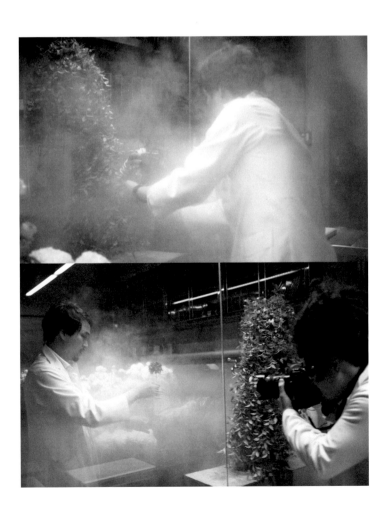

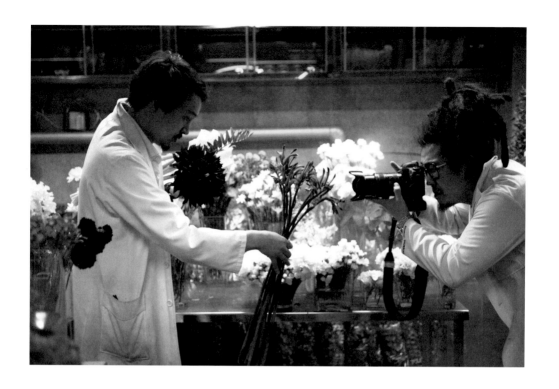

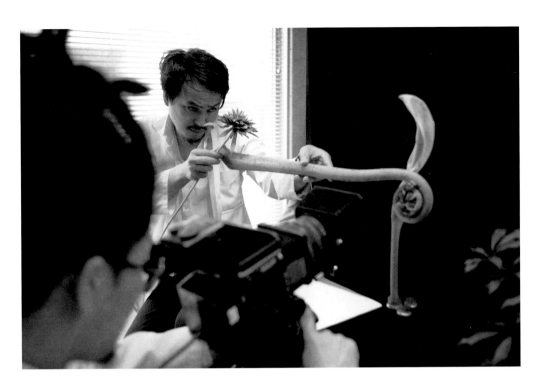

Makoto Azuma
florist and artist

Born in Fukuoka in 1976. Since the year 2000, he has worked together with Shunsuke Shiinoki as a florist in Tokyo, and in 2002 they established the specialty florist shop Jardins des Fleurs. Since 2005, Azuma has been exhibiting his creations internationally, including at such venues as the Fondation Cartier pour l'art contemporain (art performance *Kehai,* 2006) and the NRW-Forum Düsseldorf (2008). He has participated in the *Second Nature* exhibition at 21_21 designsight, Tokyo (2008–09); with the work *Shiki-1* for the Japan Industry Pavilion at the World Expo 2010 Shanghai; in the exhibition *Alter Nature: We Can* at the Z33 art center in Belgium (2010–11), with the work *shiki × bulb* in the exhibition *Instant Design* at the Triennale Design Museum, Milan; and with the work *Time of Moss* within Kenya Hara's *Designing Design* exhibition at the Beijing Center for the Arts (2011). His creations, which have been described as "botanical sculptures," have attracted a great deal of attention from the art world. His first book (with Shunsuke Shiinoki), *2009–2011 Flowers,* was released in 2011. Since 2012, he is the creative director of Suntory Midorie, an urban ecological development project. He lives and works in Tokyo.

http://www.azumamakoto.com/

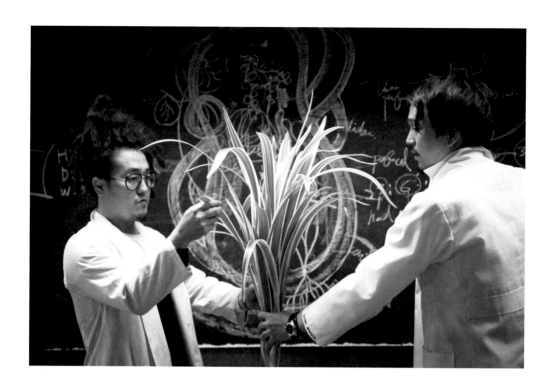

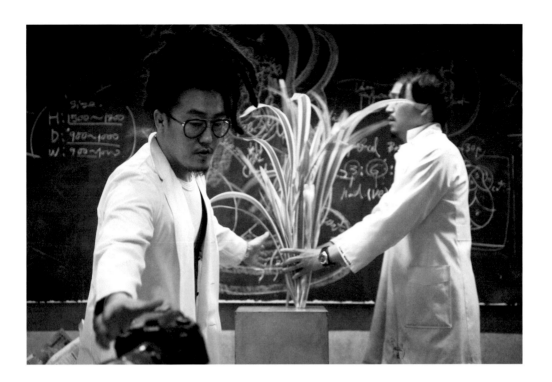

Shunsuke Shiinoki
florist and photographer

Born in Fukuoka in 1976. He began his career as a florist in 2000 with Makoto Azuma, and in 2002 they established the specialty florist shop Jardins des Fleurs. Having demonstrated a great aptitude for photography, since 2005 he has continuously challenged the incomparable beauty, mystery, and vitality of nature through his camera. Only his photography can hold on to the tenuous existence of flowers as they ceaselessly metamorphose and decay. His sensitive and magical work seems to suspend time, giving flowers an eternal life. His first book (with Makoto Azuma), *2009–2011 Flowers,* was released in 2011. He lives and works in Tokyo.

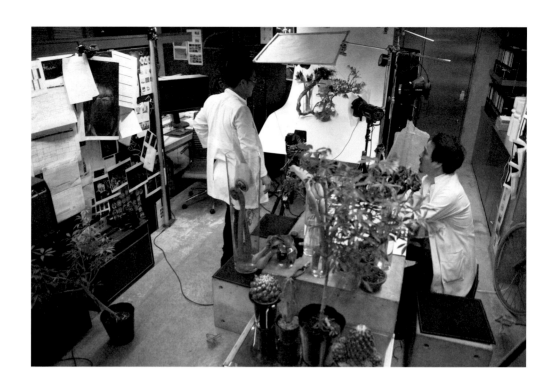

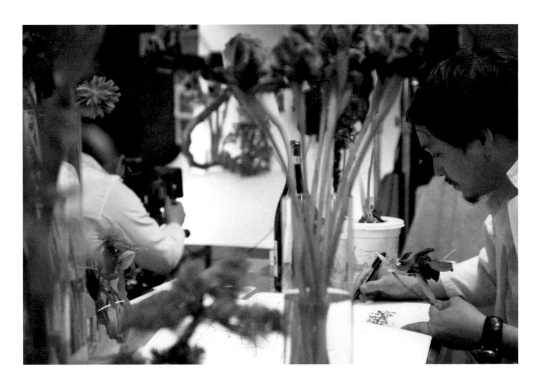

Azuma Makoto Botanical Congress
Since 2012

Makoto AZUMA
Shunsuke SHIINOKI

Eri NARITA
Mika KAWAI
Takuto AIKABE
Yuri OTAKEGUCHI
Takahide HIRATSUKA
Takeshi OUCHI

The Index of Flowers (pp. 433–503) was compiled
by the above members.

Encyclopedia of Flowers

Flower works by Makoto AZUMA
Photographed by Shunsuke SHIINOKI

Editor: Kyoko Wada
Design: Kenya Hara, Kaoru Matsuno, and Chen Fangju | Nippon Design Center
Translations: Ivan Vartanian
Copyediting: Jonathan Fox

Printing and binding: Sun M Color Co., Ltd.
Paper: b7 TRANEXT by Nippon Paper Group, Inc.

Lars Müller Publishers
Zürich, Switzerland
www.lars-mueller-publishers.com

ISBN 978-3-03778-313-9

Printed in Japan